Some Liked It Hot

KRISTIN A. McGEE

✸

Some Liked It Hot

JAZZ WOMEN IN FILM AND
TELEVISION, 1928–1959

✸

WESLEYAN UNIVERSITY PRESS

Middletown, Connecticut

Published by Wesleyan University Press, Middletown, CT 06459

www.wesleyan.edu/wespress

"Let's Fall in Love"
By Ted Koehler and Harold Arlen
© Copyright 1933 by Bourne Co.
Copyright Renewed
All Rights Reserved International Copyright Secured
ASCAP

Library of Congress Cataloging-in-Publication Data

McGee, Kristin A.
 Some liked it hot: jazz women in film and television, 1928–1959 /
Kristin A. McGee.
 p. cm. — (Music/culture)
 Includes bibliographical references and index.
 ISBN 978-0-8195-6907-3 (cloth: alk. paper) —
 ISBN 978-0-8195-6908-0 (pbk.: alk. paper)
 1. Women jazz musicians in motion pictures. 2. Big bands in mo-
tion pictures. 3. Jazz in motion pictures. 4. Motion pictures—
United States—History—20th century. 5. Television broadcasting
of music. 6. Variety shows (Television programs)—United States.
I. Title.
 PN1995.9.J38M34 2009
 791.43'6578—dc22 2009000997

 Wesleyan University Press is a member of the Green
Press Initiative. The paper used in this book meets
their minimum requirement for recycled paper.

For Kathy and Charles McGee

Contents

✪

Part Four: Variety Television and the 1950s

Illustrations

✺

Acknowledgments

❀

This book evolved in part from earlier work at the University of Chicago from 1999 to 2003. During my time there, I was fortunate to receive expert scholarly advice from some of the field's leading international researchers of music and/or film including Philip Bohlman, Martin Stokes, Jacqueline Stewart, Travis Jackson, and Ronald Radano. Phil Bohlman has continued to provide inspiration, mentorship, and advice with regard to the direction of this project and has contributed expert commentary for several of the book's chapters. I am utterly grateful for his support, enthusiasm, and unerring optimism. Martin Stokes has similarly provided constant inspiration and scholarly advice with regard to both earlier drafts of the manuscript and more recent chapters.

In 2003, I was fortunate to receive a Franke Fellowship at the Franke Institute of the Humanities. There I grew both personally and intellectually within the rich intellectual atmosphere of the Institute's environs and during the weekly research meetings. I am especially indebted to the Institute's Chair, Dr. James Chandler, who suggested the first part of this project's name. Thanks also to Margot Browning, who provided a close and critical reading of several chapters.

Sherrie Tucker provided valuable input for the chapter on the International Sweethearts of Rhythm and independent film and also alerted me to important African American side-lining films. Mark Cantor offered valuable and expert commentary, providing important contextualization to SOUNDIES as well as access to his extensive archival film and production collection.

I am especially grateful to a number of colleagues who have volunteered to read various versions of chapters from the book. Celia Cain knows the content of this project better than any other, as she has willingly elected to participate in weekly discussions of chapters, readings, and films. Our conversations dating from 2004 until the present have made a

profound impact upon the organization, writing, and style of this book and there are no words to describe how grateful I am to have her as a colleague, friend, critic, and confidante. Other scholars who have offered their expert criticisms of various chapters of this book are Ron Radano, Jacqueline Stewart, Fabian Holt, Travis Jackson, Ashley Miller, the reviewers of Wesleyan University Press, the reviewers of *Women and Music,* and the reviewers of *Popular Music and Society.* I would also like to thank Parker Smathers, Leslie Starr, Peter Fong, John Bealle, and the University Press of New England copy editor for their expert guidance and reviews.

Much of the audio/visual research of this book has been carried out at various archives and film collections. Many of the films examined for this book have been generously offered for research purposes by Fred J. MacDonald of the MacDonald and Associates' Film Archive in Chicago. MacDonald's unparalleled jazz-film archive was indeed one of the richest sources of early female jazz films and television programs available. Throughout my many visitations, Dr. MacDonald suggested new films and provided copies, as well as imparting important historical data concerning dates, musical numbers, and musicians names. His memory for such details was critical to the historical documentation for these many (and often uncredited) films. Further, Dr. MacDonald's own works on the subject of television provided much-needed historical contextualization for the relationship of jazz women to early television programs. I am also grateful to have had the expert help and advice of the Library of Congress's Zoran Sinobad, who provided stills of the International Sweethearts of Rhythm, and Rosemary Hanes and Bryan Cornell, who alerted me to important collections, recordings, and films. Debbie Gillespie of the Chicago Jazz Archive has consistently suggested resources from that archive in addition to notifying me of relevant exhibits and materials including a scrapbook of Paula Jones, trombonist with the Ingenues, that was on exhibit at the Chicago Historical Society. Callista Jippes and Jan Veeman of the University of Groningen provided essential video transfers and captured stills. Susan Meyers also generously offered a personal promotional photo of her great-aunt's group (she played cello), Phil Spitalny's Hour of Charm Orchestra. Thank you also to Flori Kovan who alerted me to the extensive collection of filmed interviews of Virgil Whyte's Musical Sweethearts at the Smithsonian and provided detailed knowledge of her father's all-girl band. Kovan also offered some essential connections between the 1959 film *Some Like It Hot* and White's earlier all-girl swing group.

I wish also to thank my family and friends for their loving and enthusiastic support—all of the McGees, Johnsons, Soines, Andersons, and Drommerhausens. Thanks are also owed to my friends Gerry Couquillard, Ron

and Melissa Howe, Wiebe Cazamier, Meredith Miller, Rikky McRae, and Ruth Wasserman, who listened to my stories, provided encouraging words, and shared their personal insights about research and writing.

Finally, I remain eternally indebted to the women who willingly shared their stories with me about playing jazz, swing, and popular music during these three decades. Thanks especially to Roz Cron, Clora Bryant, Doris Swerk, Helen Jones, Anita Linder, Rosetta Reitz, and Jane Sager. Your stories of musical adventure, professionalism, and your intimate conversations taught me things I could never have imagined. I hope this project has in some way conveyed the many images, narratives, and sentiments that you shared with me.

Introduction

❊

One of the girls, violinist, photographs so well she looks to be a "ringer" until the later passage demonstrates her fiddling. All girl angle, of course, is the catch to this one.
— *Variety,* review of the Ingenues (1928)

But where others murder the classics, Hazel Scott merely commits arson. Classicists who wince at the idea of jiving Tchaikovsky feel no pain whatever as they watch her do it. She seems coolly determined to play legitimately, and for a brief while, triumphs. But gradually it becomes apparent that evil forces are struggling within her for expression. Strange notes and rhythms creep in, the melody is tortured with hints of boogie-woogie, until finally, happily, Hazel Scott surrenders to her worse nature and beats the keyboard into a rack of bones
Says wide-eyed Hazel: 'I just can't help it.'
—"Hot Classicist" in *Time,* 5 October 1941

·Playing in an orchestra to most men is a job. To a woman it's an honor.
—Ina Ray Hutton, *Los Angeles Times* (Ames 1956)

American mass culture emerged not from momentous events and grand designs but through small gestures, some spontaneous and collaborative, some methodical, and others appropriative and exploitative. Its earliest forms inevitably entailed experiments in cultural taste, including a multitude of negotiating acts such as the gendering of genres, the riffing of cultures, and the racializing of bodies. Always there were small maneuvers behind the scenes: a director's cut, the multiplying of frames, an unexpected instrumental break, or a harpist's astonishing acrobatic act. Mass culture depended upon new technologies to capture these small gestures and was invigorated by the optimism of entrepreneurs willing to stake their reputations at the dawn of a new century where the making and breaking of fortunes, the rapid erection and abandonment of entertainment vestibules, and the radical restructuring of gender roles were softened by the incorporation of attractive and desirable "girls"—as spectacles, flash acts, novelties, triple threats, erotic songstresses, innovative soloists, musical wizards, cultivated amateurs, and soothing choirs. Performing women were many of these things at different times, and always

prodigious and versatile. Indeed, "variety," the foundation of mass culture's initial viability, evolved into a mass-mediated theatrical form and a cultural ideal in and of itself.

This is the stuff of America's real jazz culture, born from the breaching of urban boundaries, from intensified physical contact (often sexual and racialized). It came of age in rundown tenements, prostitution districts (like Chicago's notorious Levee), and crowded rent parties. And it reached its zenith in exclusive rooftop cabarets enlivened with chorus girls, blackface entertainers, and jazz singers, in elegant ballrooms teeming with frenzied dancers, and in picture palaces showcasing double features and the most entertaining stage bands—places providing refuge from the crowded and confrontational environs of the burgeoning urban metropolis. The decade's sobriquet, the "Jazz Age," suggested all these glorious constitutive parts. Yet it often also neutralized the many identities and mixed relations that hastened the birth of mass culture: African Americans, Asian Americans, Italians and Poles, Cubans and Puerto Ricans, Jews, Catholics, Christian Prohibitionists—and especially women. Indeed, during the first half of the twentieth century, women, as performing subjects, personified "experiments in cultural taste."

During the first decades of the twentieth century, "jazz," a paradoxical catchphrase, embodied a range of contradictions from all things urban and musical to all things innovative, creative, and progressive, or conversely to all things contaminated, feminized, commodified, and debased. It also implicated the cultural contact of diverse racial, social, and cultural groups and elicited the energy, optimism, and abandon characterizing America's new entertainment spaces. Yet "jazz," cunningly adopted by the culture industries, also coded and denied the labor and creativity of those not frequently associated or credited with its origins, its production, its creation, its evolution, and its elevation as America's "true art."

This book examines jazz's contradictions by illuminating the tenuous yet persistent relationship between the media and popular culture female performers, especially jazz women during the first half of the twentieth century. At stake are the fascinating and diverse representational strategies adopted by performing women as jazz instrumentalists or as popular musicians in the emerging mass-mediated forums such as vaudeville, variety, radio, film, and television. Deconstructing these visually and aurally centered texts, one gains a broader perspective of how new technologies, variously implemented in the context of an expanding mass culture industry, supported, sustained, or prohibited professional women's performative and musical lives. Further, these representations speak not only to the various modes and strategies adopted by jazz women and their producers in

the localized jazz world, but also to underlying tensions surrounding the transformation of gender and race relations in public contexts from the second industrial revolution to the more conservative yet economically prosperous postwar era.

By critically examining visual and aural media such as sound film and television, I highlight the historically rooted and highly selective representation of feminine musicality. In so doing, I reveal pervasive and residual anxieties (betraying nineteenth-century antecedents) about changing notions and behaviors for expressing sexuality, race, and class. In many ways, the proliferation of public spaces incorporating jazz styles into their musical offerings indicated urban America's resistance to *and* absorption of cultural difference. These popular culture venues also became sites for contesting nineteenth- and twentieth-century value systems, frequently worked out through the naming of musical genres and the codification of musical categories.

During the early decades of the twentieth century, nationalistic and appropriative rhetoric proclaimed jazz to be America's "true" national culture. Given the simultaneous underrepresentation of female instrumentalists and jazz performers in the resulting jazz canon (excluding the handful of blues and jazz vocalists), investigating the ways that women have interacted with this highly volatile and convoluted phenomenon provides greater understanding of how women have been constituted by and constitutive of American cultural values. At times they are exemplars of professionalism and specialization; at others, mere by-products of mass culture's increasing commodification.

Performing women, although generally excluded from developing, controlling, or implementing new technologies, have been consistently and actively recruited as testing grounds for the incorporation of new mediums in the public domain. For example, Edison's earliest Kinetoscopes provided Americans a more intimate and private mechanism to satisfy their Orientalist desires for viewing exotic, dancing, musical women. These same films were variously and clandestinely distributed, while at the same time uncatalogued. Yet they remain some of the most cherished of late-nineteenth-century film documentations. Indeed, it is often the reproduction of women's fascinating popular culture mediations that hastens the public's commercial engagement with experimental new technologies— justified in the name of science and progress, implemented to document mass culture's exotic, sexualized others.

During the twentieth century, the active cataloguing of iconic American male jazz artists—documented in various audio reproductive mediums from electrographic studio recordings to broadcasts of live jazz sessions—

curiously peripheralized the contributions of female groups and instrumentalists, rendering the process of reconstructing these women's musical lives arduous and frustrating. While archives dedicated to jazz greats like Duke Ellington are well funded, well stocked, and heavily referenced, the historical documents that could provide such useful source material for female jazz musicians remain comparatively few. What is left are a number of general and brief industry reviews and a plethora of fascinating visual media, discovered by curious collectors who sometimes dismiss their cultural value, yet anxiously guard these artifacts for their indescribable appeal. In this book I examine women's roles as objects of reproduction technologies, as well as the complex motivations for cataloguing and defining musical genres.

Visual media of female jazz musicians pop up in the most unexpected places: in zoos, basements of Victorian homes, film studio storage rooms, and personal collections. Yet their cultural significance is consistently devalued. These films are casually mentioned in conversations with jazz historians as novelties, a description that fails to recognize the immense popularity and wide circulation of female jazz and popular music performances from the 1920s through the 1950s. Yet because of their estimation as rarities, spectacles, or novelties, finders often use them for varying purposes, without preserving the original context. And because of copyright exclusions, compilers are often forced to cut out original credits, resulting in films that are uncredited, cut up, or pasted into new compilations. Yet these documents survive because of the strange and perhaps fetishistic attraction that they produce upon discovery—as if one has stumbled onto an artifact of an exotic, forgotten culture.

If nothing else, these visual and aural media provide indisputable documentation of women's real engagement with jazz culture, with American popular culture, and, more important, with the expanding sphere of mass culture. Their creation prompted both exploitative and beneficial relationships between female performers and the growing mass-entertainment moguls, whose vertical integrationist efforts, beginning during the 1920s, initiated a complex infrastructure resulting in the current oligopoly of transnational media corporations. And women's presence and visual representation as popular artists remains critical to these expansionist cultural and economic alliances.

In many ways the sheer number of mass-mediated texts of female popular and jazz performances suggests a unique moment in American music history: when women were permitted—and encouraged—to enter into and perform popular music in heretofore male-dominated public spaces and professional domains. During the transitional decades of the 1920s and

1930s, a public debate on race, gender, and popular music arose, unleashing a discourse that ultimately disrupted the all too narrowly conceived jazz canon. By tracing popular debates concerning women, race, and jazz, I hope to explain women's eventual exclusion from the jazz canon. An analysis of race, gender, and the jazz canon is essential to understanding women's social, philosophical, and musical presence in American culture during the first half of the twentieth century.

Throughout the book, I employ a comparative approach to elucidate the historical impact of race upon musical performance and representation of and by women in jazz. This approach allows me to explore and contrast the public musical practices of black artists and racially mixed "all-girl" bands, such as Hazel Scott and the International Sweethearts of Rhythm, with those of the more visibly mediated "white" female artists and ensembles, such as Peggy Lee and Ina Ray Hutton and Her Melodears.

My analyses of mass-mediated female jazz performances draw heavily from the disciplines of ethnomusicology, gender studies, and cultural studies. I examine how women constructed alternative identities as jazz musicians, defying the prevailing gendered representations of the highly unstable prewar and war years and the more economically stable postwar years. Specifically, I implement critical apparatuses of recent inquiries in cultural studies to investigate how perceptions of women in the mass media influenced public associations of gender and race with the performance of female jazz. In doing so, I compare how perceived racial or social differences variously influenced the presentation and performance practice of women of color with those of white women musicians.[1]

Recent explorations in gender studies guide me to examine male-dominated musical ideologies and their influence upon the development and expansion of all-girl bands and female instrumentalists. In particular, I investigate how certain pervasive, socially constructed feminine and masculine musical aesthetics informed women's personal musical development while they undertook careers as jazz musicians. Finally, I examine how issues of sexual identity are played out in terms of performance practice and the presentation of group identity both for women of color and, comparatively, for white female musicians.[2]

Sherrie Tucker's important historical ethnography of the many all-girl bands active during the 1940s, *Swing Shift* (Tucker 2000b), informs the analysis of all-girl bands discussed in this book. Tucker weaves together hundreds of personal interviews with jazz women in order to foreground "women musicians who already imagine themselves" in jazz and swing history (28). Her swing history focuses upon the 1940s, in part because of the high visibility of female musicians, but also because of the ways that

discourses of "gender, race, nation and labor" resonate with World War II female performances (28). In some respects, this project's theoretical approach resembles Tucker's, by combining ethnography and historiography with other cultural, musical, and gendered explorations. However, I examine a wide range of gendered performances from more than four decades of rapidly transforming social, gendered, racial, and cultural activity. I begin with an analysis of sound films and vaudeville during the Jazz Age and continue into the forms of domesticated popular culture activated by the medium of television, which provided some of the few performing opportunities for jazz artists in the postwar decade.

This book attempts to provide an alternative and broader examination of women's presence in jazz and in American popular music during the first half of the twentieth century by critically examining the various ways that female jazz musicians were represented in mass-mediated texts from the 1920s until the 1950s, and especially as these mass-mediated texts critically informed the restructuring and transformation of, and (sometimes) prohibitions against, other types of female jazz performativity.

I am reminded of my first jazz film presentation at a national musical conference, after which a highly revered jazz scholar cuttingly asked: "Why would you work on something that has already been written about by Sherrie Tucker?" I found this question both surprising and disconcerting considering the lack of perspectives that have been published on the subject of women in jazz. In retrospect, I wished that I had responded, "Would you have asked the same if I had presented a paper on Louis Armstrong or Charlie Parker?" I imagine the answer would have been no. Indeed, this book arises in part to redress the far too few perspectives on women's participation in jazz during the twentieth century. Specifically, I believe that expanding the discussion to include other forms of cultural and comparative analysis will enliven the debate, foreground the subject, and provide additional historically rooted documentation of women's presence in American popular music as promoted by the pervasive and influential culture industries.

By focusing upon representations of jazz women in mass-mediated texts, I present women's heavily gendered and racialized performance practices as both productive and symbolic of social and cultural norms. The various identities promoted of popular performing women speak to underlying power structures that are in no small part powerfully projected in the mass-mediated sounds and images of Hollywood creations as well as the less established experimental visual mediums such as the early short subject sound films.

By tracing the changing receptions and modes of female musical activity from the late 1920s through the late 1950s, I identify an emerging modernist

cultural criticism that eventually alienated women from the narrowing sphere of jazz practice. As I uncover these debates, I interrogate the mechanisms of canon formation (especially those ideological systems emerging during the 1930s) that privileged a certain kind of "universalist" yet highly gendered jazz history—one that generally failed to account for the cultural activities and performances of female musicians in the realm of jazz instrumentalism and more broadly in the world of mass culture.

By examining how dominant and hegemonic mediated representations in the culture industry informed and altered women's public performances, one recognizes an overarching set of gendered belief systems that both inspired women to resist dominant and masculinist ideologies, and in other forms, to refashion and adopt certain stereotyped and gendered performance practices. By recognizing those types of discourses surrounding various modernist, mass-mediated culture productions such as the revolutionary short subject musical films, chorus-girl acts in vaudeville, and female specialty acts in variety television, I expand a stream of jazz criticism initiated by cultural jazz scholars such as Gabbard (1995), Stowe (1994), Gendron (1995), Lott (1995), and Tucker (2000b), whose works more fully investigate the masculinist ideologies of much of jazz historiography by broadly integrating analyses of other forms of cultural production, most notably film and television.

While drawing upon the works of feminist performance scholars including Hayes and Williams (2007), Carby (1986, 92, 94, 96, 99), Placksin (1982), Handy (1981, 1983), Tucker (1996, 2000), and Dahl (1984) and their investigations of dominant gender ideologies and sexual representations, as well as the many narratives afforded by these jazz women, the critical framework of this study differs in two distinct ways. First, I have attempted to provide a thorough analysis and comparison of female performances to other gendered, and seemingly more remote, cultural phenomena. In chapter 2, for example, I examine those cultural frameworks that supported blackface chorus-girl acts in vaudeville and Broadway revues; I contrast these performances with the types of musical and visual performances exhibited by early all-girl vaudeville and jazz bands, such as the Ingenues. I also compare the ways that groups of uniformly typed "girls" in Broadway productions and Hollywood film musicals informed the visual representation of all-girl bands in short subject films and in theatrical settings.

My discussion of the dozens of nearly unexamined all-girl, jazz-band films lays claim to these women's extensive visual exposure during the 1930s and 1940s. Only a few of these, such as the Hour of Charm's appearances in Universal's *When Johnny Comes Marching Home* (1943) have been addressed by jazz scholars such as Tucker (2000). By connecting these films to

other historical "texts"—from reviews of all-girl performances and jazz recordings to jazz women's own recollections—I reveal the cultural foundations for the organization, promotion, and presentation of all-girl acts during the late 1920s as highly visual, gendered, racialized, and sexual spectacles that drew upon modern notions of technology, leisure, mass entertainment, ethnic assimilation, and musical novelty. These types of Jazz Age femininity did not entirely withstand the vast gender transformations of World War II. By tracing the various manifestations and public reception of all-girl jazz during these two decades, I unveil the changing perceptions of jazz and the accompanying associations of race, gender, and sexuality that altered the ways that modern women presented themselves as public performers and as jazz musicians during the 1940s and 1950s.

Typically, authors like Placksin (1982), Dahl (1984), D. Handy (1983), Tucker (2000b) and Gourse (1995) have provided excellent accounts of these women's professional lives, but little has been put forth concerning the actual musical sounds produced by such bands as the Melodears, the International Sweethearts of Rhythm, and Dave Schooler's 21 Swinghearts. Therefore, its dedicated theoretical analysis of several musical recordings produced by all-girl bands and female jazz musicians on film and television further distinguishes this work from most scholarship on women in jazz during the last century. The lack of musicological scholarship is, of course, partly determined by the relative difficulty in finding recordings of female instrumentalists. By comparing more formal musicological identifiers, including the various repertoires, stylistic performance preferences, and individual soloing vocabularies of the all-girl bands with some of the popular male big bands, I acknowledge the professionalism exhibited by many of these musicians, as well as the widely divergent musical styles presented by bands, many of whom chose to classify themselves, in varying degrees, as either "sweet," "hot," or "swing" much in the same way that male bands aspired to certain reputations as swing, jazz, society, or dance musicians.

These highly debated musical allegiances (noted and categorized by the jazz press) color our understanding of how "sweet" repertoires exemplified by Phil Spitalny's Hour of Charm became more "feminized" during the war despite the considerable popularity of "sweet" male bands during the 1920s and 1930s. Further, one recognizes opposing trends by "hot" swing bands like the International Sweethearts of Rhythm, who self-consciously prioritized musical sounds, rhythmic articulations, and soloing vocabularies to distinguish themselves from the increasingly publicized "European" femininity of many white all-girl bands modeled after the expert musicians of the Hour of Charm. By comparing the musical sounds of female bands

to male bands, women's unique musical styles, skills, and creative contributions begin to emerge, finally sharing the airwaves with more canonical male sounds.

The eleven chapters of this book explore historical precedents for the success of female jazz musicians, especially during two decades of socioeconomic difficulties, and of the pressure placed on male jazz musicians by World War II and the postwar years. Other prominent discussions investigate topics such as the relative influence of popular theatrical forms from vaudeville to variety revues upon the earliest jazz women performances, the mediated representations of female bands in recordings, film, print, radio, and television, and the conflation of race and music as they are played out in public spaces. Finally, the musical sounds themselves are prioritized with a comparison of "feminized" band repertoires, improvised soloing vocabularies, and "sweet" and "swing" performance styles. Invaluable considerations for such an analysis are the various constructions of musical femininity put forth by the media and the producers of all-girl bands, and female jazz artists, the process of integration (especially in the South), and the concomitant coping mechanisms induced by mixed all-girl bands on tour.

I conclude this book by examining the journalistic, historical, and popular culture mechanisms that further implicated women's musical performances in the erosion and deterioration of big band jazz. By tracing debates in the jazz trade magazines (especially *Down Beat*), I uncover the expansion of a modernistic discourse that simultaneously blamed and alienated female jazz musicians. During the late 1940s, many of the most famous "hot" jazz venues, like those on Los Angeles's Fifty-second Street, were replaced with strip joints and variety theaters featuring "girly acts." Jazz critics bemoaned the transition from "jams to gams," yet failed to articulate men's own culpability in jazz's public and creative destabilization. During the 1910s and 1920s, the expansion of and support for public displays of male desire centered on sexual spectacles and all-girl acts, first appearing in burlesques, variety revues, and vaudeville acts.

Public support of mass-produced female sexual spectacles was later supported and reinforced during the 1940s by the enormous success of wartime pinups and sexy female bandleaders like the former burlesque and striptease artist Ada Leonard. Widely circulated representations of pinups and bandleaders inspired and nourished such newly organized public, modern, and popular cultural vessels for male desire. Popular demands for heavily mediated, mass-produced, and streamlined representations of female sexuality in the service of public affirmations of male desire did much to destabilize jazz venues—sites once designated for individual creativity and artistry.

The brief resurgence of all-girl bands and female jazz hosts during the 1950s recalled the tone of the early 1940s: women performed as all-girl spectacles in a variety-revue context, distributing feminine glamour, swing, and wholesome vaudeville-style acts. The short-lived reentry of all-girl bands into the public sphere through the heavily mediated and visually attuned medium of television spoke to women's continued peripheralization as visual objects and feminine spectacles over creative musical subjects. Yet their continued success also suggested the skill, ingenuity, and expertise of these performers.

In contrasting gendered presentations of all-girl bands in films, recordings, and live performances, I posit that jazz women of the 1920s through the 1950s both resisted and promoted established and newly emerging gender ideologies. Jazz women resisted masculinist and sexist ideologies by asserting personal and musical agency: women asserted their creative power through improvised performances and through their increased public visibility and professionalism during national and international tours. Their personal power also arose from their expanded wage-earning capabilities. Further, jazz women promoted constrictive gendered ideologies: from the pejorative "triple threat" female persona to widely circulated publicity campaigns depicting the "novelty of feminine uniformity," and residual Victorian representations evoking the "cult of white womanhood" as women's performances reenacted these highly popular and carefully constructed spectacles of femininity, sexuality, and musical eroticism. Clearly, jazz women of these decades consciously and sometimes reluctantly cooperated and collaborated with media producers, bandleaders, and music managers to ensure that their performances were culturally received in ways that enabled these bands to profit financially and commercially. These heavily mediated gendered performances also ensured that all-girl bands successfully competed with the popular male jazz bands of the day and, more important, with the highly fetishized all-girl spectacles presented in film, variety revues, and vaudeville.

In a sense, black musical women became cultural referees, negotiating musical, racial, and gender boundaries to create a musical genre both prodigious and accessible within the dominant culture as well as the African American community. These women clearly recognized the values of the media industry; in turn, they understood on a deeper level how their alternative modes of performing and creating were frequently misunderstood, misrepresented, or ignored altogether in favor of stereotypes that facilitated their exclusion from the more financially profitable mass-mediated forums.

The severe exploitation of jazz musicians in general is well documented.[3] Indeed, copyright, publishing laws, and corrupt recording practices failed to ensure payment of royalties and residuals, forcing many performers to be paid on a one-time basis. Moreover, black musicians often

earned considerably less than their white male counterparts; women musicians earned the least of all. Regardless, most jazz women were forced to pay union wages for the right to perform in public venues. The International Sweethearts of Rhythm's second arranger and coach, Eddie Durham, recounts some of these exploitative practices:

I worked with them awhile, and I started not getting along with management. I couldn't stand by and see them take money like they were takin'. We played the Apollo Theater again, those girls got thirty-two dollars a week (approximately half of union scale, Durham says), and I said, "Well, what did they (management) tell you?" "Well, we gotta have money to pay for the bus (the Sweethearts had a live-in bus complete with beds, air conditioning, and bathrooms); we gotta pay the mortgage on the home (in Arlington)." And I didn't tell them they didn't have no home. The man (their backer) owned that home. He gave them that home just to live in, but they didn't buy it. (Placksin 1982, 133)

In addition to unfair pay scales, jazz women encountered equally hostile philosophical and sexist attitudes. An unsigned *Down Beat* article of 1938 illustrates one particularly potent masculine point of view:

Why is it that outside of a few sepia females, the woman musician never was born capable of sending anyone further than the nearest exit? It would seem that even though women are the weaker sex they would be able to bring more out of a poor, defenseless horn than something that sounds like a cry for help. You can forgive them for lacking guts in their playing but even women should be able to play with feeling and expression and they never do it.
("Why Women Musicians are Inferior" 1938)

Both the anonymity of this tirade and the willingness of *Down Beat* to publish it reveal a latent yet permeating sexism. The explicitly masculinist and racialized tone of this passage represents one particularly prevalent political ideology. Here, women are defined as physically inferior, yet are somehow expected to have greater expressive and emotional capacities. Further, the anonymous author promulgates racial stereotypes by admitting a few black (sepia) female musicians into the masculine institution of jazz.

The eloquent yet densely coded rebuttal by Rita Rio, one of the more successful (white) women bandleaders of the time, cryptically acknowledges the unique position of women in popular music, while offering an equally gendered interpretation of feminine musicianship.

The feeling, tone and phrasing . . . is a quality which girls alone are more likely to possess because of the aesthetic nature of their sex. I think our mutual public will agree that a warm vibrant tone is much more pleasing than the masculine sock so often emphasized by our men bands. I notice girls, because of their feminine tendency, cooperate to make a rhythm section a united unit dependent on each other, rather than the masculine tendency to lead on his own instrument. . . . Either beautiful music or swing music is much more pleasing with a delightful picture than with a trite male band in its uniform tuxedos. Girls find a pleasing picture does not detract from good musicianship. (Driggs 1977)

Rio's rebuttal is interesting in its evasion of the charges levied at women instrumentalists. Her defense of women's musicianship includes their propensity for unified section playing free from masculine egoism and their ability to construct pleasing pictures while exhibiting good musicianship. Interestingly, Rio reaffirms four of the prevailing Victorian feminine attributes: humility, warmth, beauty, and unification (a domestic sacrifice of the self for the good of the group). These characteristics reveal an equally potent feminine neurosis, albeit bred by the economic constraints placed upon female performers to be both beautiful and feminine.

In later chapters, I continue to examine the various ways that all-girl bands and female jazz artists navigated the increasingly mass-mediated and visually represented landscape of American popular culture. It is no coincidence that the theme of this book adopts visual mediums as its point of departure. Indeed, the number of visual texts and especially films and televised variety programs featuring female jazz artists dwarfs that of the audio recordings. By emphasizing such mass mediums as film and eventually television—which provided a significant structure for reifying, refashioning, and transforming public enactments of gender, race, and sexuality staged through American popular music (and particularly jazz)—one gains a broader picture of how women contributed to the expansion of mass culture and to a uniquely American form of cultural identification.

In chapter 1, I provide a theoretical examination of the highly gendered discourse surrounding mass culture, popular music, and jazz during the transformative interwar decades of the late 1920s and into the 1930s. First, I examine the important role that culture theorists, moralists, music critics, and active citizens played in these modernist debates, which often implicated the "modern" woman as both victim and cause of deteriorating social values and familial structures. I then examine representative texts by jazz women and by the gendered constituency of jazz culture to illuminate the heightened awareness of public gender positions during the radicalized Jazz Age and into the Great Depression in the context of segregated public spaces. While these debates prioritized urban culture, equally radical transformations such as industrialization, urban migration, and the commodification of leisure pursuits in the form of recordings and films transformed mass culture's power to constitute personal identities, affiliations, and allegiances—but also to displace prior constitutive affiliations such as ethnicity, religion, and language.

Chapter 2 examines the increasingly connected domains of the culture industries to illuminate how two Jazz Age and Depression-era female jazz groups, one white and one black, continued to work in older mediums such as stage shows and variety revues while also expanding into the new

and often disrupting technologies of sound film. By comparing the activities and reception of the Ingenues with those of the Harlem Playgirls, whose musicians were not afforded the same mass-mediated performance opportunities of film and of recordings, one recognizes the debilitating and impenetrable race barrier. These barriers implicated the financial advantages awarded to "white" jazz groups, whose music adopted and appropriated black music and dance. At the same time, black groups like the Harlem Playgirls worked in similar environments of vaudeville theaters and picture palaces and dedicated their performances to African American audiences, whose localized knowledge of regional jazz and blues styles, of theatrical conventions from vaudeville to black musical theater, provided their own wealth of popular and vernacular influences—which were often stereotyped, imitated, or reworked for white audiences.

Chapters 3 and 4 discuss the relatively new medium of short subject sound films to examine the prolific and contrasting popular musical styles of two groups rarely mentioned in canonical jazz histories of the 1930s: Ina Ray Hutton's Melodears and Phil Spitalny's Musical Queens (later to become "The Hour of Charm"). These two groups engineered the dominant strategies for representing professional women musicians that persisted into the 1950s, albeit with variances to accommodate wartime and then postwar audiences. Both groups, backed by powerful booking agencies and promoted within all three mass-mediated cultural forms of film, radio, and theater, provided not only commercially successful, but also prodigious musical performances that featured virtuosic female soloists, further developing the range of gendered, jazz, and popular musical repertories deemed appropriate, novel, and even "natural" for female instrumental groups. The codification of musical genres as "sweet," "swing," and "hot" during this decade implied that the directors and managers of these groups prioritized particular aspects of prior cultural forms like minstrelsy or chorus-girl acts to promote all-girl bands as entertaining, feminine, and, with growing frequency, erotic, "modern," or novel. The intersections of genre, visual representations, and musical performativity remain central to discussions of these two groups, who provided some of the most dominant images of all-girl bands during the Great Depression.

Hazel Scott's complex musical persona, her prolific instrumentalism, and her proclivity for "swinging the classics" are the subjects of chapter 5. Her shattering performances inspire analyses of the powerful specter of race as both prescriptive and "instrumental" in directing jazz women's musical careers, their public reception, and their professional choices during the 1930s and 1940s. Scott's prolific musical skills were applauded in the most esteemed theatrical jazz venues and were featured in the increasingly

popular feature-length musical film. The problematic reception of Scott's performances spoke of a potent aesthetic inculcated early in the twentieth century in response to African American performers who aspired toward classicism yet were consistently denied such opportunities. In the face of such racism, musical geniuses like Scott enacted novel and cunning mechanisms to enable personal agency, musical freedom, and respectful public presentations. Through comparisons to Lena Horne as a musical film performer and of their similar roles as "specialty acts" in predominantly white Hollywood films, I illuminate the differing expectations of dominant (white) audiences and African American audiences.

In chapters 6 and 7, I investigate wartime all-girl swing by foregrounding the visually and sonically constructed forums of Hollywood musical features and of the newly invented SOUNDIES. By comparing and contrasting a number of short films with a few swing-centered feature-length films, one begins to understand how women's relationship to the male dominated jazz-band world was facilitated through these mass-mediated narrative structures. By again looking to the varying genres of "swing," "sweet," and "hot," and then connecting musical genres symbolically to popular wartime female images and icons such as the Hollywood pinup and the substituting war worker, I reveal the continuing strategies enlisted by both female musicians and all-girl band managers to respond to dominant and contentious attitudes toward female jazz instrumentalists. In particular, I examine a number of SOUNDIES of Dave Schooler's 21 Swinghearts as examples of the continued practice of "swinging the classics" so popularized by Hazel Scott during the 1930s and 1940s. I then contrast these with all-girl jazz groups led by such sexually attractive female theatrical leaders as Thelma White and Ada Leonard to point to ways that female jazz instrumentalists continued and managed to perform a predominance of jazz, boogie-woogie, and swing, the so-called hotter and more masculinized popular music styles of the war era. Finally, by looking at swing-centered Hollywood films (and in particular those two Universal films that star Phil Spitalny's Hour of Charm), I extend the discussion of musical gender and genre within the context of visually centered mass mediums, which began to displace live performance venues for jazz musicians during the late 1940s.

In chapter 8, I highlight the film performances of the International Sweethearts of Rhythm, the only known example of a female "black" band that was documented on film during the 1940s. The International Sweethearts of Rhythm were also one of the most skilled and popular of the many prolific African American and mixed jazz and swing bands touring the nation's theaters, vaudeville houses, and camp shows during World War II. The many skilled and improvising all-girl band groups, including Eddie

Durham's all-girl band and the Darlings of Rhythm, were closely followed by the black press and by a select few jazz critics, such as Leonard Feather. However, only the International Sweethearts of Rhythm secured appearances in both the short and popular SOUNDIES and for independent black feature film. The International Sweethearts of Rhythm's feature *That Man of Mine* (1946) provided but one visually mediated alternative image of black female musicianship during the 1940s, which drew from dominant Hollywood genres but also proposed new modes of representing feminine musicality, professionalism, and improvisation in the more localized independent black film genre.

Chapters 9 through 11 attempt to answer questions about jazz's postwar fallout and of the general hardships incurred by jazz musicians who had maintained successful performance and recording careers during the 1930s and 1940s but who struggled during the more conservative McCarthy era. By looking again to new and expanding mass mediums and especially to television, I identify new forums exploited for representing female musicianship, for mediating gender roles, and for defining an expanding middle class — and ultimately a more assimilated and homogenous American popular culture. In particular, I examine the highly popular television format of vaudeo in the postwar years and through the late 1950s. Variety television's incorporation of established theatrical and film formats from vaudeville to variety (as well as its continued support of the star system, albeit, with preferences for mature Hollywood performers, whose televised images were informalized) provided some of the only opportunities for female jazz women after the war. Indeed it was often those women who had successfully navigated the changing landscape of mass culture and of jazz and popular culture before and during the war who were frequently selected as guests or hosts of variety television programs during the late 1940s and 1950s. In particular, I compare four prominent television performers during this era: Ina Ray Hutton, Hazel Scott, Peggy Lee, and Lena Horne. The resurgence of vaudeville and variety formats and their penchant for mixing musical, generational, and gendered genres provided one mixed forum for television's mass and largely middle-class audiences. These jazz women's prior experience with other mass-mediated forms including short subjects and feature-length films endowed them with a variety of techniques for navigating television's expanding mass audience.

PART ONE

✵

JAZZ CULTURE AND
ALL-GIRL FILMS

✵

CHAPTER ONE

The Feminization of Mass Culture and the Novelty of All-Girl Bands

❋

The door to novelty is always slightly ajar; many pass it by with barely a glance,
some peek inside but choose not to enter, others dash in and dash out again; while a
few, drawn by curiosity, boredom, rebellion, or circumstance, venture in so deep or
wander around in there so long that they can never find their way back out.
—Tom Robbins, *Villa Incognito*

Beginning in the 1920s, the appearance of all-girl bands in vaudeville, va-
riety, and film theaters significantly contributed to America's rapidly ex-
panding mass-culture industry.[1] These all-girl bands gained currency in
part because of the widely successful and highly sexualized spectacles of
"girl acts" previously featured in a variety of popular theatrical contexts.
During the 1920s and 1930s, all-girl bands, more often than not, were pro-
moted as the featured attraction of a motion picture house's "stage show,"
which provided one to two hours of live vaudeville-style entertainment be-
fore the showing of feature-length films. For a quarter, film patrons were
also treated to a variety show of twelve to fifteen acts that often included a
jazz band, dancers, comedians, acrobatics, blues and operetta singers, and a
whole range of novelty acts from whistlers to saw players, jugglers, and
mimics.[2]

The sheer variety of live entertainment offered to theater patrons during
the late 1920s and early 1930s involved dozens of live musicians; enough to
constitute both a jazz band and sometimes a full theater orchestra, not to
mention the various vaudeville performers included in a variety-style stage
show. The gamut of music programmed for stage shows, which incorpo-
rated everything from blues, jazz, Tin Pan Alley and ragtime, to light classi-
cal works, "ethnic" ballads, cakewalks, and melodramatic serious songs dis-
plays the variety of musical offerings movie patrons were accustomed to
hearing. Such variety, which spanned theatrical and musical conventions

from the nineteenth and early twentieth centuries, incorporated aspects of minstrelsy, burlesque, vaudeville, carnival and tent shows, and more formal theatrical genres such as opera and serious drama. This wealth of musical and theatrical entertainment was in part required to accommodate the wide range of popular tastes represented in the mass audiences of vaudeville's theaters (Snyder 1989; Hall 1961).

White all-girl bands booked on the prosperous and multi-faceted RKO (Radio-Keith-Orpheum) circuit also worked with the nation's leading booking agencies. William Morris and Irving Mills, the top New York and Hollywood booking agencies, recruited and promoted all-girl bands during the 1920s and 1930s. Irving Mills sponsored the Melodears and William Morris managed the booking for the Ingenues. The prominence of these booking agencies and their widespread connections to radio, theater, and film, enabled a few specially selected white all-girl bands like the Hour of Charm, the Melodears, and the Ingenues to take advantage of the most prestigious and visible performance outlets on the national entertainment circuits.

Female instrumentalists were actively engaged in 1920s' Jazz Age culture as dancers, vocalists, and jazz band instrumentalists. A survey of Jazz Age and swing performance reviews, however, suggests that most of these all-girl bands failed to secure serious analysis by jazz journalists or mass-culture critics. While the relatively new field of jazz criticism sought to legitimize itself during the 1930s, writers tended to conceive of jazz as a male domain and therefore disavowed the cross-fertilizations of all-girl musical groups, especially those featured within new forms of mass culture. Furthermore, because of these critics' attempts to elevate the reception and valuation of jazz artists, many of the most prolific writers, such as Roger Pryor Dodge, Charles Delaunay, Winthrop Sargeant, and George Frazier, focused more upon jazz recordings than live performances and were reluctant to highlight the mass-mediated contexts within which most male jazz artists similarly developed (Welburn 1989, 84).[3]

In order to contextualize the performance contexts for all-girl bands, I shall first review the body of literature that traces the industry's conscious attempt to "feminize" such popular entertainment genres as cabaret, vaudeville, film, and variety revues (Kibler 1999; Hansen 1987 and 1991; Stamp 2000; Latham 2000; Erenberg 1981 and 1988). By the 1980s, popular culture scholars began to consider the generally neglected influence of women upon American public culture during the 1920s and 1930s. As spectators and performers—and especially as chorus girls—these women profoundly altered gender relationships of public leisure activities. By linking all-girl jazz to the earlier and increasingly commodified spectacles

of "all-girl revues" and chorus-girl minstrelsy acts, I argue that the unprecedented popularity and prominent role of all-girl bands in the stage show/soundfilm combinations and struggling vaudeville theaters was partly facilitated by the careful construction of a "feminine novelty" that codified and synthesized some of the contradictory signifiers of mass culture during the modern age. Because of the highly segregated and convoluted racial climate of these two decades, the adaptive strategies of white and black all-girl bands differed to accommodate varying racial and spatial proscriptions. This subject is more fully addressed in chapter 2, which highlights the careers of the all-white Ingenues and all-black Harlem Playgirls.[4]

The Feminization of Mass Culture

By the turn of the century, producers and organizers of various forms of entertainment, including vaudeville, variety revue, and film, devised various ways to encourage "respectable" female patronage and by extension, promote the refinement, morality, and cultural uplift of its productions (Glenn 2000; Stamp 2000; Kibler 1999). Their efforts to create "respectable entertainment" with programs suitable for entire families were in large part successful, as women began attending theaters in greater numbers during the 1910s. To further encourage female patrons, vaudeville management began regulating theater patrons' behavior by prohibiting prostitutes from entering and by barring lewd commentary in the galleries. These behavior codes, along with the theater's self-monitored censorship of harsh language and "inappropriate" humor by vaudeville entertainers, successfully encouraged middle-class women to attend performances (Kibler 1999).

In her autobiography, vaudeville veteran Sophie Tucker confirms the radical change in vaudeville audiences during the 1910s and largely credits theater mogul Tony Pastor with the rapid increase in female attendees:

Back in the hoopskirt era few women went to shows. It wasn't considered proper or refined. And probably most of the shows weren't. The old man went and got a big kick out of it, but he wouldn't have taken missis along on a dare. Maybe Tony Pastor foresaw that this country was going feminist. Maybe he just figured shrewdly that if you could sell five tickets to a family you made more money than by selling just one. Anyway, he got the bright idea of putting on shows that women would want to come to. The motion-picture industry has been built up on the same idea.
(Sophie Tucker 1945, 46)

Tucker began performing in supper clubs and burlesque theaters and gradually worked her way up to vaudeville and cabaret during the first two decades of the twentieth century. Her rich exposure to the pantheon of New York nightlife meant that she witnessed firsthand these radical

changes in audience participation. According to Tucker and others, by the second decade of the twentieth century, women constituted the majority of attendees for vaudeville theaters' matinee performances (Sophie Tucker 1945; Erenberg 1981 and 1988; Kibler 1999).

Similarly, women's participation as entertainers significantly altered during the first decades of the twentieth century and continued a transformation that began as early as the 1870s, a period in which American audiences enjoyed the first all-female burlesque troupes (Allen 1991). The inclusion of all-girl bands along with female comedians, opera singers, solo dancers, chorus girls, and dramatic actors extended a practice initiated with nineteenth-century female minstrelsy and burlesque and was also indicative of vaudeville and variety's attempt to feminize and expand its entertainment for a wide range of patrons, male and female, and to entice members of both the upper and working classes. Because ticket prices remained reasonably low, these luxurious theaters also provided one of the first twentieth-century meeting places for men and women from a spectrum of ethnic, economic, and social groups.

However, male patrons and culture critics did not wholeheartedly embrace the rapid transformation of theater audiences. Growing numbers of editorials and the organization of male theatrical groups and unions like the "White Rats" (a male vaudeville union of more than 14,000 members by the second decade of the twentieth century) also voiced concerns about changes in theatrical content and reception.[5] While mass-culture critics faulted the overmechanization of the nationally organized vaudeville circuits as well as their leaders' so-called spineless submission to the growing film and radio corporations, they also criticized what they perceived to be the overfeminization of twentieth-century vaudeville productions. During the second and third decades of the twentieth century, mass-culture critics, and American modernists lamented the erosion of vaudeville's "robust, authentic masculine aesthetic" and its increasing reliance upon scandalous female stars or attractive "debutantes" with little vaudeville experience. Mass-culture critics rebuked Albee and Keith, the founders of the national vaudeville circuits, for overmechanizing theatrical conventions and for instigating an overtly feminized theatrical culture that catered to women's perceived sentimentality, artifice, and low intellectual capacities (Kibler 1999, 206).

Jazz Culture and Its Critics

During this same period, cultural theorists, sociologists, and a growing body of popular music critics similarly analyzed the cultural, social, and political effects of jazz music upon American society. Tantamount to these

discussions were debates about the "modern women" and her relationship to the burgeoning jazz culture. In certain editorials, women were blamed for the commercialization and corruption of urban culture. In others, writers expressed concerns for young women in a protectionist voice, replicating Victorian prescriptions. Women's roles as wives and mothers were allegedly threatened by the "cheap" and "fast-paced" attractions of urban jazz and theatrical nightlife. The more vehement philosophical projections of mass culture's social wages (as articulated by Frankfurt theorists, for example) tended to speak of women indirectly as the commodified objects of an undifferentiating and oversexualized mass culture.

Adorno's now largely refuted 1930s jazz and popular music essays epitomize some of the concerns circulated by cultural theorists; the essays assert that popular music, and especially jazz's mass appeal, had the potential to spawn an inarticulate and undiscerning middle class. Moreover, jazz, as conceived by Adorno, preconditioned the masses for fascism.[6] By 1936, Adorno not only associated jazz with the loss of the modern subject but, in a Freudian sense, with the most base unleashing of the libido in public domains. He cited specifically coupled dancing as analogous to jazz music's presupposed and imagined replication of the rhythms of sexual intercourse. In his treatise "On Jazz" Adorno articulates what he believed to be the psychologically and socially dangerous effects of the highly popular jazz "hits," especially as they became the soundtracks for incidental film scenes:

In film, jazz is best suited to accompany contingent actions which are prosaic in a double sense. . . . From this fact, too, stems the significance of the hits of contingency, where a chance word, as a scrap of the everyday, becomes a jacket for the music from which it spins forth: "bananas" and "cheese at the train station" . . . have often enough knocked their erotic and geographic competition out of the field. All too willingly, the hits give their contingency a sexual meaning which is by no means an unconscious one; they all tend toward the obscene gesture. The cheese then reminds us of anal regression; the bananas provide surrogate satisfaction for the woman, and the more absurd the nonsense, the more immediate its sex appeal.

(Adorno 2002, 486)

In an effort to contextualize Adorno's indirect references to obscene filmic sexual/aural signifiers, one can think of the highly popular 1930s Betty Boop cartoons, which were also some of the first films to feature recordings of young jazz musicians like Louis Armstrong and Cab Calloway. Betty Boop's highly coded Jazz Age sexuality represents such a combination of innocuous film actions and the sexually charged innuendos implied by these novel musical/filmic juxtapositions; they were also contemporaneous to Adorno's writing on the subject.[7] In these cartoons, jazz music provided the backdrop for whites' fantasizing about forbidden sexual objects

(such as teenage flappers and miscegenation), albeit in highly coded or co-medic contexts.

For example, one particularly potent yet satirical Betty Boop cartoon, "I'll Be Glad When You're Dead You Rascal You" (fig 1.1) depicts a tied-up Boop encircled by grunting and ravaging "jungle" savages. Louis Armstrong's disembodied head floating above the previous chase scene provides the primitivistic sonic and visual imagery for Armstrong's jazz singing and trumpet playing of this well-known tune. Boop's sexual utter-ances while being tied up by "dark savages" (who eventually and symboli-cally orgasm via a massive volcanic eruption) provided an "over-the-top" comedic depiction of the highly racialized and sexualized exoticism that was a mainstay of modernistic and mass-produced popular culture.

In addition to Adorno's concern for obscene sexual signifiers through the mass medium of film, his "On Jazz" critique further correlates jazz dance and its relationship to jazz music with the act of sexual consummation:

The pace of the gait itself—language bears witness to this—has an immediate refer-ence to coitus; the rhythm of the gait is similar to the rhythm of sexual intercourse; and if the new dances have demystified the erotic magic of the old ones, they have also—and therein at least they are more advanced than one might expect—replaced it with the drastic innuendo of sexual consummation. This is expressed in the ex-treme in some so-called *dance academies,* where *taxi girls* [Adorno's emphasis] are available with whom one can perform dance steps which occasionally lead to male orgasm. Thus, the dance is a means for achieving sexual satisfaction and at the same time respects the ideal of virginity. The sexual moment in jazz is what has provoked the hatred of petit bourgeois ascetic groups. (Adorno 2002, 486)

Like many mass-culture critics of these decades, Adorno references women indirectly or dismissively in his critiques of popular music, a form that he often associates with the "modern" jazz of the 1920s and 1930s. When refer-enced, however, women are frequently invoked not as jazz musicians them-selves but rather as trivial, mundane, or commodified conduits for the pro-fane exercising of male sexuality. It is not difficult to determine Adorno's discomfort with the conditions of women's increasing public presence and what he believed to be their commodified relationship to jazz. In this quote, Adorno's single reference to performing women is as taxi girls and dance academy instructors. More visible, however, were the performing women who worked as chorus girls (the women most rigorously con-nected to the culture of mainstream jazz), women who commonly pro-moted and exhibited the latest dance crazes in sync to the latest jazz record-ings and live performances, and to a lesser extent, the all-girl jazz bands that toured the United States and abroad from the 1920s through the 1940s.

The increasing prevalence of the phrase "modern women" in 1920s and 1930s newspaper editorials, magazines, and other printed media

Figure 1.1. Betty Boop ravaged by savages in *I'll Be Glad When You're Dead You Rascal You* (Paramount 1932)

extended both sides of the "feminism" versus "traditionalism" debate with regard to women's changing roles in society as well as their relationship to jazz culture. In her *Chicago Daily Tribune* review of the 1923 movie *Has the World Gone Mad!* Inez Cunningham summarized many sentiments of the day:

The picture is another feeble blaat [*sic*] about that great institution, the modern woman. Blaming her for jazz, cabarets, cigarettes, facial operations, cosmetics, beautiful clothes, loving to keep her youth, neglecting her housework and similar crimes. Of course, I admit that jazz is a crime—but why blame it on the MODERN woman. If a woman invented it, it was long ago when the world was young. But is that Mother's fault? I ask you? (Cunningham 1923)

Blaming women for the rise of jazz was common in newspaper editorials and mass-culture critiques. The dominance of female performers in white and black urban cabaret culture during the second decade of the twentieth century through the 1930s—and especially in all-girl revues performing with the most popular white, mixed, and black jazz bands—led to the provocative assumption by some "thrill-seeking" Americans that women had actually "invented" jazz. Those male performers like Will Rogers who appeared in these female-dominated revues during the second and third decades of the twentieth century commented humorously on the overwhelming feminine character of these male-produced shows. As the only male performer in the 1915 edition of the *Midnight Frolic* (a New York rooftop cabaret), Rogers claimed that he was forced "to dress with two of the chorus girls' chauffeurs and Melville Ellis' [a costume designer] valet" (Erenberg 1981, 216). One can imagine that young couples frequenting the many cabarets and variety revues of this time would have gained a one-sided picture of jazz culture as so many of the revues profited from the current craze and desire for public displays of female sexuality, however prescribed, coded, and objectified these may have been.

Beyond jazz music and the appearance of white and black jazz bands in cabarets during the second and third decades of the twentieth century,

women came to participate in the music via jazz dancing. In big cities like New York and Chicago, the famed "Creole" and light-complexioned African American chorus groups like the Cotton Club dancers attracted white and black audiences to their particularly innovative, rigorous, but heavily exoticized jazz routines (J. J. Brown 2001; R. A. Bryant 2002; and Latham 2000). The nationally publicized relationship between Irene and Vernon Castle and James Reese Europe's specially orchestrated jazz music initiated what was perceived by white society as a more "respectable" and "safe" space for young white women to participate in jazz culture, jazz dance, and black musical culture without having to frequent what they felt to be dangerous and sexually unrestrained black nightclubs and neighborhoods. The Castles' massive marketing campaign, which emphasized their image as a respectable, cosmopolitan married couple, facilitated a restructuring of post-Victorian attitudes about public dancing, gender interactions, and jazz music (Cook 1998).

Moreover, James Reese Europe successfully marketed the "Creole" sonic constituency of his society orchestra, a racial category that evoked associations with mixed European and Caribbean cultures and therefore enabled a defiance of the rigid segregation conventions of the time. His highly orchestrated dance music also borrowed musical genres coded as European American, including marches and society dance music. The Castles' particular style of dance, in combination with the more "refined and elevated" jazz music of James Reese Europe, enabled them to normalize jazz dancing for both middle- and upper-class social groups, whereas coupled dancing during the Victorian and Edwardian era was frequently associated with loose morals, excessive sexuality, and even prostitution (Cook 1998).

By the 1920s, black cabarets and vaudeville theaters like the Lafayette or Connie's Inn also featured African American chorus girls, all-girl bands like the Harlem Playgirls and seasoned vaudeville and theatrical performers like Bessie Smith in their evening revues. These clubs, many of which were in Harlem, initially attracted predominantly black audiences; eventually, however, as jazz became more popular and prevalent in uptown clubs and cabarets, whites became emboldened to seek out all-black revues, traveling out of their neighborhoods (slumming) to infiltrate black urban cabaret culture. Unfortunately, with these developments, black patrons were often pushed out or prohibited from entering clubs like the Cotton Club, which featured the most successful black musicians and entertainers (Erenberg 1981, 252–259).

In response to changing public gender contexts, a discourse emerged by the second decade of the twentieth century that either implicated women in the commodification of jazz culture or that simply denied their existence

as performers and musicians—especially as jazz music became more re-spected as an (African) American art form and consequently canonized by white historians, critics, and journalists.

During the Jazz Age, jazz became a metaphor for an unfathomable va-riety of cultural signifiers implying both positive and negative aspects of modernity. Cultural theorists and writers often inserted the term to elicit a sense of spontaneity and innovation—or conversely to connote something corrupt and contaminated. Avid fans and critics were infuriated by the blitheness with which promoters adopted the term for a variety of synco-pated and popular musics. Wilder Hobson, writing about the musical style and development of jazz in 1939, underscores some of this confusion, which developed upon the heels of the success of jazz-dance orchestra leader Paul Whiteman:

The Whiteman ensemble is a large, expert dance orchestra (or small concert group) whose chief activity has been the glossy presentation of popular tunes, novelties, and light modern compositions. This is emphasized because Whiteman's publicity was a particularly striking example of why the word "jazz" quickly lost any semblance of a generally accepted meaning. Before Whiteman's debut it had at least had definite connotations of noise and confusion; afterwards it was applied to virtually any music in fox-trot or one-step tempo. "Jazz" was a ninety-piece rendition of *Hava-nola* by the St. Louis Symphony Orchestra, Rudolph Ganz conducting. It was the music of the Seven Syncopated Sirens, a band of girls directed by Grayce Brewer, trombonist—"on the latter instrument, sometimes known as the sliphorn, Grayce is said to be a wonder, and can get more and different kinds of noises out of it than the famous Rodeheaver of the Billy Sunday forces." Jazz was a somewhat raggy, Debus-syesque piano solo called *Kitten on the Keys* written by Zez Confrey. It was Brooke John's banjo plunking while Ann Pennington dances. (Hobson 1939, 79–80)

Hobson, one of a few early jazz writers with extensive experience perform-ing jazz and Dixieland music, was also one of the earliest white jazz histo-rians to talk about the social, racial, and cultural context within which the myriad of jazz styles emerged. In his book *American Jazz Music*, Hobson moves beyond typical Depression-era debates between "moldy figs" and "modernists" concerning issues of "authenticity" that sought to legitimate jazz as high art. His writing concentrates instead upon the various musical, geographical, and regional movements as well as the unexpected interrela-tionships among pre–World War II jazz musicians. However, even Hobson's more broad-minded thinking did not avoid offhandedly remark-ing upon the assumed novelty appeal of all-girl bands performing jazz.

In a philosophical sense, jazz entered popular discourse much earlier than the Jazz Age. As early as the middle of the second decade of the twen-tieth century, the term "jazz" fostered debates on the recent phenomenon of the "modern women." In these reviews, women's assets and faults were hashed out in editorials featured in literary magazines, newspapers, and

ladies' journals. In 1923, for example, an anonymous female author (as those women who dared to debate gender roles in public editorials often were) depicted the modern woman with an emphasis upon the changing physical stature and personality of the desirable modern woman (who is presumably white):

The beautiful woman of today is svelte and at times petite. Despite the mania for jazz, of which we hear so frequently, a study of the situation will reveal that actually we live in a sane era. From this deduction we must realize that women must be viewed as feminine creatures. The perfect beauty of today is not modeled after Venus, who, by the way, had big feet. The modern woman should not be more than five feet four inches in height. Her figure should be well formed and her features regular. And above all, she should possess something of which the Greek goddesses never dreamed—personality. ("Darling of the Gods" 1923)

The emphasis upon women's feminine visual characteristics coupled with fears about lax gender roles in public jazz spaces prompted variety producers like Florenz Ziegfeld to reassure middle-class male and female patrons of the purity and femininity of his celebrated jazz-dancing chorus girls.

What is intimated but not directly articulated in mass-culture criticisms of these two decades are the offhand and seemingly incidental assertions of women's role within mass-culture contexts. Jazz was alleged to unleash base sexual urges, urges that ultimately compromised (and even emasculated) the male subject as artist, composer, or writer and further destabilized prescribed gender roles. Jazz became the rallying cry for moralists, clergymen, and female traditionalists who detested the corruption of the "modern woman" as she became easy prey to the contagion of jazz music and jazz culture.

In 1931, for example, Schumann-Heink, a female operatic contralto who performed regularly for radio during the 1920s, was quoted in the *New York Times* as associating jazz with the demoralization of the modern women:

But the modern woman has no heart. . . . All that is important in her life is the lipstick, jazz and bridge. She does not want children. Modern women never will accomplish anything toward world peace by conferences. Let them have good, warm meals ready for their husbands when they come home tired from a day's business. Tell the women to build homes and raise their children properly. Then we'll have peace. ("Modern Woman Has No Heart" 1931)

This blurry reference adopted the metaphor of women as the physical and heavily sexualized jazz residual commodity, a metaphor later adapted by respected jazz writers like Schuller and Rust in their jazz biographies and record reviews.

Other Jazz Age theorists similarly expressed anxieties over women's expanded public presence, especially with respect to mass-culture contexts; that is, women's appearing more frequently as performers, dancers, jazz musicians, and patrons in film houses, vaudeville theaters, and jazz clubs. Most likely, it was women's increased visibility in theaters featuring jazz music that projected women as the root cause of the jazz problem. *Harper's Monthly* replicates this idea in an editorial by Florence Guy Woolston in 1921:

It is the fashion, nowadays, for men to issue pronunciamentos about us from their conventions. The businessmen pass resolutions about our flimsy blouses, the musicians credit us with creating jazz, the automobile manufacturers deplore our reckless driving, the reformers regret that we cause so much divorce. The ministers make a specialty of us. No conference of clergymen is complete without an edict about women and modern life. At the last annual meeting of the Methodists, most of the evils of our time were attributed to modern women, and the statement made: The new feminism is drawing the best of our womanhood from marriage and motherhood, while loose ideals on the permanence of marriage are being imported by Russian barefoot dancers. The hand that stops rocking the cradle begins to rock the boat of our family life. (Woolston 1921)

While it is difficult to surmise what is implied by the frequent negative assertion during the 1920s that women invented jazz (especially considering the rigidly masculine narrative presented by jazz historians during the twentieth century), one can look to the changing performance and reception contexts for women in mass culture for a more nuanced indication of the motivating forces behind these proclamations. I would argue that the radical transformation of women in public popular culture contexts incited a moral panic surrounding jazz and that women's activities as fans, performers, instrumentalists, jazz dancers, and vocalists fostered a "feminized" image of jazz culture during the 1920s. In this sense, the increasingly negative discourse of a feminized jazz culture provided a psychological compensation for changing gender contexts. Nonetheless, the intersecting discourses connected to such a moral panic over American's increasingly feminized jazz culture should be distinguished from a more radical and direct assertion that women alone, composed, created, and invented jazz.

In addition to the all-girl jazz revue craze, this sentiment of feminization was likely influenced by the unexpected and widespread popularity of African American female blues and jazz singers during the 1920s. During the experimental stages of the phonograph industry, African American female artists like Mamie Smith ("Crazy Blues," 1920), Bessie Smith ("St. Louis Blues," 1926) and Ma Rainey first recorded what are now considered "classic" or urban blues on the "race" series of the major recording

companies like Columbia, RCA, and OKeh. While widely known and appreciated within black cultural spheres, urban blues became a revolutionary new musical style to the broader dominant culture as whites and non-African Americans purchased these recordings in record numbers during the mid-1920s (Kenney 1999, 119–124). Indeed, Mamie Smith's highly profitable "Crazy Blues" sold more than two million copies during the first two years after its release by OKeh Records ("Mamie Smith" 2007). The great success of Bessie Smith's "St. Louis Blues" and Ma Rainey's many 1920s jazz/blues recordings introduced white audiences and urban and rural black audiences to the urban cosmopolitan fusions of Tin Pan Alley, jazz, and instrumental blues.

Similarly Sophie Tucker's jazz renditions toward the end of the second decade of the twentieth century, were also considered novel and innovative in the popular music and theatrical world (of course, the dominant culture lacked exposure to the genre). Tucker gained entrance into the world of popular music via vaudeville and cabaret acts originally in the style of African American blues singers and shouters and sometimes in the pervasive blackface convention, a style that came to be known as "coon shouting" during the early twentieth century. Eventually Tucker incorporated more contemporary styles into her repertoire, including Tin Pan Alley and jazz. In her autobiography, Tucker goes so far as to claim that her rendition of jazz during the cabaret era of the middle of the second decade of the twentieth century was largely responsible for its spread in New York prior to Prohibition. She writes of her residing at that time at the famous Reisenweber's, a New York dinner cabaret:

The Boss [William Morris, Tucker's agent] sold them the idea of giving the customers something different in entertainment—a vaudeville headliner, a woman who could sing and with her own band. It was a new idea, but it worked. Once again it proved how well the Boss understood the entertainment world. Following his advice, Reisenweber's started the Jazz Era and changed New York nightlife completely. We opened two days before Christmas, 1916. We entertained during the dinner hour and put on a late show. My band played for the dancing during dinner and again during the supper hour. Another band relieved them until the supper crowd came in. . . . [T]he entertainment was the best in town had to offer. One proof of this is that all the other places started to copy what we were doing at Reisenweber's. People began to demand jazz bands and something more than ballroom dance teams and a line of girls. (Sophie Tucker 1945, 156)

Of course the Boss was none other than the entertainment guru William Morris, a successful agent for African American jazz musicians, including Duke Ellington and Cab Callaway, and also for all-girl bands during the 1920s and 1930s, including the Ingenues. In this context, his suggestion to incorporate the newest jazz styles into her act was not surprising. Moreover,

Tucker was merely doing what she had consistently done throughout her long performing career: incorporating elements of musical theater, black popular music (in this case, jazz as opposed to her earlier "coon shouting" songs) and the highly physical entertainment style of burlesque and vaudeville. Ironically, it was not Al Jolson who ushered in the Jazz Age for white mass audiences but rather Sophie Tucker, proclaimed as early as 1915 by the national press as the "Queen of Jazz"—even as this title wantonly disavowed the African American roots of the music.

Perhaps it was the great success of these "white" and "black" theatrical and cabaret performers, like Bessie Smith and Sophie Tucker, in combination with the highly desired chorus-girl acts and solo jazz dancers that created an image of jazz as feminine during the Jazz Age. Additionally, the rapid appearance of young, unmarried women in nightclubs, theaters, and cabarets fostered an association of the "modern woman" with the nationally expanding jazz culture.

All-Girl Jazz Bands in Mass-Culture Contexts

Discourse surrounding women's roles as silent film, cabaret, and vaudeville participants often resembles the one-sided representations of early theatrical sexual spectacles, a discourse that fails to articulate the ongoing tensions between feminine subjectivity and objectivity. The now dominant image of burlesque and its emphasis upon sexualized feminine performances designed for male audiences illustrates the ways that particular theatrical spectacles became heavily sexualized during the early twentieth century. One has only to look at British, European, and early American forms of burlesque and variety revues to see the feminine contribution to theatrical forms that until the 1870s had appeared to be less explicitly sexualized, affording a higher degree of female agency and subjectivity for star performers like Eva Tanguay and Anna Held (Allen 1991). Gendered receptions of all-girl bands during the 1920s and 1930s similarly foreground such tensions as well as the over narrow portrayals in media reviews, which prioritize the visual spectacle of these early all-girl performances. These one-dimensional descriptions fail to account for the potentially heterogeneous responses available not only to musicians but to male and female jazz-band viewers during the Jazz Age.

During the 1920s, press releases for all-girl bands typically appeared in newspaper advertisements for film theaters' stage show presentations. Vaudeville announcements in newspapers and industry magazines like *Billboard* and *Variety* similarly inserted quick, pithy captions for upcoming bills. In these reviews, all-girl bands like the Ingenues or Dixie Sweethearts

were lucky to receive mention of their band names, beyond the more general "all-girl" descriptor. A typical vaudeville release from the *Chicago Daily Tribune* (1933) is representative: "The vaudeville bill at the Palace theater this week includes: James Barton—Dancing clown and waggish entertainer whose 'drunk' was once a 'Follies' sensation. The Ingenues—Most celebrated of the all-girl bands—16 pretty musicians displaying their versatility" ("Vaudeville Bills" 1933).

For less publicized all-girl bands, the group's name would often be left out, which effectively highlighted the band's role as the featured novelty act on the bill. These announcements were often inserted in the entertainment ads for movie theaters, vaudeville houses, and picture palaces. The more expensive ads were often bookmarked by two symmetrical, leggy chorus girls surrounding the caption "all-girl Revue" or more creative alliterative captions like "45 Palpitating Platinum Blondes—All-Girl Revue" (Display Ad 1 1935).

The growing popularity of all-girl bands and their integral connection with the spectacular girl acts, as well as their dependence upon vaudeville and film—two of the most debated, theorized, and mass-mediated forms of American popular culture during this era—invites similar investigation into the ways that women as patrons experienced sexual spectacles, girl acts, and popular music (especially swing and jazz) as performed by these early "novel" groups. Superficially at least, the representation of all-girl bands paralleled a similar trend in film and theater performances that variously objectified and stratified gender divisions and images of women to contain women's rapidly expanding public independence and to facilitate a largely masculinist and sexualized male gaze.

Based upon recollections concerning female attendance by some of these early jazz women, it appears that female spectators attended these performances and exhibited a variety of responses to what they heard and saw at vaudeville theaters, picture houses, and variety revues. Peggy Gilbert, an early and prolific reed performer with several theatrical all-girl bands performing on the vaudeville circuits during the late 1920s and 1930s, claims that she only began to envision a career in jazz after hearing the all-girl band, the Gibson Navigators on the Orpheum circuit, in a motion picture house in Iowa City during the early 1920s (Placksin 1982, 82). Saxophonist Roz Cron also recalled her reaction to an instrumental "girl" act on a Boston vaudeville bill during the 1930s: her father took her to see the Siamese saxophone duo the Duncan Sisters, who apparently not only played saxophones "back-to-back" but also performed on roller skates. Cron, eleven at the time, remembers wondering if the two women actually ever saw each other (e-mail from Cron, July 2007). Rather than surprise and inspiration, Cron expressed her complete horror upon recognizing the bizarre attention that

these female instrumentalists received (interview with Cron, 2001). Women performers and female audiences' reactions to musical and theatrical "novelties" equally informed the often contradictory forums within which women gained images of female musicians during the 1920s—as illustrated by these two very different responses to female jazz of this period.

What is suggested by these few jazz women's recollections as well as these female-centered analyses is that women's quickly expanding influence as spectators and as performers generally altered the gendered dimensions of public spaces of mass entertainment during the early part of the twentieth century. Their performative agency, extravagant spectatorship, and various modes of reception caused anxiety for patriarchic culture protectors and classical film orchestrators, who feared women's all too hasty advancement upon the urban landscape of cultural production (Stamp 2000; Hansen 1987 and 1991; Kibler 1999; Glenn 2000).[8] Ironically, it was during this unstable transitional period, in the 1920s—where live performances in American vaudeville theaters began to incorporate sound films, and where the newly wired sound film theaters began to phase out live performances—that all-girl bands received their first breaks. The well-established feminine clientele of vaudeville, variety revues, and more recently sound film as well as the heightened interest in jazz, swing, and syncopated popular music set the stage, so to speak, for such feminine jazz performances. Further, the preeminence of nontraditional female artists ("scandalous stars") was not antithetical to vaudeville promoters' artistic philosophies: promoters were keen to produce respectable "feminized" programs (in contrast to the sexualized early-twentieth-century burlesque houses and male-dominated and -attended nineteenth-century vaudeville)[9] and therefore supported the careers of female entertainers both as leading acts and as amateur dancers and professional chorus girls.

The inclusion of all-girl jazz acts, therefore, with their combined aural and visual enticements, and their adaptation of the aesthetics of all-girl spectacle and feminine novelty, betrayed desperate but creative efforts by vaudeville management to compete with the spectacular visual and aural effects of sound film, the elaborate live-entertainment presentations of the opulent picture palaces, and the sexual spectacles of the increasingly popular theatrical revues. Eventually the financial success and popularity of all-girl bands ensured their place in nationally acclaimed musical theatrical productions like the Ziegfeld Follies,[10] in historic popular theaters like the Apollo, in sound films, and even in the elaborate picture palaces. With their slowly dilapidating yet richly decorated and highly ornate interiors, vaudeville theaters such as the Palace in New York City provided all-girl bands with their first performance venues.

CHAPTER TWO

The Ingenues and The Harlem Playgirls
America's Versatile Vaudeville, Jazz, and Stage-Show Spectaculars

"My dear young lady" said the clergyman, in grieved tones as he listened to an
extremely modern woman tear off some of the very latest jazz on the piano, "have
you ever heard of the Ten Commandments?"
"Whistle a few bars," said the young lady, "and I think I can follow you."
—Christian evangelist, quoted in the *Wall Street Journal*

All-girl bands continued to perform in vaudeville theaters and film houses during the 1920s and the 1930s. However, the highly racialized segmentation of performance spaces differently affected "white" and "black" female groups who sought professional opportunities during these two decades. This chapter focuses on two swing-era all-girl bands, the Ingenues and the Harlem Playgirls, to explore commonalities and differences between "white" and "black" all-girl bands active during the overlapping periods of the Jazz Age and the Great Depression. Although the Ingenues' professional careers began during the mid-1920s, their performances into the mid-1930s were comparable to the African American Harlem Playgirls in their established relationships to vaudeville, variety, and "stage show" presentations exhibited in vaudeville theaters and picture palaces. While the Ingenues, however, received ample opportunities to perform for the most mass-mediated contexts, from film to variety and radio, the Harlem Playgirls, working in the highly proscriptive and segregated context of the 1930s-era culture industries, were not given opportunities to appear in the developing technological mediums of short subject films and electronic recordings. Given these racial and social divisions, African American women musicians were rarely afforded opportunities to appear outside live black performance venues except as specialty artists, chorus girls, or star vocalists.

Although rarely included in contemporary jazz or film histories, there were dozens of extremely popular, highly visible, and audible all-girl jazz bands active during the 1920s and 1930s, including Ina Ray Hutton and Her Melodears, the Harlem Playgirls, Miss Babe Eagan and Her Hollywood Redheads, Phil Spitalny and his Musical Queens, Lil Hardin-Armstrong's All-Girl Orchestra, the Dixie Sweethearts, the Ingenues, Wayman's Debutantes, and many more (D. Handy 1981; Placksin 1982).

I have chosen to focus first upon the all-"white" Ingenues, because they represent a particular type of mass-mediated, vaudeville-style jazz band that successfully incorporated elements of the "girl craze" so characteristic of the 1920s and 1930s. From a practical standpoint, this group is also attractive because primary source material for the Ingenues exceeds that for many of the other all-girl jazz groups of these two decades.[1] Moreover, the highly prolific Ingenues performed in three important mass-mediated performance contexts[2] during the 1920s and 1930s: vaudeville, variety reviews, and short subject films. They also performed internationally in France, Great Britain, South Africa, Latin America, and Australia, announcing to the world their particular vision of the "modern American woman."

I then focus on the less visibly mediated Harlem Playgirls, who quickly established a national reputation for themselves during the mid-1930s as one of the best and hardest-swinging female jazz groups in the United States. They performed throughout the country until the early 1940s; upon disbanding, many of the group's leading members went on to perform in the prestigious Darlings of Rhythm and the International Sweethearts of Rhythm. Like the Ingenues, the Harlem Playgirls competed against male swing bands and performed in the leading (black) vaudeville and variety theaters and ballrooms in the country, including the Apollo and the Savoy.

By examining the differing performance contexts of the Ingenues and the Harlem Playgirls, I reveal that the theatrical and mass-mediated contexts in which the most commercial and successful of the white all-girl bands honed their professional skills was as responsible for their eventual exclusion from the jazz canon as it was for their popular acceptance and durability during these two decades. Moreover, the segregated organization of the film and recording industry (which generally prohibited black female musicians from appearing in those mediums funded by the major studios, including Paramount, Columbia, and MGM) occasionally featured African American musicians—female instrumentalists like Hazel Scott who performed as specialty artists in white-centered musical films. Unfortunately and consequently, little primary source material remains with which to study the musical performances of these early African

American swing groups, leaving this chapter lopsided, a by-product of the deeper racism guiding American civic and cultural institutions during these transformative decades. Finally, I postulate that the emerging discourse of jazz journalism looked precisely to these mass-mediated contexts to condemn certain forms of "commercial" jazz as overfeminized and -sexualized and therefore not worthy of inclusion into the initial "drafts" of the jazz canon.

The Ingenues

The Ingenues were one of the first nationally successful white, vaudeville all-girl bands and also the first female jazz band to perform throughout the world. Of the all-girl bands, the Ingenues also enjoyed one of the longest professional performing careers of the first half of the twentieth century, ensuring steady employment for some of the original members for more than a decade, from 1925 to 1937. The band began performing in vaudeville theaters and film houses in Youngstown, Ohio, then toured various cities in the Midwest, including Detroit. Eventually they were booked on the prestigious Orpheum (later to become the Radio-Keith-Orpheum circuit) route stretching from Chicago to the Pacific Coast during the late 1920s ("Fair Co-Eds" 1927). One *New York Times* article suggests that the Ingenues were organized and recruited by vaudeville agent and producer E. G. Sherman in 1925 and explains his motivation as such: "The idea occurred to Mr. Sherman that it might be a novelty to modernize the ladies' orchestra—to make it a youthful ensemble retailing popular tunes" ("Fair Co-Eds" 1927). Sherman claims in the article that the traditional ladies' orchestra, like the Lafayette Ladies Orchestra, was neither capable nor trained to perform the latest modern popular repertoire; nor had they been promoted on the popular stage. He cites changing conventions in variety revue and vaudeville houses for creating the proper atmosphere within which women could be featured in such a novelty band.

Beginning in Kansas City, Sherman scouted for young girls, visiting small towns and convincing dubious parents "who balked at the idea of their daughters leaving home to travel in a stage troupe." Later in the article, the author attempts to confirm the high social status of the young women by listing the educational and familial backgrounds of some members at random: "Genevieve Brown from Hardinsburg, Ky., is the daughter of ex-State senator Brown, prominent in Kentucky politics. She was educated at the University of Kentucky at Lexington" ("Fair Co-Eds" 1927). Attempts by journalists to distinguish these young "European-American" women from the established—and racist—stereotypes of performing

women in jazz contexts betrays the common associations frequently drawn during these decades between musical genres and notions of race and class.

While the instrumental makeup of the group varied during the 1920s and 1930s, the instrumentation resembled a typical society dance band/orchestra of the early 1930s, which often included nineteen to twenty-one musicians separated into four sections: woodwinds, brass, rhythm, and strings. An undated publicity poster taken from trombonist Paula Jones's scrapbook lists the names of the musicians without any corresponding instrumentation.[3] From the film performances in *Maids and Music* (1937), we see four trumpets, five woodwinds (saxophones and clarinets), three trombones, four rhythm instruments (piano, drums, bass and guitar/banjo) and strings (two violins, cello, and harp), and one director. An earlier undated photograph reveals only fifteen musicians, including cello, two violins, harp, banjo, tuba, trombone, two trumpets, four woodwinds, and piano. Again, the women are not named.

Between long vaudeville runs at theaters in California and Chicago in 1926 and 1927, the band set out on a series of national tours and performed extended runs at film houses, vaudeville theaters, and ballrooms. During their performance at the Palace in New York, Florenz Ziegfeld contracted the band for his 1927 Ziegfeld Follies, one of many Follies' revues that touted the slogan "Glorifying the American Girl." The band's huge success with the Follies garnered them international tours in Europe, South Africa, Asia, and Australia in the late 1920s and early 1930s. Although the band performed well into the 1930s, I found only a few primary sources indicating performances after 1932; the band did, however, make several short films and recordings for Vitaphone and Vocalion in the late 1920s and early 1930s including the short subject Vitaphone film, *The Band Beautiful* in 1928. According to Linda Dahl, the Ingenues was led by multi-instrumentalist Louise Sorenson during the mid-1930s who was praised in 1937 by *Down Beat* for her versatility and leadership skills: "[She] studied to be a trumpet player but can play every instrument in the band and has exceptional knowledge of harmony and how to handle orchestrating for a band with so much versatility. She has led bands under her own name and has traveled with bands on two world tours in 28 countries" (*Down Beat* [April 1937?] in Dahl 1984, 51). One late reference to the orchestra surfaced in a 1937 issue of *Down Beat* that included only a photo and a short blurb about seventeen-year-old Ingenue harpist Pat Hurley ("With Ingenues Orchestra" 1937). I suspect that the band's popularity began to wane as vaudeville and variety revue entertainment forms became less profitable and less able to compete with musical sound films.

Deeply entrenched in the vaudeville tradition, the Ingenues participated most often in variety revues and vaudeville performances, which featured a

range of entertainers from mimics, shout singers, and acrobatic artists to dance troupes, comedians, and mimes. Frequently, an evening's entertainment would be divided into two halves: the first consisting of several shorter vaudeville-style acts and the second featuring a complete stage show by the Ingenues. For picture palaces, the vaudeville revue was often programmed immediately prior to one or sometimes two full-length feature films. For example, the Ingenues' performance at the Wintergarden Theater in 1928 was part of a larger program that included a double film feature, *Somehow Good* and *Lady Raffles* ("Entertainments" n.d.). During their "stage show" set, the Ingenues not only performed big band arrangements of jazz and popular music, but also provided light classical works, ballet dances, jitterbugs, vocal specialties, and comedic routines.

Beyond their appearance in stage shows following or preceding feature films, the Ingenues, like many other all-girl bands, including Ina Ray Hutton and her Melodears and Phil Spitalny's All-Girl Orchestra (not yet the Hour of Charm), often performed as the leading musical attraction and supporting band for all-girl revues. The all-girl revue phenomenon was most successfully orchestrated and exploited by Florenz Ziegfeld, who recognized Americans' desire for mass entertainment composed of predominantly young, beautiful, and often indistinguishable female performers, whether dancers, singers, novelty actors, or all-girl bands. This concept greatly contrasted with the aesthetics of nineteenth-century vaudeville with its lineup of male comedians, actors, musicians, mimics, blackface artists, and a few celebrated female stars. It was in these newly wired and sometimes ostentatious picture houses—liminal spaces in the development of mass-entertainment vestibules—that women became privileged sites for negotiating not only changing structures of architecture and technology, but also of prescribed gendered behavior. During the 1930s, picture houses like the State-Lake theater in Chicago prominently displayed sketches or pictures of "platinum blondes" bookending their advertisements for sound-film offerings with enticements of "A stageful of Living Beauty! Blonde Bombshells in one hour of high revel! . . . 16 Pulsating Perils! Pulsating All-Girl Band" (Display Ad 10 1935).

Women not only bookended film marquees in newspaper advertisements; they were photographed as performers directly outside or within the marquees of picture palaces and variety theaters. In more extreme marketing campaigns, women's bodies were literally displayed as samples of a show's feminine appeal. For the premier of *The Hollywood Revue* (MGM, 1929), for example, with its two hundred chorus women, female performers were physically required to stand in the theater's giant marquee before daily shows (fig. 2.1).

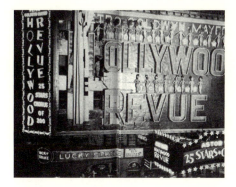

Figure 2.1. Live chorus girls advertise MGM's "Hollywood Revue," the Astor Theatre, New York, 1929 (Hall 251–252).

The Ingenues also posed in a number of configurations that supported the overall aesthetic of variety revues and automated chorus lines: for example, they were photographed as a saxophone choir of platinum blondes serenading the famous rodeo performer Cowboy Strickland in San Diego, California (fig. 2.2).

And in Madison, Wisconsin, the Ingenues posed for a more informal yet equally novel milieu as they serenaded cows at a dairy farm in 1930 (fig. 2.3). This time, however, the women appear to have lost their platinum status.

By April 1929, the Ingenues traveled to Paris to commence their run at the variety theater La Florida. The Florida's promotional picture presented the twenty-two Ingenues sitting cross-legged with cropped ruffled skirts and banjos cocked upward toward their faces. The photo also indicates a typical vaudeville percussion lineup including trap set, vibraphones, timpani, bells, and gong. The tuba and percussion are elevated on risers behind the twelve banjo players.

Musically, the Ingenues' 1932 stage show was also designed as a complete vaudeville act. A review from a Durban paper provided one of the most detailed descriptions of the Ingenues' vaudeville-style revue:

After some 50,000 miles of travel, 22 enthusiastic young women employed their £7,000 worth of instruments to bring Broadway to the Opera House last night. The band's set included jazz and classical music, tap dancing, and vocal specialties. Soloists included the trick trombone of Miss Paula Jones and the violin and piano duos of Miss Mina Smith and Miss Genevieve Washburn performing Kreisler's "Liebesfreud," Rimsky-Korsakov's "Chanson Indone" and a Beethoven minuet. The first half of the bill was colored with various forms of entertainment. The review opened with the magic of "the mathical entertainer," Mr. Jack le Dair who wields magic with giant matches. Following the opening act, the highly revered mimic, M. Maurice Chevalier performed a number of sentimental songs including "Louise" from "Innocents in Paris." Mr. Ernest Shannon provided imitations of "Valentine" and also recited various stories, "some new, some old." The St. Moritz skaters do wonders on wheels with the grace and rhythm of ice-skating, all in the space of about eight square feet.

("Broadway Comes to Town" 1932)

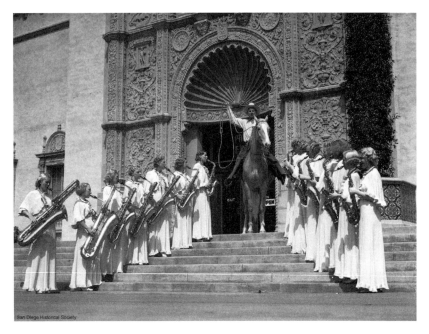

Figure 2.2. The Ingenues with Cowboy Strickland at the San Diego Fine Arts Gallery, 1935.
Courtesy San Diego Historical Society.

This review further betrays the growing practice of programming a popular stage and jazz-band act after a vaudeville bill. Here the Ingenues' stage show occurs during the second half of the program and follows a rather typical vaudeville program.

By the end of the 1920s, the Ingenues became very popular with cosmopolitan theater audiences and their reputation gained them auditions with some of the nation's leading theatrical productions. In 1927, Florenz Ziegfeld immediately "bagged" the orchestra for the Ziegfeld Follies ("What's Going On" 1927; "The Ingenues" n.d.). Apparently, Ziegfeld first discovered the Ingenues at the Palace where he attended the vaudeville-style revue three times before approaching the band. Other female all-girl band members later gained experience performing with the Follies, most notably Ina Ray Hutton, who appeared in the Follies of 1934. According to the *Morning Telegraph*, the Ingenues competed with Paul Whiteman's orchestra for the Follies' 1927 run. The *Telegraph* emphasized Ziegfeld's surprise and delight at the fine appearance of the women musicians: "Flo was delighted to find slim pretty girls in the orchestra and said that he expected to see a band of women wide in the beam and aged in the wood. [Instead he] found cuties who were expert instrumentalists and will be a genuine novelty in a revue as [he] intend[s on] presenting them" ("Ziegfeld 'Buys' Ingenues. . . ."

1927). Clearly, women's ability to garner the more commercial performing opportunities depended upon their youthful and attractive appearances.

At that time, however, all-girl bands' images as novelty acts did not necessarily imply musical amateurism; rather, their novelty status as competent female instrumentalists was a desirable asset cultivated by the producers of big-time Broadway revues (Paula Jones Scrapbook 1927). In vaudeville and variety revue, "novelties" or "specialty" acts suggested a particular genre of performance essential to each program. Within a typical vaudeville bill featuring eight to ten acts, each approximately fifteen minutes in length, the novelty or specialty number might be positioned in the fourth or sixth spot, each time preceding the two star performers. Specialty acts might range from mind readers, contortionists, freak acts, flash acts, and high divers to unusual and exceptionally versatile instrumentalists (Kenrick 2007; Snyder 1989, 66–67). Female novelties were often conceived of as innovative and adventurous short acts that consisted of female performers exhibiting skills not often associated with femininity. By the mid- to late 1930s, advertisements for female musicians in newspapers specifically mentioned auditions for all-girl bands as novelty acts within a particular revue. The classifieds of the *Chicago Daily Tribune* in November 1938 simply read: "Jean Cotton's All-Girl Band open for engagements, novelties" ("Classified Ad 11" 1938).

From a program for the Ziegfeld Follies' twenty-first anniversary, one recognizes the musical variety and diversity of popular music anticipated by theater fans. "Jazz" music as such embraced a wide variety of vocal and instrumental styles from Tin Pan Alley to syncopated dance music to rural southern black vernacular genres, including cakewalks, blues, and minstrelsy tunes performed on banjos and harmonicas. Novelty numbers often featured the wide variety of musical instruments showcased by the Ingenues. One such novelty was highlighted in scene 14 of Ziegfeld's 1927 revue entitled "Melody Land." The scene presented twelve Ingenues symmetrically seated at twelve white baby grand pianos as "12 Pianists." A *Chicago*

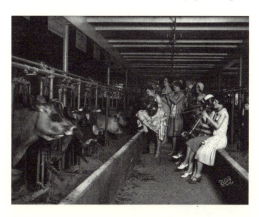

Figure 2.3. The Ingenues at a dairy farm in Madison, Wisconsin, 1930. Courtesy Wisconsin Historical Society WHS Image ID 2115 ("Wisconsin Historical Images").

Figure 2.4. The Ingenues' banjo number in *The Band Beautiful* (Vitaphone 1928).

Tribune review of this act mentioned this scene in combination with the beauty of the female performers:

On the beauty side these is a particularly effective first act finale built around the Musical Ingenues, a ladies' band, assisted by ten lady pianists each provided with a small upright piano. In front of them are sixteen graceful, Albertina Rasch girls and the chorus, costumed in golden yellow with waving yellow plumes as headdress. A sort of glorified field of waving grain in effect, swept by a melodious breeze.

("1927 Follies" 1927)

Other female attractions included "A group of Ziegfeld Beauties," the Military Dancing Girls in "Stars and Stripes," and the dancing troupe of the Albertina Rasch Girls. The emphasis upon female spectacles, often via similarly typed chorus girls dancing in scant costumes or marching patriotically to the "Stars and Stripes Forever" attained its most lavishly mediated execution in the subsequent Busby Berkeley musicals which statically positioned attractive but unremarkable young women in symmetrical designs. Berkeley's own experience choreographing chorus lines and female spectacles for Broadway revues foregrounded his gendered filmic vision during the 1930s (Rubin 1992, 26–32).

Beyond connections to all-girl spectacles in musical revues, the Ingenues were also connected to both nineteenth-century and twentieth-century musical genres, including minstrelsy and jazz. The group was frequently billed as the "Female Paul Whitemans of Syncopation." Paul Whiteman, celebrated during the 1920s as the "King of Jazz," was praised for his "sweet" orchestrations and sophisticated treatments of jazz harmonies and rhythms. Whiteman's brand of jazz was further valued for civilizing, elevating, and cultivating the raw materials of a more "primitive," "raucous," and "primal" music epitomized by the improvised jazz and Dixieland of the early 1920s. Whiteman's famous Aeolian Hall concert in 1924 commemorating Lincoln's birthday was billed by Whiteman himself as an "Emancipation Proclamation, in which slavery to European formalism was signed

away" (Whiteman quoted in Rogin 1996, 138). As cultural theorist Michael Rogin dryly points out, "Whiteman was emancipating jazz from enslavement not just to Europeans but to black Americans" (Rogin 1996, 138). One movie reviewer sanctified Whiteman's "righteous" efforts, claiming that he took his orchestra "into the sacred precincts of Aeolian Hall in an attempt to make an honest woman of Jazz, at that time a cheap and notorious wench" (Rogin, 1996, 138). Here it is not difficult to recognize the overt negative sexual associations of gender and the subconscious implications of female theatrical performers' loose moral fiber. Despite his affinity for black music and black musicians, Whiteman's frequent public estimation of his particular contributions to modern music often incorporated negative notions of race and gender, thus indirectly dismissing African American and feminine contributions to mass culture during the 1920s.

One also recognizes the way that mass-culture critics often invoked gender to connote something base, cheap, and heavily commodified. Huyssen (1986) also examines how mass culture came to be equated with an overarching, destabilizing, and commodified femininity during the nineteenth and early twentieth century as lionized by modernity's masculinist and "autonomous" avant-garde. By pointing to modernity's major philosophers of the nineteenth and twentieth centuries, including Nietzsche, Adorno, and Greenberg, Huyssen adroitly illuminates the rhetoric of masculinist writers who sought to "Other" mass culture by gendering its public manifestation as feminine (52–62).

Whiteman himself acknowledged the African origins of jazz in his autobiography but claimed that jazz's true artistry was white: "Jazz came to America three hundred years in chains." Implicating the European refinement and authorship of jazz, he continues, "Negroes themselves knew no more of jazz than their masters" (Whiteman and McBride 1926, 3). By positioning jazz against "highbrow," imitative, European-based musical cultures, Whiteman attempted to authenticate its national production: "Jazz is the spirit of a new country . . . the essence of America" (4). Whiteman's efforts mirrored those of other nationalist composers like Grainger or Bartók who attempted to mine the raw materials of "folk" songs and reconfigure them within the context of elevated art musics to represent a new cultural/ national consciousness. In this sense, symphonic jazz arrangers and/or composers like Whiteman and Gershwin (who frequently borrowed from black musical sources) depicted the musical utterances of African Americans as "folk" song rather than original, self-authored jazz compositions.

As the "female Paul Whitemans," the Ingenues legitimated their own musical performances by aligning themselves with the "King of Jazz." Such comparisons also served to distance these young, white, female performers

from the imagined crude and vulgar origins of black musical culture. Aligning itself with the "Queens of syncopation" (as opposed to Queen [singular] of Jazz), female musical appropriation of black styles remained largely anonymous and failed to acquire the individual mastery and ingenuity of autonomous jazz composers and directors. As "syncopators," a term that prompted notions of both instrumental jazz and light, popular music, the Ingenues similarly mediated some of the changing associations of the term during the Jazz Age. However, the Ingenues could only stylistically *re-create* Whiteman's more original music. Association with Paul Whiteman offered two forms of cultural distancing that facilitated these women's increasingly prominent and potentially threatening public presence. The first identification (with Whiteman) enabled the necessary distancing from the dangerous associations of urban black music, and the second (with syncopation), from the innovation and authenticity of white, male jazz.

Each woman of the ensemble mastered several instruments and performed them during the course of the evening. Many members of the orchestra also sang and danced for specialty numbers. One review of the Ingenues' vaudeville performance at the Palace in Chicago praised the novelty and musicianship of the group while also emphasizing the youth of the women: "There's really something new under the vaudeville sun at the Palace this week in the melodious, marvelous, musical sixteen young women who form an orchestra billed as the Ingenues" ("Band Girls Play Something New" n.d.). For their Vitaphone short in the late 1920s, the nineteen "girls" performed the various woodwinds and brass instruments typical of a big band, and then replaced their band instruments with banjos, accordions, and harmonicas. Featured members Adelheid Liefeld performed solo instrumental pieces on the cello while trombonist Paula Jones also danced and provided comedic relief on her "trick" trombone.

Another review by Fred High in an unidentified clip introduced the Ingenues as "16 College Girls, with Peggy O'Neil" and described their show as representing "an endless variety and an inexhaustible range." High also praised the "showmanship and musical talent plus pep and good taste" exhibited by the ensemble. He claimed they furnished "one surprise after another" ("Fine Palace Bill Makes Big Hit" 1926). During the band's world tour in 1928, one review of the Ingenues' performance at the Wintergarden Theater highlighted the great versatility of orchestration and musical genre exhibited by the various women:

Each member of the band is versatile. They all, at least double on some other instrument. For instance, one girl plays on instruments so widely separated by period and usage as the harp and banjo. Another distributes her attentions between the cello, sax, and bassoon. Offering mainly jazz, the band's work strikes one as very efficient.

Being "ingenues" does not debar their playing as having the precision as a military band. Though the players are feminine, the brass is "fierce" in the fortes, but the players can tone these instruments down to a whisper. Another feature of the music is the constant change of colour, and some interesting instrumental grouping is effectively demonstrated. The "Ingenues" jazz music is snappy; they give a plantation air with the necessary atmosphere, and can play an extremely seductive waltz.

("Entertainments" n.d.)

The last musical descriptor betrays the rigorous musical, aesthetic, and gendered requirements for all-girl bands as they cunningly negotiated a variety of feminine, racial, and theatrical tropes. These included cultural vestiges of the Victorian era, racial conventions of minstrelsy, and the more radical gendered and musical innovations of the Jazz Age. Here the author praises the band for displaying all three: first, as the band delivers the ethos of the proper, cultured Victorian women ("extremely seductive waltz"); second, as they produce the modern innovations of popular culture with their up-tempo jazz (jazz music that is "snappy"); and, third, by reproducing in retrograde the theatrical conventions of minstrelsy ("Plantation air with the necessary atmosphere").

Other international reviewers completely avoided ascertaining the band's musical qualities and resorted instead to lengthy treatises comparing the relative physical attributes of the various band members (fig. 2.5). One Australian journalist dwelled upon the physiques, visages, and dispositions of the women, all the while legitimating his position as preeminent "beauty queen" judge:

Paris had a much easier job than mine. It was only 2 to 1 against him picking the winner. With me the odds were 19 to 1 that I was wrong; but by a bit of head-work, I reduced it to tens. For safety reasons I made my selection from the frame of photographs displayed in the Tivoli lobby, announcing the arrival of the Ingenues. Believing myself to be a bit of a physiognomist, after careful study of the pictures shown, I selected Miss Adelaide Leyfeld [Adelheid Liefeld], cellist, for soul and sentiment, and Paula Jones, who does her stuff on the trombone, for wit and devilment. Just have a squiz at the two pictures, and tell me if I am not right! You bet I am. First. I argued, a girl of soul and sentiment would surely select a cello to express her emotions. I love the cello. No other instrument is capable of such turbulently tender harmony. Never blatant, never assertive, yet capable of rising to heights reserved resonance. One thing I have always wondered at is, why the Angels of Paradise bother with harps when they might have taken the cello. Perhaps harps are easier to play. (D.H.S. 1928)

His "review" of the Ingenues' performance at the Tivoli was guised in the form of a "conversation" with two of the band members, Adelheid Liefeld and trombonist Paula Jones. The author's prose style, half Runyonesque, half Victorian romance, is replete with superfluous, elaborate descriptors and copious references to sublime and enticing women. Similarly, Mr. Maloney, the owner of the Tivoli, gushes about the "bevy of beautiful girls from

Figure 2.5. Paula Jones's "trick trombone" in *The Band Beautiful* (Vitaphone 1928).

America," comparing the women of the Ingenues to Tennyson's "Dream of Fair Women" of which he protests were "after all, a figment of his fevered imagination while these were women of warm flesh-and-blood, pulsating with the joy of life, and no man could, with a clear conscience and experienced judgment, say that one was more lovely than the other" ("Fine Palace Bill Makes Big Hit" 1926). Depending on the contexts of their international performances, critics depicted the Ingenues variously as Victorian white women; independent, world-traveling jazz musicians; or mechanized, choreographed chorus girls.

By the end of the Ingenues' South African tour in 1932, three leading members conspired to quit the ensemble to accept a local engagement at the Durban Café. One of these women was none other than the band's leading soloist and comedic performer, Paula Jones. One can only speculate as to these young "collegiate" women's motivations for leaving the secure financial and musical environment of the Ingenues, with its built-in structure of managers, arrangers, booking agents, national press coverage, and access to publicity forums from radio broadcasts to film releases. Perhaps the chance to earn better wages, assert greater musical control over arrangements and repertoire, and, most significant, the freedom to improvise and perform in a more intimate musical setting emboldened these women to go solo. Or perhaps the declining economic climate of 1930s jazz motivated these women to leave their large ensembles. After all, other leading jazz performers who began in the well-known big bands and novelty orchestras of the 1930s abandoned these large and expensive organizations to pursue careers as soloists in smaller jazz combos: Benny Goodman, Gene Krupa, Charlie Christian, and Louis Armstrong are just a few examples. Beyond the more pressing economic concerns, these players may have viewed their big band tenures as stepping-stones toward greater musical prestige, independence, and artistic control. As one of the most publicized members of the Ingenues, trombone soloist Paula Jones must have shared these same musical aspirations.

The news of the women's departure from the band was so significant that local papers reported the incident. One headline read: "Cannot Remain in Durban: American Jazz Girls and Immigration." Another reported: "Immigration Ban on Girl Players—Dilemma of Three Ingénues—Hitch in Accepting Durban Contract." South African immigration authorities, however, refused the women temporary residence. According to these articles from 1932, Frances Gorton (accordion), Paula Jones (trombone), and Ruth Carnahan (saxophone and trombone) were refused residence by the South African immigration authorities because they were unable to obtain proof of employment for two years and were therefore denied permission to remain in South Africa. Soon after, Jones, Gorton. and Carnahan were forced to sail with the other Ingenues on the "mailboat" for America. After the early 1930s, documentation of the many international tours of the group begins to wane. The specific trajectories of the various musicians were no longer featured in newspaper reviews and announcements. The band did, however, perform in a short subject film, *Maids and Music*, to which we now turn.

Maids and Music

Like many all-girl bands of this era, the Ingenues were deeply entrenched in the theatrical conventions of vaudeville that musically exploited and revived feminine adaptations of minstrelsy. In *Maids and Music* (1937), the Ingenues (listed this time as Ray Fabing's Ingenues) perform a combination of popular songs, jazz compositions, and a medley of American folk/vernacular tunes, including "Oh! Susanna," "Turkey in the Straw," and "She'll Be Comin' 'Round the Mountain." Like other specialty musical vaudeville acts of the 1920s and 1930s, this film incorporates a variety of music to accommodate the diverse tastes of its audiences.

The film begins with a fast-paced flash rendition of Duke Ellington's "Caravan" in a typical nightclub setting. The music is led by an ebullient dancer (possibly Louise Sorenson or Ray Fabing) who combines an unorthodox conducting style with a series of jazz steps including the Charleston, "truckin," and high kicks. During the 1930s, male band directors like Cab Calloway similarly incorporated jazz dancing into their original and visually intriguing stage routines. Female bandleaders, however, like Ina Ray Hutton and the leader in this film expanded jazz directing by adding elaborate physical dancing within a more "feminized" theatrical role.

After the extensive jazz and dance sequence, the film fades to a new setting where the Ingenues are symmetrically positioned in three ascending risers before the women begin the medley number. The film ends with an

orchestrated version of W. C. Handy's "Saint Louis Blues," a highly popular and frequently programmed jazz piece during the 1920s and 1930s.

Urban audiences of the 1930s would have understood or at least recognized the black vernacular roots of these rural southern melodies from this second sequence, especially as filtered through the familiar compositions of Stephen Foster. Indeed, when performed by European American vaudeville performers, these songs were frequently racialized and connected to nostalgic, romanticized, and/or satirized southern musical-performance contexts long established through nineteenth-century minstrelsy and blackface vaudeville. The musical and feminine representation in this sequence aesthetically parallels the abstract presentation of women in the spectacular all-girl revues as well as the 1930s Busby Berkeley musicals. Here, the women, presented in simple country dresses and nearly identical curlicue hairdos, are arranged in three tiers outlining a V-formation (a design not yet established as a patriotic emblem).

In each tune of the medley, the girls play the same novelty instruments. First, we hear "Oh! Susanna" performed by twenty-five smiling girls plucking banjos in perfect unison. As one frame fades out, the second frame fades in with "Turkey in the Straw," with twenty-five foot-stomping girls blowing twenty-five harmonicas. Then the women bring back their banjos for an abbreviated version of "She'll Be Comin' 'Round the Mountain." As this frame fades out, the girls rematerialize, fanning twenty-five accordions all playing "Nobody's Sweetheart." And so on in an endless parade of feminine novelty and uniformity.

The variety of musical material and range of musical instruments suggested the move toward feminizing theatrical genres, however coded and cautious. Directors and producers like Ziegfeld and Sherman stylistically recreated "old-fashioned" racialized formulas like minstrelsy to temper the radical gender positioning of these all-female revues. Like children, the women are depicted as pliable creatures, easily trained to learn new and simple tricks that were both novel and cute. Significantly, these women's musical associations with black southern roots revealed the similar practice of representing and depicting black musicians as childlike, playful, primal, malleable, and intuitive (Bohlman and Radano 2000; Agawu 1995; Lott 1993a; Pieterse 1992).

While the Ingenues' performance of minstrel songs seems insignificant (and even bizarre in the context of big band jazz at the height of the swing era), the choice of repertoire enabled a "white" feminine reading of blackness that essentially precluded these women being accepted as serious jazz musicians. Moreover, the use of novelty jazz bands performing a mixture of popular music, jazz, and minstrelsy songs in vaudeville contexts did not necessary have purely feminine gendered antecedents. Even Whiteman's

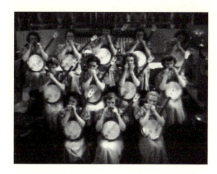

Figure 2.6. The Ingenues playing harmonicas in *Maids and Music* (Pictoreels 1937). Courtesy Fred MacDonald.

band performed symphonic arrangements of popular minstrelsy tunes during the 1920s. By the late 1930s, however, big band jazz had established its own place in the popular music industry and no longer needed to satisfy the eclectic demands of musical theater.

Nonetheless, what these musical vignettes suggest is not these women's versatility and skill, but rather their assumed predilection for collaborative, homophonic ensemble playing with a generic repertoire of unoriginal, hand-me-down folk tunes. The vernacular musical repertoire linked these female musicians to everyday folk culture and dissociated them from the realm of high art with its repertoire of innovative jazz written and reworked by master composers, arrangers, and orchestral conductors.

Black Vaudeville

Like the Ingenues, black all-girl jazz bands performed most frequently during the 1930s in theatrical and mass-mediated contexts, including the combined stage-show/feature-film presentations that were incorporated into movie house and vaudeville theater programs. A survey of African American newspaper advertisements and music reviews proves that black all-girl bands existed early in the twentieth century. Black female instrumental groups, like their white counterparts, performed in a variety of settings: most often on vaudeville stages, but also in music theaters, in hotels, and for civic functions in the nation's larger cities with sizable black populations, like New York, Chicago, Baltimore, Pittsburgh, Kansas City, and Los Angeles.

Bands like the Queens of Rhythm, the Harlem Playgirls, the Dixie Sweethearts and Lil Hardin-Armstrong's all-girl band also traveled on the black theater circuits and were frequently booked by the notorious black talent agency, the Theater Organization Booking Agency (TOBA), as they performed one-nighters in the territories and fulfilled weeklong theater and ballroom engagements in the larger American cities.

Reviews from African American newspapers from the 1930s including the *Chicago Defender,* the *New York Age,* and the *Pittsburgh Courier,* suggest that black all-girl bands also participated in variety reviews and stage shows as headlining acts in the various vaudeville and film combination circuits. Because of the limited distribution of black-cast films, black all-girl bands typically headlined in African American neighborhoods for black patrons while opening for the more commercial, and largely white, Hollywood productions.

Black-owned theaters began cropping up in the early twentieth century shortly after the great migrations of southern blacks to northern cities. In Chicago, the number of black residents increased 700 percent between 1890 and 1910 and then rose again by 148 percent between 1910 and 1920 (Grossman 1989, 127, 135, 278). By 1919, Chicago's black population had grown from 44,130 in 1910 to 109,458 in 1920 (Carbine 1990, 33). Film historian Mary Carbine confirms the proliferation of more than twenty movie theaters in Chicago's Black Metropolis during the early twentieth century. These theaters, which were not always black-owned, did cater to black patrons, and provided second-run Hollywood movies along with vaudeville and musical performances (Carbine 1990, 15). Many of these theaters developed in an area colloquially known as the "Stroll," a region in Chicago's south side (between Twenty-sixth and Thirty-ninth Streets) that became the focus of business, shopping, and leisure activities during the early twentieth century. During the 1920s, the region just south of the "Stroll," near Forty-seventh and South Parkway, was renowned for its active nightlife, with more than twenty movie theaters, and several vaudeville and musical venues (Carbine 1990, 15).

Carbine (1990) argues that urban black patrons and performers encountered mass culture in culturally, racially, and ethnically specific ways as they localized, reinterpreted, and musically interacted with films; in so doing, they bolstered local identifications and "reduced the homogenizing impact of mass entertainment" (10). More specifically, black patrons who inhabited the theaters on Chicago's south side sought refuge and asserted cultural difference from the hegemonic and racially restrictive atmosphere of downtown film houses:

On the Stroll, the institutions and enterprises of the black bourgeoisie, as well as popular sites for recreation by working and migrant blacks, drew upon what Grossman describes as the "familiarity and relief" of a black world. It is in this context, imbued with a consciousness of cultural autonomy, social difference and struggle, that black Chicagoans encountered commercial entertainment in the movie theaters. (Carbine 1990, 15)

In these theaters, black moviegoers could enjoy movies without Jim Crow seating restrictions, as well as interact with the films in culturally

specified modes of behaving that may have been censored in the predominantly white downtown movie palaces. More importantly, black consumers could actively select and patronize those black artists, actors, and musicians that established careers for themselves in the highly popular black vaudeville and music circuits. Both the Monogram and the Grand theaters on South State Street were part of the TOBA vaudeville circuit that booked black acts throughout the Midwest and across the South as part of the movie-vaudeville entertainment combination. While TOBA's control and exploitation of black artists earned the circuit the appellation "Tough on Black Asses," the organization did allow black talent to become a regular feature in the movie houses on the Stroll (Carbine 1990, 22). Vaudeville and black theater stars like Butter Beans and Susie (with pianist Lil Hardin-Armstrong), S. H. Dudley, Kid & Coot, Jazz Lips Richardson, Adelaide Hall, the Darktown Minstrels, and Bert Williams shared vaudeville bills with popular jazz and swing bands like those of Fats Waller, Duke Ellington, Fletcher Henderson, and Count Basie. Similarly, all-girl bands like the Harlem Playgirls and Lil Hardin-Armstrong's all-girl band shared bill with the famous black comedians and actors who circulated on the TOBA routes and performed in movie theaters during the 1920s and 1930s.

Carbine (1990) suggests that the migration of blues and jazz musicians upriver from New Orleans and Saint Louis facilitated a constant flow of new artists to perform in the movie houses. She further asserts that black vaudeville and black musicians eventually superseded the film's preeminence: "the insertion of black musical performance into the theatrical venue eclipsed the mass-entertainment component, and the picture house served as a center for the development and appreciation of popular black music" (25). Significantly, whites generally did not patronize the black theaters in Chicago's south side. Whites already had access to jazz performances provided by black musicians in black and tan clubs. For films, whites typically preferred to attend the more elaborate downtown picture palaces. Thus, "the movie theaters offered a culturally autonomous setting for jazz performance, where black musicians played for black audiences" (25).

The Harlem Playgirls

One of the most popular African American all-girl bands to perform in the black theaters and film houses of the 1930s was the midwestern Harlem Playgirls. The group was organized in 1935 by Minneapolis-based drummer Sylvester Rice under the encouragement of the management company the Stecker Brothers. Rice was undoubtedly motivated by the success and novelty of the already prominent midwestern African American all-girl band,

the Dixie Sweethearts. In less than one week, Rice set out to organize a viable all-girl band to tour the country. Rice recalls the pressure of having to construct a professional touring dance band in less than one week:

The first rehearsal was the sorriest mess I have ever heard. Orvella and I went out and got drunk afterward and I was on the verge of tears. We had just left Eli's band and they were really swinging. I had one week to whip the band into shape and hit the road. We did it, rehearsing day and night. Learned about twenty five numbers and when we finished playing them, we'd start right over. I could write several books about this band and then not fully cover the weird things that happened. However, the band did jell and by the time we hit the West Coast the girls were an excellent attraction. (Driggs 1977, 15)

Rice even admits his fierce competitive tactics as he resorted to hiring some of the Dixie Sweetheart's best musicians for the Harlem Playgirls just as the Sweethearts were embarking upon their West Coast tour (Driggs 1977, 15). By 1936, the Harlem Playgirls had received a fifty-week contract to tour on the TOBA vaudeville circuit with a group that featured Orvella Moore as singer and pianist. At that time the group was still run by Sylvester "Sunny" Rice (McWilliams 1936).

Many all-girl bands were organized by booking agencies that were looking to increase their novelty markets and broaden their name recognition by expanding their roster of sexy acts. In doing so, these booking agencies would often hire well-respected bandleaders to recruit, rehearse, and direct the newly formed all-girl bands for a limited time until the band became musically established. At such a time, management typically hired a female bandleader who had already established a name for herself on the vaudeville circuits as an entertainer or headlining act. She was usually highly attractive and musically accomplished as a singer, dancer, or instrumental soloist. Such was the case for the Harlem Playgirls' first female bandleader, Eddie Crump, who had previously worked on the TOBA circuit as a dancer, singer, and headlining star.

Little more is known of Eddie Crump, but the band's second leader, Baby Briscoe, was an established New Orleans entertainer who had worked with many prominent jazz bands as a singer and dancer including Lil Hardin-Armstrong's all-girl orchestra and Joe Robichaux and his Rhythm Boys. One review of the band noted the prestigious and prolific touring experience of Baby Briscoe:

The Harlem Play Girls who are routed to appear here for three nights beginning Nov. 11 are now doing great work under the direction of "Baby" Briscoe, versatile and flashy New Orleans band leader. Formerly appearing with Joe Robichaux, Lil Armstrong, the Five Joy Clouds, the Four Coeds and Troy Brown, Miss Briscoe has had a great wealth of experience on the road. Miss Briscoe is rousing out her first year with the all-girls band and has enjoyed tremendous success as the band's leader.

Her ability to keep the girls in the groove while swinging out with their hot numbers, has won her a good reputation as a band leader. In addition to directing, Baby Briscoe will soon play trumpet. For sometime now she has been studying the trumpet and will soon be heard blowing the instrument. ("Cleveland, O. Nov. 3" 1938)

Tucker claims that Baby Briscoe later sang and "wielded baton" for the Darlings of Rhythm in the 1940s as Joan Lunceford (Tucker 2000b, 211). However, the *Chicago Defender* mentions a number of acts that featured both Lunceford and Briscoe in variety revues, and sometimes the two performed together ("Opening of Rhythm Club Gala Event" 1937). Briscoe also went on to produce all-black revues such as the "Bottoms Up Revue" in 1942 (Hayes 1942).

Featured trombonist Lela Julius eventually stepped in as the Playgirls' leader in 1938. Rice again noted the experience of the various women bandleaders: "Lela Julius had been a trombone player in several bands before heading up the Harlem Playgirls at their first appearance at the Apollo Theater in New York in 1937" (Driggs 1977, 17).

Like the popular white all-girl bands touring vaudeville circuits during the 1930s, the black bands also received accolades for their combined visual and aural accomplishments. Reviews typically noted the band's musical and feminine charms. One review included a promotional photo of the band's rhythm section and was captioned "Here's Feminine Rhythm . . . And How!"

Pictured above are members of the rhythm section of the Harlem Play Girls orchestra now touring the country. Each time the band is heard, the leader of the band, pretty Eddie Crump, gets her pretty ear full of compliments on the band. It's a fact folks; they can play as good as they look. ("Here's Feminine Rhythm" 1939)

Another review comments upon the prettiness and cunning of the musicians, depicting the women as something like charming coeds:

"Group of Clever, Pretty, Talented Girls." This group of lovely girls is known as the Harlem Play Girls. They've been on a four months tour of these United States and have been very successful in their attempt to please Mr. and Mrs. Public. This is the only sepia all-girl unit on tour in the U.S. and is in great demand by dancers everywhere. They recently finished a week's engagement at the Howard Theater in Washington D.C. Now playing one-nighters in Virginia and West Virginia.
("Group of Clever, Pretty, Talented Girls" 1937a)

Of course this was not the only "sepia" all-girl band performing in the United States; the Harlem Playgirls would have performed in the same venues as Lil Hardin-Armstrong's all-girl band as well as the Dixie Sweethearts.

Like the male vaudeville bands that toured on the Keith-Orpheum circuits, women performing in vaudeville bands frequently performed in a variety of capacities, from dancing to singing and musical comedy repartee. Various press releases confirmed the band members' highly diverse theatrical

skills; this one is probably from the band's 1937 Midwest tour: "Miss Eddie Crump and her Harlem Play Girls, novel all-feminine swing aggregation which has been breaking records out in the provinces and is due in the East next month. The girls sing, dance and play." Although this review offers little indication of the band's musical and theatrical performance content, it's clear that the Harlem Playgirls also mediated expectations from theater audiences who were accustomed to seeing groups of light-skinned chorus girls singing, dancing, and playing in unison.

A 1936 review of the group after their playing a casino in Denver also favorably listed the girls' versatile musical and theatrical abilities:

This is the hottest orchestra that was ever heard here. They are not only musicians but entertainers of the highest type, producing their floor [show] from members of the orchestra. Eddie Crump, directress, really knows what a baton is made for and she is an artist at producing swing music. (T. S. Williams 1936)

The repeated exposure of black and white audiences to African American chorus-girl acts in theaters, variety revues, and black and tans certainly facilitated the acceptance of the Harlem Playgirls in vaudeville houses and movie theaters during the 1930s.

In October 1937, the Harlem Playgirls were affectionately coined the "Queens of Swing" to legitimate their abilities as jazz musicians and probably to participate in the ever-increasing demand for swing. Associations with Benny Goodman as the "King of Swing" were undoubtedly understood by black audiences, who recognized the black origins of the more commercially successful "swing." In 1938, the band secured their second headlining performance at Harlem's Apollo Theater, the highest honor for black jazz bands throughout the country ("Thanksgiving Week Attraction at the Apollo" 1938). The band returned to the Apollo in December 1938 to perform with a vaudeville-style revue featuring celebrated comics Willie Bryant and Jackie "Moms" Mabley and the vaudeville duo of Lewis and Van.

By 1938, the women's reputations were so established as a serious swing group that the *Chicago Defender*, a longtime promoter of female musicians and entertainers, printed a list of the Playgirls musicians: Alice E. Proctor, Marjorie Ross, Bessie Comeaux, trumpet; Lelia Julius, trombone and guitar; Harig Thompson, Margaret Backstrom, Violet Burnside, reeds; Orvella Moore, piano; Jennie Byrd, drums; Gwen Trigg, bass; Baby Briscoe, directress (W. 1938a).[4] Other members in varying years are gleaned from the society pages or brief "mentions" in historical newspapers and the *Chicago Defender*. Mary Shannon, for example, played trumpet with the group in 1935 (The Matron 1935). Madge Fountaine, first alto sax player (and reeds) had previously played professionally in New York and also in

Lil Hardin-Armstrong's all-girl orchestra ("Harlem Playgirls Lose Saxophonist to Cupid" 1938).

While the Playgirls' appearances were frequently and briefly mentioned in the society columns of African American newspapers, they eventually garnered full reviews of their well-received "swinging" presentations in the late 1930s, such as this one from 1937 after their performance at Chicago's Savoy Ballroom, where they were coined the "rhythmic swingsterettes":

With petite, dark eyed and dimpled Eddie Crump as the batoness, the orchestra has a winning way of presentation. Time after time . . . voicestress as well as instrumental solos came forth with something entirely new or done in a different way. . . . Their own theme "The Playgirls Serenade" greeted the dancers throughout the night. Other numbers that were outstanding with the Savoy Hoppers were: a combo of "Trees" and "Roseroom," "Swampfire," "I Know Not" and the "Organ Grinder's Swing." Eddie's rendition of "Posin'" was a tremendous hit with the dancers. ("Harlem's Hot Play Girlies A Savoy Hit" 1937)

In 1938, before the group's successful run at the Apollo (with Bill Robinson), they toured the Midwest and performed a prestigious battle of the bands contest in Chicago's esteemed Savoy ballroom competing against Johnny Long's swing group (W. 1938b).

By 1939, the same year that Billie Holiday recorded her socially radical adaptation of "Strange Fruit," the Harlem Playgirls were breaking box office records in the South. Promotional blurbs began to mention each musician in the ensemble and remarked upon the "swinging" capabilities of the band. The Harlem Playgirls' reputation as a great swing band extended beyond their novelty status as an all-girl band. Indeed, the band frequently performed on the same bill as notable male swing ensembles, including the bands of Don Albert and Nat Towles, as the following review shows:

GREAT BANDS AT MARDI GRAS: New Orleans, La. Mar. 3—New Orleans had for its Mardi Gras season some of the best swing bands in the country. Don Albert and Nat Towles played in a Battle of swing. The Harlem Play Girls Exclusive Bunch club and Victor and his Music Masters were selected for the Pittsburgh Courier Kiddie Party. ("Great Bands at Mardi Gras" 1938)

In 1939, one review claimed that the band was so successful as a dance band (swing band) that even the women didn't mind the added feminine competition:

And Even the Women Raved Over Them. When a woman compliments another woman, that is something. And the female jitterbugs really liked the music of the Harlem Playgirls as they swung out in Jesse J. Johnson's brand new Paradise Deluxe Gardens in St. Louis Thursday and Friday nights. June 15 and 16. Note the smiling faces and interesting poses caught by photographer Davenport as the Harlem Playgirls did a little "stand-up." ("And Even the Women Raved Over Them" 1937)

As all-girl band scholar Sherrie Tucker confirms, many of the Harlem Playgirls' featured soloists pursued professional careers as touring musicians well into the 1940s. Harlem Playgirl trumpet player Jean Ray Lee, for example, later played with the Darlings of Rhythm and Eddie Durham's All-Stars in the 1940s. Similarly, tenor soloist Margaret Backstrom (Padjo) later played in Eddie Durham's All-Stars and then defected to the Darlings of Rhythm. The famous Tiny Davis, trumpet soloist with the Sweethearts of Rhythm, also appeared on some of the earlier rosters of the Harlem Playgirls. Dixie Sweethearts drummer Henrietta Fontaine, for example, later played with the Darlings of Rhythm in the 1940s (Tucker 2000b, 204). Other Dixie Sweethearts members Marjorie Pettiford and Violet Burnside also continued to perform with all-girl bands during the 1940s. Both Pettiford and Burnside later toured with the Sweethearts of Rhythm in the 1940s (Tucker 2000b, 204).

It appears that the group stopped playing sometime in 1940. However, notices of the Harlem Playgirls' whereabouts were still appearing in early 1940 (Purdy 1940) and the group led a three-month "Dixie" tour including the southern states of Georgia, Tennessee, and North Carolina ("Harlem Play Girls Now on Dixie Tour" 1940).

Theorizing African American Female Performers

While the instrumentalists of the Harlem Playgirls were frequently compared to contemporaneous male bands of the 1930s, these women's performances also responded to the highly successful female jazz and blues singers as well as the more visible chorus girl acts featured in variety revues, cabarets, and black and tans. In many ways, it appears that the Harlem Playgirls' publicity managers attempted to eradicate some of the primitivist and sexualized associations of jazz singers and the highly visible 1920s chorus girl acts by carefully constructing physical descriptors and photographs that employed images of respectable femininity and class. However, the Harlem Playgirls also adapted some of the gendered theatrical conventions of chorus-girl acts in their theatrical, film house, and vaudeville performances. In this respect, African American reviewers attempted to highlight the "charming" and "pleasing" appearances of these women while also praising their expert musical skills, and multifaceted theatrical contributions.

These complex representations signaled a desire to reposition African American performing women's class and respectability, in a manner consistent with the tenets of racial uplift promoted by the black literati and upwardly mobile black Americans. These representations further contrasted with those feminized subjects frequently constructed in political,

sociological, and literary texts depicting African American chorus girls and jazz and blues singers. In these discursive texts, written representations frequently emphasized the libidinous and contaminated urban settings within which chorus-girl and female jazz performances took place.

Public indictments against African American chorus women and female jazz performers contradicted these women's newly won economic gains. Clearly performing was an attractive alternative to other forms of urban labor. Jayna Jennifer Brown's (2001) research on African American chorus girls' contributions to popular culture during the 1920s and 1930s posits that "women of the stage musicals of the 1920s . . . embodied the pleasurable mobilities of the modern age" (220). Brown surveys a number of black theatrical musicals during the 1920s including Sissle and Black's *Shuffle Along* (1921) and *Chocolate Dandies* (1924) and Lew Leslie's *Blackbird* and the *Plantation* revues in London. Her analyses focus on the chorus women and headlining female artists of these productions, including Florence Mills, Valaida Snow, Josephine Baker, and Ethel Waters.

Brown's analysis closely relates to the ways African American female jazz bands negotiated prevailing ideas about black female performativity and creativity during the 1920s and 1930s. By investigating reviews of these productions, she reveals the debilitating proscriptions issued by white audiences to black female performers, who were made to enact a certain imagined idea of "colored folk" or African indigenousness during the 1920s and 1930s (Brown 2001, 240).

Chorus girls' mediations of Jazz Age cultural, sexual, and racial prescriptions redefined a postmigration urban modernity through their financial success, independence, transnational mobility, and the up-tempo physicality of their urban lifestyles and theatrical performances. In an effort to compete with white all-girl spectacles, promoters of African American chorus girls and musicians of the variety stage, revues, and black musical films implemented a range of contradictory signifiers and promotional adjectives in their publicity campaigns, including modern, primitive, natural, organic, jungle, and urban. In the heavily racialized, "negrophile" fictional texts, jazz women were depicted in less positive terms, with descriptions that suggested a more sexualized, "contaminated," and hybrid performativity. Brown (2001) eloquently summarizes such contradictions:

Black women variety artists performed versions of racialized femininity prefigured in earlier periods of colonial expansion that circulated throughout the world. Discourses of scientific racialism and romantic nationalism constructed fantasies of a black folk, sprung from the soil of the United States. Linked to European and British fantasies of African and colonial female subjecthood, both eugenicist fears and miscegenist desires were mapped onto the light-skinned bodies of the colored chorus girls. (220)

As in black musical film genres, the aesthetic, gendered, and racial meanings of black artistic genres radically altered during the 1930s. During the Jazz Age, chorus girls' increased financial security, urban modernity, and transnational mobility symbolized increased self-reliance, cultural freedom, and creativity. These images effectively inspired thousands of independent black women to migrate to the black metropolis during the 1920s. Conversely, during the 1930s, light-skinned chorus girls came to represent modernity's failure, as women were more frequently characterized as contaminated and appropriated objects of white commerciality and desire. During the 1930s, chorus women were likened to Babylon girls as they came to represent false promise, city ways, greed, and uncontained sexuality. In response, culture producers and pundits began to reductively characterize performing black women as either moral or amoral, and often aligned these women according to their musical repertoire in an effort to "restore a lost heartland to black culture" (Brown 2001, 270). In this duplicitous structure, black female musicians were often categorized either as "morally suspect" women performing the urban-based musical genres of jazz and blues or respectable women performing sacred musical styles, including gospel and spirituals.

During the Jazz Age, and after the great urban migrations, black activist voices representing the upper and middle classes bemoaned the presence of the growing urban "slums," centers catering to urban vice, especially those places where women's bodies became vehicles for the traffic of urban pleasures. Black feminist scholar Hazel Carby (1992) probes the female representations of African American women's bodies during the first half of the twentieth century as depicted in editorials, literature, and in the works of celebrated Harlem Renaissance writers, including Langston Hughes, Zora Neale Hurston, and Claude McKay. She claims that women's bodies became contested subjects because they symbolized so many of the traumatic ruptures experienced by African Americans during and after the great urban migration. Accordingly, women's bodies embodied many of the contradictions of urban American culture as they became sites for white male desire, fantasies of miscegenation, and performative symbols of lost colonial subjects. African American female performers' mass-mediated performances incorporated images of primitive, exotic, and libidinous beings even as their innovative jazz dances were appropriated for their spontaneity and creativity by the dominant culture.

Carby cites passages from Jane Edna Hunter's 1940 autobiography *A Nickel and a Prayer* to articulate some of the "moral panic" expressed by the growing black middle classes in response to an expanded urban popular culture. Hunter's prose is representative of those upwardly mobile African

Americans who attempted to establish themselves in the metropolis and variously distance themselves from what they felt to be the excessive vices and primitive urges engendered by the new urban "slums." Hunter's prose expresses some of the moral panic that gave rise to numerous debates regarding the perceived deviant behavior of prostitutes, burlesque entertainers, and theatrical performers, who were variously depicted as naive and lazy women, preferring the easy professions of vice and urban spectacle over good, clean, hard work. Of particular worry were the nightspots, cabarets, and jazz bars that provided white and black patrons with intimate images of "immoral," and over-"sexualized" African American female entertainers.

In light of the pervasive associations of African American performing women with social and cultural disruption, it is all the more surprising that, during the 1930s, the Harlem Playgirls managed to successfully perform hot jazz while also dancing and singing. These performances reveal their complex relationship to the theatrical world and the more established position of African American performers in mass-mediated contexts as well as in the more localized traditions of black theater and black touring shows that were designed exclusively for black audiences. Musicians like Lil Hardin-Armstrong, Blanche Calloway, Valaida Snow, and Hattie McDaniel (a sometimes drummer) also performed in a variety of contexts, including black vaudeville groups, circuses, and black revues. Within these forums, female musicians were versatile performers who not only played jazz, blues, ragtime, and Tin Pan Alley, but sang, danced, and performed comedic routines.

In America's expanding metropolises, all-girl bands performed stage shows in vaudeville theaters and film houses but also in nightclubs, casinos, cabarets, and ballrooms. By the 1930s, the established inclusion of chorus-girl acts and all-girl bands in cabarets, nightclubs, and in stage shows presented before feature films created an unusual and unprecedented juxtaposition of gendered representations in public spaces; bands like the Harlem Playgirls would have provided the musical accompaniments for the various chorus-girl acts, but just as frequently would have provided dance sets in prestigious black ballrooms. Certainly, the sheer mobility of the Harlem Playgirls as they traveled across the United States as well as the financial rewards garnered by these performances countered some of the anxieties prompted by such unprecedented gendered and musical/theatrical innovations.

In what ways are these feminized representations concurrent with the experiences and transformations brought about by performing jazz women? In general, negative accounts of black female performers are thrown into stark contrast with those positive accounts articulated by female entertainers and blues singers who found support and economic opportunity in the

nightclubs, cabarets, vaudeville circuits, and prostitution districts of the black metropolis. In most cases, African American women's reflections of their lives as entertainers, musicians, chorus girls, and dancers reaffirmed the more independent, financially rewarding, and mobile professions available to African American performing women. Indeed, both Ethel Waters and Alberta Hunter doubled their salaries when they quit their jobs as domestics to become chorus girls with traveling theatrical groups. Waters later wrote of the nurturing relationships she experienced with female prostitutes, admitting how they provided attention, clothes, and motherly affection (Waters 1989, 17–19). While Carby (1992) locates these performing women as blues singers, their contributions to black theater, variety revues, vaudeville, and film as jazz singers, Tin Pan Alley, and blues singers should not be overlooked. According to Carby:

The twenties must be viewed as a period of ideological, political, and cultural contestation between an emergent black bourgeoisie and an emerging urban black working class. The cultural revolution or successful renaissance that did occur stemmed from this terrain of conflict in which the black women who were so central to the formation of an urban blues culture created a web of connections among working-class migrants. The possibilities of both black female liberation and oppression were voiced through a music that spoke to the desires which were released in the dramatic shift in social relations that occurred in a historical moment of crisis and dislocation. Women's blues was not only a central mechanism of cultural mediation but also the primary means of the expression of the disrupted social relations associated with urban migration. (Carby 1992, 754)

Carby's analysis, though eloquent, in some respects subsumes the many women performing within the category of blues singers. She prioritizes the connections among social conflict, migration, and African American female performances to the socially transformative performances of blues women. In this respect, she fails to articulate the very connected but diverse experiences of jazz singers, jazz instrumentalists, dancers, and Tin Pan Alley stylists, as well as blues singers to the radical changes effected by migration, mass culture, and African American musical and theatrical creativity and ingenuity.

One could argue that the Harlem Playgirls' performances successfully refigured some of the primitivist and jungle-inspired theatrical contexts of African American chorus-girl acts in juxtaposition with representations of respectability, class, and instrumental musical prowess. Their performances undoubtedly aided the elevation of public perceptions of African American professional women. Arguably, it was these heavily innovative gendered jazz performances of bands like the Harlem Playgirls and the Dixie Sweethearts that gradually inculcated a socially acceptable public space for the rapid transformation of gender relations brought about by migration, mass culture, and theatrical jazz.

Jazz histories rarely mention the activities and popularity of all-girl bands during the 1920s and 1930s. Further, the theatrical/film contexts in which many early jazz and swing bands (male and female) performed is often casually mentioned or simply ignored. While lesser-known bands like the pioneering Queens of Rhythm probably performed in a variety of settings from the grueling one-nighters at Territory locations to the more profitable ballrooms and dancehalls, they more prominently participated in the vaudeville–motion picture combinations that persisted well into the 1940s. Black bands led by Duke Ellington, Cab Calloway, and Fletcher Henderson also performed in the once prosperous and predominantly white vaudeville theaters as well as the famous black theaters like the Harlem Opera House and the Apollo Theater, venues that consistently provided patrons a wide variety of entertainment from vaudeville acts to variety revues and musical comedy.

Film shorts adopted the specialty format provided in vaudeville and musical variety and especially those performing popular music and jazz during the 1930s. The Ingenues had been recorded as early as 1928 for Vitaphone and probably others during the 1930s. The medium of film became one of the most implemented mediums for recording female jazz and instrumental groups during the 1920s and 1930s. In many cases the number of films outnumbers the number of recordings made of "all-girl" bands. The visual emphasis upon female performativity certainly informed the choices made by managers and industry executives for recording all-girl bands during these decades.

During the early decades of the twentieth century, the mass-organized theatrical circuits of vaudeville intentionally promoted the cultural mixing of high and low in an effort to accommodate the vastly diverse gendered, social, and ethnic backgrounds of its growing audiences. Near the turn of the century, "white" all-girl acts were included in film houses and vaudeville theaters to compete with the flashy and extravagant revues, and were promoted as groups of similarly typed "girls"—a publicity campaign that reduced their performances to mediated and mechanized commodities and created an increasing interest in sexual spectacles. These spectacles integrated the industrial revolution's values of efficiency and automation while also interjecting various tropes of modern life from racially constructed notions of "exotic" and "hot" jazz, to images of innovation, novelty, versatility, and musical amateurism.

White all-girl spectacles, with all of their racialized associations to vaudeville and further back to minstrelsy and burlesque, constituted the philosophical and artistic groundings for a particular type of gendered presentation for Jazz Age and Depression-era all-girl jazz bands. These

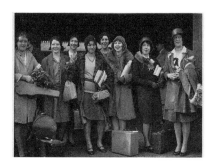

Figure 2.7. The Ingenues at Central Station, Sydney, Australia. Courtesy of State Library of New South Wales ("Hood Collection Part II").

highly successful all-girl jazz performances, in the context of American segregated performance venues, to varying degrees, combined and transformed the theatrical and filmed presentation of gender, sexuality, and spectacle in the chorus-girl acts and all-girl revues. All-girl ensembles and orchestras like the Ingenues provided fans with expert and versatile professional female musicians, similarly dressed, who not only played instruments but danced, sang, and led comedic skits.

Indeed, the seemingly incomprehensible range of musical material exhibited by both "white" and "black" all-girl bands was not altogether inconsistent with the artistic renderings of earlier vaudeville and variety revue programs, which consciously attempted to seamlessly weld high and low, classical and popular, and masculine and feminine genres—all the while patronizing the various ethnic, rural, and "homeland" connections of newly arrived urban immigrants.

For black all-girl bands like the Dixie Sweethearts and the Harlem Playgirls, female musicians were required to (and probably enjoyed doing so) perform a number of roles in their theatrical stage shows as jazz musicians, dancers, and comedians. The well-theorized moral panic within the growing black metropolis as articulated by the growing black bourgeoisie over African American performing women's bodies necessarily altered the ways that management marketed black all-girl bands: highlighting their versatility and connection to Jazz Age and Depression-era black musical genres, while also presenting the women in culturally uplifting terms to distance them from frequent accusations of immorality levied against blues singers and chorus women.

The intentional mixing of high and low cultural genres in vaudeville, the feminization of the nationally expanding mass-culture genres (theaters and palaces) via the ubiquity and success of the all-girl revue and the self-conscious move toward "cultural uplift" by the vaudeville and film industry provided the necessary social and gendered milieu for all-girl jazz music. Attempts by theater moguls to attract the more masculine and middle-class

clientele of vaudeville surrendered to commercial interests in providing family-oriented theater for women and children. Once a marker of vaudeville's refinement, during the 1920s, women became associated with its decay and implicated in broader, modernist discussions about the mechanization of mass culture—most potently symbolized by the popular chorus-girl acts.

Within all-girl bands, the cultural mixing of musical repertoires, the special attraction of classical female soloists, the sensation appeal of multitalented female bandleaders, and the inclusion of comedy, singing, and dancing drew upon vaudeville's and variety revues' earlier cultural conventions, which significantly relied upon the public's familiarity with both popular music and light classical melodies. In this respect, white all-girl bands were more likely to perform symphonic arrangements of well-known popular songs or light classical melodies familiar to their audiences than to perform newly composed jazz works. Black all-girl bands were more likely to perform jazz, blues, and popular music. However, both black and white bands like the Queens of Rhythm, the Ingenues, and the Harlem Playgirls readily admitted their allegiances to vaudeville, revue, and sound film as well as their desire to embrace all things modern—in their flashy novelty acts, their access to the latest technologies, their sporty flapper costumes, and endless displays of musical versatility. Such novel talents enabled, for the first time, all-girl jazz to see the world, and for the world to see all-girl jazz. Indeed, all-girl bands, like the talented and well-traveled Ingenues (fig. 2.7), glimmered at home and overseas, outshining their vaudeville hosts, just as the spotlights of America's first mass entertainment gave way to the flickering lights and synchronized recordings of sound films.

PART TWO

✵

ALL-GIRL BANDS AND SOUND FILMS
IN THE SWING ERA

✵

Phil Spitalny's Musical Queens

✳

During the 1930s, all-girl bands continued to draw from vaudeville genres by performing a variety of musical material and incorporating a variety of acts into highly orchestrated stage-show routines. Many popular all-girl bands during the 1930s similarly combined the theatrical talents of established Broadway and variety female performers to front female jazz bands, providing captivating personalities and capitalizing upon their appeal as attractive, multitalented performers who could dance, sing, and entertain—in theater lingo, "triple threats." Charismatic female bandleaders like Baby Briscoe, once leader of the Harlem Playgirls, originally honed their talents on the vaudeville and musical theater circuits before leading male and female jazz bands and inspired a similar trend with white audiences, as famous female variety revue and vaudeville performers began to lead all-girl stage bands during the 1920s. By the 1930s, Ina Ray Hutton and her Melodears, bolstered by Irving Mills and Paramount film studios, became one of the most successful all-girl bandleaders, in part because of her prior successful career in Broadway and vaudeville. Moreover, with the expanding technological developments in the entertainment industry, all-girl bands no longer performed exclusively in live venues like vaudeville theaters and ballrooms; they also found a place in the burgeoning mediums of sound film, electronic disc recordings, and radio.

As new mediums evolved to reproduce the sounds and images of all-girl bands during the 1930s, a more heavily feminized gendered instrumental style was developed by Phil Spitalny's expanded "girls orchestra," a style that contrasted with the 1920s "flapper" girl bands, such as the Ingenues and Green's Faydettes, who were celebrated and admired for their novelty, versatility, and jazz proclivities. Spitalny's prolific group supported both classical symphonic players and brass and reed instrumentalists who could play jazz and improvise. Despite these women's jazz and

classical skills, promotional materials rarely highlighted the "hot" capabilities of professional members. More frequently they referenced Spitalny's musical role in paternalistic terms, as a classically trained maestro who acted as musical mentor, introducing these young women to the refined venues of the variety stage and picture palace. As the most publicly represented and commercially sponsored all-girl orchestra during the 1930s, Phil Spitalny's All-Girl Orchestra owed their success, in part, to the persistent advertisement of the group's attractive, refined, and feminine image—but equally to the group's unparalleled professional instrumentalists and featured soloists whose first names became household words during the 1930s.

In the following sections, I compare the Depression era's most visible and mass-mediated all-girl groups, the Melodears and the Hour of Charm. These were the two most successful "white" all-girl groups engaged with and benefiting from the growing vertical integration of the culture industries. Yet their public representations, musicality, genre preferences, and performative styles contrasted greatly. In many ways the various mechanisms adopted by these groups, from musical genre preferences to sartorial choices indicated the changing climate of publicly mediated gender representations featured in visually oriented media, including film. Moreover, these group's highly gendered performance styles suggested the growing influence of religious and moralist groups, who increasingly asserted preemptive powers over mass-mediated popular culture texts. The subtle differences introduced by both groups from the mid-1930s to the late 1930s, further revealed changing relationships among civil bodies, urban culture, the media, and moralist institutions like the Women's Christian Temperance Union (WCTU). Nevertheless, Ina Ray Hutton's Melodears and Phil Spitalny's Hour of Charm provided unprecedented opportunities for the nation's leading European American female musicians, who earned handsome professional salaries, and appeared in expanding mediated outlets—notably film, radio, and variety. Finally, both groups provided exposure and accolades for some of the nation's leading classical and jazz soloists including Evelyn Kaye, Mardell Owen, and Lil Singer.

Phil Spitalny and His Musical Queens *Bring You the* Hour of Charm

It's not surprising that Phil Spitalny's first all-girl band established itself playing movie houses throughout the East Coast and Midwest. After all, Spitalny gained his reputation in the 1920s leading the all-male Victor Recording Melody Masters in stage shows for picture houses in Washington, D.C., and New York. In 1927, for example, Spitalny and the Melody Masters

headlined a stage show at Loew's Palace Theater in Washington, D.C. One review of the Palace's stage show emphasized the attraction and appeal of the Chester Hale Girls, a popular 1920s female dancing troupe who later appeared in many movie musical spectaculars of the 1930s ("Palace" 1927a, 9).

The commercialization of "girls" was well under way by the second decade of the twentieth century with the introduction of chorus girls and chorines in Broadway revues and burlesque shows. By the 1920s, groups of similarly typed chorus girls and dancers were soon incorporated as individual vaudeville acts (in contrast to their repeated appearances in variety revues) presented at movie houses.[1] It's easy to imagine how Spitalny came upon the idea of incorporating a group of young, attractive "girls" into a stage-show orchestra. The increasing desire for gazing upon groups of attractive "girls" and the burgeoning urban craze for jazz supported such a novel combination. Moreover, the success of 1920s all-girl bands like the Ingenues, the Hollywood Redheads, and the Bon Jon Girls provided the necessary commercial precedents.

By 1934, Spitalny had acquired the necessary musicians to constitute a full "girls" orchestra and the expanded group began embarking on national theatrical tours. The orchestra performed hundreds of times during the 1930s and 1940s at movie theaters as the featured band of an evening's stage show.[2] Typically, they performed in theaters franchised by the national entertainment agencies, such as the Paramount in New York, for films featuring a star-studded circle of Hollywood actors, most notably Betty Hutton, Bing Crosby, Jack Benny, Fred Astaire, and Martha Raye. At the Paramount in 1935, for example, Phil Spitalny and his All-Girl Band (with "30 musical stars featuring Maxine, Evelyn, and 3 Little Words") performed "in person" before the Paramount picture *Rhythm on the Range* starring Bing Crosby, Frances Farmer Burns, and Martha Raye (*New York Times,* 2 August 1936, 4).[3]

By 1935, the women musicians under the direction of Spitalny had come to be known as the "Hour of Charm" because of their weekly coast-to-coast radio broadcasts on CBS. The *Hour of Charm* radio broadcast became so popular that it aired for more than thirteen years, first on CBS from 1934 to 1936 and then on NBC from 1936 to 1948. The hourlong program combined a variety of musical selections of the group, often featuring light classical works, sweet orchestrations of popular and theatrical songs, choral arrangements, and a few jazz pieces. The original CBS broadcast, the *Hour of Charm,* aired weekly from Milwaukee, Wisconsin, and offered a variety-style program that showcased talent from throughout the Midwest. The program's national sponsor, General Electric, dedicated segments of each week's show to educating the public and advertising its many products from photo bulbs to fluorescent lamps. Early broadcasts consisted

mostly of musical selections by the *Hour of Charm* with featured solos by "Evelyn and her magic violin" as well as vocal solos by the orchestra's classically trained singers, "Jeannie" and "Maxine." During its first few years, the women's last names were never mentioned on the show, perhaps to instill an aura of familiarity, intimacy, and feminine informality. However, the exclusion of last names effectually rendered amateur status upon these professional women musicians.

By late 1939, the band's promotional campaign for live performances relied more heavily upon the band's radio image of charming young girls who not only played instruments but also sang in choirs and glee clubs. In October of that year, promoters began advertising the group as "Phil Spitalny and his All-Girl Singing Orchestra." The radio program was so successful that film advertisements began simply mentioning the *Hour of Charm* to reference the all-girl orchestra (*New York Times*, 8 October 1939, 10).[4]

The group's many outstanding soloists such as Evelyn Kaye performed weekly in special arrangements for the group. Additionally, each program hosted composers, musicians, and guest speakers who discussed various timely subjects deemed suitable for family listeners. The *Hour of Charm* frequently dedicated weekly broadcasts to various civic and social organizations espousing wholesome social values constituting "everyday" American culture. In March 1936, for example, the *Hour of Charm* dedicated their segment to university students with a program entitled "Sweetheart of Sigma Chi" ("On the Air Today" 1936a).

To their credit, the *Hour of Charm* frequently showcased women artists on their weekly program. By performing the works of female composers, the *Hour of Charm* significantly promoted and familiarized audiences with otherwise little-known music professionals. In May 1936, for example, two female composers, Lee Lawnhurst and Mabel Wayne, were featured as the *Hour of Charm*'s musical guests performing their songs "Accent on Youth," "What's the Name of That Song?" "It's Dangerous to Love Like This," "In a Little Spanish Town," "Ramona," and "Through My Venetian Blind" ("On the Air Today" 1936b). By October 1936, the *Hour of Charm* had become so successful that it was taken up by NBC for a weekly coast-to-coast broadcast on the "Red Network." The promoters of the "new" program presented the "All-Girl" show as a forum for the "American Girl" to "step into the radio spotlight both as musician and as composer." The "sparkling new series" advertised the showcasing of both women soloists and women composers ("Another All-Girl Show" 1936). This presentation, which emphasized the musical compositions and arrangements of the women musicians and composers over the contributions of Spitalny, was indeed striking.

By the mid-1930s, journalists sought to credit the contributions of the female composers, arrangers, and soloists presented on the *Hour of Charm*. One press release, promoting the rebroadcast of the *Hour of Charm* on WRC (Washington, D.C.), looked forward to the musical features by Evelyn Kaye and Maxine Marlowe (baritone songstress). For the season's premiere, Mabel Wayne, one of the *Hour of Charm*'s regular contributors, composed "Meet the Future President" sung by "Maxine and the Three Little Words." Other anticipated selections were a medley of tunes written by "women" featuring Evelyn Kaye on the tune "I Love You Truly" ("On the Air Today" 1936). Because of the *Hour of Charm*'s promotion of female artists, in 1938 the orchestra received the "achievement award of the radio committee of the Women's National Exposition of Arts and Industries," for "the most distinguished work of women in radio during the last year." The award was presented not to Maestro Spitalny, but to the four original members of the orchestra: "Evelyn Kaye, first violinist, of New York; Maxine Marlowe, vocalist, of Columbus; Pat Harrington, first trumpet player, of Denver, and Gypsie Cooper, first saxophonist, of Erie, Pa." The award marked the opening ceremonies of the "seventeenth annual Women's National Exposition of Arts and Industries at the Grand Central Palace" ("Girl Orchestra Wins Achievement Award" 1938).[5] Again, the attention lavished upon the distinguished talents of the orchestra's leading soloists over that of the director revealed an increasing interest during the 1930s to recognize female innovation and achievement publicly in mass-mediated forums like radio.

Musical selections during NBC's first four years, 1936–1940, tended to exploit popular tunes dressed up in semiclassical arrangements (or, less frequently, dressed down as "sweet" jazz arrangements). The ratio of vocal to instrumental arrangements remained consistent from week to week with vocal selections often outnumbering instrumentals. Quaint and familiar tunes like "Shortnin' Bread," "Rosa Lee," and "Dinah" represented the kind of popular music programming favored by the program's producers. However, the program's consistent inclusion of light classical works, especially those that featured technically difficult passages by Evelyn Kaye, the orchestra's leading soloist, clearly suggested elevated social expectations of specialized private musical education and cultural refinement. Some of these light classical works, such as the "Merry Widow Waltz" and the "Blue Danube," both exploited the prodigious techniques of the musicians while downplaying their professionalism. Even so, these semiclassical pieces were often no less difficult than the more serious and canonical works by Wagner, Beethoven, and Brahms. They simply catered to expanding, middle-class popular tastes, as Americans both asserted their knowledge of European

symphonic music and expressed their preferences for lighter, highly melodic, popular songs.

Occasionally, "exotic" and film-inspired pieces saturated with musical clichés signifying "distant others" provided relief from the program's predominantly Western art and popular repertoire. Musical allusions to "exotic others" also encouraged radio audiences, gathered around speakers in the comfort of their living rooms, to fantasize about these young and largely unmarried women as worldly, cultivated individuals in faraway, interesting places. Musical arrangements sometimes suggested recognizable "Latin" genres, by the percussive flourishes of a flamenco guitar or by the plodding "Bolero" rhythms dispersed between the snare and tympani drums. Facile yet recognizable musical symbols intimated a certain modernistic exoticism ciphered through the pleasing lens of young, female, amateur musicians. Of course, each musical number was interspersed with ads and descriptions of the latest and most technologically advanced GE products. A 1938 broadcast plugged GE's revolutionary presence at the World's Fair with its magnificent Edison Tower. In short, through its weekly broadcasts, the *Hour of Charm* successfully packaged domestic feminine musicality, scientific innovation, and cultural exoticism as familiar, everyday entertainment, streamlined through the national channels of American radio.

In addition to the program's many musical selections and advertisements by corporate sponsor GE, the *Hour of Charm* occasionally incorporated editorials by political commentators. Dorothy Thompson spoke as one of the *Hour of Charm*'s first editorialists in the late 1930s. Thompson, the daughter of a minister with "knowledge of the parsonage from back home" provided an articulate and well-documented commentary on the recent introduction of the Fair Labor Act, legislation requiring a minimum wage of 25 cents an hour. Contrary to the emcee's introduction, Ms. Thompson never mentioned the "parsonage back home" but rather limited her analysis to legal concerns, as she detailed the various shortcomings of the new law. Arguably, the narrator was permitted to speak freely because of her religious affiliations. The pious undertones of the *Hour of Charm* broadcasts rendered her invitation natural and fitting. Nonetheless, the tone of her piece was decidedly political. Thompson's commentary was followed by a sweet rendition of Charles Gounod's "Ave Maria" sung by the all-girl orchestra with solo inserts by Evelyn and her "magic violin."

Listeners to the *Hour of Charm*'s weekly broadcast frequently wrote letters to radio stations inquiring about the band's repertoire, particular names of soloists, and even for identifications of various novel sounds produced during the show. In 1937, for example, several hundred letters inquired as to a particular "weird whistle sound" heard at the end of some of

the orchestra's numbers. Apparently, the sound "rises up the scale and is held for two bars to conclude the melody." Spitalny unraveled the mystery for a *Washington Post* review, claiming that the sound was produced by "pretty 22-year-old Mary Bawn, a former Baltimore socialite." Strikingly, the article noted that Miss Bawn received $250 a week for "three quarters of a minute's work on the program." Women's salaries were rarely mentioned in reviews of the band's performances, except to occasionally discredit their musical contributions. Apparently Bawn, who graduated from the Peabody Conservatory of Music in Baltimore and became one of the violinists in the orchestra, injured her arm and was therefore invited to sing "Three Little Words." During one rehearsal, Bawn began experimenting with various vocal effects. After placing her tongue back in her mouth and singing, she produced the eerie "musical saw tone" ("Spitalny Identifies Weird Song Ending" 1937).

While the band's late 1930s promotional material depended more heavily upon their visually mediated feminized images and vocal capabilities, as early as 1935, Spitalny sought to legitimate the musical qualifications of female instrumentalists. He refuted current cynicisms about women musicians, which predicted: "There will be petty jealousies, you can't rely on them, they won't show up for rehearsals and most of them will go off and get married just as you have the orchestra set." Spitalny contended that women musicians were "just as capable as men." To support his claim, he asserted that "women are good musicians because they are extremists. They love harder, they hate harder and they work harder. Besides, women take much more pride in their work." Spitalny even claimed to have recruited the entire string section from the Juilliard School of Music. The orchestra's concertmistress, Evelyn Kaye, was mentioned by name and even praised for her many scholarships and extensive experience as a featured performer with such theatrical productions as "Music in May," "Nina," and "East Wind" ("Woman Orchestra Makes Radio Hit; Spitalny Proves Contention That They Equal Men" 1935). Notably, Spitalny avoids mentioning the orchestra's more masculine-gendered instrumentalists like the trumpet, trombone, and tuba soloists.

A few months later, in July 1935, *Washington Post* writer Nelson Bell cast Ina Ray Hutton and The Hour of Charm in the same review because of the close proximity of the two bands' performances at the Earle in Washington, D.C. The Melodears had recently concluded their stage show at the Earle and therefore afforded local patrons the opportunity to compare the two all-girl bands. Bell speculated about the band's relative popularity and undertook the task of comparing and contrasting the "style and method of program and musicianship" of each ensemble, musing "it will be interesting

to observe what response is elicited by Spitalny's aggregation of visual and auricular charmers."

With the Melodears, Bell criticized Hutton's band for ignoring "even the finer aspects of popular music" and favoring "pulchritude and periphery," while praising the Hour of Charm for "bearing down" on the "world's better musical compositions, for their own sakes," and permitting the "allurements of the flesh to take second place." He did admit, however, in a backhanded compliment, that "Phil is no Ina Ray out there in front of his orchestra. He doesn't tap dance, he doesn't squirm all over the place and he does not, thank heaven, wear Miss Hutton's revelatory costumes. He doesn't even do a Noel Coward shower-bath act! So What." Bell's bottom-line musical test betrayed common assumptions about all-girl bands led by attractive and sexy bandleaders like Ina Ray Hutton. According to Bell, "the point is that these two bookings, Ina Ray and Phil, coming close together at the Earle, will offer a finer test of whether the Washington public wants music as the raison d'être of its band acts, or merely as a background for gyratory blondes" ("Phil Spitalny and His Women's Orchestra will afford Test of Capital Taste" 1935).

A separate review of the Hour of Charm's stage performance at the Earle raved about the performance and praised the band's abilities by ranking them above all other recent stage bands presented at the Earle, male or female:

The most musicianly, the best lighted and the most effectively costumed "band act" that has played a Washington stage in more years than you can count on the fingers of your hands is presented at the Earle Theater this week by that meticulous maestro, Phil Spitalny, and his "Hour of Charm" orchestra of feminine instrumentalists. . . . Spitalny has brought some fine orchestras to Washington stages, but never one to approach this one in the perfect blending of all those elements of entertainment that make for a deftly rounded interval of variegated and skillful instrumentalism. ("Earle" 1935)

The reviewer similarly praises the expert musicality of the group, highlighting the variety of musical offerings and even the skill of selected soloists: "Into this potpourri of musical expression of widely different schools are interpolated touches of highly developed musicianship that bring to the fore a concert violinist of the first rank, a saxophonist that is a female Rudy Wiedoft, a songstress who 'sings like a man,' a first trumpeter and first trombonist, who have no superiors, and an acrobatic tap dancer who is tops" ("Earle" 1935).

During the 1930s, journalists began to compare the musical contributions of individual performers to Spitalny's overall role as the group's musical director. One reviewer of the *Hour of Charm*'s stage show, opening

for the Bing Crosby screen hit *Rhythm on the Range,* again at the Earle, confirmed the merit of the individual performers, asserting "Phil Spitalny's astonishing girl orchestra seems to get better all the time. Apparently assured that the girls are well seasoned and not to be spoiled by individual applause, Mr. Spitalny now introduces them by name which is very nice and enlightening." The writer then praises Maxine (providing no last name) and the singing trio of the "Three Little Words." The author's final plug, however, credits, overall, the guidance and expert arrangements of Spitalny, himself: "The Spitalny version of the 'Bolero' was handsome and stirring. The same goes for the rest of the numbers, but we must qualify this by remarking that the answer is the Spitalny arrangements" ("Rhythm Reigns On New Bill at Earle Theater; Bing Crosby Hit on Screen and Phil Spitalny Is Smash on Stage" 1936).

Detailed reviews of the band's repertoire were unique to the Hour of Charm; most all-girl band reviews merely depicted the general style of the group, minimally mentioning repertoire, and more often prioritizing visual qualifications. Reviews of the Hour of Charm frequently included names of songs, and mentioned the names of composers and arrangers as well. This review provided a concise description of the orchestra's repertoire:

Perhaps the best idea of the "turn" may be deduced from a conventional announcement of the numbers that are played in the order they are rendered. They are, then, the Liszt thing (2nd Hungarian Rhapsody), "Bugle Call Rag," "Dinah," Ravel's "Bolero," "Carioca," Nevin's "The Rosary," a fight between Cab Calloway and Ted Lewis by sax and trombone; two pianos in "Nola" and it is not Lopez speaking; Tchaikovsky's "1812 Overture"—in which the pit orchestra joins—and as an encore, "Broadway Lullaby." ("Rhythm Reigns On New Bill at Earle Theater" 1936).

From this list, one recognizes the diversity and skill of the Hour of Charm soloists and instrumentalists in both the classical and jazz domains.

More than a year later in 1936, a review of the Hour of Charm's Earle stage presentation again praised the variety of musical material: "The program being played by this remarkable aggregation of young women is one that runs a fairly complete gamut of the full range of music. We have a medley of excerpts from favorite grand operas, and at the opposite end of the scale, 'The Bugle Call Rag.'" The reviewer noted the "girl's" singing and specialty numbers, again depicting them as novelties, while not, however, ignoring the serious reception of the orchestra: "Interspersed with these contrasting numbers are vocal solos, concerted chorals and all of the other novelties usually included in the conventional 'band set.' The Spitalny interval of melody is not by any means conventional. It is diversified, brilliant and genuinely noteworthy" ("Feminine Band at Earle Best Town Has Seen; Spitalny's Direction Able" 1936). Nelson Bell, the same writer that

earlier compared the Melodears with the Hour of Charm, supplied a list of the band's musical selections, which closely resembled programs from the previous year with the addition of "When Day Is Done," "Play, Fiddle, Play," "Music Goes 'Round and Around," a "Glen Echo Park" descriptive that was "generously dedicated" to the *Post*'s writer, Nelson Bell, and Gershwin's "I Got Rhythm." One wonders if the Hour of Charm dedicated one of their songs to every journalist that provided praise of the band's leader, Phil Spitalny.

Once again, Bell attributes the band's superior musicianship to the "energetic coaching and infallible guidance" of Spitalny in addition to, but not second to, the individual proficiency of every member of the orchestra. Bell also credits the expert artistry of Evelyn Kaye (providing her full name) for her "technique, tonal quality and inspirational interpretative sense" ("Feminine Band at Earle Best Town Has Seen" 1936). Kaye arranged Liszt's "Second Hungarian Rhapsody" for the orchestra, although reviews rarely credited her compositional contributions.

The Hour of Charm's stage presentation at Loew's Capital in Washington, D.C., in 1939, was similarly praised for the variety and range of musical repertoire. The *Post*'s reviewer praised the group for their "rare gift of mastery of both the classics of standard music and the crazy rhythms of modern swing." Music journalists generally accepted and even admired the musical mixing of styles and genres presented by the Hour of Charm. One reviewer enthusiastically depicted the band's musical transgressions: "It merges the finished musicianship of a schooled symphony with the wild abandon of a rug-cut-jam session and punctuates its concerted numbers with solo, trio, glee, sextet and comic interludes that complete a program of great variety and uniform excellence." The author seemed unbothered by the band's perhaps unconventional mixing of musical repertoires. His review of the show even praised Evelyn's "brilliant arrangement of Liszt's Second Hungarian Rhapsody," then eagerly remarked how the "second number swung to the opposite pole of musical effort and raised the temperature of the Capital almost to the boiling point; it was that 'hot.'" The reviewer continues: "Reverting later to the more dignified and austere in musical expression, Schubert's 'Ave Maria' was impressively played and effectively sung by the 'All-American Glee Club,' led by the deep throated Maxine" ("Hour of Charm Feminine Orchestra Dominates a Feeble Screen Feature" 1939).

The rest of the review elaborated upon the musical selections and soloists: "Evelyn's 'magic violin'—and it is just about that—won immediate appreciation in 'You and the Night and the Music' and a special arrangement of 'Deep Purple,' disclosing the full beauty of the 'singing strings' of

a violin sextet" ("Hour of Charm Feminine Orchestra Dominates a Feeble Screen Feature" 1939). This appears to be the first mention of Evelyn's "magic violin" as performances and radio announcers continued introducing female musicians by their first names. Other soloists mentioned were Marion McLenahan, "a distaff drummer, who is surely the Gene Krupa of her sex" and the women of the "Three Little Words." Stage shows during the 1930s typically included a featured male tap dancer, perhaps to provide some masculine energy to this otherwise completely feminine program.

Women who were invited to audition for the Hour of Charm were required to sign a three-year contract that prohibited them from marrying during the contract's duration. Remarkably, in 1936, one *Washington Post* writer discovered that "even with their three-year contract (which has a marriage ban) soon up for renewal, Phil Spitalny finds that none of his girls is contemplating marriage this year. Only six would be willing to sacrifice careers for home making." Rather than investigate why the majority of women preferred playing over marriage, the writer instead provides quick blurbs about the kind of men each of these six women would leave their professional performing careers for. First mentioned is Maxine, featured vocalist, who would be willing to give up her career for "a six-foot Englishman or Frenchman, good looking, rather even tempered, with the happy faculty of mixing well in all sorts of gatherings and engaged either in law or medicine." Gypsie Cooper, saxophone soloist, claimed the writer, "would abandon her work for someone who is carefree, jovial and sympathetic; a college graduate, American, $25,000 a year."

Ironically this is the same Gypsie Cooper who provided a lengthy interview for *Metronome* magazine, also in 1936, about the merits and musical fortitude of women musicians, claiming that most preferred earning professional salaries as performers over marriage. The article continues with the other women's various descriptions of ideal marriageable men, ending with Kathleen Williams, the string bassist, who purportedly admitted that she'd "even propose herself if a broadminded, honest, ambitious man who was fond of outdoor sports happened to strike her fancy, even if he didn't have a dime" ("Leap Year? Not for the Hour of Charm Girl Musicians" 1936). Predictably, women musicians are portrayed as eager to leave their professional lives even for penniless, broadminded men.

The Hour of Charm Swing High and Low

By the mid-1930s, the Hour of Charm's sweet musical alignments prompted associations of elevated breeding and parlor music as well as an outmoded nineteenth-century femininity that continued to provide fodder

for all-girl bands during the 1930s and 1940s (Tucker 2000b, 81–85).[6] All-girl bands playfully and commercially blurred the boundaries of high and low and sometimes approached classical music with more complexity than "sweet" male bands as they mediated notions of a highly gendered nineteenth-century musicality: the racialized associations of swing and the feminized and masculinized connections of musical genre, from the classics to theatrical popular music. Residual images of a nineteenth-century gendered musicality, domesticity, and sexual modesty ensured that women's "troping" of the high art/low art dichotomy was effected in a highly coded, and sometimes ironic manner (and more so than was possible for male musicians).

White all-girl bands frequently "riffed" upon the high-low musical spectrum, and occasionally their musical directors sought to legitimate their musical preeminence by adopting a modernistic profile. The Hour of Charm's director, Phil Spitalny, proposed "light dance music" as worthy of inclusion in the realm of serious music. Spitalny advocated the programming of light numbers that are "melodic, rhythmic, well played tunes which will satisfy the ear and the emotions, without overtaxing an intellect which has not been trained so that it may grasp the beauties of the greater classics" (Heylbut 1938, 639). In this sense, Spitalny mirrored the sentiments of modernist swing advocates, who declared that the symphonic arrangements of dance music required the technical mastery and training of serious, classical musicians (Gendron 1995). Further, Spitalny contributed to a discourse espoused by contemporaneous symphonic jazz directors and composers like Gershwin and Whiteman, who envisioned symphonic jazz as the American equivalent to Europe's most contemporary, advanced, and sophisticated modernist art compositions—which similarly drew from folk and ethnic music sources to promote a growing nationalistic musical consciousness as expressed by the works of Stravinsky, Bartók, or Ravel, for example. The explicit requirements for the women in the Hour of Charm expressed by Spitalny were that they perform a classic repertoire ranging from sonatas to concertos, exhibit a gift for rhythm and melodic perception, and read music fluently (Heylbut 1938, 640).

Like the jazz modernists who claimed that swing and dance band music were merely newer forms of jazz, Spitalny claimed that jazz, swing, and dance-band music were merely different titles for the same thing (Heylbut 1938, 640). Further, Spitalny stressed how audiences preferred the refinement of dance music over the "noisy brand of jazz" popular more than fifteen years ago. He claimed that audiences appreciated the finer type of jazz where the "melody is projected by strings, wood-winds, or muted brasses, while the rhythm is marked by accentuation rather than by blaring tom-tom beats" (Heylbut 1938, 640). Spitalny reaffirmed his

point by differentiating between serious dance music and "raucous" jazz, which he described as "cannibal music" (Heylbut 1938, 639).

Finally, when asked about his choice to lead an orchestra of women over men, Spitalny cites the musical advantages of performing light music with a group of "girls":

If I were seeking an effect of power, of heavy beats, of a sort of military precision that convinces you against your will, I should certainly not go to work with a group of girls, but the effect desired was one of charm, of mellowness, of floating, elusive persuasion. And so it seemed the most natural and logical thing in the world to assemble a band of women and ask them simply to go on being charming women in their playing. (Heylbut 1938, 640)

As mentioned, the Hour of Charm's lead alto-saxophone player, Gypsie Cooper, was featured in a *Metronome* article in 1936 that attempted to situate women jazz performers in the broader modernist debates surrounding swing, jazz, and dance music. Cooper's pointed response to the article's title "Can Women Swing?" illuminated rampant stereotypes about women performers in the 1930s. She writes:

It seems strange for me, a woman—and a lady, I hope—to inject my voice into this man's magazine. But the editor is responsible—blame him. He asked me to write upon the subject "Can Women Swing?" in my own way, so here goes. The question itself implies the condescending way (Note to editor—Don't delete this) in which men have always looked down on the fair sex—they're nice enough in their place but they never will be able to equal a man in anything. Oh yes, it's still a man's world but I notice the ladies are coming along. (G. Cooper 1936)

Cooper's resentment about the blatant sexism experienced by women musicians is obvious in these first few sentences. She continues to offer examples of the ways that female musicians can swing and, if given the proper opportunities and training, would excel in the modern music traditions. She also offers explanations for why few women attempt to improvise or play within a swing style. One reason, states Cooper, is that women are afraid to play out or take risks for fear of ostracism or of being labeled amateur or novelty act. According to Cooper, men who make technical errors are given leeway, while women are considered inept. The usual double standard forces women musicians to play much better than their male counterparts in order to be taken seriously. Cooper reaffirms this standard in her commentary:

I feel that I know the prejudice any mixed [gendered] audience has against us before we have even been given a chance to prove ourselves. As for instance at any time during any program, should a reed close on a clarinet or a note crack in the brass, the reason immediately becomes, "because they're just a bunch of girls." Let the same slips happen in any male organization, and they do happen in the best of them, such accidents are passed off as being "unavoidable." (G. Cooper 1936)

Cooper's entreaty presciently contrasted with 1940s reviews of female entertainers and musicians, which frequently mentioned the women's social and romantic status as single women and potential mates, over the women's extensive professional experience (Tucker 2000b). Conversely, Cooper claims, "more and more women are seeking independence rather than romance, who realize that talent alone does not suffice and who are becoming more serious about the work. They have chosen and are taking their places with the best of the male swing bands." Cooper wants to situate women in the sphere of modern swing music, in preference to legitimating light music ("feminine" music) as serious art music, as was the case for the Hour of Charm's modernist aspiring conductor Phil Spitalny.

In addition to the particular representation provided by the Hour of Charm's weekly radio broadcasts during the mid-1930s, the mass-mediated circulation of feminized images via the audio/visual/musical images of film during the heavily censored Production Code administration era further contributed to an emerging dominant representation of white female musicality. The Hour of Charm filmed several shorts for Vitaphone and Paramount beginning in the 1930s; in these shorts, one recognizes the subtle codification of a developing feminized film aesthetic that enabled professional female musicians to accommodate changing gender prescriptions from the mid-1930s into the 1940s.

Phil Spitalny and his Musical Queens

In 1934, *Phil Spitalny and his Musical Queens* was filmed by Vitaphone, the relatively new synchronized sound-film technology developed by Vitagraph and acquired by Warner Bros. in 1926 (figs. 3.1 and 3.2). Vitaphone shorts arose after several decades of experimentation in synchronized sound and film. Although many studios developed various versions of sound film, it was Warner Bros. that first began to distribute their synchronized sound shorts through the newly incorporated Vitaphone

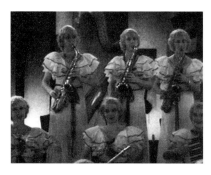

Figure 3.1. Saxophone section in *Phil Spitalny and His Musical Queens* (Vitaphone 1934).

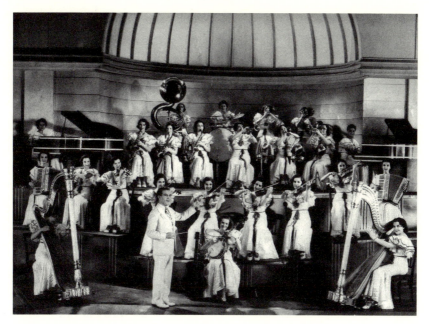

Figure 3.2. Phil Spitalny and his All-Girl Orchestra. Courtesy Susan Meyers.

venture. During the 1920s, Vitaphone shorts were exclusively licensed to produce sound pictures using the technologically advanced Western Electric system (Bradley 2005, 20).

The first Vitaphone shorts often featured lofty subjects, such as symphonic poems or operatic arias (Bradley 2005, 21). Originally Warner Bros. released their Vitaphone shorts in sequences intended as "top bill" in film theaters throughout the country. Indeed, the first Vitaphone program included an hourlong prologue of shorts, and most of them of "high" cultural value meant to deliver the arts to the masses. With the artistic legitimacy of Vitaphones established through the success of their first prologue, *Don Juan* (1926), they set their sights on gaining a wider audience (Bradley 2005, 25). According to Vitaphone historian Edwin Bradley, these early Vitaphone sequences were designed to test public tastes; eventually Warner Bros. incorporated musical artists from the opera stage, vaudeville theater, and leading jazz nightclubs. Indeed, Sam Warner, leading advocate of sound shorts, envisioned musical and comedic shorts as a cheaper and mass-produced replacement for live variety and vaudeville acts in film theaters (Bradley 2005, 20–23).

It was Al Jolson's four blackface numbers in Warner's second Vitaphone program, however, that cemented the genre's relationship with musical comedy and American vernacular popular music—and especially

those musics associated with black styles. By 1927, Warner Bros. eventually began pacing their sound shorts to accommodate prior mass audiences' theatrical tastes, by corresponding their timing and order to more traditional vaudeville acts (Bradley 2005, 29). Vitaphone shorts, initially programmed to boost the appeal of a number of New York feature premiers, initiated a trend that further streamlined the purpose and placement of sound shorts to Hollywood feature-length films. By 1928, despite the number of dramalets and newsreels produced by the company, Vitaphone had gained a reputation for featuring not only musical comedy and vaudeville performers like Al Jolson, but also popular music performers of the day including the Happiness Boys, the Croonaders, the Rollickers, the Yacht Club Boys, the blues singer Florence Brady, the Broadway comedienne Florence Moore, and male and female impersonators like Karyl Norman and Kitty Doner (Bradley 2005, 41). By 1929, Vitaphone was so productive, producing more than four hundred shorts a year, that vaudeville artists were scheduled to make films after their last live evening performances in Brooklyn's twenty-four-hours-a-day studio (Bradley 2005, 44).

By the late 1920s, in order to compete with Warner Bros, all of the major film studios were successfully exhibiting sound shorts including Fox's Movietones and the variety of shorts produced by Paramount, RKO, MGM, Pathé, Universal, United Artists, and Columbia. These companies similarly incorporated a variety of high and low cultural acts to attract film's expanding mass audiences (Bradley 2005; Eyman 1997). During this time, the two film corporations that most actively produced musical shorts, Vitaphone and Fox Movietone, both incorporated vaudeville and popular music subjects into their programs.

During the 1930s, Vitaphone shorts continued to incorporate prologues with a variety of musical styles. All-girl musical groups—proven popular subjects as early as 1928 with Vitaphone's shorts of the Ingenues and Green's Twentieth Century Faydettes (or Flaperettes)—continued to be attractive novelty subjects. The Ingenues' first Vitaphone sequence featured a compilation of popular tunes entitled *Syncopating Sweeties*, including the popular jazz staple "St. Louis Blues."[7] Vitaphone released other all-girl musical acts including a 1929 *All Girl Revue* featuring Jean Rankin's Blue Bells Orchestra.

Phil Spitalny had also worked with various sound film companies during the 1920s including Fox Movietone. In particular, Spitalny produced several shorts that featured his Pennsylvania Hotel Orchestra, including two 1928 Metro Movietone shorts (called "Acts"); a 1929 Metro Movietone Act, *Ship Ahoy*; and a 1930 Metro Movietone Revue, *Bits of Broadway*.

It wasn't until 1934 that Spitalny's all-girl orchestra was invited to perform for Vitaphone in a piece that mirrored the presentation of earlier

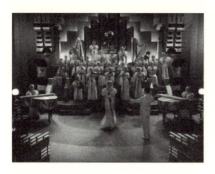 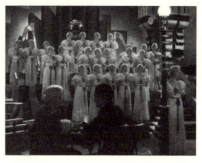

Figure 3.3. Spitalny's choir in *Phil Spitalny* *Figure 3.4.* Maxine and choir in *Phil Spitalny*
and His Musical Queens (Vitaphone 1934). *and His Musical Queens* (Vitaphone 1934).

all-girl bands but on a grander scale. Vitaphone's Musical Queens' short features four varying musical pieces showcasing the immense technicality, musicianship, and versatility of the professional women in Spitalny's orchestra (figs. 3.3 and 3.4). Indeed, each piece provides special solo spots for vocalists or instrumentalists. The short begins with an upbeat jazz instrumental, followed by a choral arrangement of "Let's Fall in Love," followed by the vocal and dance specialty "Dinah," and closing with the "Finale," a virtuosic instrumental number. Visually, the short illuminates the women in soft, ambient lighting, displaying a highly modern, architectural stage design, and showcasing Art Deco objects including lampposts, silhouetted jettisoning skyscrapers, and angular objects, setting off both the nightclub podium's construction and the group's symmetrical instrumental arrangement (two harps, two pianists, two pillars. . .). The women wear long, white-ruffled gowns, and each sports platinum blonde, pincurled hairdos in the style of 1920s cosmopolitan society women.

The Musical Queens open with an upbeat jazz piece showcasing various short and pre-rehearsed solos, including saxophone, trumpet, banjo, and drums. The second piece is introduced by the leading violinists and two harpists in an opening cadenza that then transitions into the popular vocal song "Let's Fall In Love," a choral piece led by alto soloist "Maxine," and featuring the dramatic feminized lyrics: "Let's fall in love / Why shouldn't we fall in love / Our hearts are made of it / Let's take a chance / Why be afraid of it?"

The third number, an upbeat vaudeville-style jazz version of the popular piece "Dinah," features many textural, tempo, and stylistic changes including syncopated rhythms, small-group barbershop harmonies, a jazz rhythm section ("4-beat shuffle"), and a dizzying specialty act performed by the harp player who effortlessly transforms herself into an acrobatic tap dancer. This dancer's finesse, skill, and speed surpasses those of Ina Ray Hutton and rivals those of Eleanor Powell

(the most commercially viable Hollywood female tap artist of the late 1930s and 1940s).

The final piece provides a virtuosic display of all the group's instrumentalists, orchestrated in a breathtaking variety of musical styles incorporating Russian classical exuberance, folklike exoticism ("gypsy melodies"); patriotic march rhythms, and sweeping filmic textures. The two pianists, the violin section, and tight brass section are highlighted in this finale.

Sirens of Syncopation

In Phil Spitalny and his Girls' Orchestra's (not yet officially the Hour of Charm) spirited Paramount musical short, *Sirens of Syncopation* (1935), the film's opening credits are accompanied by a grand Sousa-like march, performed by the orchestra in white gauze, polka-dotted strapless gowns with layers and layers of white ruffles flowing over the risers and draped delicately around white satin slippers. In this musical short, these lavish and excessive garments effectively disguise the women's individual physical traits and provide instead a kind of amalgamate spectacle, prompting notions of Southern belles and fairy-tale fantasies. Each girl is lavishly adorned to appear identical and symmetrical and highly feminine.

For the orchestra's last musical number, this time a reverent choral arrangement of "Dinah,"[8] the women are rearranged in a diamond configuration and softened by iridescent lighting, reminiscent of a choir of angels illuminated by silver beams in a holy cross formation. In contrast to their earlier upbeat "jazzy" version in 1934, this arrangement appears much more somber and less inspired by jazz textures and improvisational styles. As a choir, the women stand poised and passive, their arms positioned politely behind their backs. The musical tone of this popular tune suggests a sweet and serious chorus. However, as the tune transitions into a more playful quartet, the words become explicitly audible and appear unusual in the context of 1930s heterosexual gender expectations. Consider a song sung by twenty-five identical, "virtuous" women extolling their amorous desires for a gal called Dinah. Are they meant to relinquish completely their own assumed heterosexual desires and instead, personify, en masse, a singular male voice, perhaps a soldier abroad, homesick and dreaming of Dinah? Here, these professional women act in unison as the vessels for a central male voice and their collaborative aurality points to the ways that women's individual voices were musically disavowed. Musical uniformity ciphered through abstracted images of femininity prefigured the representation of many all-girl bands later presented on film during the 1940s in feature films and in SOUNDIES.

Despite the classical virtuosity exhibited by many of the groups' soloists, initially at least, Spitalny's Girls' Orchestra performed an equal number of jazz hits, often in the style of the Original Dixieland Jazz Band (ODJB) or in the sweeter variety of Paul Whiteman's symphonic jazz orchestra. Another early film (credits missing, but appears to be from the early 1930s) features the group performing a rapid-paced "Tiger Rag" including mind-numbing sectional solis in syncopated harmonies and featuring an arrangement expertly accentuating all of the usual percussive effects and embellishments, instrumental noises, and short but captivating eight-bar solos. Arguably, of all the "white" all-girl orchestras, Spitalny's featured many of the very best instrumentalists of the United States. This version of "Tiger Rag" attests to the expert musicianship of the orchestra and musically parallels contemporaneous versions of the ODJB. Ultimately, comparing film shorts of the Jazz Age and Depression-era all-girl groups confirms their proficiency in both the worlds of orchestral jazz and symphonic chamber music. Eventually, however, through the group's successful and heavily feminized *Hour of Charm* program, regular performances began to downplay the group's jazz and swing repertoire in favor of their sweet and symphonic material.

The "Blonde Bombshell of Swing"
Ina Ray Hutton and her Melodears

✸

While Spitalny's Hour of Charm orchestra may have been the most commercially profitable as well as mass-mediated feminine instrumental group during the 1930s, other all-girl bands led by versatile female bandleaders continued to deliver musical sets emphasizing popular songs and dance-band music, especially jazz and swing. The most publicized all-girl dance-band leader during the 1930s was Ina Ray Hutton, popular Broadway performer who led her all-girl jazz band, the Melodears, for five years. According to *Variety*, Alex Hyde, who managed all-girl bands and vaudeville units in the 1920s including the Melody Maidens, approached Irving Mills in 1934 about organizing an all-girl band to be fronted by Broadway star Odessa Cowan.[1] Irving Mills agreed but requested that Odessa Cowan change her name to Ina Ray Hutton to draw from the publicity attached to Woolworth heiress Barbara Hutton (Bell 1934; Driggs 1977, 16).

After Spitalny and his All-Girl Orchestra, Hutton and the Melodears were the most recorded and filmed all-girl band during the 1930s, an era that witnessed a significant transformation of gender representations in the entertainment industry in large part because of the influence of the Production Code Administration (PCA) of the Motion Picture Producers and Distributors of America (the censorship agency). This agency monitored Hollywood films well into the 1960s, shaping the characterizations deemed acceptable for female actors, musicians, and entertainers filmed for short subject and feature-length films.

Hutton, born in 1916, was early exposed to Chicago's theatrical world by her mother, pianist Marvel Ray and her father, a theater actor. She debuted as a singer and dancer at the age of eight and by her fifteenth birthday, was head-lining the famous vaudeville theater, the Palace in New York as one of Gus

Edwards's *Future Stars* (1930). During the early 1930s, she also became the featured performer at Chez Paree in Chicago. According to *Variety*, Hutton's early musical hits included "Full of the Devil" in Lew Leslie's popular revue *Clowns over Clover* and "Never Had an Education" in George White's *Melody* (*The 1936–37 Motion Picture Almanac,* 466). Hutton remained active in the waning days of variety and was signed by Ziegfeld for the Follies of 1934.

At the height of her Broadway success, Hutton began leading the all-female Melodears. Gaining a reputation as the "Blonde Bombshell of Swing," she danced, sang, and conducted the Melodears until 1939. During the 1930s, the band toured vaudeville and film circuits performing at the most prestigious theaters including the Palace and the Savoy. They frequently performed on live radio and starred in a number of musical films, as I discuss later in this chapter.

Irving Mills, the wealthiest and most powerful music booking agent in the country, also worked with celebrated swing and jazz artists, including Duke Ellington and Cab Calloway, and his reputation and financial clout provided unprecedented opportunities for the Melodears. In 1934, the same year that the Melodears began publicly performing, Irving Mills also formed the Cavalcade Orchestra, a mixed-gendered group that may have been one of the first commercial popular music orchestras to employ a significant number of female musicians. However, despite the group's commercial success, Mills disbanded the group after only six months (Dahl 1984, 49).

During the first theatrical performances of the group, Hutton merely adapted her Broadway skills as a headlining performer—dancing and singing in front of the band for their variety-style stage shows. Eventually, she chose to extend her performing responsibilities to directing the band while also dancing and entertaining. One *Washington Post* journalist claimed that it was his off-hand remark that inspired Hutton to "wield a baton" while dancing in front of the band: "Just because I said in Saturday's review that she employed no baton in conducting the orchestra, she used one Saturday night in the first number. That's the way these blondes are!" (Bell 1934).

The Melodears comprised top female jazz musicians from the United States and even from Canada, many of whom had actively performed in vaudeville jazz groups during the 1920s.[2] Some of the most prominent players included Canadian-born Ruth Lowe Sandler who played piano with the Melodears from 1934 to 1938. In addition to performing jazz, she was a prominent composer and wrote "I'll Never Smile Again" in 1939, a song catapulted to fame by a young Frank Sinatra, who performed it while touring with the Tommy Dorsey band. Sandler later wrote lyrics for another signature Sinatra song, "Put Your Dreams Away for Another Day" in the early 1940s (Gamester 1990).

Other members, well established in New York's professional music world, provided inroads for up-and-coming female performers. Pianist Gladys Mosier, for example, a member of "Ina Ray Hutton's traveling jazz band," urged an unknown Maxine Sullivan to move to New York and introduced her to bandleader Claude Thornhill. Thornhill then recorded her singing the Scottish folk tune "Loch Lomond"; the recording launched Sullivan's singing career ("Jazz singer Maxine Sullivan dies" 1987). Marian Gange played guitar with Ina Ray Hutton and was an early inspiration for jazz-guitar soloist Mary Osborne (Wilson 1981). Mardell "Owen" Winstead from Jacksonville, Illinois, played trumpet with Ina Ray Hutton during the 1930s (obituary for Mardell Winstead, *Washington Post,* 23 September 2003, B06), and Mirian Stiglitz Saperstein toured as a saxophonist with various all-girl bands including the Melodears during the 1930s. Zackie Cooper also played saxophone and piano with Ina Ray Hutton beginning in 1939 in New York City (Cooper 1928–58).The Melodears also featured a number of expert jazz soloists. The most prominent soloists appearing in shorts from 1936 and 1937 are guitarist Helen Baker, tenor saxophonist Betty Sattley, trumpeter Mardell "Owen" Winstead, trombonist Alyse Wells, pianist Betty Roudebush, and drummer Lil Singer.[3]

Like the Ingenues, the group mostly toured as a stage band (as opposed to a dance band), often playing variety shows and film houses in Chicago, New York, and Washington, D.C. In 1934, for example, the Melodears headlined Loew's State Theater with "17 female musicians" and a variety of specialty acts including the Frazee Sisters. Also on the bill was a classical cellist (Yasha Bunchuk), a musical comedy songster duo (Medley and Dupree), a juggler, and the Yellowjackets, a dance sextet ("Melodears on Loew Bill" 1934). By the mid-1930s, the Melodears had become a commercially successful national attraction with bandmembers earning seventy-five dollars a week for theater performances, wages comparable to those of other theater musicians during the 1930s, but paling in comparison to the *Hour of Charm*'s 250 dollars for soloist appearances on its weekly radio broadcasts ("Spitalny Identifies Weird Song Ending" 1937).

After mastering a variety of swing, jazz, and popular arrangements provided by Mill's expert arrangers Eddie Durham, Alex Hill, and Will Hudson, the Melodears recorded twice in 1934, becoming the first all-girl band to be recorded during the 1930s, first for Vocalion and later for Victor (Driggs 1977, 16). Ina Ray Hutton and her Melodears appeared in several short subjects and one feature-length film—all of them produced by Paramount Pictures including *Ladies That Play* (1934), *Feminine Rhythm* (1935), *Musical Fashions* (1936), *Accent on Girls* (1936), *Star Reporter* (1936), *Swing Hutton Swing* (1937), *Melodies and Models* (undated), and *The Big Broadcast of 1936*

(1935). During the 1930s, Paramount, a pioneer in the musical short subject genre, produced many musical short subject films of famous jazz, variety, radio, and theater entertainers including Louis Armstrong, Bessie Smith, Fats Waller, Artie Shaw, Ginger Rogers, Cab Calloway, Ethel Merman, and Bing Crosby. Most of the Melodears' Paramount shorts were directed by Fred Waller who worked during the 1930s as Paramount's special effects and photography director. Waller also oversaw a number of Paramount's excellent musical shorts, including Duke Ellington's *Bundle of Blues* (1933) and *Symphony in Black* (1935) (featuring an eighteen-year-old Billie Holiday).[4]

After the Melodears appearance in their only feature-length film, the *Big Broadcast of 1936*, the group was solicited for a number of films and picture house contracts. Hutton and the Melodears' rapid rise to fame in the entertainment world was duly noted in press reviews:

The success scored by Ina Ray Hutton and her Melodears as features in Paramount's Big Broadcast of 1936 musical film, has led to a contract for a new feature short and a flow of offers for star billing in contemplated full-length musical subjects. . . . Ina Ray Hutton "that blonde bombshell of rhythm," and her Melodears, all-girl orchestra combining charm and expert dance music have set up a unique record in theater annals for return engagements. Contracts have just been offered for Ina and her orchestra to play two deluxe theaters for the third time within the short period of a year! ("Harlem Talks of Greats of Music World" 1935)

Hutton's fascinating theatrical and musical appeal was also regularly noted in stage-show reviews. One press release praised the sensual appeal and good looks of Miss Hutton in 1930s "jive" lingo:

Add Harlemese: That Chicks a solid sender! Explanation: the girl has youth, beauty and charm calculated to arouse masculine enthusiasm, just the opposite of a 'beat out chick' one who has lost fascinating qualities. . . . Ina Ray Hutton, eye-satisfying leader of the Melodears is a great grandniece of General Pickett, of Civil War Fame. ("Rialto Gossip" 1934)

The use of jazz slang in reviews of popular jazz and swing performances betrayed an urban modernist aesthetic and a racialized notion of popular culture. Vernacular jazz lingo further indicated a performer's hipness and inclusion in the subculture of jazz musicians.[5] Moreover, the use of jazz slang by both swing fans and the growing popular music industry extended the nomenclature of swing "addicts" that had seized the country during the 1930s, elevating jazz and swing musicians to the status of international celebrities (McRae 2001). Beyond offering its users hipness and pizzazz, jazz lingo also afforded musicians a counter to mainstream music and to elitist establishments and their formalist music criticism.

Other reviews noted Hutton's infiltration of the male-dominated world of swing and jazz, portraying the Melodears as a refreshing break from the standard masculine makeup of popular music fare:

Ina Ray Hutton, at the Chicago Theater, is causing veteran theatergoers to discover that something new can be done with a jazz band. She has 17 girl musicians in gay costumes seated at ornamental music stands, and they "get hot" and "go to town" with as much spirit as any males in the jazz profession. For people who have grown a bit weary of "the boys" who are so prevalent in the field of popular music, these young women, called "Melo-dears" are refreshing. It is Miss Hutton herself, however, who arouses genuine enthusiasm. She is a Jean Harlow type, with a figure worth bragging about. She is as brisk as Eva Tanguay used to be; she wiggles the baton in a frenzy of triple time; she makes quick changes into gorgeous gowns, and she tap dances with skill and fury. In other words, she is a clever performer with a dynamic personality. (Collins 1934)

Having developed her talents with the Ziegfeld Follies, Hutton naturally capitalized upon her skills by dancing and singing for the Melodears variety-style stage show. In August 1934, she and her Melodears participated in a stage show at Loew's Fox during the feature run of *The Old Fashioned Way,* starring W. C. Fields. Beginning 1 September 1934, the Melodears performed a stage show at Loew's State Theater in New York. The *Washington Post* praised Ina for her dances that "remain the last word in tap and swing expression of prevalent moods in popular rhythms." The *Post* also praised the band's instrumental skills with their arrangement and swinging rendition of "Trees." Hutton's unique conducting style also won praise: "Miss Hutton still lives up to her taffy-blonde beauty and leads with her chin and her knees almost as much as she does with her swingish baton." Of course most reviews of the Melodears favorably mentioned Miss Hutton's lavish gowns: "The act is colorfully staged and Miss Hutton's gowns—what there is of them—probably will ravish feminine eyes" ("Ina Ray Hutton's Music . . ." 1937).

Beyond the band's musical expertise and their many appearances in mass-mediated contexts like film, radio, and variety, the group also competed with the top-ranking male bands during the late 1930s. In 1937, for example, Ina Ray Hutton and Lucky Millinder participated in the relatively new "Battle of the Band" contest at the Earle in Philadelphia (*Variety* 24 December 1937, 43). Black bands also competed in the ever-popular battle of the bands format, one of the most reviewed and historicized contests occurring in 1938 between Count Basie and Chick Webb (*Pittsburgh Courier* 21 Jan 1938, 20).

From 1934 to 1939, Hutton toured music halls, film theaters, and vaudeville circuits with the Melodears. Maintaining a full orchestra with expert female instrumentalists and soloists, however, proved challenging as replacements for women were extremely difficult to find. Moreover, during the Depression era, the changing climate of representations and attitudes toward professional working women necessarily influenced the attitudes and motivations of female instrumentalists.

In a 1940 interview, Hutton depicted these as well as other challenges in-cluding maintaining a balance between sex appeal and professionalism:

I wanted to lead a band. It looked simple. Just waving a baton and waving—. You know. The boys liked it. . . . We played the provinces. I guess I saw all the men in American out front. Some of them tried to get back stage—some sent mash notes. But I kept the sex in the saxophones.

Hutton recalled the pervasive expectations and misconceptions concerning the professionalism of the female musicians—and, more importantly, the professionalism of Miss Hutton herself, who was fully aware that it was largely her sex appeal that attracted male audiences.

In this interview, she continued to detail some of the normal hazards of rigorous touring schedules and fame, issues that affected both male and fe-male bands during the 1930s. In particular, Hutton addressed such obsta-cles as road hazards and theft:

There were a lot of laughs, and some tough breaks, too. One night in Flint we had a long haul to the next job. So we piled in the bus and started driving. It was wet out— both rain and drunks. A car hit us and the bus turned over. It was a mess. I had to crawl out a broken window. Then a woman asked me, "Are you Miss Hutton? I'd like your autograph." Everything happened on one job in Nebraska. My wrist watch and bankroll were stolen. The girls lost their instruments. And a firecracker blew off a couple of my fingernails. ("Ina Ray Hutton comes up the hard way" 1940)

By 1940, Hutton had decided to disband the Melodears, become a brun-ette, and organize an all-male dance band. Recognizing the changing gen-dered cultural climate as films and theaters began to move away from all-girl spectacles and revues, Hutton admitted to *Down Beat* in 1940 that she was "abandoning sex appeal and getting by on musical merit alone" ("Ex-Glamor Girl" 1940). Nonetheless, Hutton later worked with an all-girl band in 1949 and then again in the early to mid-1950s for variety television programs. Hut-ton continued to work, albeit less vigorously, with all-girl bands through the early 1960s (obituary for Ina Ray Hutton, *Variety*, 22 February 1984, 110).

Ina Ray Hutton and the Melodears: The Big Broadcast of 1936 *(1935) and* Star Reporter *(1936)*

Band numbers are by the Ray Noble and Ina Ray Hutton combinations, both quickies. Noble drew a round of applause at the Broadway Paramount, and his music warranted it. For the Hutton sequence, the camera wisely keeps its glim on Miss Hutton.
—*Variety,* 18 September 1935

Between 1932 and 1938, Paramount produced four *Big Broadcast* va-riety films, each featuring a number of radio and stage personalities with

appearances by Benny Goodman, Cab Calloway, Bill Robinson, George Burns, Gracie Allen, Bing Crosby, Amos and Andy, and the Mills Brothers and, most notably, Bob Hope's "Thanks for the Memory" from 1938. The *Broadcast* series continued the Hollywood trend during the transition to talkies whereby studio moguls "raided" Broadway theaters and later radio playlists for established performers adept at incorporating sound and especially the human voice in dramatic narratives, comic routines, and popular music sequences for short and feature-length film subjects ("Vita's Play Talking Films as Road Show Substitutes" [1928] and "The Rape of Vaudeville" [1926]). Al Jolson and Eddie Cantor were two prominent variety performers who successfully transitioned to the talkies during the late 1920s (Jenkins 1990).

Further, beginning in the early 1930s with the onset of the Depression and the crisis in public entertainment mediums such as film and variety, film companies increasingly recognized the threat and growing popularity of cheaper and more domestic entertainment forms (especially radio). Moreover, crooners like Bing Crosby expanded radio's popularity during the peak years of the Depression and inculcated a more intimate and feminized aesthetic for radio's domestic audiences (McCracken 1999).

Initially, most of the major studios reacted to radio's growing prominence by limiting the use of radio performers in their films. Paramount, however, reversed the trend with the *Big Broadcast* series, a film based upon both variety formats and radio themes and personalities. In fact the *Big Broadcast of 1936*'s central plot focused upon the trials of a fledgling radio station. Paramount Pictures, recognizing the advantages of incorporating radio stars into their *Big Broadcast* series, fortuitously revived the musical film genre after a brief downturn in film attendance during the early 1930s (Barrios 1995, 365–367). Early musical film historian Barrios describes Paramount's incorporation of radio stars as "a reversal of the curiosity value of the sound era; audiences knew and loved the voice and would now be introduced to the faces that accompanied them" (Barrios 1995, 365).

Paramount's *Broadcast* series of the 1930s also reflected a compromise between the older trend of musical films featuring a variety-style program and the newer practice of introducing radio elements familiar to audiences: weekly dramatic and comedic serials like *Amos and Andy,* and ballads popularized explicitly through radio broadcasts by American favorites Bing Crosby and Rudy Vallee (McCracken 1999). Indeed, most of the featured *Big Broadcast* series performers were established New York radio and theater personalities.

In each *Broadcast* film, thinly constructed plots supported a number of otherwise unrelated musical, dramatic, and comedic acts drawn also from

variety, radio, and vaudeville. The spatial and contextual abstraction and perceived distancing of each musical sequence also facilitated the otherwise problematic appearance of black and white artists in the same film. Typically, Paramount included black artists established as dancers and musicians rather than as dramatic actors. Thus, the question of dramatic interracial collaboration was avoided. While blacks and whites had shared the silver screen before, black actors were typically limited to stock characters taken from southern theatrical genres or represented in service roles as butlers, mammies, nursemaids, porters, or drivers.

With the advent of sound in film and with the increasing influence of the Production Code during the mid-1930s, black artists were often pushed out of dramatic roles altogether to avoid racism accusations by the NAACP or by the Production Code. However, as "specialty acts," black artists were provided new opportunities to appear as musical performers, and in this capacity they were no longer exclusively typecast in subservient roles (Cripps 1993a).

Although mixed-race bands had begun recording and performing in the mid-1930s, their representation on film could potentially have offended southern white audiences. Paramount, therefore, solicited Benny Goodman's mixed-quartet for the *Big Broadcast of 1937* on condition that black pianist Teddy Wilson would record the music with the quartet and then be substituted by a white actor for the filming of the scene. Wilson refused and Goodman appeared with his all-white orchestra instead (Knight 1995, 25).

The *Big Broadcast of 1936* was unique in its presentation of a diverse pool of musical and theatrical talent as well as being one of the first films shot in several international locations, from Shanghai to the coast of North Africa to Cuba. Along with Hutton and her Melodears, musical guests included Ray Noble and his orchestra, Bill Robinson, a young Ethel Merman, Bing Crosby, the Vienna Choir Boys, an early appearance of Dorothy Dandridge and the multitalented Nicholas Brothers. The 1936 *Big Broadcast* press book indicated eight additional musical acts, noting that they were heard but not seen. These were the Rhythmettes, The Ingenues, The Three Tones, The Three Shades of Blue, The Singing Guardsmen, and The Uptowners.[6] (In fact, the Ingenues were cut from the film, as were three other musical selections.)

While the black performers in this production are rarely included in the film's dramatic scenes, some of the best black theater and radio performers are featured in many of the musical variety numbers, including those by Bill Robinson and the Nicholas Brothers. The Nicholas Brothers, however, are the only black characters integrated into the film's main plot. Presented as teenagers, their performances proved less problematic for a then

still predominantly segregated film industry. Their adolescent (although they were near adults during the filming) status deflected the problem of adult interracial interaction. In the film's sequences, the brothers contribute to film's fledgling radio station as actors and performers for weekly broadcasts while also soliciting funds to keep their radio station's hour-long musical-dramatic program afloat.

Ina Ray Hutton and Her Melodears appear in the *Big Broadcast of 1936* as one of the competing acts for the "Big Broadcast's" contest prize. The Melodears cameo in the film bears no import to the film's plot, beyond its entry in the contest under the sponsorship of the American Broadcasting Company (later ABC). The contest, billed as an "international event," was introduced by the film's narrator as "The Big International Broadcast, the great competitive program coming to you from the four corners of the earth." During the 1930s, advertising a program's range of "international" talent as opposed to a film's interracial content deflected a racialized politicization; it also symbolized America's growing cultural prestige throughout the world even at the height of the Great Depression and the nation's more contested involvement in colonial expansionist pursuits.

Although not included in the *Big Broadcast* film, the Melodears filmed two other musical numbers on the same set in addition to their fast-paced "Earthquake," an instrumental piece designed to capture viewers' attention and confirm the technical abilities of the band. In total, the three musical numbers were later released as a separate Paramount short subject film entitled *Star Reporter* (1936). Most likely, Paramount intentionally filmed a number of musical numbers so that both a short subject film and a "specialty" for the feature could be slated during the same session.

In *Star Reporter* (fig. 4.1), beyond their impressive "Earthquake," the band also performs the modernistic "Jazznocracy" and a Tin Pan Alley popular song, "I'm a Hundred Percent for You." Opening this Paramount short, a filmed radio announcer introduces Hutton, highlighting her past as a Broadway performer and downplaying her role as a conductor and bandleader:

Many of the brilliant stars of stage, screen, and radio are graduates of the Broadway nightclubs. One of the most glamorous of these is the pretty little spitfire of syncopation, Ina Ray Hutton. Practically overnight, she flashed across the gay white way as the leader of her own all-girl orchestra. Today one of the most popular of all headline acts is Ina Ray Hutton and her Melodears.

Their first brief "flash" jazz piece "Earthquake" is performed in a big-city nightclub filled with balloons, tinsel, Art Deco furniture, and sophisticated lights. Their particular brand of "flash jazz" was reminiscent of music performed by the all-girl bands featured in Broadway revues and vaudeville

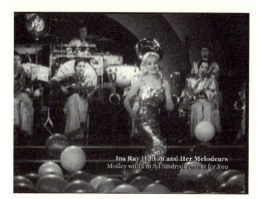

Figure 4.1. Ina Ray Hutton dances
in *Star Reporter* (1936).

acts of the Jazz Age. The final piece, "Jazznocracy," is an unusual musical arrangement drawing from classical, theatrical, and film music genres. This number reflects modern jazz influences, including muted brass effects, earthy plunger growls, and various textures created by the wahs and vocal articulations of mouthpieces (aka Bubber Milley). The unusual and highly colored orchestration of the clarinets with the trumpets and trombones suggests a musical style in concert with the most modern, eclectic, and orchestral jazz styles of the day—and also influences of Ellington's earliest film work. Chromatic and dissonant flourishes in the woodwinds padded with earthy, deep wahs in the trombones, lead to the piece's final foreboding section, wherein the trumpets and trombones descend ominously into the final cadential gong. This section is almost expressionistic in its musicality, film technique, cinematography, and choreography. Here Hutton dances to the dark aggressive music while retaining her characteristic "peppy" jazz-inspired routine.

All of the numbers featured in *Star Reporter* present the Melodears performing without sheet music, as was common practice for most all-girl bands of the day. All-girl bands, marketed as spectacles and visual pleasantries, frequently discarded any visual impediments that may have hindered a complete "showcasing" of these women. Thus most all-girl bands represented on film during the 1930s and 1940s performed without music stands or sheet music, an added challenge for all-girl bands and one that was also taken on by African American jazz bands during the same period but for different reasons (as black bands were thought to be unable to read music notation).

Beyond the visual requirements of all-girl bands in the context of variety and spectacle during the 1920s and 1930s, women were required to prove themselves as professional musicians to dubious critics and fans unconvinced of women's capabilities as jazz musicians. These sentiments mirrored requirements for other types of performing women including

actors, comedians, and dancers. Bob Thaves's famous quip about Fred Astaire: "Sure he was great, but don't forget that Ginger Rogers did everything he did, backwards . . . and in high heels" is representative (Ginger Rogers Official Site, homepage). Thaves's ironic recollection encapsulates the added challenges for popular-culture performing women during Hollywood's Golden Era.

In their earliest filmed performances, the sartorial choices for both Hutton and the Melodears indicated influences from more radical and subcultural art forms emerging during the 1920s. Here the women wear costumes that may have been inspired and adapted from the more fluid gendered representations encouraged in intimate settings like cabarets and burlesque theaters. The variety of masculine and feminine attire popularized in these genres and featuring "queer" performers (who dared to radicalize normalized theatrical couture and sport modern short and cropped hair styles) certainly colored the ways that commercial all-girl bands were first represented.

In the *Big Broadcast* and *Star Reporter* sequences, Hutton wears a rather typical 1930s-era gold-sequined gown while the girls sport stylish, pleated bell-bottom pantsuits. Hutton is both glamorous in her expensive and sensual gown, yet her athletic choreography and intermittent banter suggested a peppy and assertive performer. She would offer more conservative yet elegant performances in later films with her all-male orchestra, such as *Ever Since Venus* (1944).

The *Broadcast* series epitomized the variety of music available to Americans via musical theater and radio during the 1930s and the wide range of musical tastes shared by American consumers from the sweet choral arrangements of the Vienna Boys Choir to Ray Noble's society dance-band orchestrations. The film also features a wide range of cultural humor, from vaudeville clowning, to the New York humor of Gracie Allen and George Burns, to the blackface comedy of Amos and Andy.

Women in the film are presented in a number of stereotyped roles, mostly as exotic dancers, churning out the "contagious," "hot" rhythms of the jungle, as novelties or as crazy foreign duchesses. For example, the movie features the LeRoy Printz dancers as "jungle" dancers producing geometric and exotic designs in black ostrich-feather skirts and lavish headpieces during Ethel Merman's musical sequence, "It's the Animal in Me," complete with live dancing elephants. The exoticism of an African jungle and "primitive" dance had been popularized earlier by the famous black and tan chorines of the Cotton Club. The addition of fantastical animal acts to these primitive scenes suggested a synthesis of modernist artistic themes, as well as reflecting the exoticism and fetishization of women's bodies previously showcased in variety productions, cabarets,

and burlesque houses. These heavily racialized dances belied a modernist fixation with primitivism and "othered" subjects and also suggested an emerging exotic cinematic semiotics prioritizing "hot" rhythms, jungle settings, and scantly clad women.

In contrast to the more independent, comedic, and sexually variable characterizations of 1920s and early-1930s white female stars like Fanny Brice and Mae West, mid-1930s Hollywood films featured leading women whose characterizations reflected the types of femininity promoted by the more conservative Hays Office after 1934. Indeed, the Production Code effectively stifled the film careers of 1930s leading women like Mae West. West's unique ability to personify an independent sexual woman, whose characterizations satirized a variety of social and cultural groups, proved too risqué and threatening to the various institutions guiding the PCA during the 1930s including the Catholic Church Legions of Decency and the WCTU (Women's Christian Temperance Union).

Other mass-mediated representations of urban working women, such as the fictional Betty Boop, similarly reflected changing public attitudes. Heather Hendershot's (1995) investigation of the changing representation of working and performing women of the 1930s focuses upon the changing design of Betty Boop during the pre- and postcensorship era (and at the height of the Melodears career). She suggests that the Fleisure studio (under the auspices of Paramount) redesigned Betty Boop after 1934 to eliminate offensive or morally suspect representations of sexuality and ethnicity. Hendershot argues that the redefining of Boop's appearance, class, and sexuality in 1934 (the first year the Production Code was put into practice) actually proved productive in redefining notions of race, sex, and class—in a context where "contested industrial and social factors converged." Betty Boop's pre-1934 appearances as a highly sexualized, urban, working, flapper girl, and then after 1934, as a higher-class, domestically situated, married woman, mediated some of these tensions, while also betraying the industry's masculinized attitudes about working women and women's roles in public culture (Hendershot 1995, 127). In Hollywood and other mass-mediated texts, the image of working women in glamorous and provocative or vampish clothing and in public contexts coded them as desirable sexual women *and* as targets for harassment: the latter, because of increasing resentment toward women's encroachment on the labor force and on public sectors like the stage and ballroom.

How, then, were jazz women affected by heightened labor tensions and changing attitudes toward working women during the Depression era? Also, how did these sentiments influence the various modes of performing for jazz women featured in the mid-1930s Paramount shorts?[7] For one,

studio executives were forced to provide entertaining programs and show-case the talents and versatility of female instrumentalists in ways that allowed them to renegotiate gendered images popularized during the 1920s, rendering the images more radical and variegated. In short, film producers managed to feature jazz women while also responding to the growing conservatism initiated by Hollywood's censorship agency. These representational tensions contributed to creative new modes of gendering female musicians as attractive, novel, versatile, and feminine during a period of rampant joblessness and increasing resentment toward working women, who were often thought to benefit from cheaper wages for "feminized" work denied men in the failing industrial and economic sectors. These gendered and economic anxieties bleed over into popular culture spheres and especially into the masculinized realms of jazz and popular music.

In some respects these modes of performing and the various representations of Ina Ray Hutton and the Melodears during the 1930s substantiate the growing conservatism within the film industry, albeit in ways less obvious than dominant characterizations of women promoted in feature-length films. In this sense, the Melodears appear highly modern, attractive, and musically more adventuresome in their earlier films. Moreover, their appearances draw from a variety of sartorial and performative representations, including the Melodears' androgynous pantsuits and Hutton's more functional low-heeled tap shoes, enabling more physical choreography. These small gestures registered with viewers and journalists, who commented upon the physical costuming of performing women. Later, the Melodears no longer sported modern dress pants but appeared in full-length gowns. Further, the frequency of Hutton's costume changes as well as the growing infrequency of her athletic tap routines suggested connections to the more feminized gendered representations dominant in film after 1937.

These images, although probably not the outcome of direct censorship, subtly corresponded with the climate of censorship and erasure imposed upon both female and African American performers working for the major studios like Paramount during the mid-1930s. Hutton's later films from 1937 and then again during the 1940s, present a more strategic view of femininity and performance, one less athletic, less masculine, and less variegated. Hutton's ability to balance a highly attractive and versatile image with her more masculinized role as a bandleader of a jazz group and also as a solo tap dancer was significant during this transformative period.

As Cripps (1993a) points out, blackface and black characters simultaneously disappeared as the influence of the Hays Office expanded and as film studios attempted to avoid denigrating racial characterizations, blackface,

and black stereotypes. Many studios reacted by simply removing black characters from film rosters. In many ways, creative or radical women's performances felt to be oversexualized or over physical were also streamlined, censored, or scripted out altogether during the late 1930s, in favor of more prescribed and demarcated feminine roles.

However, short subject films, infrequent targets of the Code, provided outlets for 1920s- and early 1930s-era ethnic and sexual humor as well as a greater range of popular music tastes exhibited on urban stages from Tin Pan Alley to ethnic folk songs and especially jazz and swing. Paramount's short subject musical films, then, provided one of the few forums for black artists and jazz women to contribute distinctively to Hollywood during the 1930s. Unfortunately, most of the films of female jazz instrumentalists from this era provide few images of African American female jazz instrumentalists, but many of the more commercial "white" all-girl bands, most notably the Melodears and Spitalny's Musical Queens.

Paramount Shorts: Accent on Girls *and* Swing Hutton Swing

During and after 1936, Ina Ray Hutton and her Melodears were filmed for a number of Paramount shorts including *Accent on Girls* (1936) and *Swing Hutton Swing* (1937). In many ways, *Accent on Girls* typified musical shorts of the 1930s: promoting popular bands and performers in nightclub or theatrical settings who provide three to four musical numbers for the film's "audiences." *Accent on Girls* (figs. 4.2 and 4.3) similarly features a revue scene entitled "Club Hutton Shake" set in a big-city nightclub, "The Hutton Club," after Ina Ray. The film's cinematography exemplifies the most experimental film technology of the period as engineered by Paramount's special effects and photography director Fred Waller. The music performed by the Melodears varies from Tin Pan Alley and popular dance tunes to ragtime, swing, and a variety of New Orleans and Chicago jazz styles (probably indicative of the variety of arrangers working for the Melodears, including Eddie Durham, Will Hudson, and Alex Hyde). Some of the arrangements resemble small jazz instrumentals popularized by Django Reinhardt's jazz quintet; others reflect a more experimental filmic jazz style suggestive of Ellington 1930s film output: unusual tone colors, stacked pyramids, mixed-section orchestrations, and rapid time changes.

The film opens with chaotic and glamorous city shots animated by flashing lights, city noises, theater marquees, and busy traffic images. The camera pans in on the nightclub's entryway: "The Hutton Club," where women, exclusively, work as bellhops, coat-checkers, and bartenders. The

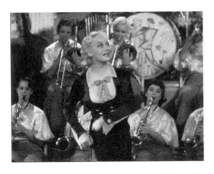

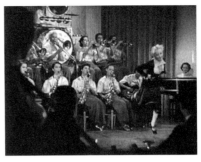

Figure 4.2. Hutton features the Melodears'
saxophones in *Accent on Girls* (Paramount
1936).

Figure 4.3. Hutton tap dances in *Accent on
Girls* (Paramount 1936).

notion of women as nightclub employees during the Great Depression
would have provided an erotic and fantastical context in contrast to the
usual feminized workplaces of offices, department stores, hospitals, and
schools. Close-ups of fashionable and trendy couples—the women in furs
and feather-netted hats, both people smoking and drinking martinis while
conversing at small café tables—symbolized the luxurious leisure lifestyle of
these privileged few cosmopolitans.

In the film, the Melodears sport short-cropped, bobby-pinned hair, styl-
ish billowing pants, and white-lapelled satin blouses, a uniform that ap-
pears decidedly more androgynous than the band's later 1930s full-length
gowns. In some ways the sartorial choices seem almost outdated, featuring
late 1920s hairstyles and clothing. Nevertheless, the girls are presented as
entirely modern, stylish, and a little satirical in their masculine-made-
feminine evening attire.

This trend was very popular in cabarets and vaudeville houses, where
women performers, singers, and dancers often wore sexy or feminized ver-
sions of male clothing—sometimes satirically referred to as "passing fash-
ions" (Doan 1998)—in order to pique and attract their male and female pa-
trons. Leading Hollywood actresses (for example, Marlene Dietrich and
Katharine Hepburn) similarly popularized masculine clothing both in their
celluloid roles and outside the studio. During the 1920s, fashion, as a vehi-
cle for expressing gender, sexuality, and class, became a medium for crea-
tively redefining jazz women's allure, femininity, and musical vitality, while
also responding to the subcultural trends of New York cabaret. During the
Depression era, however, as men and women responded to increasingly
unstable economic conditions as well as changing structures of production,
Hollywood representations of queerness, gender bending, and "passing
fashions" became more contentious signifiers and resulted in greater efforts

by the Code to censor destabilizing images that during the 1920s had appeared more fluid and less threatening (Lugowski 1999, 4). As queer film theorist Lugowski remarks: "Concern over gender roles would occupy a central role in the ongoing struggle among studio profit motives, the varying demands of differently positioned spectators, and what was seen as the need for 'suitable' representation in light of the Depression's crisis of masculinity and the family" (Lugowski 1999, 8).

In Hutton's club, female employees wear short ties with pleated pants and blouses or sometimes sport more revealing outfits—such as the coat-check girls, whose sexy costumes of black bodices and fishnet tights sheathed by masculine tuxedo jackets effectively sabotages their image as working women. Ina, however, wears a full-length black satin dress with long sleeves, white buttons, and a white lace bowtie. Somehow, she manages to expertly dance in this form-fitting dress while executing her routine with athleticism, exactness, and exuberance.

The Melodears open the film playing "Hobo on Park Avenue," a fast-paced jazz number composed by one of the band's arrangers, Will Hudson. This upbeat showpiece captures the attention of patrons as they coolly order drinks, or converse at small, linen covered tables. The following musical numbers featured some of the Melodears most-often programmed material, including "Everybody's Truckin" and "Devil's Kitchen."

Eventually, the camera leads toward the stage where the Melodears are performing the last choruses of "Hobo on Park Avenue" and featuring a number of improvised solos. Hutton's band contained a number of the most talented and professional "white" instrumental soloists in the United States. In this first number, the trombonist (probably Alyse Wells) stands for the first improvised jazz solo and is given full camera attention for the duration of her solo. This positioning is unusual: most of the white all-girl bands soloists were usually not shown and merely provided an opportunity for a chorus of female dancers to enter the stage.

The next number, the popular song and dance "Everybody's Truckin" (composed by Fats Waller) introduces the theme of "slumming," a popular nighttime activity for white urbanites, and music lovers who ventured into black neighborhoods, benefiting from black performers' policy of admitting whites to black and tans. In the context of Hutton, a white performer singing these lyrics, the term also implied a breaching of class boundaries, as upper-class whites temporarily reveled in the voyeuristic and participatory activities of New York's lower and middle classes. Ina sings of "Harlem soul," and how "folks downtown were coming to Harlem." She sings of the latest dance craze whites learned from Harlem folks called "truckin'."

For the producers and directors of all-girl bands, "blackening" through the refashioning of jazz dance and the allusion to black "soul," became a means of aligning these performances to the most innovative musical styles. Unlike white, male bands, however, women's appropriation of black jazz relied more heavily upon spectatorship, sexuality, alluring fashions, and the privileging of a male gaze that facilitated transgressive racial fantasies by combining notions of "hot" black music and a euphoric incorporation of black dance into the context of mainstream Broadway dance routines. These routines were most clearly mediated and transformed by the highly energetic and creative yet appropriative gestures of female bandleaders like Ina Ray Hutton and the director of the Ingenues who found great inspiration from both subcultural and mainstream sources including jazz music, Broadway choreography, and black vernacular dance genres.

In *Accent on Girls*, the music performed by the Melodears is an interesting blend of old and new styles from Tin Pan Alley and ragtime to jazz and swing. The band is arranged on three risers with the drums prominently displayed on the top middle riser. The drum set-up resembles that of many contemporary swing bands, with the long row of bells and chimes, the large tympani, woodblocks (monkey skulls), and a full-sized Chinese gong. The drummer uses these novelty instruments in a more traditional vaudeville style for theatrical effect or for comic punctuation. The saxophones remain in front, with the trumpets and trombones on the second tier. Hutton's band uses two pianists, one on the right and one of the left—standard practice for white all-girl bands during the late 1930s and early 1940s including Phil Spitalny's All-Girl Orchestra and Dave Schooler's 21 Swinghearts. In her various routines in these three numbers, Hutton performs steps popularized on the Broadway stage and in the jazz club including the time-step, the Harlem slide, the shuffle, "balling the jack," and the Stomp.

The third musical number in *Accent on Girls*, "Devil's Kitchen," again provided a vehicle for showcasing the many fine soloists of the Melodears, including the trombonist (probably Alyse Wells), the trumpet player Mardell Owen, and the pianist (probably Betty Roudebush) who performs an unusual chorus (eighteen measures) in a heavy-handed stride style. During this sequence, Waller's cinematography becomes more avant-garde and narrative, as the camera focuses upon a couple of male patrons swiftly drinking their ales. As the men become intoxicated, their view of the performers gradually distorts and they begin to see Hutton dancing in twos, then threes, and finally a dizzying chorus line of Inas dancing in unison, at which point the men literally fall over each other in a filmic vaudeville pun: they were literally "knocked-out" by a "knockout."

This illusory and surrealist effect of multiple Inas dancing in unison was similarly exploited by Waller with the famous African American dancer, Earl "Snakehips" Tucker in his earlier Paramount film, Ellington's *Symphony in Black* (1935). Snakehips's quadrupled dance sequence similarly suggested a funhouse effect as he danced in four identical frames elegantly attired in a black tuxedo. His image, multiplied diagonally against a backdrop of mirrors provided an exaggerated effect of frenetic feet and hands and thus a fetishization of the dancing body's anatomy.

Swing Hutton Swing

The Melodears produced a number of shorts during 1936 and 1937. In contrast to *Accent on Girls,* with its catchy and attractive theme, comic narrative structure, and diverse gender representations, their 1937 Paramount short *Swing Hutton Swing* (fig. 4.4), simply featured a jazz band performing in a rather typical stage-show setting. For this short, Hutton and the Melodears appear in an elegant but predictable, theatrical stage with no effort at representing a live audience. The film provides the context to showcase several popular and jazz-based musical numbers: the opening instrumental overture to "Organ Grinder's Swing"; followed by a vocal feature, "Bugle Call Rag"; followed by an instrumental and vocal medley of "Stardust" and "Organ Grinder's Swing"; and then a dance/vocal specialty "The Suzie Q"; and finally closing with the instrumental flash piece, "The Melodears Swing."

The women perform in a rather normal jazz band setup, with woodwinds and brass set in front of the rhythm section and once again bookended by the two pianists. In this short, the group sits in a single row, rather than the more typical configuration of brass and reeds separated by individual risers. Unlike the earlier and more experimental short subjects, however, this musical short simply features the band playing musical selections; in its simplicity, it prioritizes the musical capabilities of the Melodears over the dancing capabilities of Hutton. Indeed, the sequence quickly transitions to a "hot" trombone solo (again probably Alyse Wells), followed by Mardell Owen's expert trumpet solo, and ending with Betty Sattley's rapid, tenor solo. During the sequence, each female musician is foregrounded in the film's frame during her improvised solo. The redesign of the film highlights music over spectacular visuals, movement, and costumes (as in later musical shorts): Hollywood was in transition.

The film's second number features the vocal group The Winstead Trio (including two guitars) who sing their version of "Bugle Call Rag" backed

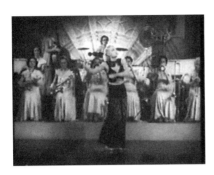

Figure 4.4. Hutton and the Melodears in *Swing Hutton Swing* (Paramount 1937).

by the Melodears' sprightly arrangement. By 1937, "Bugle Call Rag" had become a Tin Pan Alley, jazz, and swing standard and had gained in popularity because of various recorded versions including those by Cab Calloway and Benny Goodman.

For the third number, a medley of "Stardust" and "Organ Grinder's Swing," the band appears in full-length gowns while Hutton leads the group in a new fringe-embellished gold V-neck gown, conducting in a fairly traditional style. The "Stardust/Organ Grinder's Swing" medley is constructed as an instrumental ("Stardust") followed by a short vocal and tap dance feature ("Organ Grinder's Swing") for Hutton.[8] The medley begins and concludes with the "Stardust" theme.[9]

"Organ Grinder's Swing" was first adopted and composed for big band by Will Hudson (who was also Jimmie Lunceford's arranger). Many groups performed and recorded the piece in the mid-1930s including the Harlem Playgirls, Jimmie Lunceford, and Ella Fitzgerald (with Chick Webb's band in 1936). Indeed, it was Fitzgerald's landmark recording that was the first to immortalize her unique scatting. In 1936, Lunceford's promising young arranger, Sy Oliver, further augmented the piece for the band's 1936 recording session. Since then, the piece has been interpreted in a number of swing and sweet contexts by jazz artists like Coleman Hawkins, Django Reinhardt, Tommy Dorsey, Hal Kemp, and Lawrence Welk. Other popular versions were recorded by the singing quartet the Mills Brothers, the child star Shirley Temple, and (in the 1960s) by jazz and blues organists Jimmy Smith and Jack McDuff.[10]

In Hutton's version, the medley is introduced with a slow, saccharine version of "Stardust" and is "sweetly" rendered by the saxophones with wide, heavy vibrato. Hutton sings the single verse of the "Organ Grinder's Swing" just before her elaborate tap number. The band then introduces the initial "Stardust" refrain with a tempo almost half as slow as the "Organ Grinder" theme. The Melodears' tightly pitched, clean, and powerful brass section is featured to full effect on the "Stardust" melody. The

arrangement is peppered with short, probably precomposed but expertly rendered, instrumental solos: first a trombone solo, followed by Owen's trumpet solo, and ending with Sattley's tenor solo. Each soloist performs the standard two chorus, eight-bar progression. The clarinets belt out high sustained notes on the "and" of three, resolving to the tonic chord with a "wah—ah."

For the "Organ Grinder's" theme, the saxophones support the vocal verse with the same melody. During the four-bar breaks, the brass swing into a boisterous, punctuating riff just before Ina sings the single verse that Ella Fitzgerald had previously left out:

> Who's that walking down the street?
> Looks like organ grinder feet
> When he push that handle down,
> Music goes around and round,
> Wo hoh, asiag
> Woo hoh, asiag
>
> Drop a nickel in his hat
> Like a rich aristocrat
> Every nickel that you sink makes that organ grinder swing
> Oh oh, asiag
> Woo hoh

The band recapitulates the "Stardust" refrain as the brass take the first A, and then the reeds adopt the second phrase. The guitar provides short improvised riffs between the melodic phrases of the saxophones. The band finishes the medley with a lush crescendo and retard on the final phrase with the brass sustaining the top voicing.

Lunceford's earlier 1936 version resembles that of the Melodears in its artful and surprising development with its unique orchestration and unusually slow tempo. The melody of the piece is borrowed from the children's ditty "I like Coffee, I like Tea" or otherwise known as "Mama sent me to the store." Oliver's arrangement effectively re-creates the timbres of an organ grinder through his combined voicing of the clarinet, trombone, and muted trumpet (partially inspired by Ellington's similarly voiced trio in "Mood Indigo").[11] The growling trumpet paired with the dulcet bass line of the baritone and the distant woodblocks simulates a lighthearted, intimate jazz combo. The minimalism of this arrangement, in combination with the various small group sections, creates a distinct departure from other 1930s jazz arrangements, which typically favored fully arranged heads with similarly grouped sectional harmonizations (as in the reeds, brass, or rhythm sections). Oliver departed from such conventions by arranging small sections (often only eight measures long) of diverse groupings of instruments for trios, duos, and quartets.

The Melodears' comparable arrangement of "Organ Grinder's Swing," a unique contribution to 1930s jazz and dance band music, reflected the seriousness with which the leading industry composers treated Hutton's group during the mid-1930s. Although references to all-girl dance bands continued to articulate the novel appeal of such units, the Melodears had established a place in the leading ranks of jazz and swing bands with their expert renditions of such timely pieces.

The second musical sequence of *Swing Hutton Swing* provides an opportunity for Hutton to sing and display her expert tap-dancing skills. The Melodears perform "Doin' the Suzie Q" introduced by Hutton as the "latest dance from Harlem." In addition to Hutton's dance solo, guitarist Helen Baker is informally highlighted in a number of call-and-response solo passages. To facilitate her rigorous dance routine, Ina wears a wide-rimmed, black-lace pantsuit with a halter-top, accessorized with a stunning "diamond"-studded belt. After singing a verse and refrain, she then elaborates the lyric's dance references, performing versions of "Truckin'," the "Suzie Q," the time-step, and various other jazz steps.

Swing Hutton Swing concludes with "The Melodears Swing," a number written "especially" for the Melodears. Hutton appears in yet another glamorous costume, this time adorned in an elegant A-line sequined gown, dancing a bit and conducting with the various riff choruses featured in the brasses and woodwinds. This up-tempo instrumental finale again features the band's leading improvisers including those by Baker on guitar and Sattley on saxophone.

Hutton Jumps the Gender Line: Ever Since Venus

Who's Ina Ray Hutton?
Only the world's greatest lady maestro.
— *Ever Since Venus*

The incidental music is given full benefit of Miss Hutton's light baton.
—*Product Digest*, 23 September 1944

Shapely Ina Ray Hutton and her band do nicely with the musical chores.
— *Film Daily* 22 September 1944

In 1940, Hutton disbanded her all-girl unit, left Irving Mills, and auditioned musicians for an all-male unit. Although not immediately successful, by 1942, Hutton's new group was selling out picture palaces, ballrooms, and variety theaters. Hutton's band received warm praise for their appearance at the Earle Theater in Washington, D.C., in June 1942:

Apostles of pulchritude and students of dynamic swill have their innings this week of Friday, June 19. On that date, the pyrotechnic Ina Ray Hutton will touch off her

fireworks on the stage of the Earle Theater, as flaming young conductor of her new all-male orchestra. . . . The explosive Miss Hutton is unique among the leaders of "name" bands. She conducts with the sum total of her rich physical and temperamental endowments—hands, arms, eyes, legs and torso. She also sings a bit. . . . From this ample and versatile experience, the red-hot Hutton has evolved a technique of orchestra conducting that must be a constant source of wonder to Stokowski, Kostelanetz and the rest of the less sinuous maestros who, somehow, seem to get along all right without the tap-dancing and the Snakehips. There is only one Ina Ray, which is probably just as well for the national nervous system!

("Musical Bombshell soon to shake Earle Stage." 1942)

Ever Since Venus was the first full-length film to introduce Ina Ray Hutton as the bandleader of an all-male orchestra. During the film's musical features, Hutton is represented as a serious conductor who also sings and dances rather than her prior role with the Melodears as a dancing and singing conductor. During the band's first number, Hutton is presented facing the band and simply marking time. The second number positions her facing the audience and singing about two popular dances of the forties, the samba and the boogie woogie.

The film's opening ballroom scene clearly anticipates audiences' anxieties about female bandleaders leading male bands. Dreifuss, the film's director and writer must have understood the confusion felt by music fans upon seeing the gorgeous Hutton beating time with utmost precision and then effortlessly falling into step and singing and dancing a boogie-woogie jazz samba. The mere fact of her dancing and singing counteracted her newly elevated position as a real "maestro." Unfortunately, for professional women, these abilities were not considered acquired talents finely honed with years of experience and hard work, but rather as innate feminine abilities rarely considered worth mentioning in the higher artistic circles of music criticism, let alone within the increasingly narrow field of jazz scholarship.

In the film's opening nightclub scene, Mr. Hacket and Mrs. Hacket, owners of the leading cosmetic company, the House of Milo, attend Hutton's performance to consider her band for a possible advertisement campaign. Upon seeing Hutton, Mr. Hacket is instantly excited by Hutton's glamorous, lean, feminine figure. The savvy, manipulative, and petty Mrs. Hacket, recognizing her husband's barely contained sexual attraction, insults Hutton and identifies her not as a conductor but as "just a blond waving a stick." The conversation begins:

MRS. HACKET: "You didn't tell me the bandleader was a woman."
MR. HACKET: "Oh, didn't I? It must have slipped my mind."
MRS. HACKET: "What mind? To me she's just a blond waving a stick. We must be very careful not to engage an attraction that might prove to be a distraction."

Mrs. Hacket's comment succinctly characterizes the problem of Hutton's performance persona. Is she a sexy variety entertainer, distracting men with her alluring dance moves and form-fitting gowns? Or a serious bandleader in the same league as other schooled musically literate orchestral conductors? Evidently the two were not compatible.

Consider the polemic over jazz and swing music in the 1940s and the controversy between those critics who claimed that jazz was an authentic American art form worthy of canonization and those who felt it demeaned classical music and the Western art tradition with its rough and unpolished "spontaneous" improvisations. The breadth of Hutton's musical personae presented problems for those on either side of this polemic. Hutton could not easily be categorized as a serious composer and bandleader; nor could she simply be identified as a true jazz performer. In general, she was referenced to her chorus-girl past and introduced as a great Broadway star. While Hutton's early introduction to the music business, as the child of a pianist mother and actor father, endowed her with the necessary training and experience to wear many hats simultaneously, these attributes were rarely appreciated by jazz and classical music critics.

Granted, all-girl bands provided some opportunities for women to express themselves in new musical roles. Nonetheless, the predominance of certain feminine stereotypes constricted female musicians and bandleaders. By 1940, Hutton began to resent her status as glamour prop, set in front of a novelty all-girl band. Naturally, in order to coexist with other serious male bandleaders, she was required to alter her image and present herself in a more conservative vein. *Down Beat*'s 1940 publicity shot captioned the new Hutton: "Ex-Glamour Girl" above a photo of the new cropped brunette in a modest, high-cut collar with the descriptor: "The 'blonde bombshell' of dancebandom, now leading a new (male) stage band under MCA guidance, says she has abandoned sex appeal and will get by on musical merit alone" ("Ex-Glamour Girl" 1940).

Appropriately, the Hutton of *Ever Since Venus* alternates between conducting and dancing and singing. Her roles are finely separated, enabling Hutton to incorporate her various talents at distinct times. When displaying her dancing or singing capabilities, the film completes the illusion of specialization: Ina is seen passing the baton to another instrumentalist to suggest that the band requires a conductor to accompany the new dancing Ina or singing Ina.

Finally, during the film's finale, Hutton unveils her true multifaceted technical prowess, with a fast-paced tap dance that sets her apart from all the other female dancers. Here, she wears a much less constricting pantsuit and sailor top with low-heeled tap shoes. Her athleticism is reminiscent of

her many expert performances with the Melodears throughout the 1930s. Generally, however, Hutton's interaction with the Melodears in her earlier films exhibited a leader more spirited, less restrained, and more adventuresome in her willingness to lead the band by interpreting musical phrases and breaks with her movement and dancing.

By the mid-1940s, with tax increases on public entertainment venues, the damage wrought by the recording ban, and the rising costs of supporting a full twenty-one-piece band (as well as a declining interest in "hot" swing music), many of the biggest swing organizations disbanded. In 1946 alone, eight of the most commercially profitable bands, including Benny Goodman's, Les Brown's and Ina Ray Hutton's, folded within a single month (Erenberg 1998, 213).

Fortunately for historians of American culture and women musicians, Ina Ray Hutton and her Melodears have been preserved for posterity in the radical and effervescent short subjects of the 1930s, an era marked by hardships, experimentation, and resilience—especially suited to performing women whose adaptive strategies enabled them simultaneously to mediate the more radical subcultural landscape of vaudeville theaters, cabarets, and burlesque houses as well as the growing film and radio industry.

Phil Spitalny's Musical Queens, equally adept at performing orchestral jazz, Dixieland, and symphonic works, remained unparalleled in their professionalism, versatility, and ensemble skills. Their performances from the early 1930s into the 1940s, however, somewhat reflected the gendered and racialized tensions played out in America's mass-culture performances, whether in the experimental short subjects, or later as musical specialties in feature-length films. The confluence of big-business media—including radio, film, and theater—limited the various modes available for representing musical women (not to mention those tensions surrounding working women who entered male-dominated spaces of picture houses, nightclubs, and ballrooms). Urban musical women's radical performances contributed to these tensions, and male producers acted both in concert and in opposition to profit from the continued fascination with gendered jazz.

The Melodears remained committed to a repertoire of dance-band music, hot jazz, and swing while their physical images gradually accommodated more traditional mass-mediated (Hollywood) notions of femininity. Spitalny's orchestra, once programming the latest jazz hits like "Bugle Call Rag" in the style of Paul Whiteman's orchestra or the Original Dixieland Jazz Band, next to modern arrangements of popular classical themes, gradually limited their jazz material and prioritized instead their classical or

sweet repertoire—especially during the *Hour of Charm* radio broadcast, where the visual assets of film could no longer be exploited to accentuate the delicacy and femininity of these young women via romantic lighting, elegant stage designs, and excessive, frilly gowns.

Nonetheless, even the Production Code failed to constrain the exuberant solos, dance routines, and relatively "novel" showcasing of female virtuosity immortalized on those short experiments in synchronized sound. For America's expanding mass audiences, images of female musicians—as they ascended from the vaudeville house, to the Broadway stage, to the picture palace and feature films—remained important for envisioning public domains for women and music during these two contrasting decades.

PART THREE

❇

SOUNDIES AND FEATURES
DURING THE 1940S

❇

CHAPTER FIVE

Swinging the Classics
Hazel Scott and Hollywood's Musical-Racial Matrix

✺

Her fans had known all along what was coming. Hazel Scott, star Negro entertainer
of Manhattan's Café Society Uptown, was doing what she does best, the thing that
has lifted her into showdom's top rank and made her this season's Manhattan
sensation: swinging the classics.
—*Time Magazine*, 5 October 1942

By age four, piano prodigy Hazel Scott exhibited a tendency to absorb
countervailing musical influences. Scott's early indoctrination into the
double worlds of conservatory classicism and black popular theater facili-
tated her codification of musical styles conceptualized during the 1930s and
1940s as heavily gendered and racially distinct. Her subsequent and widely
publicized appearances at New York's integrated Café Society provided
Scott with a performative model she would follow all her life.

During the 1940s, Scott's film appearances dramatically transcended
prior Hollywood depictions of black female musicality, especially in con-
trast to the more frequently cast images of blues singers, chorus girls, and
exoticized jungle dancers. In this respect, Scott was one of the first black fe-
male jazz musicians featured as a serious jazz instrumentalist in a major
Hollywood film. Further, Scott lobbied for respectable visual representa-
tions, elegant clothing, and luxurious spaces in which to exhibit her
worldly musical skills and cultivated intelligence. Indeed, her rigid insis-
tence upon similarly respectful characterizations of costarring African
American women caused Scott to be blacklisted[1] from Hollywood for
nearly fifteen years.[2]

This chapter explores the reception of Scott's early career; in particular,
her radical proclivity for "swinging the classics," a practice that for African
Americans entailed a potentially dangerous blurring of racial and gendered

musical boundaries. Comparing Scott's mass-mediated film and concert hall performances to her reception within the African American journalistic field (as well as the larger culture industry) illuminates how Scott's insistence upon respectable, individualistic self-representation, her prolific incorporation of popular, classical and jazz idioms, and her particularly physical performance style transgressed normative, performative behavior for African American female musicians. Scott's atypical musical explorations symbolically mirrored her unheralded physical mobility in the entertainment world. In many ways, the praise she received from fans and music critics was tempered by jazz purists and middle-class African American vernacularists, whose severe criticisms revealed the complex matrix of racial and gender dynamics informing popular culture during the traumatic and transformative interwar period.

Consider the context within which Scott evolved into an international musical star during the 1940s. Scott was born in Trinidad but raised in Harlem within a culturally diverse environment enriched by the expanding infrastructures of growing middle-class African American neighborhoods during the early decades of the twentieth century. African American mobility greatly influenced the expanding panoplies of ethnic, linguistic, and cultural groups negotiating the metropolitan centers of the United States during the late 1930s and early 1940s. The great restructuring of America's urban centers upon the massive migration of African Americans from rural and southern regions upward and outward, further initiated the transformation of African American musical forms, genres, and performance contexts. The unprecedented success of black musical theater revues from 1910 through the 1930s, including Sissle and Blake's *Shuffle Along* (1921) and Lew Leslie's *Blackbird Revues* (1926–39) provided transnational opportunities for black Atlantic composers, dancers, musicians, and actors (Gilroy 1993), including James Reese Europe and his society orchestra, and star female performers like Josephine Baker, Adelaide Hall, and Lena Horne.

These complex productions also facilitated creative spaces for producers and composers to extend beyond blues and jazz into forms that occasionally incorporated classical musical aesthetics and structures. The continued racism in the field of classical music performance, patronage and promotion, however, meant that many talented and passionate African American composers and musicians, sharing a desire to enter into high-art music spaces, either immigrated to Europe or in some cases tragically ended their own lives (Floyd 1990). Female performers faced with the debilitating dictates of the color line and the rigid criteria of "tall, tan, and terrific" often found Europe's multiethnic cities more amenable to African American performing women. Josephine Baker, Adelaide Hall, and eventually Lena

Horne and Hazel Scott would also spend much of their professional lives working in Europe (especially France and England) beginning in the 1920s and continuing through the 1960s (Horne and Schiekel 1965; Haney 1981; and Scott in Taylor 1982, 259).

Hazel Scott dedicated her life to cultivating an unorthodox approach to jazz improvisation. Her musical performances consistently incorporated disparate musical influences from Tin Pan Alley to swing, boogie-woogie, and classical music. Scott expanded these prodigious skills, riffing on the classics, as a performative political tool to gain entrance into sacrosanct architectural spaces like Carnegie Hall, Chicago's Orchestra Hall, and Constitution Hall (belonging to The Daughters of the American Revolution), spaces built from private endowments and government subsidies, and erected in an attempt to surpass Europe as the center of Western civilization and cultural dominance.

Scott began her professional musical career appearing in her mother's all-girl band. Alma Long Scott, a classical pianist from Trinidad, downplayed her classical skills, and directed and played saxophone in the band, which at times also featured pianist Lil Hardin-Armstrong. Hazel would eventually incorporate her mother's performance strategy by learning to alter and adapt a wide range of musical genres and performance styles to the various racialized and gendered spaces of American popular music. As a child, Scott received a scholarship to Juilliard, studying the "classics" until hired for radio engagements as a "hot classicist." Scott also performed specialty acts on Broadway, first in the "all-sepia" Cotton Club revue of 1938 *Sing Out the News*, and then on Broadway, the only African American performer in the *Vanities of 1942*, a musical revue intended to revive vaudeville.

Eventually Scott's illustrious nightclub, radio, and theatrical reputation inspired Hollywood director Gregory Ratoff to incorporate Scott into several feature films during the mid-1940s (B. Reed 1998, 116–117). Scott was so successful in her first Hollywood film, *Something to Shout About* (Columbia 1943), that she was asked to perform several "specialty acts" in other films (fig. 5.1) that frequently co-cast fellow Café Society performer Lena Horne. From 1943 until 1945, Scott appeared in both Columbia and MGM musical films including *I Dood It* (MGM, 1943) and *Broadway Rhythm* (MGM, 1944) with Lena Horne, and in all-white films including *The Heat's On* (Columbia, 1943) starring Mae West, and *Rhapsody in Blue* (Warner Bros., 1945), a George Gershwin biopic. In 1944, she was also featured in a *GI Movie Weekly* special entitled *Sing with the Stars*, which featured famous popular music performers and then enlisted viewers to sing along to popular patriotic songs, with the assistance of celebrated musicians and the ever-popular bouncing ball.

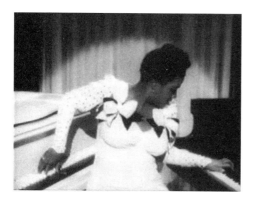

Figure 5.1. Hazel Scott's two pianos in *The Heat's On* (Columbia 1943).

During the same period, Scott declared that she intended to leave the nightclub scene to direct her talents toward concert appearances. According to *Ebony*, Scott became the first "Negro" pianist "to make the classics pay" ("Bye-Bye Boogie: Hazel Scott leaves nightclubs and moves to concert stage" 1945). Scott was so successful that she commanded nearly a thousand dollars a night for concert performances. Indeed, Scott performed several times at Carnegie Hall beginning in 1941 and continuing into the 1950s.

During the early 1940s, Scott's innovative performances at the newly opened second Café uptown in Manhattan accrued national status. Josephson opened the second Café Society hoping to draw Manhattan's upper-crust intellectual set (Stowe 1998, 1391) and felt that Scott's performances best represented the club's worldly and cultured character. I suspect that Scott's national prestige and her unique talent for jazzing the classics also inspired him to orchestrate the unusual "Bach to Boogie-Woogie" concert at Carnegie Hall in 1941, at the peak of Scott's Café Society tenure.

Swinging the Classics—The Hot Debates

Since the 1920s, dance bands and orchestras have been altering and syncopating popular and classical melodies, a practice that came to be known during the 1930s as "swinging the classics." Paul Whiteman, Raymond Scott, Maxine Sullivan, Benny Goodman, Glenn Miller, and a variety of swing musicians either performed jazzed versions of classical themes or endeavored to compose and arrange symphonic works inspired by African American jazz, blues, and gospel—musics sometimes characterized by European American symphonic jazz composers like Whiteman and Gershwin as African American vernacular or "Negro" folk musics.

During the late 1930s, swing bands and dance orchestras not only performed jazzed classics but also began releasing commercial recordings of

these modern arrangements. Although reaction to these recordings was mixed, "swinging the classics" was commercially viable until well into the 1950s. During the height of its popularity (1938–42), even so-called hot jazz musicians like Tommy Dorsey, Harry James, Benny Goodman, and Gene Krupa engaged in the practice and released compilation recordings with the theme "swinging the classics."[3]

The late 1930s saw heated debates on the issue of "swinging the classics." The *New York Times* ran several articles on the subject between 1938 and 1941 with jazz critics and dance-band musicians, including Leonard Feather and Paul Whiteman, issuing statements. Celebrated symphonic jazz tycoon Paul Whiteman was perhaps the most enthusiastic in his support for modern treatments of classical works. One particular *Times* article summarizes the protests submitted to the FCC by the president of the Bach Society of New Jersey and various listeners to CBS's radio program, who requested that jazzed classics be censored from network radio stations. Davidson Taylor, assistant to the program director at CBS, argued that Bach versions had been orchestrated and altered in countless ways since Bach's time. He correlated, historically, the diversity of symphonic orchestrations of art-music composers to argue for modern jazz versions of these timeless classics: "It is a question whether Bach would have been more annoyed with modern symphony conductors or modern dance band conductors. Bach himself consistently made arrangements of other composers."

The article then consults Whiteman, known for his various symphonic jazz treatments beginning in the 1920s (especially after his famous Aeolian Concert in 1924, which premiered one of the first "high art" receptions of a symphonic jazz piece, George Gershwin's *Rhapsody in Blue*). Within the increasingly mediated "swinging the classics" debates, Whiteman predictably supports the practice as long as rendered in an elevated and artful manner:

There's nothing inherently irreligious about swing or four/four rhythm. A bad classical orchestra can mutilate Bach just as well as a poor swing band. . . . Our experience has proved that giving the classics an artistic popular treatment has invariably increased the people's interest in classical music itself. If by playing Bach over a nationwide radio hook-up, we can bring Bach to thousands of people who would otherwise never have heard of him, I don't think we are doing anyone a bad turn. . . . Let's not forgot that Johann Sebastian was once dismissed from a job as a church organist because he improvised so much the hymn singers couldn't follow him. (Feather 1941)

Drawing connections between Bach and baroque improvisations became one way for orchestra leaders and composers like Whiteman and Gershwin to legitimize and represent their form of popular music as culturally significant, educational, yet reliant upon mass media such as radio and

film. This rhetoric further intimated the impulse to appropriate folk musics in order to support the process of nationalism and cultural codification during the height of American modernism. Beyond enthusiastic support for jazzed classics, Whiteman also became a leading spokesman for newly composed symphonic jazz during the 1930s and 1940s and continued to perform symphonic arrangements of jazz rhythms and harmonies as well as jazzed versions of classical works well into the 1950s.

Jazz critic and musician Leonard Feather also contributed to the debate in the early 1940s, suggesting that such mixed musical configurations generally inspire three different reactions:

Public reaction to this policy has fallen into three categories: There are those who condemn it unreservedly on the grounds of its bad taste, offensiveness and unsuitability; there are others who accept it as a good joke; and there are of course those who not only approve and encourage the idea but even believe the results to be beneficial to jazz.

He then articulates what he felt to be the various musical, cultural, and racial limits for true jazz artistry, suggesting that jazz music is not the appropriate forum for exploring new arrangements of classic works:

To the lover of authentic jazz, the result will probably be a hybrid. So the second policy in which the melody is partly ignored, is more likely to produce results satisfactory to the swing critic, though in this case there be so little left of the original work, that it would have been just as well to write an original jazz piece from start to finish.

Feather then decries the recent proliferation of commercial and, by implication, inauthentic performances, recordings, and radio broadcasts of dance-band versions of classical themes.

There can be no doubt of the commercial appeal of jazzed classics. Night-club audiences reserve their most frenzied applause for John Kirby's version of Debussy's "Claire de Lune". . . Hazel Scott's versions of De Falla's "Fire Dance". . . and Art Tatum's elaborations on "Humoresque." (Feather 1941)

For him, Scott epitomizes the humoristic approach toward jazzed classics. Feather resists outright condemnation of Scott's musical-racial transgressions; rather, he characterizes Hazel Scott's particular motivations for swinging the classics thusly:

Miss Scott relies mainly on musical humor, at which it is hardly fair to cavil . . . unless one also objects to a clown's burlesque of a legitimate actor or to a comedian's impersonation of the President. Art Tatum, on the other hand, is a great musician who should be satisfied to exercise his ability to play both classics and jazz authentically without resorting to bastard combinations. (Feather 1941)

Feather's characterization of jazzed classics as "bastard combinations" further intimated the racial and cultural associations persistently attached to

classical and popular genres. The suggestion of racial mixing further implicated African American women's intrusion into masculine realms and critiqued their presumed disregard of sexual and gendered musical categories. Finally, Feather (1941) attempts to legitimize his opinion by claiming that no great jazz artist ever resorted to so-called mixed-genre combinations of jazz and classical music: "It should be noted too that none of the greatest jazz has ever been produced from jazzed classics and that most of the really great swing stars have seldom, if ever, indulged in the practice. . . . Jazz does not need the classics anymore than the classics need jazz."

Café Society—The Cosmopolitan Matrix

Significantly, the expanded discourse about "swinging the classics" occurred at the height of Scott's Café Society popularity. Scott's mixed musical (and by association, racial) identity was frequently articulated in popular culture reviews of her Café Society performances. In these heavily mediated popular culture reviews, physical descriptors of Scott's live performances often preceded more serious musical assessments. In 1942, *Time* featured Scott in a two-page article entitled "Hot Classicist." *Time* began by fetishizing Scott's racialized and gendered body:

Two shapely brown shoulders and a round, roguish face, framed in a triangle of white light, showed above the grand piano's shining ebony. From the keyboard Chopin's Minuet Waltz flowed fleetly, ripplingly. For a while it surged along according to Chopin. Then watchers saw an impish flicker of a smile, an insinuating movement of a shoulder. Came the first suggestion of a hot lick; another, and another. Then Hazel Scott began to "break it down," and was off in a wild mélange of pianistics, sweet, hot, Beethoven and Count Basie. ("Hot Classicist" 1941)

However, this particular review also praised Scott's ability to effectively render the classics in a jazz style:

But where others murder the classics, Hazel Scott merely commits arson. Classicists who wince at the idea of jiving Tchaikovsky feel no pain whatever as they watch her do it. She seems coolly determined to play legitimately, and for a brief while, triumphs. But gradually it becomes apparent that evil forces are struggling within her for expression. Strange notes and rhythms creep in, the melody is tortured with hints of boogie-woogie, until finally, happily, Hazel Scott surrenders to her worse nature and beats the keyboard into a rack of bones. The reverse is also true: into Tea for Two may creep a few bars of Debussy's Clair de Lune. Says wide-eyed Hazel: "I just can't help it." ("Hot Classicist" 1941)

Scott's characterization as succumbing to evil forces once again betrayed the stigma that applied to racial musical mixing during the 1940s, likening such experimentations to uncontrollable and deviant sexual urges.

A number of other famous jazz artists developed their musical styles and public reputations by performing at Josephson's Café Society during the 1930s and 1940s, especially many female jazz musicians, including Lena Horne, Mary Lou Williams, and Billie Holiday. According to Stowe, Josephson cultivated an environment that stimulated artistic creativity and a progressive, cosmopolitan musical syncretism. Josephson spoke freely about his race politics as well as his love of modern combinations of jazz, swing, folk, and classical music. Indeed, Josephson was adamant about articulating the connections between racial politics and musical fusions and consequently encouraged his musicians to share his radical racial/musical aesthetics. Stowe claims, for example, that bandleader and pianist Teddy Wilson was once dubbed the "Marxist Mozart" and that Frankie Newton was well known in the musician's community for his outspoken left-politics (Stowe 1998, 1384).

Although owned and managed by Barney Josephson, much of Café Society's programming was left to the bourgeois-turned-rebel John Hammond, who shared a love of blues, swing, and piano jazz. Scott's musical popularity, for example, greatly expanded during her musical experimental period at Café Society where she freely mixed jazz, swing, boogie-woogie, stride, and classical music. Hammond, however, a romanticist, modernist, and jazz taxonomist, was said to have read newspapers while Scott performed at the famed Society—symbolizing how jazz purists dismissed Scott's complex musical persona as mere gimmickry. Conversely, Josephson expressed his love for Scott's particular brand of jazzed classics, which evoked both folklorism and cosmopolitism: "I love songs of the people, and I'm fond of good swing. . . . When Hazel Scott plays Bach's Prelude in C Sharp Minor! That's something! Or her Brahms Hungarian Dance No. 5" (quoted in Stowe 1998, 1384)

The sheer variety of acts programmed at Café Society—singers, dancers, and dance bands—suggested connections to the more feminized and multiethnic cabaret culture of the preceding two decades, although generally less commercial and excluding the popular all-girl choruses so central to the more racially segmented and exploitative black and tans of the 1920s. Stowe's description of a typical show at Café Society evokes industry descriptions of 1920s cabarets and contrasts with the bebop fanatic's reminiscences of smoky, masculine jazz clubs of the lean postwar years. His description is illuminating:

A typical show would also include dancers such as Pearl Primas and Beatrice and Evelyn Kraft, and a small vocal or instrumental ensemble, such as the Golden Gate Quartet, the boogie woogie pianists Albert Ammons, Pete Johnson and Meade Lux Lewis, or one of the combos led by Eddie South or Billie Moore. Many shows

included a featured solo pianist, sometimes Mary Lou Williams or Art Tatum, in addition to the versatile Scott. Finally, the show would feature a small "chamber jazz" dance orchestra (the club had a small floor for dancing) led variously by Teddy Wilson, Frankie Newton, Joe Marsala, or Eddie Haywood. The dominant theme could be described as syncretism—the blurring of cultural categories, genres and ethnic groups. (Stowe 1998, 1384)

From Bach to Boogie-Woogie

Upon the success of Hammond's "Spirituals to Swing" concerts at Carnegie Hall in 1938 and 1939, Josephson decided to stage a cabaret evening at Carnegie Hall featuring current Society artists, including their star attraction, Hazel Scott. The "Bach to Boogie-Woogie" Carnegie concert was organized to benefit the Musicians' Union (Local 802) medical fund. *Time* ran a short blurb about the event, noting the unusual notion of programming nightclub music in a concert hall:

Nightclubs do not usually hire other people's halls to give public concerts, but last week one of them—Manhattan's "Café Society"—did exactly that. It hired Carnegie Hall. And it was the first time that nightclub entertainers had tried their hands so publicly on Bach, Beethoven, Schubert. The concert's label, 'From Bach to Boogie-Woogie,' accurately covered the efforts of the Negro Societarians.
("Café Society Concert" 1941)

Another *New York Times* review praised the variety of talent and musical styles exhibited in a "simmering" Carnegie Hall:

It continued warm for April at Carnegie Hall last night. The musicians who hold forth customarily at the night clubs, Café Society downtown and uptown, took over the stage and they made it simmer. There was jazz sweet and hot; there was a bit of Schubert and Gounod and Paganini done straight; there was boogie woogie piano playing, there were singers, pianists, fiddlers and full orchestras; and finally there was a free for all, known to the trade as a jam session. (E. Taubman 1941)

The sold-out event included most of Café Society's featured musicians from the early 1940s including Lena Horne (billed as Helena Horne), the Golden Gate Quartet, Pete Johnson, Albert Ammons, and Kenneth Spencer. Other artists, including John Kirby, Art Tatum, and Eddie South, were also credited for artfully rendering swing versions of the classics. The *New York Times* signaled approval: "John Kirby and his orchestra took over for a siege of delightfully fused ensemble work. . . . Eddie South, violinist, who can play hot and straight, did his stuff alone and with his ensemble" (E. Taubman 1941).

The great success of the first "From Bach to Boogie-Woogie" Carnegie Hall concert in 1941 further reinforced Scott's title as the supreme "hot classicist." Several critics for the *New York Times* and the *Chicago Defender*

even characterized Scott as the reigning star of these Carnegie Hall productions. Her glowing reviews resembled the praise heaped on Benny Goodman after the celebrated 1938 and 1939 "Spirituals to Swing" Carnegie Hall concerts. For example, *New York Times* critic Edward Taubman depicts Scott's unusual talents as the highpoint of the evening:

The shining star of the evening was a dusky belle named Hazel Scott, who can play the piano straight and swing, who can sing and who can decorate any stage you like. Miss Scott took Liszt's Second Hungarian Rhapsody, a Bach Two-part invention, Falla's Ritual Fire Dance and Chopin's Minuet Waltz, played introductory sections with a forthrightness of a sound musician. Then she let them swing. With O'Neil Spencer at the drums, she gave performances that had immense gusto and wit. It's a good guess that the composers would not have minded. (E. Taubman 1941)

Still other reviews reassured readers of Scott's appropriateness in such an esteemed cultural space as Carnegie Hall, underlying the racial and class associations that continued to characterize American concert halls during the Hammond concerts. The *New York Times* emphasized Scott's class and cultivation: "The other night Hazel Scott moved from Café Society to Carnegie Hall and was perfectly at home, thank you. . . . Miss Scott plays gutsy yet cultivated swing, with considerable variety of effect" ("Other Reviews" 1941).

In the *Chicago Defender*, Scott is once again characterized as the star of the event:

Hazel Scott was the outstanding contributor of the evening. With O'Neil Spencer at the drums, she took hold of the stage and with her nimble fingers racing across the black and white keyboard of the concert grand she took Liszt's Hungarian Rhapsody . . .playing them straight and swing. Her expert showmanship and bubbling personality soon had her audience in the palm of her hand, and it refused to let her go. Unlike the usual Carnegie Hall audience, it called out, actually yelled for more. ("Harlem Stars At Carnegie" 1941)

In the same *Chicago Defender* review, other contributions to jazzed classics were also favorably mentioned including Art Tatum's "Humoresque," John Kirby's "Claire de Lune" (Debussy), and fiddler Eddie South's riffs on Paganini works ("Harlem Stars At Carnegie" 1941). Another ad presented a full-page photo of Hazel Scott and Lena Horne as the "chirping song stylists" who "triumphed before throngs in Broadway's famed Carnegie Hall" ("Display Ad" 1941).

While the *Times* simply celebrated the versatility and skill of the musicians, the African American newspaper, the *Chicago Defender*, sought to indoctrinate jazz and swing into a national consciousness by laying claim to its status as true American art. One review proclaimed the importance of swing and boogie-woogie in the pantheon of great American folk music and

indirectly referenced a body of discourse put forth by Harlem Renaissance black literati, writers, and politic thinkers like Zora Neale Hurston, Langston Hughes and W. E. B. DuBois, who sought to legitimize and incorporate African American cultural contributions into the national and historical canon of American art: "To many students of American music this is news and to those who have penetrated beyond the scarcely dignified connotations of the name and background of music, the history of boogie woogie music is a colorful one, worthy of a place in any complete analysis of American folk music" ("Bands Show Boogie Woogie to Broadway" 1941). This particular review belies the powerful specter of race "in the house of music" (Radano and Bohlman 2000, 1) and of the debilitating effects of racial-musical segmentation during the 1940s.

What distinguished these two Carnegie Hall jazz concerts from the now canonized and historicized John Hammond "Spirituals to Swing" concerts of 1938 and 1939, was the incorporation of innovative, and experimental female jazz improvisers whose urban cosmopolitism contrasted the more publicly circulated and established female genres of gospel and blues as performed by Helen Humes and Sister Rosetta Tharpe in the 1930s. In this respect, Josephson's programming of leading Café dancers, the Kraft Sisters, as well as its reigning female musical soloists, Lena Horne and Hazel Scott, indicated a more progressive approach toward modern jazz, canonization, and gendered performativity.

The second Café Society/Carnegie Hall concert took place in 1943 and featured many of the same Society musicians with the addition of Teddy Wilson and his band. Scott was once again praised for her class and musical ingenuity: "Hazel Scott, who is in a class by herself, gave her share her usual fillip."

New York Times critic Howard Taubman reported the mixed clientele of this particular concert, underscoring the sometimes tense interaction among class and racial groups in these prestigious spaces: "The capacity audience seemed to relish everything, though it was not made up entirely of the swing coterie. One bewildered lady, who probably bought her ticket expecting the usual Carnegie program observed, 'There's a lot of jazz.'" To which Taubman responds, "Lady, it wasn't Bach!" (H. Taubman 1943).

Hazel Scott was invited again to perform in Carnegie Hall in 1945, this time in a solo recital. Scott neglected, however, her jazzed classics for a concert split into two distinct parts: the first half dedicated to the classical works (played straight) and the second to improvised versions of jazz and popular music. For the first half, she chose to play works by Scarlatti, Bach, Chopin, De Falla, Ravel, and Rachmaninoff, fulfilling her desire to perform the classics straight. Critics tended either to praise her versatility or downplay her classical technique in contrast to her unique skills at "putting

over" African American folk music. One *New York Times* review, although generally favorable, concentrates on critiquing her musical skills and musicianship: "If Miss Scott's playing of the 'classics' appeared a little theatrical, a little mechanical and a little hard, it also had its brilliance and its elegance. Rhythm is one of the player's strong points, a rhythm that is altogether American and gets its character largely from an insouciance that is at the core of Miss Scott's style" ("Hazel Scott, pianist, in varied program" 1945). Here the pervasive tropes of black musicality equated with rhythm, intuition, and natural emotivity (Radano and Bohlman 2000; Agawu 1995) drive this reviewer's reception of Scott's performance.

Hollywood's Racial-Musical Matrix

Although Scott's musical accomplishments remain peripheral in canonical jazz histories (and, to some extent, feminist jazz surveys), Scott's performances speak to the complicated cultural, political, and musical landscape of the 1930s and 1940s. Significantly, Scott became the first African American female instrumentalist to participate in (predominantly white) Hollywood cinema. Like Horne, Scott was one of the first black female entertainers to portray characters that were both cultured and educated, the polar opposite of previous stereotypical black roles. In the black press, Scott was praised for turning down degrading roles of strumpets or maids, the parts more usually offered to attractive black women. Because of her complex cultural musical persona, Scott most frequently portrayed herself in her many Hollywood appearances. A discussion of Scott's musical contributions as well as her representation in these films is therefore enlightening, especially in contrast to her reception in jazz and concert-hall circles.

Rhapsody in Blue

In the Warner Bros. biographical film of George Gershwin, *Rhapsody in Blue* (1945) Gershwin's character first acquires an understanding of black music via performances of blackface vaudevillian Al Jolson. Throughout the film, Gershwin's deepest musical inspiration is gained from everyday black people and, more specifically, from black musical sources. The usual tropes of white ingenuity and artistry given voice through the refinement and cultivation of an emotive, primitive, and unpolished blackness dominate the film. Here, Gershwin articulates his deep desire to compose a people's opera, claiming that he wanted to make the classical music public "blues-conscious," an example of what post-structuralists term "disavowed exclusions."

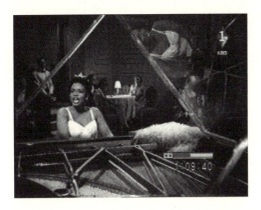

Figure 5.2. Scott plays
Gershwin in *Rhapsody in Blue*
(Warner Brothers 1945).

Hazel Scott's scene (fig. 5.2) takes place in a swanky Parisian nightclub attended by Gershwin and his acquaintances (Gershwin briefly lived in France to study composition). As Gershwin walks into the club, the camera pans in on an elegantly attired Scott seated at the piano and performing a free-flowing version of Gershwin's "The Man I Love," which Scott sings in French and then in English. Scott then improvises a Gershwin medley incorporating bits of "I Got Rhythm" and "Fascinating Rhythm." She embellishes these tunes with bits of boogie-woogie, stride, and swing and then incorporates a classical approach, with a cadenza-like impressionistic section. *Time* noted Scott's contribution to the film:

> The shimmering ragtime of many a half-forgotten early hit, beaten out by an invisible Oscar Levant; the brazen love call of the Winter Garden smash Swanee, groaned in all its original agony by blackfaced Al Jolson . . . and The Man I Love given an added pinch of pepper by Hazel Scott's post-graduate left hand are only a few of the courses served up in this lavish Gershwin feast. ("The New Pictures" 1945)

From a dramatic perspective, Scott's performance in this film appears rather mundane. Her dazzling musical performance is overshadowed by the diagetic functioning of her performance as incidental nightclub music for Paris's haute culture and educated expatriates. This particular "functional" role was one way that studio producers resolved the problem of racial mixing in Hollywood films during the 1940s. Both Scott and Horne managed to perform riveting explorations of modernistic mixed-genre music; yet their appearances were consistently trivialized in order to facilitate benign and staged contexts of African Americans entertaining whites. Nonetheless, their musical performance styles and choice of repertoire enabled considerable differences in their reception by jazz critics, African American journalists, and influential industry "negrophiles."

Horne and Scott both appeared in the MGM musicals *I Dood It* and *Broadway Rhythm* as "specialty acts." In some respects both demanded new

contexts and characterizations of African American women. In general, Horne's eroticized visual representation functioned differently and enabled a larger crossover appeal—in contrast to Scott, whose specialized jazz musician characterization often proved problematic for Hollywood film critics.

Broadway Rhythm

In her earlier Hollywood film, *Broadway Rhythm* (fig. 5.3), Scott performs only one musical number and her scene bears no relation to the general plot of the film. During the film, the camera pauses upon a supper-club marquee—"Hazel Scott Playing Nightly"—and provides the segue into Scott's impromptu nightclub performance. Scott performs a swinging improvised version of Chopin's Waltz no. 6 in D-flat Major (Op. 64, no. 1) for this particular scene. She is seated at the piano, illuminated on a darkened stage, wearing a stunning yellow-and-white satin full-length gown, embroidered with white and yellow feathers. We first see Scott on stage alone, until gradually the other musicians are highlighted in elaborate silhouettes and spotlights. However, no audience members, film characters, or nightclub personnel are shown; thus Scott appears to perform exclusively for the camera.

She begins with eight measures of introductory material performed in an expressionistic but nonsyncopated form. Then the bass player and drummer begin playing, silhouetted behind Scott and her grand piano. Finally the other musicians are fully illuminated as the various sections of the entire big band consume the spotlight. Scott's improvisation is temporarily halted while she extends an octave thrill from Chopin's original score, as the band's arrangement becomes more elaborate and polyrhythmic. Scott reintroduces the first theme in a fast stride-style improvisation before the climactic half-time triple-swing ending.

The *New York Times* generally panned *Broadway Rhythm*, but the musical performances of Scott, Horne, and others were praised (Crowther

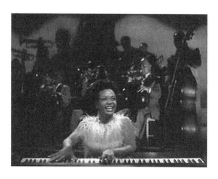

Figure 5.3. Hazel Scott and band in *Broadway Rhythm* (MGM 1944).

1944). In the film, Lena Horne, sings "Somebody Loves Me" in a musical theater number as the featured singer of an all-Black scene auditioning for the Broadway producer "Sam." The film's only black actor, Eddie "Rochester" Anderson ("Little Joe" from *Cabin in the Sky*) fulfills the role of the head producer's butler, cook, and messenger as well as the manager of Lena Horne, although his character is presented as an opportunistic hustler and jokester and generally treated with disdain.

GI Movie Weekly: Sing with the Stars

In addition to her feature-film specialty scenes, Scott performed in musical shorts and government-sponsored morale films, offering music and entertainment for African American soldiers during World War II. Considering Scott's musical and visual popularity as well as her status as a pinup, her feature on the *GI Movie Weekly: Sing with the Stars* (figs. 5.4 and 5.5) was not at all surprising. As in her specialty film numbers, Scott incorporates her swinging the classics technique into this morale-boosting film. She begins the film performing a jazzed classic, Liszt's Hungarian Rhapsody no. 2 in C-sharp Minor, which she had recorded previously on the Decca label for an album entitled *Swinging the Classics* in 1941. Scott begins with a slow

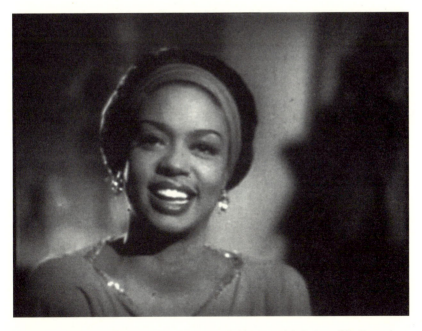

Figure 5.4. Close-up of Hazel Scott in *GI Movie Weekly: Sing With the Stars* (War Department Official Film 1944).

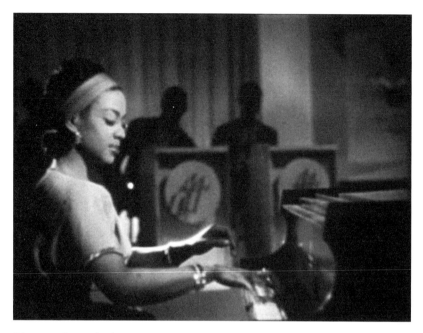

Figure 5.5. Scott solos in *GI Movie Weekly: Sing With the Stars* (War Department Official Film 1944).

introduction of the theme, and then plays the second theme with her right hand in a nonsyncopated manner. Soon after, she alters her left-hand technique, transitioning into a heavy-handed stride piano style. Scott's soloing is highlighted while also supported by a six-piece band, backgrounded in modernistic silhouette. After her dizzying and prodigious performance, Scott proclaims her support for the "fellas" with tender words of encouragement in an unassuming and highly feminine voice. She begins rather coyly making references to swinging the classics:

Hello fellas—That was Mr. Liszt I just put behind the 8-beat. I'm awfully glad we can get together like this because I have another song I want you to hear. It's an awfully good song. You men are writing new music to it. And the lyrics are in the headlines. The bazookas sing it. It's part of every longtime sonata you guys in field artillery are riding [writing?] all over Europe. It's your song, so listen to it, will ya?

Scott then leads a rousing version of "There's Going to Be a Great Day" in a forceful marchlike tempo with the quintet rolling rigorously behind her. She delivers the first verse in a rather staid, rhythmic manner. The band plays faster Dixieland in the background. Scott then takes a chorus over the melody but increases the tempo to excruciating speed, executing an aggressive

jazz piano solo and then transitioning back to the final A section, this time exuberantly singing the chorus. The song briefly pauses while Scott invites the audience to sing along. The bouncing ball appears as the enthusiastic and imperfect vocals of eager military men are heard singing along. Scott then begins with a four-bar intro of a boogie-woogie, before the rest of the band reenters with a powerful riff accompaniment. The song continues with a variety of jazz and popular music rhythmic transformations including blues, boogie-woogie, swing, and march. Lyrically the song betrays its militarist intent: "When you're down and out". . ."Every Jap we get . . . There's gonna be a great day." . . ."There'll be pride and joy when we hit Tokyo." Scott closes by warmly encouraging the men: "Keep singing it, fellas. You're the ones who are making it come true." She follows with a twelve-bar boogie-woogie, augmented during a second chorus with the full big band playing along for a sixteen-bar blues chorus before the closing shout chorus.

I Dood It

In 1943, Scott performed two impressive musical numbers in MGM's *I Dood It* (figs. 5.6 and 5.7), which also featured Lena Horne in one extravagant musical production entitled "Jericho," a number incorporating a dizzying number of musical genres from opera to swing, boogie-woogie and also orchestrating a full chorus, big band, and elaborate rhythm section with musicians from Count Basie's band. Scott enters the stage with her entourage of musicians and porters smartly attired in stunning bright tuxedos and top hats. The band casually warms up, while the producers ask if Miss Scott finds the piano to her liking, to which she responds with an arpeggio, saying, "I guess it will do." She then begins with an impromptu romantic theme before transitioning into some fast-paced boogie-woogie. The instrumental piece precedes Miss Horne's extravagant entrance in

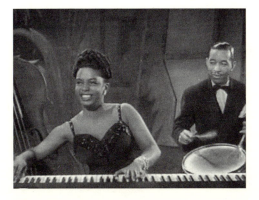

Figure 5.6. Scott solos with drummer in *I Dood It* (MGM 1943).

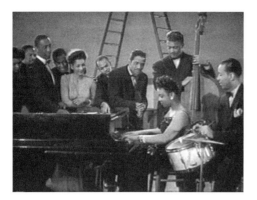

Figure 5.7. Scott plays stride with band in *I Dood It* (MGM 1943).

which she apologizes for being late, claiming "it was impossible to get a cab"—her only line in any of her 1940s MGM movie musicals. Scott continues to perform for Horne's featured act but is secondary to Horne's status in this number. *Time* noted both Scott's and Horne's contributions:

Hazel Scott blends swing and quasi-classical music to the disadvantage of both and the delight of millions. Comely Lena Horne proficiently marshals Count Basie's Band and numerous choristers through a particularly unpleasant stretch of sub-operatic Africorn about the walls of Jericho. ("The New Pictures" 1943)

Scott's and Horne's mixing of musical genres is pointedly criticized by this reviewer, who reserves his strongest disdain for Scott and her "quasi-classical" musical technique, while Horne is praised for her good looks and proficiency with jazz—however tainted by such European genres as opera and choral music.

Comparing Lena Horne's reception to that of Hazel Scott suggests that Scott failed to garner the same crossover appeal achieved by Horne during the 1940s. Scott's unorthodox physical performance style and her complex musical repertory proved problematic for music, film, and cultural critics. Perhaps equally damaging was the resistance by many jazz critics to situate female jazz instrumentalists in the same sphere as female vocalists. For jazz purists, Scott's hybrid music appeared inauthentic and overcommercialized. Moreover, Scott was frequently attacked for what were characterized as crude and aggressive stage antics. American journalist and film critic, James Agee, depicts Scott's image in one particularly scathing review: "The quintessence of this special kind of vicious pseudo-folk, in my opinion is Hazel Scott." He claims that she plays "with a slobbering, anarchic, vindictive, rushing affection which any mediocre elementary piano teacher would slap her silly for."

The severity and hostility of this diatribe is laid out in his final commentary claiming that Scott is an entertainer who "relies chiefly on being

'niggerly'" and cites her "grimaces of creative mock-orgasm and her exploitation of her bust and armpits" (Agee 1958, 432). Arguably, Scott's musical/physical mannerisms would have been read differently if executed by a man. Comparing other stride pianists like Pete Johnson and Albert Ammons, who performed with a high level of physicality and animated expression, Scott's performance mannerisms appear less exceptional. The sheer energy required to perform this highly percussive style of piano playing naturally precipitates such intense physical expression, not to mention the over-the-top entertainment conventions of musical performance descended from physical forms like vaudeville and musical theater.

Throughout Agee's criticism, he appears most disturbed by Scott's "racially marked, physically and sexually expressive performance style," which further horrifies him because she attempts, he says, "to dress it up with her classical pose" (Agee 1958, 432). Most revealing is Agee's utter contempt for black female performers' crossing over into more established "European" as well as masculine musical domains. Agee bluntly states that he dislikes how Scott "presumes to 'dignify' the folk by 'classicizing' it" (1958, 435).

In contrast, when reviewing black male jazz performers, Agee expresses pity rather than contempt for artists like Louis Armstrong, who he claims also participate in Scott's brand of "corruptive self-deceit" (1958, 432). These types of criticism betrayed white liberals' penchant for privileging black artists who excelled in what they perceived to be "authentic," "Negro" cultural forms. In these reviews, Agee criticizes African Americans feigning intellectualism or presuming familiarity with "high"-art forms.

While Horne was lauded for her ability to interpret blues, swing and jazz, Scott was criticized for venturing into high-art musical domains. Her manipulation, troping and "signifying" upon notions of high and low offended and shocked jazz purists, folk advocates, and classical music fans alike. Horne devotees, including James Agee and John Hammond, valued Horne's restrained musical persona while denigrating Scott's outwardly aggressive physical gesturing. In the case of Horne, Hollywood cultural scholar Sherrie Roberts likens this to a kind of "muting of one's race" (Roberts 1993, 179). Horne's star text more clearly drew upon an imagined and romanticized "natural" blackness and therefore proved less disruptive for jazz critics and Hollywood producers, as purveyors of these heavily mediated, segregated musical spaces.

Years later, Horne recalled her first experience auditioning for MGM's moguls, claiming the producers Arthur Freed and Louis B. Mayer suggested that she alter her look because she was told that she did not appear the way a "negro" entertainer should. She was advised to either appear more exotic (as in South American or "oriental") or rather exaggerate her

blackness with dark makeup (Monti 2000, 117–120). Eventually Horne chose to simply perform as herself, but her complicated racial reception within Hollywood meant that like Scott, Horne's musical contributions would remain distinct and separate from the larger narrative of these films.

More often than not, Scott's musical persona repelled cultural critics and jazz journalists. Her ability to speak several languages and her mastery of the romantic and classical concert repertory complicated facile notions of black musicality. Champions of African American vernacular art were similarly vexed by Scott's complicated gendered and racialized star text. Scott's ease with established white cultural genres incited black critics to reprimand her for failing to show solidarity with the more traditional (and by implication, authentic) black cultural forms. Within the black musical theater world, Scott was sometimes criticized and resented for trying to gain access to white cultural social circles.

The classicization of jazz music began during the late 1930s with a proliferation of jazz music journals, jazz journalists, hot clubs, and an increased demarcation of the formal properties of jazz, including a representation of genres, harmonies, rhythms, and improvisation styles. This discursive expansion accompanied the first teleological jazz-music presentations in Carnegie Hall during the late 1930s and which continued throughout the 1940s and 1950s. Concert-hall jazz series organized throughout the United States included Norman Granz's *Jazz at the Philharmonic* and more recently, Winton's Marsalis's *Jazz at Lincoln Center*. The proliferation of canonizing and preservationist jazz concerts and festivals constituted part of the struggle to codify genres, to solidify notions of folk, art, and popular music, and to define normative behaviors for performing race and gender in the international arena of jazz performance.

Hazel Scott's unique approach to "swinging the classics" elevated her status and instigated one of the most debated musical practices of the 1930s and 1940s. The reception of her heavily mediated performances, however, betrayed the convoluted cultural landscape of racial segregation, gendered prohibitions, and the pervasive American fascination with black sexuality and expressive culture. Americans' desire to construct essences of black sexuality through music were often accommodated through the commodification of jazz culture and its parallel mapping of public spaces—or, in the words of Hazel Carby, through the policing of black women's bodies in urban contexts (Carby 1992).

During the highly transformative post-Depression era, African American performing women literally staged a public struggle for respectable

musical voices *and* bodies. Hazel Scott's heavily mediated performances intimated a desire to draw from spheres traditionally cast as high, male, and European. Like Chuck Berry's equally coded 1950s anthem, "Move Over Beethoven," a performance imbued with pleasure, verve, and signification, Scott's ability to put "Liszt behind the 8-beat" so to speak, coyly announced black women's presence in the foreground of public culture, a presence reflecting and simultaneously transforming the racial/gender/cultural matrix of American jazz. Scott's obsessive drive to riff on classical and vernacular musical genres was a plea for self-representation and personal creativity at a time when African American performing women were often exploited and seldom afforded such justifiable pleasures.

Pinups, Patriotism, and Feminized Genres

❂

We were mortified, so we went down to the theater where she was playing as a stripper. But when we saw her, she was so gracious and never took really anything off. She could handle herself so beautifully—and, boy, was she beautiful! And such a good leader . . . , [of] course she played the cello a little bit. She used to laugh at that. That's how she got in all the bands? She was a cello player. . . . She was just lovely.
—Trumpet player Jane Sager on Ada Leonard, 2002

I now broaden the cultural scope of previous explorations of wartime swing by enlisting a comparative discussion of female performances of jazz and popular music via the new audio/visual mediums of SOUNDIES (in contrast to the ever-popular Hollywood musical films, which, during the war, became important mechanisms for disseminating the newest and most commercially desirable gendered and performative images). By examining the performance of all-girl popular musical genres from "swing" to "sweet" in these mass-mediated contexts, I also highlight the various and frequently intersecting constructions of mass-mediated wartime sexuality promoted by Hollywood and the war industry. Critical examinations of the rhetoric surrounding all-girl musical performances during the 1940s disclose an emerging system of gender, sexual, and racial stereotypes. These stereotypes vastly differed from other newly activated wartime female personas; for example, the asexual "Rosie the Riveter."

During the war, the continuing feminization of jazz through the gendering of genres such as "sweet," "swing," and "hot," all-girl bands on film, and recordings produced by swing orchestras doubling as female choirs and showcasing classical soloists all contributed to an extended feminized characterization of wartime popular music. These highly visual *and* aural mediated performances popularized instrumental music presented by "light" orchestral groups and also continued to promote 1930s-era big

bands, providing dance music for the growing legions of swing. The continued categorization of musical genres in the service of the war industry in racialized and gendered terms ultimately led to a postwar backlash that attempted to weed out women's participation in jazz. Exclusionary actions in the jazz press and within the jazz community further inculcated a modernist aesthetic that enabled, for the first time, the convincing conception of jazz as high art.[1]

As 1940s all-girl band scholar Sherrie Tucker points out, during the war, popular, mass-produced representations of Hollywood pinups reinforced the war industry's promotion of all-girl bands as desirable and nonthreatening feminine objects whose participation in swing organizations came to symbolize the democratic and pluralistic ideals of the war effort (Tucker 2000b). Throughout the 1940s, many of the most commercially successful white female bands maintained their prominent positions partly because of their highly gendered and sexualized performances. As such, female bands performed for military audiences, toured nationally, and garnered profitable theater and ballroom contracts because of their prodigious musical skills — but also because their overdetermined sexualized or feminized images often prevented them from directly competing with male bands. The most seasoned female instrumentalists often fulfilled their roles as expert performers of swing and sweet music in these heavily mediated groups, having developed their skills touring with all-girl bands beginning during the 1930s. Yet sensationalized publicity campaigns prioritizing glamorous and sexy female bandleaders, along with highly gendered performance styles and feminized musical genres, often overshadowed and upstaged the many "nameless" accompanying professional women instrumentalists and soloists that constituted the foundation of "all-girl bands" during the 1940s.

Further, the expanding visual mediums of short subject films and the new medium of SOUNDIES continued to portray female musicians by drawing upon heavily feminized visual and aural tropes. In order to understand how female musicians responded to the dominance and ubiquity of Hollywood feminized images, I first examine the ways that the image of the pinup, one of the most widely circulated female representations, was constructed, disseminated, and received by Americans during World War II.

In her study of Hollywood female stars of World War II, Shari Roberts illuminates the relationship among Hollywood pinups, industrial technologies, and wartime sexual representations. Her analysis postulates an increasing visibility of technical and "scientific" codifications of femininity and sexuality during World War II. According to Roberts, sexual images of Hollywood stars like Betty Grable and Lena Horne were co-opted and

mass-produced in the form of "pinup" photos to bolster morale and to enforce and stabilize acceptable heterosexual desires in potentially abnormal homosocial environments. Moreover, the conflation of technology with feminine sexuality betrayed "a cultural desire to suppress female independence and sexuality with technology" (Roberts 1993, 29). Curiously, the valuation of Grable's body as the American ideal helped create the illusion of "controlling the threat posed by the awesome new technologies of the Second World War through the pinup's hybridization of the public glamour photo and the private snapshot" (Roberts 1993, 29)

Similarly, Robert Westbrook (1990) contends that pinups were supported by the state during the war to construct and exploit private obligations of Americans in an "attempt to convince its citizens to fight for its defense" (591). Accordingly, the overwhelming popular support of the war was not achieved through an insistence on a political obligation to the state; nor was it achieved through ideological and universal appeals. Rather, American citizens were persuaded to defend their country because of appeals to uphold their private obligations to families, parents, fighting buddies, children—and most of all, to protect wives, mothers, and girlfriends against the encroaching and demoralizing enemy. In short, American citizens were asked to fight to preserve a "unique and richly (commodified) American way of life" (Westbrook 1990, 591).

The state, Hollywood, and the war propaganda machine mutually constructed cultural models of women as objects of obligation and did so by disseminating attractive pinups that reinforced the notion of "women as prescribed icons of male obligation" (Westbrook 1990, 589). The most popular pinup, Betty Grable, surpassed all others precisely because of her perceived ordinary and typically American feminine charm. Grable's photos best represented the average middle-class woman, and readily symbolized the ideal American wife and sweetheart, reminding men of what they were fighting for.

According to *Life* magazine, Grable's popularity increased rather than decreased after marrying popular trumpeter and bandleader Harry James in 1943. Evidently the war industry's endorsement of two popular cultural products—swing and pinups—also provided the context for the most popular of all: marriage. Popular support seems less surprising in light of the state's efforts to convince citizens of their private obligations through the mass dissemination of pinups. This support was in part achieved by representing all-girl bands as American sweethearts and "objects of obligation" as well as bearers of swing—a music thought to embody the American values of freedom and democracy.

Lena Horne and the Erotics of Miscegenation

In addition to Grable's "all-American" Anglo-Saxon feminine image, Hollywood infrequently promoted nondominant and more "exotic" types of feminine sexuality that implicated America's convoluted conception of race and ethnicity. In particular, Lena Horne emerged as a prominent wartime sex symbol through a variety of mediated texts including the fetishized representations of her mass-produced pinup poses as well as her many "exotic" and brief musical film appearances. Roberts's (1993) analysis of Lena Horne conveys the cultural and racial significance of Horne's wartime persona, whose reception betrayed larger wartime anxieties about race and femininity. Horne's unprecedented mainstream popularity arose via a complex matrix of white beauty ideals, civic and racial protests, and through a racial fascination of what Roberts coins the "erotics of miscegenation" (96). By deconstructing Horne's cultural significance for both the dominant culture and for African Americans, she reveals how Horne maintained both white standards of glamour and beauty, while actively fulfilling her civic and "racial" duties by protesting the continued Jim Crow policies of the military. Further, Horne's unprecedented miscegenistic appeal was achieved by cultural processes that rendered "her racial difference invisible, by metaphorically disembodying her, then re-embodying her on a deracialized frame: as merely feminine, as child-like, as a fetish comprised of food; as the black stereotyped body; and finally, as music" (Roberts 1993, 96). Indeed, Horne's racial invisibility was believed to be a chemically achievable goal for many black women during the 1930s and 1940s. Horne's appearance in many "skin-lightening" ads during the 1930s attested to the value placed on white beauty standards as well as the potent aesthetic of the color line in the black community, which often ascribed "prettiness" to lighter-skinned African American women.

Horne's subsequent civic protests during the war validated and legitimated her popularity among black audiences and white liberals alike. During one of Horne's USO tours, for example, she was praised by the black press for halting her performance to protest segregationist policies, which frequently offered entertainment for white soldiers *and* German prisoners of war, while barring black soldiers. In 1945, the *Chicago Defender* praised Horne for her bold actions: "Clashing head-on with the Army's super–Jim Crow policy, the sepia screen star halted her USO-sponsored tour of Southern camps in protest against anti-Negro bias" ("Lena Horne Quits USO Tour in Row Over Army Jim Crow" 1945). Clearly, Horne's political activism complicated her prior beauty testimonials favoring lighter, brighter skin.

Roberts further examines Horne's symbolic role as female sexual substitute by defining her dual racial significance for black and white soldiers:

> Horne's presentation as the pin-up girl for black soldiers demonstrates the deployment of Horne as the figure who would prevent the phantasmic rape by black men of white women (stars). As a cross-over pin-up figure, however, her image was simultaneously raped in fantasy by white men. Her star text thereby arrested interracial erotics in the black population of men and facilitated interracial erotics in the white population of men. (Roberts 1993, 105)

Ample testimonials provided by white soldiers confirmed Horne's sex appeal during World War II. White movie actor Richard Basehart, for example, confessed to Horne that he carried her photo all through the Battle of the Bulge. Horne herself later lamented that mainstream white culture provided several white pinups, while black soldiers had only one (Roberts 1993, 104).

During the war, Horne often performed for patriotic radio broadcasts. In addition to her performances of jazz and popular music, her participation in a 1944 *Jubilee* radio broadcast connected the sexual associations of jazz with the erotic appeal of pinups, as suggested by her erotically charged introduction: "We have a sweet and heat to distribute to you so edge in closer, closer, just a little closer, that's enough. . . . And now I see the baton pointing in my direction, which means a 'pinup' song." Horne's ability to suggest the titillating, dangerous, and slightly taboo aural implications of jazz while foregrounding her visual desirability as a female object is striking, considering the obvious obstacle presented by radio.[2] Significantly, the International Sweethearts of Rhythm shared bill with Lena Horne on the *Jubilee*'s Broadcast 84. Their musical collaboration further promoted the combined tenets of sexually attractive objects and of the pluralistic and democratic appeal of swing (as performed by the collaborative yet improvising International Sweethearts of Rhythm).

Horne's musical career was often depicted as both progressive and assimilationist, as Horne became one of the first black singers to perform with an all-white band. After starring with Charlie Barnet's band, she was applauded by the black press for her progress in interracial relations. Horne's visual appeal, however, remained dependent upon segregationalist cultural dictates: she continued to appear either in black cast films like *Stormy Weather* (1943) and *Boogie Woogie Dream* (1942) or in nonspeaking parts as a "specialty" artist in dominant Hollywood musical films of the 1940s and 1950s, including her numbers in *Panama Hattie* (MGM, 1942), *I Dood It* (MGM, 1943), *Swing Fever* (MGM, 1943), *Broadway Rhythm* (MGM, 1944), and *The Ziegfeld Follies* (MGM, 1946). In her many musical specialty numbers for MGM, Horne's contributions remained auxiliary,

yet her diverse musical talents, sex appeal, and various "exotic" cultural representations greatly enhanced these film's eroticism, mass appeal, and popularity during the war.

Hazel Scott

Like Lena Horne, Hazel Scott's performative image embodied a feminized "double V" ideology. Her musical performances, attractive physique, and active political life facilitated her representation as a leading wartime sex symbol (for African Americans) and as a progressive African American citizen. Scott's activities and musical appearances were frequently featured in black editorials, musical reviews, and in civic progress reports, such as the NAACP's weekly newsletters. Like Horne, Scott's attractive appearance, cultured disposition, and musical persona similarly facilitated her crossover into dominant musical and cultural spheres, earning her roles in several Hollywood feature films during the early 1940s (but as a specialty artist whose musical numbers were scripted out for southern audiences). Although Scott contributed less frequently to Hollywood films, her roles in *Something to Shout About* (Columbia, 1943), *The Heat's On* (Columbia, 1943), *I Dood It* (MGM, 1943), *Broadway Rhythm* (MGM, 1944), and *Rhapsody in Blue* (Warner Bros., 1945) similarly expanded the variety of respectable representations available for African American musical women during the war era.

Next to Lena Horne, Scott's picture was one of the most requested pinup photos by African American soldiers during World War II. However, Scott's instrumentalism, her physicality, and her diverse musical skills inspired a radically different reception by the dominant press, by white jazz critics, and within the black literary community. Hazel Scott was generally applauded in black journals as much for her artistic merit as for her civic and social contributions. Her marriage to Congressman Adam Clayton Powell in 1945 was heralded as an illustrious union in which both white and black civic leaders congregated to wish the couple well (Conrad 1945; "Hazel Scott is Queen Once More in Warner's 'Rhapsody in Blue'" 1945). Because both Scott and Powell exuded worldly, liberal ideals and engaged in social activism, their marriage received extensive praise in the black press. Moreover, Powell's successful enactment of more civic legislation in a single term than all three black congressmen before him was frequently mentioned in relation to Hazel Scott's performative career ("Bye Bye Boogie: Hazel Scott Leaves Night Clubs and Moves to Concert Stage" 1945).

In the dominant press, Scott was idolized for her good looks, glamour, and sexy figure as much as for her musical proficiencies. Coverage of Scott

in mainstream periodicals typically included photos of Scott's busty profile. Even African American lifestyle magazines like *Ebony*, delivered "cheesecake" reviews commenting upon Scott's 36-inch bust and spectacular low-cut gowns. In response to these erotic representations, by 1945, Hazel Scott was unanimously selected by Battery 600 (an African American unit) as the headquarters' top pinup girl ("Battery 600 Selects Hazel Scott as Pinup" 1945).

Double-V Pinups

During the war, Lena Horne and Hazel Scott afforded two and only two kinds of contrasting and symbolic wartime pinup sexuality for black military personnel. Nonetheless, local African American affiliations promoted other types of wartime femininity, published in the black press and sponsored by various civic organizations. Community-based black pinups more actively embodied the political aspirations of the Double V movement than their white pinup counterparts, Betty Grable and Rita Hayworth. Patriotic pinups were supported not merely by the media, but by local organizations, including churches and universities. As early as 1942, the *Pittsburgh Courier* ran a contest for the "'Courier Double V' Girl of the Week," which presented women in a variety of roles sporting workclothes, bathing suits, and conservative church attire. One "Double V" pinup photo was captioned:

Attractive Edmonia Jackson . . . Lincoln University Graduate is doing her bit on the home front by preparing herself for skilled industry in the present huge wartime all-out to beat the Axis. Miss Jackson hails from Springfield, Ill. And holds the distinction of being the only race woman enrolled in her class. She is pictured at a lathe in the machine shop of Vashon High School where the National Defense Machine Shop Training School sponsors classes. ("'Courier Double V' Girl of the Week" 1942)

Other *Courier* Double V "Girls of the Week" even selected white women who were outspoken about the fight for a double victory. Another praised the "beauty and patriotism" represented at the "Double V Water and Beauty Pageant" ("'Double V' Water and Beauty Pageant Reveals Beauty and Patriotism" 1945). Double V caught on as musical fodder and was adopted by Lionel Hampton in 1942 with his "Double V" band. One photo presents Lionel Hampton and his Double V band surrounded by the International Sweethearts of Rhythm showing their support, while Hampton continued his tour of the Deep South ("'Double V' Band a Hit" 1942). Although the image of the pinup greatly influenced the musical images and performance practices of all-girl bands, the implications of women as "private obligations" varied according to cultural specificities.

Meanings accrued communal and therefore public (in contrast to private) allegiances when performed and received within the context of African Americans' struggle for "Double Victory."

Ada Leonard "Takes (It) Off" with Her All-American Band

During the 1940s, a wide variety of all-female instrumental groups existed, drawing upon a variety of musical styles, espousing particular performance aesthetics, and promoting varying types of visual appeal—each responding in its own way to the images of the pinup, of the "Double V" performer, or to the notion of female war workers. Those bands drawing most heavily from the ethos and cultural capital of wartime pinups were also those who hired sexy and attractive female bandleaders to lead and entertain in front of professional female instrumentalists. Prominent examples include the bands led by Rita Rio and Thelma White. The most literal wartime musical "pinup" enlisted for such a role, however, was Ada Leonard, a professional dancer and theatrical entertainer who began performing with her "all-American" girl band in 1940. Leonard's group toured America's white military camps, national theaters, and ballrooms from 1940 until the end of the war.

To capitalize upon Leonard's prior performing experience as a burlesque performer and highly desired USO attraction, *Variety* first introduced her as an ex-stripper trying a new line of work. The reviewer clearly indicated the commercial and novel appeal of the "aggregation," stating that the unit "faces the handicap of all girl bands, a tough obstacle on the strictly musical end." The review also emphasized the wardrobe of Miss Leonard, stating its importance for the overall showmanship of the group. During one 1940 performance, Leonard was praised for her four gown changes, which "drew whistles from the guys and ah's from the femmes" ("State-Lake, Chi" 1940).

Saxophonist Roz Cron played with Ada Leonard's band during the early 1940s before she began touring with the International Sweethearts of Rhythm. Just out of high school, Cron had gained experience playing in small dance bands and combos in her home town. She recalled the strange and uncomfortable experience of traveling long distances by train and performing in the various elaborate costumes that were required not only of Leonard, the featured visual attraction, but also of the women instrumentalists:

Anyway, after that it wasn't a month later that I received a call and I don't know how it happened but I went on the road with Ada Leonard's orchestra. It was a little bit established. I wasn't aware of it at all. It was the first time in my life, I'd had to wear full-length evening gowns. I couldn't cope with it, it had flounces and taffeta,

you know it was beyond me, I just felt so unprofessional. Girl's band . . . ? Anyway, I went on the road with them. After some theater work in Chicago, we started doing one-nighters in the South and we traveled by train. These were old dirty, dusty Southern trains. No air conditioning, of course, so the windows were always down. Everything from the nearby farms would come floating into the windows. And we would travel on that sitting upright, never resting. We traveled coach. So I was wearing my loafers under my taffeta, because we would be running from the gigs sometimes all dressed running to the train station in the middle of the night and no time for anything else.[3]

After their initial run in Chicago, the band gained notoriety performing major theaters throughout the country. Press reviews continued to sensationalize Leonard's burlesque past such as this *Down Beat* headline: "Strip-Tease Ada Leonard Fronts Ace Fem Outfit." The article, however, did specify the band's prior existence under the direction of saxist Bernice Little of Oak Park and also acknowledged the talent of some of the musicians recruited from Spitalny, Hutton, Rio, and the Coquettes. As typical for journal promos, the article stressed the availability of the girls, noting that only two of the girls were married.

In 1941, another less enthusiastic plug for the group announced the band's tour of army camps: "Ada Leonard and her all-girl ork has been signed to play at army camps throughout the country for the next 16 weeks. A morale builder?" ("Ada Leonard Ork Will Tour Camps" 1941). Finally, a more favorable review by *Down Beat* actually included various opinions and experiences of the women musicians themselves. Manager of the band Bernice Little expressed pleasure at "jam sessions with the men musicians in the camps." Trumpeter Jane Sager was enthusiastically compared to Harry James as one of the "nation's outstanding girl musicians" ("Ada Leonard Band Clicks in Army Camps" 1942).

Jane Sager gleefully recalled her experiences touring USO camps with Ada Leonard's big band during World War II. Sager played first trumpet with several all-girl bands including Rita Rio's and Ina Ray Hutton's. Sager became a highly sought-after soloist because of her reputation as an expert classical and jazz trumpet player. In jazz circles Sager was often compared to Roy Eldridge and she later acknowledged him as a mentor. As a young player, Sager had sought his instruction after sitting in on jam sessions at the Three Deuces in Chicago. She also studied for several years with Chicago Symphony trumpet soloist Ed Luellan, who provided her with impeccable technique, a masterly tone, and expert sight-reading skills.

Because of her diverse and exceptional talents, she was requested to coach Leonard during rehearsals in conducting and musicianship. According to Sager, during the first few months after Leonard began directing the band, Ada would look to Jane at the beginnings of tunes and Sager would

discreetly beat the pulse of the song with her trumpet. Sager recalled seeing Leonard for the first time after hearing of her reputation as a stripper:

McGEE: Did you help her pick up the conducting?
SAGER: Well, sure. But she got it in a hurry. How I'd sit up all night with her and help her. And, listen, she was so good.

Although Leonard's striptease past provided headlines for many reviews, her professionalism, grace, and musical skills impressed not only surprised audience members, but seasoned professional musicians like Jane Sager.

The effectiveness of the war propaganda machine, which emphasized the temporary status of female workers as well as promoting pinup sexuality, eventually led to misconceptions concerning USO performers' responsibilities—especially for a group like Ada Leonard's whose success relied in part upon the sensual and feminine appeal of Leonard's musical persona. These misconceptions often created uncomfortable situations for female musicians touring with all-girl bands. Sager recalled the various romantic and feminine expectations of USO female performers while touring with Ada Leonard for camp shows during 1942:

We were the first big band to play the USO. And I tell you the experiences. When we first started, we opened in Watertown, New York. Way up north there almost to Canada in the winter. And of course they thought that after we played and then entertained and did two shows a night, one right on top of the other—hour and a half shows—that we were supposed to go out with the guys and be cute. You know, mix with these guys. I said, look, if I'm gonna make my money, I make my money standing up playing my horn, I'm not gonna do anything on my back. I really was mad. Imagine, that's what they thought we were gonna do. And I noticed they had a bus full of ladies of the night for the men and then they wanted us too. We were steamed. But they took care of that in a hurry.[4]

Sager's anecdote parallels many women's recollections concerning military men's misconceptions about performers' responsibilities as sexual partners.

After leaving Leonard's band, Sager moved to the West Coast and worked with several big bands, including Charley Barnet's, for both short and extended periods. She also turned down a position with Duke Ellington because of the relentless touring schedule and the racial climate of southern tours. While living in Los Angeles, Sager worked for many of the big film studios, but sometimes found resistance to her employment just after the war, even when talent scouts confirmed that she was the best trumpet player to audition. Sager relayed several occasions where she was refused work because of her gender:

I had a couple of gigs with Benny Carter and Jackie played drums with us and Carter loved his drumming. You know he was good if Carter liked him. That was pretty fast company. This was all on the coast now. I got to do all the studios, cause the guys were all in the service. I thought, well, this California is too much. But

then after the war, the leader of *I Love Lucy*, who was the top man at CBS. But he was a great musician. I went to him, you know, he said something like, "Janie, he said you are the best lead trumpet I've ever had in the studio here." I said, if that's the case, please let me stay on? He said, no, I can't do that. He said the men are coming back and they've got family. And I said, well, what about *me*? We have to, the musicians union, and etc. And etc., politics, we have to bring the men back.

MCGEE: Were you a union member at the time?
SAGER: Always, oh yeah, you had to be, New York, Chicago, all over and out here, 47th of course. You wouldn't dare do anything without that.
MCGEE: Were the unions still segregated during the war?
SAGER: Uh, I don't want to say anything about that. Big politics and big bright politics. Played all the way. Still doing it and it always will. But they were wonderful to me while I was here, you know.

Despite the biases for male musicians after the war, Sager managed to continue professional engagements. During the 1950s, she also worked with Ina Ray Hutton for her television variety series.

Surprisingly, despite the skills and professionalism of female bandleaders, the press often reproduced statements that diminished women's roles as improvising jazz musicians. By 1942, for example, Leonard was often quoted in interviews downplaying women's jazz capabilities, declaring that "girls shouldn't play too much jazz." To support her claim, the reviewer pointed out the repertoire of the band at one Wisconsin Armory gig, citing the band's emphasis upon standards and popular arrangements. According to *Down Beat*, "the little gut-music the girls did play was limited to stock arrangements of *One O'clock Jump, St. Louis Blues*," etc. However, the reviewer did praise the drummer for her flashy solos that "stole the show" (Fossum 1942).

True to their masculine readership, *Down Beat* continued to exploit the sex appeal and stripper persona of Leonard through 1943 with sensationalized headlines and double entendres such as "Take 'Em Off, Take, etc.!" While the allusions to "taking off" (improvising) may have been less obvious, the pose of Miss Leonard was explicitly clear, with one leg unveiled beneath a shimmery gown, as she removed her silk stocking. The caption read:

This is a patriotic strip tease, if you please—and you're bound to please, or at least be pleased by this shot of beauteous Ada Leonard stripping off her silk hosiery for the duration. She waited until after Christmas so she could first hang 'em for Santa, and what do you think she got? A perfectly swell week's engagement with her all-girl band at the Golden Gate Theater here. But it didn't make the stocking look as pretty as does Ada's er-r-r-r limb! ("Take 'Em Off, Take, etc!" 1943)

Mirroring prior frustrations of maintaining personnel for all-girl bands, Leonard eventually switched to male musicians in the 1950s, claiming that girl musicians were too scarce to fill brass and reed sections and too expensive to hire (Holly 1955a). She did, however, work with an all-girl band briefly for television in the early 1950s.

SOUNDIES *and All-Girl Bands and Orchestras*

During the 1940s, all-girl bands and female jazz musicians continued to perform in live venues like ballrooms, nightclubs, and theaters, as well as for military personnel in USO camp shows. They also contributed to more mass-mediated forms like weekly radio broadcasts and feature-length films produced by the major Hollywood studios. During the war, many of the newest all-girl bands were also recruited for film as featured acts on the newly invented SOUNDIES.[5] These three-minute musical films were projected inside Panorams, the most popular of the various film projection machines, which were simply mass-produced jukeboxes designed for local viewing of internal film projectors. From 1941 on, these early film boxes were strategically positioned in hotel lobbies, cabarets, theaters, bus stations, ballrooms, and nightclubs and remained fixtures of popular culture for the next six years. SOUNDIES became an attractive medium for the promotion of lesser known and new musical acts, as they could be cheaply and quickly produced and widely distributed to businesses throughout the United States and abroad to military bases.

The most successful producers and distributors of these new film machines arose from collaborations between Fred Mills of the already successful Mills Novelty Company, the largest producers of jukeboxes, and the prominent businessman James Roosevelt, son of President Franklin D. Roosevelt. Together, they formed the Globe Mills Production Company, and later split its activities into two companies: Globe Productions and the new Soundies Distributing Corporation of America. Globe-Mills originally presented these panoramic film machines in February 1940 (Terenzio, MacGillivray and Okuda 1991, 3).

Frequently, SOUNDIES provided promotion performances of musical groups that had not yet established relationships with the major film studios. Those few all-girl bands sponsored by the big East Coast and Midwest booking agencies like William Morris and Irving Mills during the 1930s (groups like Phil Spitalny's Hour of Charm or Ina Ray Hutton's Melodears who had already produced short subjects and features for Paramount and Universal) were not, however, recruited for SOUNDIES. The small budgets of SOUNDIES and their separation from the vertically integrated entertainment mediums of radio, variety, and the major film studios provided both obstacles but also greater leverage in the choices of performers and musical material. Many all-girl bands, especially those younger groups who began performing and touring during the 1940s, were also those to be filmed for these short musical films. All-girl bands like Thelma White and Her All-Girl Orchestra, Rita Rio and her Mistresses of Rhythm,

Dave Schooler and his 21 Swinghearts, and the International Sweethearts of Rhythm all appeared on various SOUNDIES sequences. Many of these films continue to circulate on jazz and popular music compilations in video and DVD format, such as the *Meet the Bandleaders* video series, which presents a number of short musical films from the 1920s through the 1940s. Of the many SOUNDIES produced of all-girl bands during the war, only one featured an African American group, the International Sweethearts of Rhythm. (Of course, others may have been lost.)

The novelty of these sound-film boxes, in combination with SOUNDIES founders Roosevelt's and Mills' interest in reaching the widest possible popular audience, encouraged a degree of experimentation and diversity in musical genre and subject matter. Vaudeville acts, hillbilly songs, patriotic hymns, all-girl bands, "hot" jazz bands, gospel songs, operatic arias, flamenco dancing, "gypsy" campfire songs, and burlesque stripteases—all qualified for this mishmash of musical material. In addition to the various lesser known and more "exotic" numbers were simply produced performances by celebrated popular theater and radio entertainers like Cab Calloway, Lena Horne, Doris Day, Duke Ellington, Bob Hope, Lawrence Welk, Dorothy Dandridge, Count Basie, the Mills Brothers, and Bill Robinson.

The producers of SOUNDIES encapsulated the many diverse cultural and ethnic musical genres of the day, as well as what they perceived to be the most exotic, comic, and bizarre. Even so, SOUNDIES were not immune to the exploitation and misinterpretation of these many "ethnic" music cultures, as had been exhibited by the Hollywood film and music-recording industries. Such was the appeal of films like Borrah Minevitch and his Harmonica Rascals (*Boxcar Rhapsody,* 1942), which depicted Bohemian hoboes stealing liquor and living in boxcars, or skits with Creole female crossdressers, comedians in blackface, and musical cartoons such as "Hot Frogs" (1942) which layered voiceovers and musical recordings of famous jazz musicians, including Louis Armstrong and Fats Waller, over the highly racialized caricatures of frogs and monkeys.

Even admitting these overtly racist musical presentations, the sheer diversity of SOUNDIES' subject matter suggested a rather bold and inclusive racial hiring practice in the context of a largely segregated 1940s American culture. President Roosevelt's integrationist and progressive political aspirations undoubtedly influenced James Roosevelt and helped inspire his company's interest in presenting a democratic and pluralist American musical culture. Indeed, President Roosevelt had declared that music could inspire "a fervor for the spiritual values in our way of life and thus to strengthen democracy against those forces which subjugate and enthrall mankind" (Roosevelt quoted in Erenberg 1998, 184). Despite their sometimes exoticized, sexist,

and racist presentations, SOUNDIES were revolutionary, not in their often crude and hasty film techniques, but rather in their willingness to present a multiethnic, cosmopolitan, and pluralist coalition of music, dance, comedy, and drama during World War II America.[6]

The first release of Globe Production SOUNDIES actually chose one of Hollywood's leading all-girl white bands, the Lorraine Page Orchestra, to sideline to a recording of Victor Young's radio orchestra for its 1940 debut. Lorraine Page's all-girl band was one of five original acts filmed for the Soundies Distributing Corporation of America. The Music Maids, a female instrumental group (not to be confused with the female vocal group of the same name), were the fifth of these original acts to be released by Globe.[7] The Music Maids mimed instrumental parts—or, rather, in film-industry lingo, "sidelined" over the prerecorded performance of Victor Young's orchestra, who also recorded all of the original music for this first Globe Production series.[8] During the 1940s the interest and potential appeal of all-girl groups (whether real or staged) is evidenced by SOUNDIES' selection of no fewer than two female films of the first five released.[9]

The nearly simultaneous emergence of sound film with race films, race records, and "ethnic" record series in the 1920s introduced a market strategy that became the model for the subsequent 1940s music films, thereby perpetuating racial, ethnic, and language demarcations of earlier recordings and full-length films. SOUNDIES, which were presented in a series of eight three-minute acts, were designed to cater to particular communities, neighborhoods, cultures, and races. Black artists were grouped together and catalogued in a separate "Negro" section.[10] African American SOUNDIES, rather than being shipped weekly to Panoram operators, were included in the special-order items constituting the "M" series of extra Negro subjects and were available by special order only.[11] Jazz-film historian Mark Cantor asserts that owners of Panoram machines were given the choice of selecting from two possible formats on a weekly basis: a preassembled or a custom reel of eight films. He suggests that most patrons would have likely ordered the preassembled reel, which may have included SOUNDIES by a variety of artists including black artists, country artists, and other types of variety performers.[12]

Because of the influence of vaudeville, white all-girl bands were frequently packaged with a variety of "novelty" acts featuring dancers, comedians, and singers of jazz and ballads. These may have been promoted anywhere in the United States and especially to army camps at home and abroad after 1942. Some of the other all-girl bands (all-white except the International Sweethearts of Rhythm) fortunate enough to be recorded for SOUNDIES and/or short subject films were Ada Leonard and her All-Girl Orchestra, Dave Schooler and his 21 Swinghearts,[13] Rita Rio's Mistresses of

Rhythm, the Angie Bond Trio, the International Sweethearts of Rhythm, and Thelma White and her All-Girl Orchestra.

The potency of Hollywood and wartime constructions of sexuality and gender influenced how female bandleaders and all-girl bands were represented in press releases, in promotional materials, and in the more visually focused mediums of film. In the newer genre of SOUNDIES, white all-girl bands were frequently filmed in ways that seemed to identify with a highly sexualized pinup (or striptease) aesthetic while also drawing from earlier feminized forms like variety, vaudeville, and burlesque. The SOUNDIES of Thelma White and Her All-Girl Orchestra, Carol Adams and The Glamorettes, and Ada Leonard and Her All-American Girl Orchestra all featured stunningly attractive female bandleaders whose physical appeal drew from their sensual jazz dances, their form-fitting gowns, and their creative and highly physical manner of conducting all-girl bands.

Conversely, a number of all-girl films appearing in SOUNDIES provided a counter to the sexualized images of female pinups, promoting instead the domestic, private, and wholesome "girl next door" image, by reinvigorating notions of cultured Victorian women performing sweet arrangements or light classical works in richly decorated parlors for exclusive theater audiences. These identifications were achieved through a complex combination of musical genres, costuming, and musical arrangements. Even so, many of these sweet SOUNDIES also provided opportunities for female musicians to shed their roles as highly feminine, cultured, and attractive women by briefly showcasing their professional jazz skills as improvisers and soloists.

Finally, other SOUNDIES of all-girl groups attempted to combine the dominant feminized images promoted by Hollywood and the war industry by conflating the erotics of pinup sexuality and all-girl spectacles ("Sweethearts on Parade") with the increasingly feminized and racialized aesthetics of "sweet" and "hot" musical genres. Within this last category, a number of purely commercial films capitalized upon the highly charged sexuality of pinup reproductions as well as the dominance of feminized popular musical genres by provocatively arranging groups of models pretending to play instruments to either sweet versions of the classics, or conversely, by positioning static models in suggestive yet static poses holding instruments to the accompaniment of hot jazz—in this case, suggesting a more racialized and consequently eroticized musical context for showcasing American (white) women. One example of the racially inspired "hot" pinup variety is the SOUNDIE, *Lady Wonderful* (1939), which presents models holding instruments poised in symmetrical formations to "hot" improvised jazz. Similarly, Dale Cross's All-Girl "band" SOUNDIE *Mad About Her Blues* (1946)

presents glamorous (nonmusical) actresses in black-fringed bodices and fishnet stockings seductively holding brassy, big band instruments to these expert jazz accompaniments.

Indeed, the few examples of all-girl "bands"—which, upon viewing, revealed groups of gorgeous women poised with band instruments—was perhaps the most surprising and startling of the types of female jazz performance. In each example, the women were not depicted as jazz musicians but merely as models or "Sweethearts on Parade," presumably for the boys abroad. These performances, frequently set to patriotic marches or to the hottest jazz arrangements, intimated a certain racialized transgression as white women in minimal costumes sat seductively and passively. Here, unconscious associations of hot music to miscegenation and to the overtly sexualized images of black jazz dances portrayed in media must have contributed to these musical films's appeal.

The Glamorettes

To deliver an American brand of "sweethearts on parade," SOUNDIES recruited a professional female group, The Glamorettes, who worked in different capacities for the major film studios, acting out the pinup, all-girl band concept or the "sweethearts on display" image for short subject wartime morale boosting films. The Glamorettes consisted of eight professional models/theatrical performers who sidelined, danced, and configured patriotic formations for a number of musical SOUNDIES including the Fourth of July–inspired *Liberty on Parade* (1943), which showcased attractive drum corps dancers, baton twirlers, and female toy soldiers in various formations and interspersed with patriotic wartime footage of fighter pilots.

In another music-centered SOUNDIE, *Swing It, Mr. Schubert* (RCM Productions 1942), Carol Adams and the Glamourettes, touted as "America's most gorgeous girl band," dramatized a race-inflected commentary on the high-art/low-art dichotomy so often satirized in Hollywood musicals during the 1940s (fig. 6.1).[14] During the film, a number of choreographic, cinemagraphic, and aural signifiers suggested links to the established repertoires of real all-girl bands, but also to the more static reproductions of pinup poses. The Glamorettes' star performer, Carol Adams, executes various jazz-dance routines in a leggy, silver-fringed bodice and matching silver dance shoes. Throughout the film, camera shots highlight her vivacious expressions as she dances gleefully, all the while manipulating her baton to map out common jazz- and swing-era steps like the "Suzie Q" and the "slide." Intermittently, static frames highlight each woman's face and musical instrument providing glamorous "sweetheart photographs."

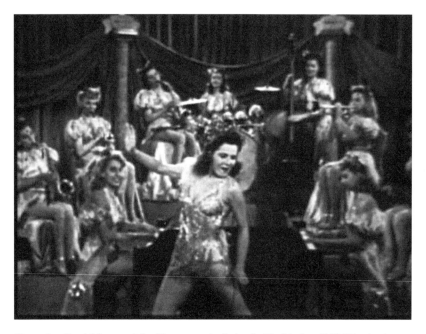

Figure 6.1. Carol Adams and the Glamorettes in *Swing It, Mr. Schubert* (RCM Productions 1942). Courtesy Fred MacDonald.

In this musical film, the Glamourettes pretend to perform a medley of swung Schubert themes (recorded by the prolific and well-respected John Kirby Sextet).[15] The juxtaposition of this musical arrangement sidelined by provocative and sexy female models effectively satirizes the upper-middle-class, amateur musical expectations for white women while also extending a popular 1920s and 1930s trend of rendering jazz arrangements of classical themes (à la Paul Whiteman) established in vaudeville and musical revues, two musical forms that drew heavily from nineteenth- and twentieth-century minstrelsy.[16] While it is clear that most of these women have no musical experience, the film does feature two female pianists who actually do play and both women perfectly replicate the short but technically challenging improvised solos recorded by pianist Billy Kyle.

The women's costumes further satirize the Victorian musical expectations of the film's title: women perform in shimmery, satin, cleavage-revealing two-pieces consisting of V-shaped split skirts with oversized (in relation to the skimpy body suits), ballooning shoulder coverings—the only Victorian sartorial gesture. Indeed these unbalanced garments would have been an uncommon band uniform for both male jazz musicians and socially "respectable" white female amateur musicians. Rather, their physical appearance relied upon the sensual and revealing costumes adorned by

pinups and chorus girls in all-girl spectacles, which appropriated jazz and blues musical accompaniments to provide the necessary soundtrack of "sex and sleaze" as these provocative groups of anonymous women uniformly danced and fulfilled Americans' desire for the perceived libidinal release and pleasures of jazz and swing. In general these sidelining pinup SOUNDIES provided a pretext to combine pinup sexuality with highly feminized popular genres: a patriotic union of wartime sexualized dichotomies including the erotic pinup and the wholesome girl next door, hot (racialized) jazz queens and cultured European amateur musicians.

Thelma White and Her All-Girl Orchestra

Thelma White (1910–2005) began leading her all-girl swing band during the 1940s after having already established her professional career as a Broadway revue performer and comedic film actress in such 1930s Code-era films as *Tell Your Children* (1936).[17] Like other famous all-girl bandleaders, White had amassed a wealth of theater and even film experience before fronting her all-girl "orchestra" in the 1940s. At the age of two, she began performing for her family's Nebraska circus as a "living doll." As an adolescent, White was dancing on vaudeville circuits with the White Sisters before working as a dancer and comedic actor for the Ziegfeld Follies and the Earl Carroll Revues in the mid-1920s. White moved to Hollywood in the late 1920s and began working in revues that frequently provided supporting bills for the new feature-length sound films. She eventually worked her way into film and starred in a number of short subjects such as Vitaphone's 1932 *Of All People* ("All-Feminine Cast seen in unusual film" 1932) as well as a number of Pathé (later RKO) shorts opposite comedic male leads Edgar Kennedy and Leon Errol including *Season's Greetings* (1931), *Hot Sands* (1931), *What Price Jazz?* (1934), and *Suzie's Affairs* (1934). White's first feature-length film, Paramount's *A Night in a Dormitory* (1930), starred Ginger Rogers. After *Reefer Madness*, she appeared in *Never Too Late* (1936) with Richard Talmadge ("Obituaries: Thelma White" 2005).

During the 1940s, White and her All-Girl Orchestra went on to entertain troops at military camp bases and appeared several times in Alaska and on the Aleutian Islands with notable USO performers like Carmen Miranda.[18] In-between USO tours, White's all-girl band also produced four SOUNDIES: "April in Paris" (1946), "Zoot" (1946), "Take It and Git" (1946), and "Hollywood Boogie" (1946).[19] These films helped promote the swing-based capabilities of female musicians while arousing military interest in White's all-girl boogie-woogie/dance-band aggregation.

Hollywood Boogie

White and her all-girl orchestra's SOUNDIE *Hollywood Boogie* (figs. 6.2–6.4) presented a slightly updated version of the blues-based riff-tune "Shoo Shoo Ya Mama," previously recorded by Lionel Hampton and his Quintet as "Hamp's Boogie Woogie" in 1937 (and again in 1947). This rather typical swing-centered film provided American audiences and soldiers the two commodities most promoted by the war industry: attractive women and swing. White's band featured a standard swing arrangement with only one pianist (as opposed to two), five saxophones, three trumpets, two trombones, and drums. In place of a full rhythm section, the pianist performed the necessary bass lines. The tune first features a boogie-woogie blues solo in the popular style of Fats Waller. The pianist is only briefly highlighted as she performs a single chorus of a twelve-bar boogie-woogie blues. The girls in the band proceed to accompany Thelma in a sung/spoken chorus in unison before screaming like crooner-crazed teen-agers, a phenomenon more commonly associated with 1950s-era bobby-soxers (fig. 6.2). Significantly, the band members even shout the jive and gibberish vocal riffs behind White's girlish calls as they chant in unison: "Shu-Shu, Shu-Shu, Shu-Shu Ya Mama; Hey Hey Hey Hey Where Who

Figure 6.2. White and orchestra scream in *Hollywood Boogie* (RCM Productions 1946). Courtesy Fred MacDonald.

Figure 6.3. White's pianist solos in *Hollywood Boogie* (RCM Productions 1946). Courtesy Fred MacDonald.

Yes You. I——see you. I——see you." The women scream in unison: "Awwwough." Then the women provide vocal percussive hits on beats three and four with the drummer before their last ecstatic scream: "Bomp Bomp. Awough . . . ," ending with the final cadential blues refrain: "I wonder boogan my woogie now." The use of jive lyrics executed by the unison voices of ecstatic young women intensified the women's femininity, while countering the more racialized associations of this boogie-woogie blues and distinguishing these professional women from male jazz hipsters who adopted swing lingo to assert their coolness, masculinity, and subcultural status. Here, the women's vocalizing is excessively feminized; therefore their musical drive, swing, and hot soloing capabilities are partially and sonically contained.

The saxophones stand for their blues-based, riff chorus. The group then explodes into a typical Fletcher Henderson–style shout chorus with saxophones and brass in heavy counterpoint. Two soloists are highlighted, each taking a single rhythm and blues–inflected chorus and featured in closeups in the camera's frame. The song develops via a modulation during the final saxophone riff while the brasses play out the last theme. White's performance relies heavily upon her energy as she dances incorporating a bit of swing, even boogie-woogie, but nothing exceedingly elaborate or technical.

Figure 6.4. Thelma White's All-Girl Orchestra in *Hollywood Boogie* (RCM Productions 1946). Courtesy Fred MacDonald.

Her attractive figure is highlighted as she dances in a snazzy black-fringed halter top with a full-length, form-fitted fringed skirt.

Each of White's four SOUNDIES provided solid dance music in the style of the latest swing bands with an emphasis on boogie-woogie and jump blues. One could have imagined White's all-girl orchestra providing hot sets for army bases with soldiers energetically dancing and strutting in the aisles. While White's good looks, sexy costumes, and effervescent dancing in front of the band provided a contagious musical energy, her movements provided a rather ordinary example of wartime dancing in contrast to Ina Ray Hutton's highly choreographed routines and stage show designs— more formal and theatrically conceived to provide revue and vaudeville audiences a range of musical styles, professional dancing, and the experience of a headlining Broadway star.

Dave Schooler and His 21 Swinghearts

Frequently, musical SOUNDIES simply continued the practice of earlier short subject films by featuring jazz and swing groups performing popular hits of the day for staged audiences. Others featured all-girl bandleaders like Thelma White in gorgeous designer gowns provocatively dancing and

singing to the accompaniment of their bands in more formal theatrical settings. Finally, others provided filmed documentation of the highly popular jazzed-classics genre, a musical practice introduced during the 1920s and further developed by a number of swing musicians, including Hazel Scott during the late 1930s. When all-girl bands performed classical themes in modern jazz or sweet arrangements, however, the film's particular feminized aesthetic frequently utilized not only important classical aural signifiers, but visual techniques to specify the femininity of these musical groups.

Beyond the more obvious visual markers of feminine and romantic costumes, ambient lighting effects, feminized sets, and stylized dance sequences, SOUNDIES of all-girl bands also relied upon a range of musical gendered signifiers. These included collaborative arrangements and the accentuation of more normative feminine instruments like violins, harps, and pianos as well as the frequent incorporation of female choruses. Some of the most successful all-girl bands often showcased female soloists while simultaneously expanding more complex musical structures to reify and subvert established notions of musical femininity. For example, arrangers of all-girl bands cunningly adapted established feminized genres and formal structures to then enable greater liberties and flexibilities for the many fine female jazz instrumentalists performing in all-girl bands.

In Dave Schooler and his 21 Swinghearts' various SOUNDIES, arrangers reworked established genres like baroque and classical music to both reinforce feminine markers and create new contexts for female musicians to perform more masculinized genres like blues, Dixieland, and swing. During the 1940s, Dave Schooler and his 21 Swinghearts released at least six SOUNDIES featuring classical themes, and expertly performed by the group's director and soloist, Dave Schooler. These included "In an Eighteenth-Century Drawing Room" (1941), "Night Ride" (1941), "Blue Danube" (undated), "Pavanne" (1941), "Scheherazade" (1941), and "Tchaikovskiana" (1941).

The most successful formula for all-girl bands in this vein, which enabled female musicians to simultaneously promote and interpret both sweet and swing musical idioms, involved performing classical tunes like Chopin's "Pavanne"—closely adhering to an established classically oriented theme or melody and then, as a kind of musical surprise, breaking into either a big band swing piece, or in other cases, establishing a more intimate jazz-rhythm section in order to highlight one of the ensemble's jazz soloists. This type of delayed jazz exposition both reaffirmed women's associations with domestic female genres and also created an interesting dramatic, musical, and visual effect; audiences were both surprised and amused by these young female musicians breaking away from their classical molds and

liberating themselves to express a more sexualized and masculinist musical form. These types of performances relied upon musical and visual aids to confirm the stereotypes of gifted, educated, and wholesome young women who then "wowed" their audiences as they abruptly transformed themselves into jazz soloists—"throwing down" heavy, swing riffs or "taking off" with "hot" Dixieland solos.

During these types of performances, all-girl bands both confirmed public expectations and dismantled them as these female musicians performed both classics and jazz. They did so in two musical and performative ways: (1) through their resignification of the culture of classical music, and (2) through their novel swing adaptations of original classical melodies. All-girl bands that integrated sweet styles and swung classics, without exception, also performed within smaller chamber music ensembles during their concerts. At the very least, these all-girl bands performed with four string instruments, usually four violins but sometimes two violins and two violas. Additionally, in these types of classically arranged swing performances, all of the reed instrumentalists typically doubled on chamber instruments, most often the flute or clarinet and sometimes the oboe and bassoon.

Dave Schooler and his 21 Swinghearts, for example, often incorporated swing into their shows by rapidly transforming themselves from chamber music musicians to big band jazz players. In these musical and performative moments, professional female musicians metaphorically and musically abandoned their perceived classical cultural roots by completely reconstituting the band into a smaller, and more "authentic" improvisatory jazz ensemble; that is, by eliminating such sweet, feminine, and classical markers as strings, harps, woodwinds (not saxophones), and classical piano soloists.

In contrast to more strictly swing ensembles like the International Sweethearts of Rhythm or Virgil Whyte's Musical Sweethearts, Dave Schooler and his 21 Swinghearts performed a predominance of lighter, popular classical tunes, and romantic ballads similar to those arranged by Raymond Scott for his commercially profitable and highly popular, rickety-tickety dance band. Doris Swerk, who played saxophone and clarinet with Schooler's band in the late 1930s, noted the band's reputation for performing classics in a swing context:

Well, see that was what Schooler was known for. That was when swing was just starting. And he was known for using the lighter classics and they were all manuscript. So they were all special arrangements for us. He had a variety of arrangers. And one in particular, the one that did "Scheherazade," was a black arranger and I often wonder, I don't remember what his name was, but I often wonder if it was Holly Abes because Holly Abes did a lot of arranging in those days. Holly Abes is a black arranger who did a lot of choral music and instrumental music arranging.[20]

In an Eighteenth-Century Drawing Room

In 1941, Dave Schooler and his 21 Swinghearts recorded a SOUNDIES of Mozart's "Easy Sonata,"[21] which was reworked during the 1930s by Raymond Scott into the popular "In an Eighteenth-Century Drawing Room" (figs. 6.5 and 6.6). After Scott's piece gained popularity, "In an Eighteenth-Century Drawing Room" was recorded by several sweet dance bands including Hal Kemp (1939), the Glenn Miller Army Air Force Band (1943), the Billy May Band (1950s) with Verlye Mills on the harp[22] and Sylvia Marlowe (1940s) on harpsichord.[23]

During the late 1930s, Scott organized a capable quintet to test new compositions and record and perform his original works. The Raymond Scott Quintette made their network debut 26 December 1936, performing "The Toy Trumpet" on the *Saturday Night Swing Session*. As music director for CBS Radio, Raymond Scott and his new Quintette performed original compositions for the weekly broadcast *Your Hit Parade,* and Scott's unique brand of symphonic jazz and popular music became extremely popular during the late 1930s.

By 1941, film companies realized the commercial potential of Scott's filmic jazz/orchestral musical style, and Warner Bros. was first to license

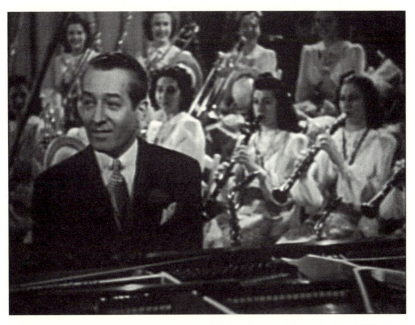

Figure 6.5. Dave Schooler's pianistics in *In an Eighteenth Century Drawing Room* (Minoco Productions 1941). Courtesy Fred MacDonald.

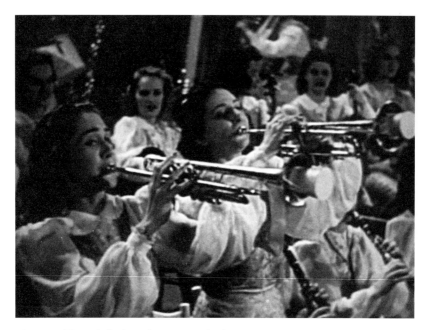

Figure 6.6. The 21 Swinghearts' trumpet section in *In an Eighteenth Century Drawing Room* (Minoco Productions 1941).

Scott's Quintette compositions. By 1943, Merrie Melodies (later renamed Looney Tunes) rarely released a cartoon without some of Scott's music. These cartoons, in effect, immortalized his early work, and overshadowed the Quintette's original popularity in concert halls and theaters. Scott tunes often quoted in Warner productions include "The Penguin," "In an Eighteenth-Century Drawing Room," "Dinner Music for a Pack of Hungry Cannibals," "Huckleberry Duck," and "The Toy Trumpet."[24] According to music historian Irwin Chusid, the Quintette's

> success was meteoric, and a recording contract was extended by the Master label (run by Irving Mills, Duke Ellington's manager.) . . . Harold Taylor, in a January, 1939 *Rhythm* magazine article entitled "You Can Keep Raymond Scott," called the music "silly," "screwy," and "smart-alec." "You get the old tom tom out and bang it a bit," grumbled Taylor, "and then play those oriental figures over it, and there you have what Scott calls an experiment in modern jazz." But there was one question; in the words of Johnny Williams, "It sold like hell." . . . The *New York Times*, in 1937, called it "a brand of music that is at one and the same time as free as a 'jam session' and as authoritatively formal as a Debussy cake walk—and not unacquainted with the humor of both." (Chusid 1992, 4–5)

During the 1930s, the collision of symphonic musical performance practices with the lighter genres of jazz, popular, and Tin Pan Alley and the influence

of mass media such as radio and film and especially of the leitmotiv film score provided the context for Scott's highly popular brand of music.

Scott's earlier Mozart adaptation provided inspiration for Schooler's musical vision and especially for this 1941 SOUNDIE. A comparison of a number of 1940s recordings with the original Scott arrangement indicates how these musics were received in more heavily gendered terms during the 1940s. In the following, I compare and contrast the well-known recordings of Scott, Schooler, and Miller to elucidate the gendered aesthetics of these varying performance practices, film aesthetics, and musical arrangements adopted by some of the industry's leading popular musicians.

In "In an Eighteenth-Century Drawing Room," Scott utilizes such musical signifiers as the tinkle of the celeste and the drummer's brush sweeping across the snare to discreetly enhance his melodies. The tenor sax and the clarinet play in unison over sprightly percussion—with the same society-band beat favored by Schooler and his 21 Swinghearts, the so-called businessman's bounce.[25] A closely muted trumpet features Mozart's melody while the reeds provide the countermelody with a clarinet solo. The clarinetist's absence of vibrato intimates a more legitimate chamber music style.

Scott's rendition is introduced by an arpeggiated four-measure celeste part and a simple four-beat shuffle executed by brushes rather than sticks. The piano provides a similar four-measure arpeggiated passage between each eight-measure theme. Scott's simple arrangement delivers Mozart's first four-bar theme as a unison clarinet and tenor soli. The second theme is rendered by a single muted trumpet with a busier and jazzier rhythmic accompaniment by the bass, now playing quarter-notes and the drums, accenting beats two and four. Scott's unusual arrangement simply reworks Mozart's themes into the more familiar (Tin Pan Alley) AABA form with three instrumental soloists— clarinet, tenor, and trumpet—followed by a muted trumpet, clarinet duo. Each solo performs the basic melody, embellishing the rhythms and harmonic content of the themes. The trumpet solo is the most adventuresome harmonically, with several chromatic passing tones and blue notes that effectively alter the major tonality of Mozart's original secondary theme.

The four-measure, arpeggiated piano passage provides the necessary transition into the final A theme, this time performed with the slower, half-note feel and a straight-toned and -articulated phrasing style. This short piece lasts only two and a half minutes, yet still features two statements of the 32-bar melody, three solos, and two contrasting styles of articulation. The three soloists refrain from heavily swinging the eighth notes; primarily they embellish the theme rather than improvise over a predetermined chord progression.

Schooler's version resembles the first half of the original Scott record-ing. The Swinghearts' arrangement showcases Schooler's prodigious solo-ing capabilities and features many technically impressive thematic varia-tions on the piano. The first theme is rendered by a muted trumpet after the soloistic piano introduction. The piano reintroduces the first theme and is developed after a short modulation to complete the piece. Unlike the Scott composition, Schooler doesn't orchestrate the satirical celeste part so prominently displayed in Scott's composition. Rather, Schooler delivers the same upper-register countermelody on the piano, which is similarly ar-peggiated in first inversion triads.

Schooler inserts a few symbolic "feminine" markers to embellish Scott's simple arrangement. Most obvious is the initial flourish of the harp to in-troduce the second half of the A theme, performed by the clarinets. Schooler performs Scott's original four-bar, arpeggiated piano passage, but slightly slower and an octave lower. Like the Scott arrangement, the first full statement of Mozart's first theme is rendered by the tenor saxophone. Schooler, however, augments Scott's version by performing various im-pressive thematic variations throughout the first and second themes. Un-like Scott's version, the 21 Swinghearts provide the second statement of the A theme before Schooler is again showcased as he embellishes, develops, and intensifies the B theme as if improvising over the development passage. The muted trumpets render the bridge with quick, staccato tonguing, and the final A theme is delivered by Schooler with the full chamber ensemble providing sustained chords beneath the final melody. Schooler borrows Scott's arrangement primarily as a template to augment, develop, and showcase his brilliant piano technique.

In 1943, Glenn Miller's swing group also recorded a version of "In an Eighteenth-Century Drawing Room," producing a more masculinized version whose arrangement is unique in its interpolation of distinct eight-measure, jazz piano choruses.[26] Here, "swing" and "classical" alternate sets under Miller's meticulous orchestration. In contrast to various symphonic classics performed by the Swinghearts and the Hour of Charm, where mu-sicians exhibit their classical, sweet, and hot capabilities within a single piece, the Miller version of Mozart's "Easy Sonata" clearly separates the chamber music sections from the more intimate and entirely improvised, eight-bar jazz choruses (in this case performed by a solo pianist). The piece begins with the first violins rendering the B theme as the violins and violas arpeggiate the harmonic progression. Spontaneously, the band transforms itself to a swing band with two syncopated hits by the brass on the "and" of beats three and four, just before the rhythm section takes over and the pia-nist solos over an eight-bar chorus with a relaxed stride-inflected left hand.

While Miller's version is much shorter, lasting less than two minutes, it does provide an interesting exhibition of both swing and classical, but not sweet. The ensemble alternates between a more traditional chamber music style to a big band swing outfit, complete with brass riffs and sustained saxophone chording to support the three improvised, piano choruses. The piece ends with the featured jazz pianist providing the recapitulation of the A theme, this time interpreted with a light, straight classical articulation.

Hal Kemp and his Orchestra also recorded "In an Eighteenth-Century Drawing Room" in 1939.[27] Jazz critic James T. Maher discusses the compositional qualities which lent such distinctiveness to the Kemp sound:

> The Kemp style was slow in evolving, and it was not simply a matter of playing a lot of notes into muted trumpets. . . . The Kemp trade-mark was the crisp sound of tightly muted trumpets playing phrases marked by accented clusters of four-note sixteenths played staccato. This feature began to be incorporated into Trotter's arrangements during 1931 and 1932. . . . The band also had an unusual way of playing sax figures that involved swiftly rolling triplets and the muted trumpets also played staccato triplets (based on Ravel's Bolero) in many background figures. A distinctive musical trick that created a special sound was the Kemp use of clarinets playing in the low (chalumeau) register, and played inside big cheer-leader megaphones with handholes cut in the sides. The special colorations that Trotter used (such as incorporating a flute into sax and clarinet colorings) gave the band an unusual blend of sound and flexibility. Although the Kemp band drew its loyal following from all age groups, it frequently returned to its old homing place, the college campus. Hal led his men at more than 400 proms before he died in 1940.[28]

Hal Kemp's performance closely resembles the original Scott recording both in the arrangement and in the manner of phrasing, articulation, and stylistic interpretation. Kemp's recording is performed a bit faster than Scott's, thereby showcasing the expert technique and articulation of Kemp's reed and brass performers. An alternate introduction features the woodwinds for sixteen measures before Scott's original four-measure, arpeggiated piano introduction. The Kemp arrangement relies upon a sweeter tonal sensibility as the woodwinds render the first theme with a bright, fast, and wide vibrato, in an uncharacteristically nonclassical manner. Like the Scott arrangement, the B theme is delivered by the muted trumpets, this time as a sectional soli rather than an individual solo. Kemp's version is fully orchestrated with no improvised solos, and no embellished piano phrases throughout Mozart's melody. Kemp's arrangement is merely a popular "sweet" arrangement of Mozart's "Easy Sonata." Like Schooler's generally classical interpretation, Kemp's heavily orchestrated version provides a consistent stylistic performance, in contrast to the Miller and to some extent the Scott version, which alternate small combo jazz sections with straight ahead, and 'legit' classical phrases.

Night Ride

Dave Schooler and his 21 Swingheart's SOUNDIES *Night Ride* (figs. 6.7 and 6.8) incorporates musical genres, arrangements, and performance techniques that reified and expanded current conceptions of swinging the classics while at the same time incorporating more familiar sweet melodies and filmic musical textures. Throughout this piece, provocative images are supported through various film-scoring textures, elicited via particular instrumental techniques such as the use of tremolo, trills, and repeated runs in the highest registers of the strings. Offbeat pizzicato attacks on the dominant and tonic further align the music to classical harmonic conventions. The alternation of the soloing of the string quartet and fast sixteenth-note flute and clarinet flourishes also provide a dramatic, soundtrack effect for the visual images intermittently edited into the film of shadowy female dancers frantically pirouetting in traditional ballet pointe shoes, flying through the dark, tumultuous sky like erotic evening nymphs. Then abruptly, the orchestra breaks into a firmly rooted Dixieland jam session after the various chamber music melodies are developed. Violins suddenly become fiddles as they swing and slur their jazz melodies in harmonies of the third and sixth. The lead clarinet delivers a characteristically 1920s 12-bar

Figure 6.7. The 21 Swinghearts' clarinetist in *Night Ride* (Minoco Productions 1941). Courtesy Fred MacDonald.

Figure 6.8. The 21 Swinghearts' rhythm section in *Night Ride* (Minoco Productions 1941). Courtesy Fred MacDonald.

blues solo, incorporating New Orleans–style jazz licks. The band's syncopated interpretation also dates the band to earlier jazz styles (1920s) as the eighth-notes are not quite swung and performed more on the beat than behind. By re-creating these earlier jazz styles, the 21 Swinghearts distance themselves from comparisons to their contemporary 1940s swing competitors like Benny Goodman, Gene Krupa, and Glenn Miller.

Tchaikovskiana

Schooler and his 21 Swinghearts also recorded a SOUNDIE in 1941 based upon various melodies of Tchaikovsky (figs. 6.9 and 6.10). The modern arrangement quaintly renamed *Tchaikovskiana*, alternates between classically oriented "theme and variation" passages and short interludes of big band swing. The strings feature the first Tchaikovsky theme in harmony with brief woodwind countermelodies. Then the tenor saxophone renders her most "legit" chamber music tone as she exhibits the second theme while the rhythmic section breaks into a jaunty bounce, accenting all four beats ("businessman's bounce") and the countermelody is syncopated but not altogether swung.

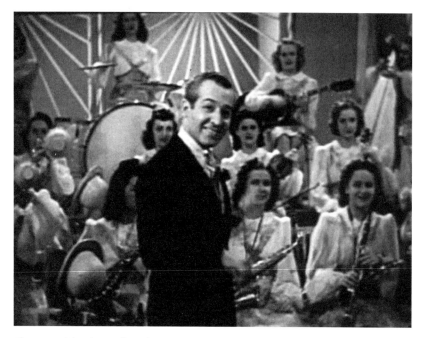

Figure 6.9. Schooler conducts the 21 Swinghearts in *Tchaikovskiana* (Minoco Productions 1941). Courtesy Fred MacDonald.

After a four-beat transition in the brass, the saxophones are featured in unison with the third Tchaikovsky theme, this time fully syncopated as the brass deliver some characteristically swing-inflected call-and-response riffs. The solo saxophone theme is rhythmically developed from the original Tchaikovsky theme to the newly articulated swing theme. The fourth theme, introduced by a trumpet solo, is then followed by a string solo as the piece transitions to the statement of the next Tchaikovsky theme by various chamber music instruments from the violins to the trumpets and clarinets. Schooler exhibits his graceful piano technique with various sixteenth-note harmonic arpeggios behind the newest Tchaikovsky theme.

While the many seemingly abrupt stylistic, orchestral, timbral, and rhythmic changes would have been unusual for many swing or sweet bands—especially for those who developed reputations as one or the other, and further for those who tried to establish a distinct sound through an overall continuity of arrangements, soloists, and orchestrations—these techniques became associated with sweet female orchestras during the 1940s because of the visually and aurally mediated genre of SOUNDIES. Bands with famous soloists, directors, and composers like Duke Ellington's or Benny Goodman's worked hard to establish their overall band personalities. Goodman became the

"king" of swing, not only because of his individual soloing capabilities, but, in part, because of the unique arrangements provided by black arranger Fletcher Henderson, in combination with the highly polished sound produced by the musicians under Goodman's direction.

Conversely, the 21 Swinghearts' mixture of swing and classical performance forms, techniques, and arrangements drew from common musical practices of mixing high and low and masculine and feminine genres. Classical, sweet, and swing allegiances and ruptures, manifested through arrangements, ensemble organizations, and rhythmic interpretations, appeared more natural for groups of women mediating and reinvigorating a history of private classical music-making.

"Sweet" all-girl bands excelled in many genres ranging from highly orchestrated original jazz arrangements with strings, to a variety of light classical works, including romantic ballads, choral arrangements of hymns, popular vocal songs, film music, and patriotic marches. Many of the classical melodies refashioned for big bands with strings were often arranged with syncopated backdrops. By "swinging the classics," musical themes and motives were cut up, augmented, and rhythmically developed, and often performed

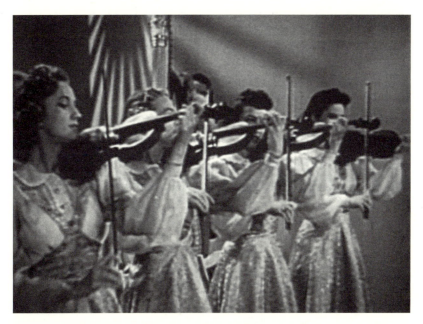

Figure 6.10. The 21 Swinghearts' string section in *Tchaikovskiana* (Minoco Productions 1941). Courtesy Fred MacDonald.

with a "rickety-tickety" articulation technique whereby instrumentalists would syncopate, but not entirely swing, eighth-notes. Dave Schooler and his 21 Musical Swinghearts perfected this type of musical performance with their many semiclassical syncopated arrangements. Some of the pieces they recorded as SOUNDIES were transformed from the well-known classical melodies of Tchaikovsky, Ravel, and Mozart. Schooler, a classical pianist, often arranged and performed extended variations of popular classical melodies as the featured soloist with his Musical Swinghearts.

Many all-girl bands featured classic tunes "jazzed up" for their stage shows, films, and theater performances. During the 1930s and 1940s, stage shows differed from dance bands in their various musical repertoires and entertainment functions. Indeed, most big bands maintained separate books for dances and stage shows to accommodate the needs of dancers and listeners. During the 1940s, audiences attended stage shows to sit passively and enjoy the various acts presented intermittently with the musical selections of the swing band. Stage shows often featured dancers, acrobats, comedians and singers, providing an entire evening's spectacle.

By comparing various recorded interpretations of some of the more popular, sweet, big band arrangements, one gains a broader understanding of the shared repertoires of female big bands with male bands. Simply situating these performances side by side encourages one to determine if a decidedly feminine performance style evolved during the 1930s and 1940s that significantly differed from male performances. Further, recognizing that male swing bands also performed, recorded, and arranged their own versions of these classical melodies eradicates the notion that "swinging the classics" was an exclusively feminine musical trend.

While black male stars were often underrepresented visually and deracinated by the fetishization of the recorded object, white female stars were valued for their physical appearance and sex appeal. Presumably, all-girl big bands failed to garner the attention of avid jazz collectors because of their primary function as pleasing pictures, sex objects, and pinups. While white "negrophiles" collected "hot" recordings of nonvisible black bands, black all-girl bands were often peripheralized and trivialized for their assumed purely physical and visual appeal. This skewed emphasis, in part, accounts for the record-breaking attendances at live performances, the number of musical films produced, and the near absence of extant recordings and dedicated reviews.

Bands like Ada Leonard's All-American Girl Orchestra, Rita Rio's Mistresses of Rhythm, and Thelma White's All-Girl Orchestra profited from the perceived sex appeal of their theatrical bandleaders. The physical appearance of female bandleaders became the selling point for these groups as

lead women sang, danced, and wore dresses and costumes that augmented their female sexuality. Frequently these female bandleaders were depicted as "triple threats," a sometimes pejorative descriptor that alluded to the women's dangerous ability to seduce through overtly sexualized "jazz" (and by association black) dance styles; their ability (or lack thereof) to sing; their physical attributes and their overall ability to entertain.

The immense physicality of these bandleaders' hybridized combinations of dance and conducting mediated and refashioned dominant as well as subcultural styles of jazz dance. Black rhythm and notions of black music became vessels for the presentation of extreme emotions. Despite bandleaders' physical creativity and ingenuity, their filmed performances inevitably facilitated a male gaze that transgressed racial boundaries and fetishized miscegenistic fantasies. As highly sexualized dancers, pulsating to the "hottest" jazz music, women became the object of a nondiscursive, yet highly racialized male psyche, much in the same way that the glamorous Lena Horne became the most popular object of transgressive racial desire by white soldiers during the war.[29]

Women leaders like Thelma White and Ada Leonard provided pinup sexuality with the contagious and symbolic dance rhythms of swing and boogie-woogie and thus delivered the most desired popular music of the day in a way that was deemed acceptable, even promoted by Hollywood and the war industry. Despite the highly gendered, sexualized, and racialized configuration of these visual and aural combinations, female musicians managed to have their day with brief instances of taking off, improvising, and performing for the most prestigious mediums developed to accommodate the mass-culture forums of radio and film.

CHAPTER SEVEN

Swing-Centered Films and the Hour of Charm

✪

During the 1940s, feature films, inspired by the variety of musical SOUND-
IES and shorts, began incorporating filmed vignettes of music and dance by
leading musicians of various races and cultures into their predominantly
white Hollywood productions. Louis Armstrong, America's favorite trum-
peter, scatter, and jazz personality, cameoed in such lily-white films as *Pen-
nies from Heaven* (1936), *Birth of the Blues* (1941), and *Atlantic City*
(1944). Benny Goodman and Count Basie supported Kay Kyser in *Stage
Door Canteen* (1943) to entertain an interracial group of American GI jit-
terbuggers. In the same era, *Airforce* presented a multiethnic crew flying
toward Pearl Harbor as they heard Roosevelt's declaration of war. This
proclamation was followed by Ellington's "It Don't Mean a Thing if It
Ain't Got That Swing." (Stowe: 184).[1]

For the most part, male musicians and bandleaders in film were de-
picted either as fictitious bandleaders or as themselves. Glenn Miller
starred in two 1940s films in one of which he played himself, in the other
the leader of a touring orchestra with a fictitious name. In *Orchestra Wives*
(1942), Miller is cast as Gene Morrison, the director and trombone soloist
for a popular swing band touring the country. Miller's role generally con-
sists of leading the band and advising band members about the appropri-
ate behavior toward wives and girlfriends while on tour. In another swing-
centered musical, *Sun Valley Serenade* (1941), Miller's band again features
prominently throughout the film as an unknown band trying to break into
the big time. Again Miller is featured as a bandleader and soloist, although
his character has few lines. When he does speak, he hardly reinvents him-
self for this dramatic task. Throughout the film, rehearsal scenes provide
the context for the band's most popular songs, including "In the Mood"

and "Chattanooga Choo Choo." The musicians are presented as professional men, leading lives of rehearsals, tours, and gigs.

A number of 1940s Hollywood films presented plots that facilitated the rather underrepresented collaboration of both black and white jazz musicians. In *A Song Is Born* (1947), for example, Danny Kaye plays a music professor who discovers the many unique voices of jazz while conducting "field" research for his "History of Jazz." After visiting ballrooms, nightclubs, juke joints, and rent parties, Kaye convinces various jazz personalities to contribute to a roundtable discussion about the origins of this new music. One such seminar involved a mass jam session that culminated with Benny Goodman (cast as the classical woodwind professor) learning to play jazz for the first time from the likes of Louis Armstrong, Lionel Hampton, Gene Krupa, Charlie Barnett, Tommy Dorsey, and Louis Bellson. Here Kaye (as a good ethnomusicologist) delineates the history of jazz from Africa to Latin America and finally to North America with aural examples provided by the many jazz musicians. The musicians interact mostly as improvisers and are unable to articulate in words the processes and patterns of this mysterious, yet contagious "hot" jazz.

Women musicians in films featuring the most popular swing bands were typically depicted as dancers or jazz vocalists touring with male jazz bands, while less frequently as female instrumental soloists or all-girl bands. As jazz singers, they were often presented as manipulative, morally suspect, and sexually promiscuous women who were necessarily "dealt with" by ultimately removing them from the bands in which they performed. In *Orchestra Wives* (1942), for example, the band's female singer is perhaps the most cynical, manipulative, as well as aggressive of all the female characters, especially in her approach to sexuality. She is presented as an unmarried woman who pursues sexual relationships with the male musicians even while they dabble with young women after shows. However, her presence on the road proves to be too great a threat to the orchestra wives and they therefore conspire to have her removed from the performing ensemble. In *A Song Is Born* (1947), the female lead is presented as a sexpot torch singer with associations to the mob who seeks asylum in the cloistered towers of a Manhattan music conservatory in order to avoid being linked to a recent murder. The singer's sexually charged character continually causes the professors to act below their intellectual capacities. Kaye as the headmaster, leading the jazz history project, demands that the jazz singer leave the conservatory. He justifies his decision by claiming that his work with other jazz musicians should ultimately involve only men and that her presence is felt to be too dangerous and distracting.

A third and final example of the excision of women musicians from the very male world of jazz performance is epitomized by the performance of the Glenn Miller band's lead singer, Vivian (played by Lynn Bari) in *Sun Valley Serenade* (1941). Here Vivian is presented as a highly temperamental diva who demands that the band cater exclusively to her featured vocal numbers. Eventually Vivian's character is pitted against a young, single, Norwegian "refugee" in a contest to win the heart of the band's leading arranger and pianist. Throughout the film, Vivian becomes more controlling as she competes against the younger and aspiring housewife. Ultimately, the singer loses and leaves the band to pursue her career in the city.

It is evident from these examples that women musicians who appeared with male bands were presented as morally suspect, overambitious, manipulative characters. Their presence continually threatened both the creativity of male jazz bands and the sanctity of the cult of white women's housewifery. In each case, the female singers were removed from their posts in order for more traditional male/female relationships to prevail. In *A Song Is Born*, the torch singer's associations to jazz link her with the underworld culture or gangsters, crime, and sexual proprietorship. In *Sun Valley Serenade*, the band's leading vocalist, Vivian, is represented as uncooperative—and by definition undemocratic—in her approach to performance and rehearsals. These presentations were in striking contrast to current notions about the utopian potential of big band jazz with its mixture of ensemble cooperation and individual instrumental improvisation. Vivian's character demanded too much, musically and personally, from her male counterparts. Finally in *Orchestra Wives*, the band's vocalist directly competes with the orchestra wives, thereby threatening the sanctified institution of marriage. Her character enjoys far too much freedom, sexually and musically, as she leads a life of late-night performances and multiple romantic relationships. Again her character's freedoms are sacrificed for the greater good of the all-male orchestra and their marriages to nonperforming women.

Conversely, women musicians rarely played themselves as bandleaders or as professional musicians. Typically, plots involving female musicians required performing contexts, which avoided the usual jazz venues of bars, ballrooms, and theaters. Exceptions included guest soloists Hazel Scott and Lena Horne, both starring in MGM's box office blockbuster musical films during the 1940s; and Ina Ray Hutton, with her all-male band in *Ever since Venus* (1944), where Hutton appears as the leader of an all-male band. Nonetheless, all-girl bands appeared infrequently compared to male bands in feature-length films during the 1940s (with the exception of Phil Spitalny's Hour of Charm Orchestra, who starred in two Hollywood features,

Universal's *When Johnny Comes Marching Home* (1943) and Abbott and Costello's musical comedy *Here Come the Co-Eds* ([1945]). However, the Hour of Charm's female musicians in *Here Come the Co-eds* are not presented as professionals but rather as college girls studying music in the safe confines of a university music appreciation class. In *When Johnny Comes Marching Home*, the women of the Hour of Charm are not conceived of as serious touring musicians but rather as temporary fill-ins for the boys abroad. I return to these two films later in this chapter.

Phil Spitalny's Hour of Charm and Hollywood's Cult of White Womanhood

Phil Spitalny's Hour of Charm Orchestra, sponsored by the most powerful and affluent movie mogul, Adolph Zukor, produced more short subject films than any other all-girl band except for Ina Ray Hutton and her Melodears. Most Spitalny shorts were produced exclusively for Zukor's Universal Pictures. During the 1930s, the Hour of Charm starred in several two-reelers with catchy titles that emphasized the women's femininity, and, of course their endless supply of charm. The ladies were perpetually waiting to charm their audiences and did so in the films *Moments of Charm* (1939), *Musical Charmers* (1936), *Big City Fantasy* (1934) and *Phil Spitalny and His Musical Queens* (1934). Significantly, the Hour of Charm's 1930s shorts prominently influenced their 1940s feminized musical image.

Sherrie Tucker convincingly reveals how the Hour of Charm self-consciously constructed a feminine musicality that signified a middle- and upper-class white womanhood. She argues that the commercial success of the orchestra, in the context of a generally hostile 1940s musical environment—where women were perceived as stealing jobs from more qualified male musicians—was only possible because of the group's carefully crafted publicity, which highlighted the women's musical (as opposed to professional) "accomplishments" and their affinity for upper-class domestic leisure activities (Tucker 2000b, 90–92).

The cultural breeding of the Hour of Charm orchestra was frequently referenced in publicity that regularly alluded to the various women's educational and musical upbringing. Prior to their film debut, Spitalny's female musicians were broadcast weekly on NBC's national radio show, the *Hour of Charm* beginning in 1934. During this show, references to individual musical training and professional experiences were overshadowed by descriptions of the woman's particular hobbies and domestic interests.

In the following discussion, I examine the strategies and representations for filming the Hour of Charm in various Hollywood swing-centered films

of the war era. Of the many 1940s all-girl bands, Phil Spitalny's Hour of Charm orchestra was certainly the most visible as well as profitable all-girl band; significantly, they also presented the most conservative feminine image. The Hour of Charm orchestra most successfully mastered the "cult of white womanhood" in their highly stylized presentation of musical femininity and repertoire of light orchestral and popular songs in their 1930s musical shorts and 1940s feature length films.

When Johnny Comes Marching Home

It was a neat thought to introduce Spitalny's musicians as an answer to the drafting of musicians.
— *Hollywood Reporter*, 21 December 1942

Spitalny is briefly introduced, just so the audience knows who he is, and from then on he's in the background to focus attention on the musical and vocal accomplishments of his girls in addition to grouping orchestra on varied level platforms for maximum camera effects on musical numbers Various specialists of Spitalny group are provided with opportunities for close-ups of their musical accomplishments on specific instruments, with Evelyn and her violin given special prominence. Camera angles and special lighting accentuate the band staging.
—*Variety*, 23 December 1942

Mr. Jones and Miss Jean are very pleasant singers, indeed; the Phil Spitalny band is most proficient in making sweet music, and the Four Step Brothers know how to move their feet, but either singly or all together, as in the case of "When Johnny Comes Marching Home," there is a limit to this sort of thing. In this instance Universal is way out of bounds.
— *New York Times*, 5 March 1943

These reviews of the Hour of Charm's contribution to Universal's 1942 feature film, *When Johnny Comes Marching Home,* reinforced the band's convincing construction of a feminine representation that cleverly enabled these professional women to perform as expert musicians while successfully distancing them from the world of professional male musicians. *Variety*'s description emphasized the ensemble's "orchestral" musical "accomplishments" as well as the visual aspects of the band's performances. The emphasis upon "girls'" musical accomplishments linked these women to a nonprofessional, collegiate musical culture, where women were showcased as feminine musical objects and not as professionals playing in a band.

The *New York Times'* review flippantly conveyed current notions about the way gender and race were rendered in cinematic texts. The reviewer's association of black dance to the mundane physicality of the body ("move their feet") as well as the necessary allusion of gender with "sweet" music, betrayed common assumptions about both black and feminine contributions to film during the 1940s, where both groups were denied creative agency and generally excluded from the individual artistic conception of a film. One is left wondering in what respects Universal is "out of bounds," whether in the

racial mixing of white women with black male dancers or in the many featured appearances of these expert female musicians. The Hour of Charm performed more than twelve musical numbers in this popular feature film, and such exposure was rare even for the most popular male bands of the day.

Phil Spitalny and his Hour of Charm Orchestra are central to the drama of this patriotic war film. Johnny, the leading man of this propaganda flick, returns home from military service on furlough to a hero's welcome as the nation's most celebrated fighter "Johnny Kovacs." Upon making the rounds in his native Irish neighborhood, Johnny visits the nightclub where he once sang under the stage name Johnny O'Rourke. Upon seeing the band, Johnny is surprised to find not the familiar male musicians he used to perform with, but instead an all-girl band, the Hour of Charm Orchestra, the club's substitute band during the war. The dialogue between Johnny and one of his younger neighborhood buddies, Donald, is revealing:

JOHNNY: The fellas are really hitting it up, won't they be surprised when they see me . . .
DONALD: Won't they be surprised when they see you . . .
Johnny enters the club and sees the band.
JOHNNY: Girls! Why, they're all girls.
DONALD: You're a genius.
JOHNNY: What happened to Bill and Joe? What did Phil do with them?
DONALD: You think you're the only guy that can get a good idea and enlist?
JOHNNY: Oh, you mean they're all in the army?
DONALD: No some are in the navy and the marines too. It's war, bub, total war.

Here the film's dialogue reinforces the idea of women politely replacing male musicians during the war to bolster morale and provide entertainment for the folks at home.

Later in the film, Johnny returns to the lodging house that also accommodates the women from the Hour of Charm during their run at the Coronet. Johnny nonchalantly enters the boarding house parlor, where some of the women are lounging, knitting, or reading while one of the pianists accompanies Joyce (the band's female vocal soloist) in a light Italian operatic aria. During the bridge, the pianist briefly hints at some heavy-handed stride piano with a quick furtive glance to the camera, as if she had "gotten" away with slipping in some "racy" music, or rather, music more commonly associated with black, male musicians. More frequently during the 1940s, women musicians in the Hour of Charm were featured as classical soloists performing composed material with the occasional eight-bar jazz, boogie-woogie, or blues solo. Indeed, more than half of the musical features performed by the Hour of Charm highlight the women's classical musical capabilities.

The musical repertoire of *When Johnny Comes Marching Home* also features a number of popular songs that would have been familiar to audiences previewing the film. These include such vocal standards as "Say It with Dancing," "My Little Dream Girl," "American Patrol," "The Yanks Are Coming" and a serious and dramatic chorale arrangement of "This Is Worth Fighting For." The notion that women should and could more aptly facilitate common or familiar tunes was reinforced by the film's musical selections. Only one original jazz piece, "Jazz Etude" was featured out of twelve musical numbers. *Variety* pointed out the group's familiar repertoire.

Total of 12 numbers, mostly familiar as standards, are presented in song, orchestral and choral arrangements all backed up by excellent musical arrangements and presentations by Spitalny and his girl aggregation. . . . The Spitalny orchestra and the maestro's famed choral group are on display for collective and individual attention.
(*Variety*, 23 December 1942, 8)

Evelyn, the only musician given special billing in the film, is known only by her first name. Her reputation as a master concert performer is partially negated by the absence of her last name and by the allusion to her "magic violin" on programs and posters. She is variously depicted not as an esteemed symphonic soloist, but rather as a folk musician with connections to otherworldly musics. One *Hollywood Reporter* review depicted her special music as "gypsy music . . . one of the highlights of this attraction" and in doing so, further distanced her from the Western art tradition of male soloists (*Hollywood Reporter*, 21 December 1942, 3).

Many female musicians from the 1940s were versatile in "longhair" music and "hot" music as well as various forms of popular music. Indeed the band's musical sequence at the Coronet begins with some hot jazz as they play a number featuring two soloists on a boogie-woogie blues. The second number features Evelyn Kaye and her "magic violin" on a virtuosic Russian theme, "Red Sarafia" with a legitimate chamber orchestral accompaniment. This Khachaturian-like concerto brilliantly displays Evelyn's talent. Finally, the band introduces a romantic ballad with the band's leading female singer, Joyce Benton. The last number is a patriotic hymn of all the girls singing in four-part harmony, wearing pristine white gowns that imbued them with a reverent or angelic quality. As if to legitimate their musical presence in the film, their final number "This Is Worth Fighting For" reassures audiences of their special, patriotic, feminine responsibilities.

Here Come the Co-Eds

In the Hour of Charm's second Hollywood film, *Here Come the Co-eds*, Universal presented the musicians as women who not only played instruments

but also sang; women who sang not as jazz singers and beboppers but as choral singers, collaborating in four-part harmony to sing sweet patriotic hymns and ballads. In this Abbott and Costello feature film, the Hour of Charm Orchestra appears in several scenes as the female college's school orchestra *and* choir. Reviews of the band's contribution to the film all highlighted its soothing and sweet musical style. A *Motion Picture Herald* reviewer wrote "Phil Spitalny and his all-girl orchestra add pleasant moments in a quieter mood" ("Here Comes the Coeds" 1945). The *New York Times* similarly noted the band's soft side: "The Phil Spitalny band is most proficient in making sweet music" (19 February 1945, 11). Finally, a 1945 review by the *Hollywood Reporter* lauded the band's sweet music: "Some great music delivery by Phil Spitalny and his doll orchestra. This charming ensemble contributes a large share of the entertainment, soothing that part of the audience which wearied of the film's constant slapstick"(26 February 1945, 10).

In both reviews, allusions to the band's soothing side, as well as the convincing presentation of a Victorian femininity are contrasted with the overbearing and presumed masculinity of Abbott and Costello's comedy. This dichotomy setup between the vulgar masculinity of the male stars in the film and the sentimentalized femininity of the female musicians was essential for the group's success.

Army Navy Screen Magazine—*"Letter From Iran"*

During the 1940s, The Hour of Charm was also featured in short subject films, many of which presented patriotic musical themes and sequences, as in one sponsored by the *Army Navy Screen Magazine* entitled "Letter from Iran" (figs. 7.1–7.5). The film is presented as a musical response to a World War II soldier's correspondence—dramatically read onscreen by an attractive, yet matronly female narrator who assures the viewers that the boys in the Persian Gulf are "in for a real musical treat." The letter requests a musical performance of the new musical *Oklahoma,* which the soldier first heard hummed by a nurse who, he claimed, had trouble remembering the words. In this musical short, Spitalny's orchestra performs an arrangement of the newly released Rodgers and Hammerstein hit song "People Will Say We're in Love" from the Broadway production of *Oklahoma.* This film begins with the obvious feminine musical signifiers of church bells and harp flourishes before the initial statement of the verse rendered by a trumpet soli. An accordion soloist is featured for the second verse, this time performed by a lovely smiling blonde. The B section of the verse highlights the band's featured violin soloists, Evelyn (and her magic violin) accompanied by her six co-violins.

Figure 7.1. Phil Spitalny and his Hour of Charm Orchestra in "Letter from Iran," *Army Navy Screen Magazine*, No. 22. Courtesy Fred MacDonald.

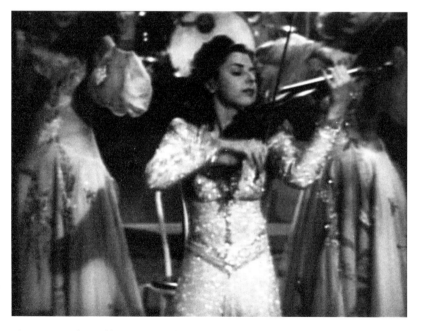

Figure 7.2. Evelyn and her "magic violin" in "Letter from Iran," *Army Navy Screen Magazine*, No. 22. Courtesy Fred MacDonald.

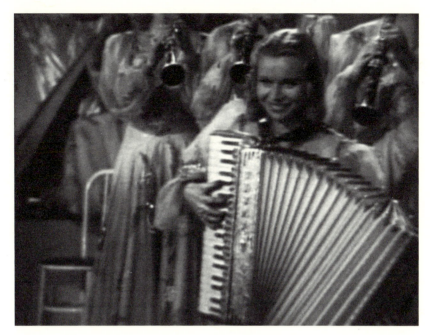

Figure 7.3. The Hour of Charm's accordion soloist in "Letter from Iran," *Army Navy Screen Magazine*, No. 22. Courtesy Fred MacDonald.

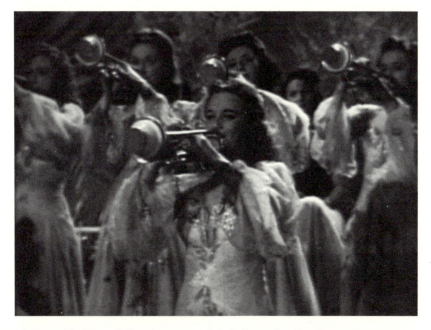

Figure 7.4. The Hour of Charm's trumpet soloist in "Letter from Iran," *Army Navy Screen Magazine*, No. 22. Courtesy Fred MacDonald.

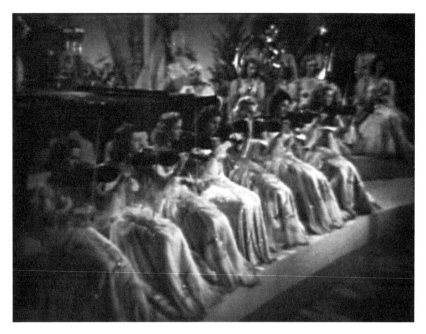

Figure 7.5. The Hour of Charm's string section in "Letter from Iran," *Army Navy Screen Magazine*, No. 22. Courtesy Fred MacDonald.

Then Vivian introduces the choir with, "I'm Vivian, now all the girls who are playing for you are forming a choir." And as if to make the vocal musical attributes of the women even clearer, she continues: "As you know, everyone who plays in the orchestra and plays an instrument also sings." As was the case for many white all-girl orchestras, the female musicians were often required to perform a number of musical tasks, with singing reigning supreme on the gendered musical hierarchy. Usually the ability to sing was mentioned in classified ads for girl musicians in the music trade papers. *Down Beat* ran one advertisement that explicitly requested a singing trumpet player: "WANTED: GIRL TRUMPET, young, attractive, sing, read and fake, union, for well-known combo, location work. Write experience, doubles if any. Send photo immediately. This is the opportunity for the right girl" (*Down Beat* 1 April 1941, 23).

The physical arrangement of the various instrumental sections further demarcated the gendered identity of the Hour of Charm. Most prominent and visible on the set are the traditionally feminine instruments of the strings, the pianos (the Hour of Charm had two) and the harp. Beyond the first row of violins, and somewhat out of focus, are the brass players and the saxophones, equally decorated in multilayered ball gowns. While the spatial prominence of the more feminine instruments of strings and pianos

was obvious, the aural femininity of "People Will Say We're in Love" was equally convincing: it was expressed by a number of sonic signifiers, including an arrangement that rendered its first musical sound by a flourish of the harp followed by a saccharine version of the tune played in unison by the strings. These visual and aural cues signaled a Victorian sensibility suggestive of well-to-do young women playing the classics in parlors for family, social acquaintances, or potential suitors. Again, the cult of white womanhood is tantamount to such musical representations.

Finally, the feminine tropes of humility and devotion were articulated by the women's last musical variation as they forgo their instruments and form a choir. The nonsensical syllables vocally arpeggiated by the choir provide the supporting harmonies for the four female soloists singing a light syncopated style. Here, the musical tone suggests childlike playfulness. The closing statement of the tune is presented as a rather somber SSAA chorale with harmonies delivered in long, slow, dramatic open-voicings, suggesting the seriousness and sincerity of the women's devotion to the men abroad. For the finale, the women stand in four neat rows in near darkness hallowed by incandescent light as they deliver their slow patriotic hymn.

Other female society orchestras, undoubtedly inspired by the highly visible success of the Hour of Charm, were groups of accomplished jazz and classical soloists led by classically trained male maestros. These conductors often featured themselves as concert soloists with the female bands. Conductors like Dave Schooler, accompanied by his 21 Swinghearts, performed a variety of concertos and light classical works that highlighted his brilliant classical technique.

Spitalny and Schooler consistently performed in tails or tuxedos, while the women musicians were elaborately dressed in billowing gowns with an endless array of ruffles, lace, and floral embellishments. While the maestro's uniforms signified class, wealth, and high art, the women's uniforms conjured images of cultured white women, Saturday-night prom dates or Hollywood images of southern belles.

The International Sweethearts of Rhythm and Independent Black Sound Film

The International Sweethearts of Rhythm, world famous all-Colored girl's orchestra . . . are
an absolutely unequaled combination of charm and of talent.
—*New York Age*, 11 December 1948

Frequently praised by critics and fans alike, the International Sweethearts of Rhythm gained a reputation not solely for their unparalleled musical capabilities but also for the visual image that they presented: one of charming, talented, respectable jazz musicians who showcased diverse cultural backgrounds and races. Indeed, the group was frequently depicted in press releases as a group of talented jazz women representing the beautiful "black and brown" races of the world.[1] Since the release of Sherrie Tucker's (2000b) recent book on the all-girl jazz bands active during the 1940s as well as D. Antoinette Handy's (1983) earlier historical account of the International Sweethearts of Rhythm, jazz scholars, feminists, and fans of the unprecedented predominantly black, all-girl band from Piney Woods, Mississippi, have come to know a great deal about this hard-swinging, professional female band that was extremely popular during the 1940s.

In this chapter, I examine the musical and visual performances of the International Sweethearts of Rhythm in an all-black cast film entitled *That Man of Mine* (1946) in the context of independent black musical films and black theatrical forms. By connecting the musical, gendered, and racial representations of these jazz women with other gendered performative texts during the 1930s and 1940s, I suggest that both William Alexander, the independent African American director of the film, and the female musicians of the International Sweethearts of Rhythm exploited the combined musical, visual, and narrative capabilities of sound film to propose a more flexible identity for female jazz musicians, one that began to challenge proscribed racial

interactions by featuring the unprecedented culturally and racially integrated International Sweethearts of Rhythm in 1946.

The International Sweethearts of Rhythm's many musical appearances in *That Man of Mine* draw from a unique tradition of all-black-cast musical films dating from the 1920s; they also, however, acknowledge more dominant white musical film conventions and styles that were popular during the 1930s and 1940s, including the "making of a musical" film formula. Alexander's presentation of the International Sweethearts of Rhythm reveals, first, his intimate knowledge of black musical film genres from the 1930s and 1940s including the all-black-cast film musicals such as *Cabin in the Sky* (1943), the short subject and sometimes avant-garde jazz films like Duke Ellington's *Symphony in Black* (1935); and, second, familiarity with the commercially dominant and predominantly white-cast Hollywood musicals of the 1930s and 1940s epitomized by the lavish Busby Berkeley musicals.

I further argue that the particular choices for representing the International Sweethearts of Rhythm in *That Man of Mine* were more likely influenced by prior and persistent visual, cultural, and racial representations of African American female performers than by the world-famous African American male jazz bands like Duke Ellington and Louis Armstrong, who similarly traveled abroad during the 1930s and 1940s. Most pervasive of these various African American representations were the highly caricatured and hypersexualized "Jezebels," the controversial but popular black chorus girl acts (the Cotton Club dancers, for example), and stars like Josephine Baker and Valaida Snow, who began their careers with black theatrical companies as chorus girls and eventually headlined these productions, often traveling and working abroad in mixed theatrical settings for predominantly European audiences (Brown 2001; Haney 1981; Francis 2004).

Feminist scholars have begun to unravel the controversial yet prominent status of performing women and especially blues singers and chorus girls during the 1920s and 1930s. Hunter (2000), Harrison (1990), and Carby (1994) investigate the racial and social politics and ideologies mediated by theatrical blues women in a variety of contexts, including black music theater circuits, dance halls, race recordings, and Hollywood films. Other scholars take seriously the influence of African American theatrical stars, especially chorus women, upon American culture during the 1920s and 1930s; for example, Brown (2001), Bogle (1980), Woll (1989), and Francis (2004). By examining chorus girls' relationship to mass-mediated performance contexts and by further illuminating the sheer volume of discourse surrounding the "chorus girl problem," writers like Brown (2001), Glenn (2000), and Latham (2000) uncover the radical gender transformations initiated by these highly popular and profitable gendered performances.

Brown's (2001) work reveals how African American chorus girls in particular symbolized many of the paradoxes of the Jazz Age: these women simultaneously embodied financial and social independence but were frequently criticized in the conservative black press as profiting from dominant white fantasies. Her research focuses upon the widely popular African American female entertainers of the 1920s and 1930s, when African American theatrical performers assumed prominence.

Because of the international prestige of black musical and theatrical forms, it is likely that the International Sweethearts of Rhythm would have been conscious of the kinds of female representations circulated. Moreover, the Sweethearts frequently performed in variety revues and stage shows (in film houses) and thus had firsthand exposure to female stars like Valaida Snow and the famous dancing "chorines."

The Sweethearts would have also been privy to the time-tested practice within the dominant entertainment industry of looking to black sources for regeneration and inspiration; white theatrical productions often borrowed, imitated, and reformulated urban black artistic forms like jazz dance and black musical forms like blues, ragtime, and jazz. Glenn (2000) and Latham (2000) point out the racial and sexual complexities of white choruswomen's performances, many of which imitated dance styles from celebrated black jazz and theatrical artists, incorporated blackface routines, and often favored hot jazz accompaniments, a musical genre that inspired a variety of racialized associations by vaudeville fans, journalists, and theatrical promoters (Radano 2000; Rogin 1996; Agawu 1995). While white chorus-girl acts performing on variety revue circuits earned more than black chorus-girl acts, they also contended with certain dominant notions of performed sexuality, as well as blackness and its assumed association with jazz and popular dance. Their performative choices were more flexible than for black chorus girls who also performed in white variety revues, in black and tans or in short subject musical films.

William Alexander and Black Filmmaking

Since the 1940s, some of the musical sequences from *That Man of Mine* have been rereleased at various times; first as SOUNDIES during the mid-1940s and then during the 1980s and 1990s. Both SOUNDIES and musical scenes from the film were incorporated into various compilation films, documentaries, and videos with the subject of women in jazz. During the 1940s, independent film producer William Alexander cut and recast musical numbers from *That Man of Mine* as short subject musical films and then sold them to be distributed as SOUNDIES by the Soundies Distributing Corporation of America.

For example, Alexander's short subject film *Harlem Jam Session* (1946) consisted of three numbers from *That Man of Mine*: "Harlem Jam Session," "Don't Get It Twisted," and "Just the Thing."

In the mid-1980s, at the onset of the third-wave feminist movement,[2] filmmakers Greta Schiller and Andrea Weiss produced and directed a documentary about the International Sweethearts of Rhythm (1986) in collaboration with female jazz collector and record distributor Rosetta Reitz. The film incorporated several of the SOUNDIES recut from *That Man of Mine* in combination with other film footage, interviews, photos, and a historical narrative of the International Sweethearts of Rhythm's profound and radical breakdown of racial and gendered barriers during the 1940s.[3] In 1990, Rosetta Reitz included the International Sweethearts of Rhythm's filmed recording of "Jump Children" (not featured in *That Man of Mine* but recorded the same year) in her *Women in Jazz* compilation video, which also included vocalists Billie Holiday, Rosetta Thorp, Ida Cox, Nina Mae McKinney, and Rita Rio and her Mistresses of Rhythm. Finally in 1993, another collection of all-girl bands was released on a video entitled simply *All-Girl Jazz Bands* (Storyville, 1993), a film that included one selection by the International Sweethearts of Rhythm and several others by Ina Ray Hutton and her Melodears, Lorraine Page and her Orchestra, Rita Rio and her Mistresses of Rhythm, and others. Accordingly, interested feminist jazz scholars, fans of the International Sweethearts of Rhythm and sound film scholars may have unwittingly encountered scenes from Alexander's original 1946 film *That Man of Mine* from any of these SOUNDIES, compilation films, documentaries, and videos.

Within this chapter, I present a detailed historical and cultural analysis of *That Man of Mine* while highlighting the International Sweethearts of Rhythms' contributions to the film. I then compare the practice of sidelining by all-girl bands to the professional filmed appearances of the International Sweethearts of Rhythm. Finally, I examine the lack of scholarship written about the International Sweethearts of Rhythm's musical films and, more generally, of all-girl bands in film, especially considering the large number of musical films produced during the 1930s and 1940s.

The International Sweethearts of Rhythm and Independent Black Film

Pretty Margie Pettiford, one of the sixteen charming and talented girls who make up the International Sweethearts of Rhythm, America's versatile all-girl orchestra.
— *New York Age*, 1 April 1943

The International Sweethearts of Rhythm was one of only a few predominantly black all-girl bands to perform in SOUNDIES and short subject

films during the 1940s.[4] William Alexander, an entrepreneurial black film-maker from New York, first filmed this band under the auspices of his Alexander Productions Company. Alexander was one of a few black filmmakers to be employed during World War II by the Office of War Information for the purpose of creating patriotic black films to bolster morale for the soldiers at home and abroad. Together with Hollywood veteran Emmanuel Glucksman and Claude Barnett, founder of the Associated Negro Press, Alexander's All-American Films was the only predominantly black-owned film company to survive the war (Cripps 1993, 132). Black film historian, Thomas Cripps locates the impetus for Alexander's patriotic films during the war:

Why not, said an agency report on black morale, make a few "morale building all-Negro films" and play them off in ghettos and "camp movie houses that served exclusively black soldiers." In this way, said an OWI man, they might exploit "all-Negro" theaters and their midnight shows by engaging "a private company" . . . to do films glorifying Negro military heroes, something in the manner of "Sergeant York" or even "Abbott and Costello" comedies "with an Army background."[5]

Like other black filmmakers of the 1930s and 1940s, Alexander worked in collaboration with established liberal white producers, most notably Emmanuel Glucksman. Together with Glucksman, Alexander successfully produced the *American Newsreel Magazine* film series for All-American Films. Cripps identified these white corporate "angles" as necessary partnerships for black entrepreneurs and filmmakers who were otherwise prohibited or had little access to state-of-the-art motion picture facilities, much less the necessary relationships with the major theater chains to garner much-needed contracts in the North and South for showing privileges (Cripps 1978, 38).

Alexander's film reveals a connection to the earlier "uplift" and "race pride" aesthetics articulated by Harlem Renaissance writers, political leaders, and filmmakers who promoted and encouraged African Americans' educational and cultural contributions to the improvement and advancement of the race. By incorporating themes of race pride and uplift through self-betterment, creativity, and moral conviction, black sound-film makers reinterpreted a strategy first articulated during the middle of the second decade of the twentieth century. Since the silent film era, black filmmakers had incorporated themes of racial pride and uplift as well as represented the assimilationist aspirations of black elites and the black middle class as they attempted to create more positive and serious race representations in film.

Jacqueline Najuma Stewart (2005) examines the movement by black-owned film companies to support and program black films with uplift themes during the silent film era. As early as 1916, the Lincoln Motion

Picture Company and the Micheaux Booking and Film Company "appealed to black audiences by focusing their efforts on producing 'high' dramas rather than 'low' comedies" (Stewart 2005, 202). Film theater managements' advertisements similarly urged their patrons to carefully consider the bookings advertised by theaters in black neighborhoods and to further resist the "so-called all-colored comedies" that, according to these advertisements, would allow would-be patrons to "save that dime as well as your self-respect." One ad even claimed: "Some day we will have race dramas which will uplift, instead of rotten stuff which degrades" (Stewart 2005, 202). According to Stewart, both Lincoln and Micheaux promoted and advertised race-pride films like *The Realization of a Negro's Ambition* (1916) and *The Trooper of Troop K* (1916), films that were thought to have "contributed positively to the advancement of the Race" (Stewart 2005, 203). Alexander's interest in creating serious films that depicted African Americans as upstanding, diligent, and creative individuals remained consistent with the aesthetic and cultural aspirations of earlier filmmakers and film promoters like Micheaux and Lincoln.

After the war, William D. Alexander was the only black filmmaker to successfully distribute black-cast short subject musical films internationally. According to Mark Cantor,[6] Alexander was one of the only producers to make short subject films[7] independently from MGM, RKO, Universal, Monogram, Twentieth Century–Fox, Republic, or Paramount. In May 1946, Alexander organized the Associated Producers of Negro Motion Pictures to broaden the scope, financial mobility, and exposure of race films. Most likely, he also sought to centralize and advertise his films and those of other entrepreneurial black filmmakers—and perhaps, to some extent, to publicize black films made in combination with influential white producers like Dudley Murphy, Ben Hersh, William Forest Crouch, and Sam Coslow.

Alexander's probable exposure to the International Sweethearts of Rhythm during their international World War II USO tour must have inspired his first feature all-black-cast film immediately after the war. Moreover, it was Alexander's own wartime American Newsreels Inc. film company that released two other music-centered feature films that included sidelining female bands: *Tall, Tan and Terrific* (1946) and *The Big Timers* (1945). Hollywood films during and after the war also capitalized upon the mass appeal of swing and consequently scripted the most popular big bands into their musical plots. Many more of these same bands became famous during the war while performing at army and navy bases in Europe and at home. Bands like those led by Harry James, Glenn Miller, and Duke Ellington were scripted into Hollywood musical numbers with musically talented stars like Sammy Kaye, Bing Crosby, and Maureen O'Hara. Benny

Goodman and the Count Basie Orchestra were featured in a number of "swing"-inspired patriotic films, including *Sweet and Low-down* (1944) and *Stage Door Canteen* (1943), respectively. Following the model of these Hollywood musicals, Alexander choose the International Sweethearts of Rhythm, one of the most celebrated and requested American all-girl bands for his postwar film debut.

Like many film directors, Alexander efficiently recut musical numbers from his feature films and sold them to the SOUNDIES Distributing Corporation of America who then distributed them as SOUNDIES during and after the war. SOUNDIES of jazz artist Billy Eckstine were recut from Alexander's *Rhythm in a Riff* (1946) and Dizzy Gillespie shorts were refashioned from the feature *Jivin' in Bebop* (1946). He probably envisioned cutting the musical numbers out of *That Man of Mine* (1946) for release as SOUNDIES or as musical shorts. Indeed, four musical shorts of the International Sweethearts of Rhythm were produced and released as SOUNDIES in the mid-1940s under the auspices of the Associated Producers of Negro Motion Pictures or as "Alexander Production" releases. The filmmaker's competitive desire to market and distribute all-black films was most successful in his widespread distribution of black musical shorts and SOUNDIES.

That Man of Mine

That Man of Mine, an "all-black"-cast four-reel film (figs. 8.1–8.7), released shortly after the formation of Alexander's Associated Producers of Negro Motion Pictures in 1946, espoused the same moralistic tones of wartime patriotism, but displaced themes of loyalty to country with loyalty to race. On one level, the tensions in the film parallel the real-life challenges faced by black filmmakers attempting to compete with Hollywood genres. Some black filmmakers opted to recast tried-and-true formats like the glamorous 1930s musicals, simply injecting them with more appropriate cultural and racial themes. Others, like Spencer Williams, began cultivating new genres that more specifically addressed the contradictions of black patriotism in light of America's continued segregationist policies.[8] While Alexander's film remained consistent with the goals set out by the postwar, audio-visual movement—which included members of the American Council on Education, the Educational Film Library Association, and the American Film Center, promoting social change through film and broader and greater presence of black characters in Hollywood (Cripps 1997, 137)— it failed to garner much critical response either positive or negative upon the film's release.

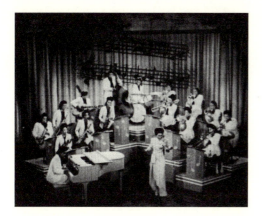

Figure 8.1. The International Sweethearts of Rhythm in *That Man of Mine* (Alexander Productions 1946). Courtesy the Library of Congress.

Alexander's presentation of the Sweethearts is unique in its portrayal of these women as serious musicians. The opening scene reveals a discussion between two very sophisticated and educated African American businesswomen about the possibility of auditioning the Sweethearts for the proposed production. We are then transported to the main theater upon the set of a daytime rehearsal where the Sweethearts are presented in professional day clothes, each wearing something different and casually working out some details before warming up on a 32-bar form. When asked to play, the band breaks into a jam session with the first chorus blown by the first trumpet player (probably Edna Williams). The trumpeter plays a couple of rotations, passing it to pianist Johnny Mae Rice, before the tenor soloist Vi Burnside blows a final chorus supported by the band's climatic shout chorus. The Sweethearts' opening number was unusual in its showcasing of many jazz soloists, as opposed to the flashy, fast-paced, and complicated arrangements presented by some of the predominantly white all-girl bands of the era; for example, with Ina Ray Hutton's prior film appearances in *The Big Broadcast* series (1936) where the band often plays fast-paced arrangements of jazz, ragtime, and Tin Pan Alley. Also, Phil Spitalny's Hour of Charm Orchestra was celebrated for its technical proficiency and ability to play both classical and jazz arrangements.[9]

The band's second number features the bandleader and vocalist Anna Mae Winburn singing a medium tempo blues. This arrangement exemplifies the succinctness of Basiesque arrangements. Finely tuned saxophone unison phrases weave the vocal stanzas together. Then the two lead trumpet players face off in a short improvised conversation in two- and four-bar breaks. Finally, the effervescent Tiny Davis sings a rougher style of blues, with the band chanting "All Right" in response to Davis's "How 'Bout That Jive?" The song ends with a flashy trumpet solo full of bravado and repetitive high-note riffs as the woodwinds showcase difficult runs and falls.

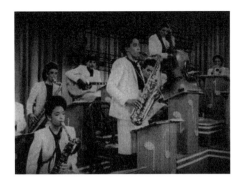

Figure 8.2. Vi Burnside solos with the Sweethearts in *That Man of Mine* (Alexander Productions 1946). Courtesy the Library of Congress.

Perhaps in response to Tiny's witty and raucous blues rendition, the two women directors then ask for another number requesting "nothing too derogatory," a comment that further signaled the "uplift" politics as well as a self-consciousness of prior black female sexual representations in film. Vi Burnside begins this final audition number with four choruses of 16-bar blues. As the blues fade out, the film returns to the office of the male producer and male director. Here the men debate the merits of serious acting and high drama versus music and dancing. At one point, the doubtful producer interjects, "You've got the have the best of everything. . . . So what else do you have but a bunch of dancers and a girl band?" Here the script betrays some of the residual stereotypes regarding female creativity and musicianship from Jazz Age African American theatrical performances. The third scene opens with the band auditioning for the male producer and director, again with a musical piece featuring many of the band's accomplished soloists. This time, the Sweethearts deliver a more arranged and chromatic jazz piece, in contrast to the earlier riff-based swing performance, and propelled by the heavy downbeats of the guitar and bass.

The next scene cuts again to the director's office where they debate the aesthetics of the potential film. Should they create high drama or sex appeal and glamour? The debate comes to the fore with the firing of the lead actress (performed by Ruby Dee in her first film appearance), who has proved herself in various serious dramatic roles. She is replaced by another woman, more glamorous and sexually appealing but also less experienced and socially inferior. The final act begins with another hot number by the Henri Woode jazz band performing an extremely up-tempo jazz arrangement with complicated, chromatic melodies more akin to bebop than swing or blues as two excellent jitterbug dancers enter the stage, following the patterns, melodies, and rhythms of the musical phrases with a finesse, athleticism, and accuracy uncommon for social dancers.

The Woode band is a smaller, seven-piece band and sounds more contemporary, even avant-garde compared to the Sweethearts.

Soon after, the Sweethearts reenter in full evening attire for their final audition, this time performing a highly complicated jazz arrangement at lightning speed as if to compete with Woode's difficult arrangement. This complicated piece affirms the women's technical expertise while also revealing their versatility in a number of musical idioms from jazz to blues, and from swing to "symphonic" arrangements. The movie ends with the producer opting for the original serious actress (who is also the director's fiancée) as opposed to the less talented, socially suspect, and sexually promiscuous street entertainer. As if to legitimate the film's timidly progressive gender angle, the Sweethearts are simultaneously congratulated for their professionalism and musical expertise and are consequently chosen as the featured musical act.

In his representation of women in *That Man of Mine,* Alexander both invokes and critiques the Western literary trope of "fallen" woman and virtuous wife (or, in Hollywood vernacular, as "slut" versus "sweetheart"). Alexander further complicates this dichotomy by (1) sanctifying more prevailing feminine representations favored by prominent black filmmakers of "respectable" black womanhood in black films; and (2) destabilizing dominant Hollywood and theatrical associations of black female entertainers as either hypersexualized theatrical performers, chorus girls, and jazz singers, or desexualized "Mammies."[10] He does so by paradoxically presenting a range of female characters, including promiscuous theatrical entertainers and dancers as well as morally upright and highly educated businesswomen. In this respect, both Alexander's and the International Sweethearts of Rhythm's musical choices directly responded to representations of African American female bodies inscribed within vaudeville and variety revue performances of the Jazz Age and the many spectacular musical films produced during the 1930s and 1940s.

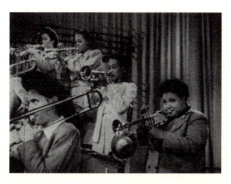

Figure 8.3. The Sweethearts brass section in *That Man of Mine* (Alexander Productions 1946). Courtesy the Library of Congress.

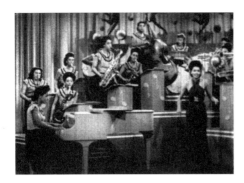

Figure 8.4. Vi Burnside's feature in *That Man of Mine* (Alexander Productions 1946). Courtesy the Library of Congress.

Feminist scholar Hazel Carby (1992) probes the female representations of African American women's bodies during the first half of the twentieth century as they were depicted in editorials, literature, and the works of celebrated Harlem Renaissance writers. Carby claims that women's bodies became contested subjects because they symbolized so many of the traumatic ruptures experienced by African Americans during and after the great urban migration. Accordingly, women's bodies embodied many of the contradictions of urban American culture as they became sites for white male desire, fantasies of miscegenation, and performative symbols of lost colonial subjects. During the 1920s and 1930s, mass-mediated African American performances incorporated images of primitive, exotic, and libidinous beings while their innovative jazz dances and vocal performances were simultaneously appropriated for their spontaneity and creativity by the dominant culture (Carby 1992).

Significantly, the Sweethearts' position in the film is secured only after they have proved themselves as serious musicians and not as sex objects, visual images, or as a "bunch of girls," with all of its allusions to novelty acts. Alexander's presentation of female musicians self-consciously negates the female stereotype favored in other predominantly white Hollywood films, which consistently presented white women musicians as feminine objects on display, musical threats to male musicians' cohesion and innovation, collegiate students, or fill-ins for male musicians who were abroad. While the moral dilemma of the film implies a broader dialectic with other all-black-cast films as well as white film genres and themes, it does so by implicating the purported socially redemptive power of music and a slightly more realistic representation of musical women. As female musicians, however, the Sweethearts are required to audition for the majority of the film before they are accepted as serious jazz instrumentalists. The Sweethearts' constant "auditioning" status was not found in swing-centered narratives featuring male bands; the professionalism and skill of male musicians like Duke Ellington

or Glenn Miller was accepted a priori. Nonetheless, in *That Man of Mine*, women are eventually treated as individuals both in their musical endeavors (though only after they have proved themselves as capable improvisers) and in their abilities as dramatic leading actresses. Such was in striking contrast to presentations of female musicians in Hollywood films of the 1940s.

Although the International Sweethearts of Rhythm are the only known example of a predominantly black, professional, all-girl band on film from this era, their presence confirms alternative artistic and political movements countering the more visible depictions of white all-girl bands in Hollywood films. William Alexander most likely chose the band because of their commercial appeal and their profound popularity with black audiences. However, consciously or not, Alexander introduced another image of jazz, one that involved a group of serious female musicians and presented them as such. Here, the women of the International Sweethearts of Rhythm are afforded a more complex relationship to the world of male jazz musicians. The women are presented as professionals and as improvisers, yet remain dissociated from the greater jazz community of juke joints, cabarets, and nightclubs. In *That Man of Mine*, the Sweethearts are both feminine (they perform in conservative full-length gowns) and serious improvisers. Their relationship to the greater jazz community, however, is never fully referenced.

Favoring the "hot" side of the jazz spectrum, most of the SOUNDIES and film appearances by the International Sweethearts of Rhythm dedicate ample time to improvisation and featured spots by the band's many fine soloists, including tenor saxophonist Vi Burnside, trumpeter Tiny Davis, and drummer Pauline Braddy. Indeed, the band's first musical selection in Alexander's film *That Man of Mine* (1946) merely presents "rhythm changes" (32-bar song form) that highlight each and every capable jazz soloist in the band. Moreover, the band's conductor, Ana Mae Winburn, is consistently presented as a bandleader and singer and never as a mere sex object. While many musical selections feature improvised solos, the band

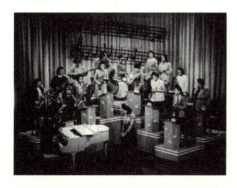

Figure 8.5. The Sweethearts warm up in day clothes in *That Man of Mine* (Alexander Productions 1946). Courtesy the Library of Congress.

also performs a good number of "flash" jazz pieces that exhibit their technical skills and solo- and unison-playing abilities. Both the Melodears and the Hour of Charm orchestra also performed a few "flash" jazz pieces to impress their audiences (and, perhaps more important, to dispel the widespread belief that women could not play with as much agility and technical proficiency as their male jazz counterparts).

The film's portrayal of these women creatively addresses their interracial makeup. Rather than directly addressing the mixed and more worrisome white, black, Asian, and Latina constituency of the group, the film presents them as an "all colored girls" unit. Shots of the band effectively obscure the "whiteness" of a few of the members with dim camera shots and hairstyles and makeup that further blur racial signifiers.

Sherrie Tucker discusses the conscious representation of the International Sweethearts of Rhythm as simultaneously "international" and "all-colored"—a strategy that contained powerful meanings for African Americans during the war, many of whom experienced more racism and sexism at home than abroad. According to Tucker, the Sweethearts' internationalism was not of a "generic variety" but rather suggested "non-European international alliances between people conceived of as black and brown" (Tucker 2000b, 185). This alignment with internationalism further proffered their connections to other prominent African American entertainers, jazz musicians, writers, and travelers who gained prestige, status, economical stability, and political prominence performing abroad via transatlantic routes (Gilroy 1993). Further, the all-colored descriptor was one way of asserting race pride and racial uplift, enabling the racially mixed constituency of the group to become a self-determined act. In this particular sense, internationalism prioritized the "blackness" and "coloredness" of the group over the whiteness of some of its members. Indeed, while touring in the Jim Crow South, white women were frequently

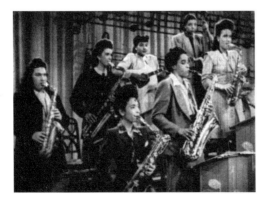

Figure 8.6. The Sweethearts' saxophone section in *That Man of Mine* (Alexander Productions 1946). Courtesy the Library of Congress.

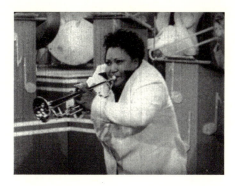

Figure 8.7. Tiny Davis's feature in *That Man of Mine* (Alexander Productions 1946). Courtesy the Library of Congress.

forced to wear hairstyles, makeup and sometimes even black greasepaint to disguise their whiteness (Tucker 2000b).

Sidelining All-Girl Bands

A number of purely commercial all-white films attempted to profit from the highly successful all-girl spectacles by provocatively arranging groups of models pretending to play instruments (a practice known as "sidelining") to prerecorded syncopated popular songs and "hot" jazz recordings. During the 1940s, nonperforming African American all-girl bands also sidelined for all-black-cast films but seemingly for much different cultural and gendered purposes than those presented by white all-girl groups in SOUNDIES.

The Big Timers, an all-black-cast film released in 1945 (also released on William Alexander's American Newsreel Films) is a forty-minute musical feature that provides a thinly veiled plot in order to facilitate the filming of an informal variety revue, hosted by Gertrude Saunders and her USO performing colleagues. The appearance of the seven-piece all-girl band, the "All-American Girl Band" occurs rather abruptly in the film as they magically materialize at the moment that Gertrude Saunders introduces her newly found Sugar Hill acquaintances to her USO performing friends. The performers gladly interrupt the dinner party to showcase a few numbers from the revue in the intimate confines of Saunders's hotel apartment.

The film's foreword proclaims the director's alliance, so to speak, with the "poor folks who work for the rich folks on Sugar Hill." Inexpensively produced on the set of a hotel in Fort Lee, New Jersey, the film introduces a young and beautiful Francine Everett as "little" Betty Washburn, a promising, young, musical theater singer, whose musical education has been supported by her mother's hard-earned savings. The mother, performed by

Mabel Page, is also one of the hotel's maids. In the film, Betty's mother conceals her daughter's low economic status from the fiancé's extremely wealthy and socially superior family by pretending to own Gertrude Saunders's (the leading USO performer) hotel apartment. To establish her credibility, Betty's mother hosts a formal dinner for the wealthy fiancé's parents. Of course the plot is foiled when Gertrude Saunders returns home early to find the two families dining in her apartment. However, Saunders, a working woman herself and sympathetic to the young woman's musical aspirations, agrees to "play along" as Betty's aunt. Eventually the hotel management is privy to the shenanigans and interrupts the after-dinner variety revue, much to the dismay of Betty's mother.

During the variety revue scene, Stepin Fetchit performs a dual role as drunken porter/waiter and featured specialty artist. He eventually joins the USO revue, delivering a comical rhyming rap at the piano as he accompanies himself with a simple stride left hand. He then enters "stage left" in front of the magically appearing all-girl band to deliver one of his characteristic routines as he pretends to slide and stutter, only half-delivering his shuffle with oversized shoes and high-waisted baggy pants.

While it's obvious that the seven-piece band is not actually playing, the film does attempt to create an impression that perhaps there *could* be an all-girl band that would indeed perform jazz and even take improvised sixteen-bar solos. At one point, during the band's featured number, "Start Swinging," the lead reed player stands up to take two choruses on the clarinet. Close-ups of her face make it abundantly clear that she does not perform. Her brief solo is followed by an even shorter four-bar solo performed by the trombonist (clumsily edited in the film), also with several close-up shots. Most of the "instrumentalists" are light-skinned African American women, with the exception of the trombonist. The film's cramped set, which could not have accommodated more than these few women, contradicts its soundtrack, which clearly features a full, sixteen-plus-piece big band.

Here the all-girl band functions simply as a sidelining group of beautiful women. Most of the women fit the dominant aesthetic for chorus-line women: they are slim, fair-skinned, and highly feminine in their presentation and they wear artful updoes and a variety of white, silk, and satin sequined and lace gowns. The producers, however, timidly suggest a real female band by presenting two close-ups of instrumental solos, first on the clarinet and then on the trombone. The politics of the color line must have contributed to the visual arrangement of these nonplaying sideliners: the slimmest and most fair-skinned women are presented in the front row or two. As the camera highlights the beautiful visages of these two women while they each mimic the motions of two brilliantly delivered, "hot" blues

choruses, it is clear that Pollard is attempting to create a suspension of belief by presenting female musicians who can improvise and perform hot jazz, even if these lovely sideliners are rather unconvincing in their "air-instrumentals."

During the film's variety scene, Tarzana, the female USO performer, is a stark contrast to Betty Washburn and her refined, romantic ballads. Known as the "Whoopie Dancer," she delivers her characteristic solo "jungle" number in a black ostrich-feather shimmy skirt and a black and tan diamond-studded bodice. She is petite and dances barefoot with a copper bracelet banded tightly around her ankle. Tarzana performs a combination of jazz moves and "jungle steps"; eventually, as the music slows to half-tempo blues, she performs her typical "slow drag" routine. While Tarzana's hybrid cosmopolitan choreography—combining the well-tested routines of the stage, modern dance innovations of the dance hall, and established moves of burlesque—may have fit well into the gendered aesthetics of USO camp shows, her performance in this intimate, domestic space for New Jersey's elite African American society seems out of place. At risk of speculation, I argue that Alexander resolved the potential dilemma of reinscribing racist stereotypes by presenting a variety of African American performing women in both *The Big Timers* and *That Man of Mine:* teasing the boundaries of mass-mediated feminine tropes while also incorporating well-worn theatrical acts to connect this film with earlier black revues and black-cast musicals.

The jazz women's costumes are also significant in that rather than wearing WAAC (Women's Auxiliary Army Corps) military uniforms—as the International Sweethearts of Rhythm sometimes did while touring with the USO, and the WAAC band always did while on tour (Tucker 2000b, 250–258)—these women wore expensive jewel-studded full-length gowns. Their highly feminized appearances contrasted with the white sidelining women in the Glamourettes SOUNDIES and also avoided the primitivist and jungle-inspired, skimpy chorus-line attire.

The film never introduces the all-girl band. They are simply anonymous USO entertainers; therefore their presence is normalized and legitimated by the public's familiarity with other all-girl bands, white, black, and mixed, who performed on the USO camp circuits, including the International Sweethearts of Rhythm (at that time engaged in their 1945 USO camp-show tour of Germany and France). Moreover, I argue that, by 1946, the novelty appeal of all-girl bands was beginning to wane; the public was by then familiar with the hundreds of real and professional "girl" bands that had been performing in America's USO camp shows, dance halls, vaudeville theaters, ballrooms, and movie palaces for the last two decades.

While African American all-girl bands did not frequently appear in early black-cast musical films, the film *Tall, Tan and Terrific*, directed by Bud Pollard and also released in 1946 on Alexander's All-American Newsreel, Inc, provides a second example[11] of a sidelining African American all-girl band. The film's title directly references the physical and visual requirements for African American chorus girls: they were permitted auditions only if they were "tall, tan and terrific," implying that they must be taller than 5 feet 6 inches, light-skinned and under twenty-one years of age (not to mention terrific dancers). In Pollard's second film, *Tall, Tan and Terrific*, the all-girl band is introduced as the "All-Girl Golden Slipper Band," named after the film's Harlem nightclub. Throughout the film, the band is cast as the supportive house band for the many established theatrical and variety revue performers employed to entertain the club's well-heeled clientele. Some of these performers included Mantan Moreland, Francine Everett, Barbara Bradford, and Dots Johnson. The sidelining all-girl band is placed far out of view to prevent a close reading of these women's instrumental capabilities; nevertheless, it is clear from the women's hand movements, sitting positions, and faces that they are not real musicians.

In contrast to white women's sidelining groups like the Glamorettes, the women's appearances in the black musical films are more functional. They simply provide musical accompaniments that support the many specialty numbers, vocalists, and comedic routines. Moreover their attractive physical appearances (according to the color-line dictates of the 1940s) provided pleasing visual backdrops for the various featured variety and theatrical entertainers including theater and film stars Stepin Fetchit, Francine Everett, Barbara Butterbeans, and Rudy Toombs. Rather than acting as sexual props for hot jazz, their appearances relied more upon normalized ideas of "substituting" female bands. This presentation contrasted with the fixations on black rhythm, miscegenation, and anonymous and sexy choreographed feminine configurations so often featured in Hollywood movies or specialty vaudeville acts.

The International Sweethearts of Rhythm's several musical performances in *That Man of Mine* clearly mediate the various hegemonic, racial, gendered, and musical constraints for women of color during the 1940s. As jazz instrumentalists, the International Sweethearts of Rhythm are treated as capable improvisers as well as versatile musicians; they perform a variety of genres from blues to jazz, ballads, and highly arranged up-tempo flashy, theatrical numbers. In contrast to these women's musical maturity, however, their film's early indictment of the International Sweethearts of

Rhythm as "just a bunch of girls" effectively sabotages their professionalism (especially as they are forced to repeatedly audition for the film's directors). Moreover, their anonymous status, in contrast to other, film-featured, male jazz bands like those of Duke Ellington and Glenn Miller, fails to position them within the greater jazz community of composers, bandleaders, arrangers, and musicians working within interconnected and international networks of nightclubs, theaters, ballrooms, and cabarets.

Alexander adopts dominant Hollywood film conventions with his "musical within a film" plot. Yet even as he incorporates well-tested black theatrical characterizations, he countermands filmic and cultural representations by including a wide and complex range of feminine personas in his film. Chorus girls, stage singers, businesswomen, respectable wives, morally suspect dancers, and "all-girl" bands—all appear with equal prominence, even as they perpetuate the stereotypes that they have previously represented in black musicals like *In Dahomey, Cabin in the Sky,* and *Symphony in Black.* Of course, Hollywood during the 1940s did not permit such a wide range for women of color.

The International Sweethearts of Rhythm's refusal to abide by the strict dictates of segregated performing groups—by employing women of the "international" races of "Black and Brown"—reinforced their sense of cultural uplift and pride, which they then transmitted to their fans in the predominantly black theatrical circuits. Although they are described at various times in the film as an all-colored band, this descriptor can be read radically as a positive assertion of "race pride" and as an assimilation strategy, enabling the International Sweethearts of Rhythm to employ Jewish women, Chinese women, and Latinas who then willingly (and sometimes out of necessity) adopted a "colored" identity while touring the Jim Crow South.

Anna Mae Winburn's cool and collected conducting style (she typically faced the audience and not the band), her sexy, form-fitting, full-length gowns, and her subtle but highly swinging vocal renditions also reinvigorated and challenged the physical and visual expectations placed upon other African American headliners like Josephine Baker, Lena Horne, and Billie Holiday. These leading women presented a complex mix of coded performances that could be as liberating, uplifting, creative, and ingenuous as they were "exotic," "primitive," and sexualized (Brown 2001; Carby 1992; Francis 2004; Harrison 1990). The professional jazz women of the International Sweethearts of Rhythm would have been privy to these various representations and strategies as they performed their ballads, jazz arrangements, and blues, including the film's title song, "That Man of Mine."

While jazz scholars have begun to investigate the medium of film and its treatment of jazz bands (Gabbard 1995, 1996), few have explicitly identified

the unique relationship of women's jazz bands to early sound film. Moreover, contemporary histories and documentations of jazz films rarely mention the all-girl bands. Indeed, one of the few reference works on jazz in film, David Meeker's *Jazz in the Movies*, cites a few films of Ina Ray Hutton and Her Melodears but none of the other all-girl bands (Meeker 1977). Male musical giants like Louis Armstrong and Cab Calloway, who became famous as entertainers and musicians, owed much of their initial success to the powerful medium of film.

The question as to why women musicians and bandleaders never fully achieved the same longevity in their careers after their brief episodes in film remains largely unexamined. For the women instrumentalists of the International Sweethearts of Rhythm, however, their involvement in both the smaller jazz community, in the larger African American entertainment industry, and the broader culture industry certainly requires an integrative analysis that takes into account the wide range of gendered performances visible during the most revolutionary and expansive period of the media industry. Performative expectations for female jazz musicians working inside and outside Hollywood and the nationally organized theatrical circuits during the 1930s and 1940s required women to negotiate musical considerations in conjunction with the more complex feminine and racialized expectations. In this respect, women were certainly filmed not merely to be heard, but to be seen. In contrast to the internationally successful 1920s and 1930s black theatrical and musical women—who often negotiated historically established expectations for racialized female caricatures in the all-black-cast musical films—one could argue that the Sweethearts' many musical and visual appearances in *That Man of Mine* began to disrupt such confining characterizations. Nonetheless, the hundreds of pre-1940s advertisements for black, mixed, and white all-girl bands, many of whom were never recorded for film or for record companies, suggest that the jazz scene and the larger culture industry offered other, less-mediated performance opportunities (especially for African American jazz women) during the first half of the twentieth century.

PART FOUR

✵

VARIETY TELEVISION AND THE 1950S

✵

CHAPTER NINE

Television, Vaudeo, and Female Musical Hosts

❂

Considering the highly gendered presentation of female jazz performativity during the war, the slogan "No Men!" from Ina Ray Hutton's 1956 television program (fig. 9.1) might lead one to believe that all-girl spectacles and musical formats thrived during the 1950s. In reality, female jazz musicians struggled to acquire professional gigs during the postwar era in both mixed-gender and unisex contexts; playing opportunities were limited in both locally mediated and mass-mediated forums.

As fewer Americans attended nightclubs, ballrooms, and variety shows during the postwar ear, private leisure activities began to supplant public outings—a transformation that drastically altered reception contexts for jazz and popular music. New domestic pastimes frequently entailed the consumption of commodities like radios, record players, and televisions, the sales of which bolstered the booming postwar media industry. The positive growth within the music manufacturing industry, however, negatively impacted live jazz musicians, who had previously profited from the craze for dancing, swing, and live performances jazz during the war. The significant expense of financing large dance bands, as well as Americans' changing tastes in popular music—evidenced by the popularity of sweeter styles, crooners, and smaller instrumental groups—further handicapped many jazz instrumentalists. The confluence of these social, economic, and cultural transformations hampered not only male but also female jazz musicians' economic viability during the late 1940s and 1950s.

During the 1950s, women faced even greater obstacles because of growing prejudices in male-dominated domains like popular music. Within the masculine field of jazz, for example, women were often characterized as stealing the precious few performance opportunities away

Figure 9.1. The Ina Ray Hutton Show motto (NBC 1955). Courtesy Fred MacDonald.

from men. The conservative climate of the McCarthy era, in which women were encouraged to return to more traditional gender roles as wives and mothers, countered professional female jazz musicians' lifestyles, which demanded rigorous touring schedules and constant professional obligations.

Nonetheless, the growing interest by Americans in the increasingly dominating mass medium of television facilitated new contexts to showcase old entertainment forms like variety revue, musical comedy, and vaudeville—forums that previously had featured all-girl bands, all-girl spectacles, and female performers. Some of the most commercially successful leaders of all-girl bands, of which many disbanded during the mid-1940s, were once again solicited during the early 1950s to be featured in both local and national musical variety television programs. Ina Ray Hutton and Ada Leonard, for example, both led all-girl bands in television formats during the 1950s.

Black and racially mixed female groups were afforded but a few opportunities to perform for television. The various obstacles confronting African Americans, especially when seeking corporate sponsorship, were reflected in the relatively small numbers of national black-cast musical variety programs after the war. A few local stations briefly featured African American female jazz musicians, including a small group led by Los Angeles trumpeter Clora Bryant in 1951.

Female jazz vocalists also began to incorporate new forms of popular music into their postwar repertoire, making them more attractive as featured guests on the family-oriented musical variety programs of the 1950s. Some of the most frequent television female jazz and crossover performers included Lena Horne, Peggy Lee, Dinah Shore, and Ella Fitzgerald. Initially, variety programs featuring popular musicians were intended as mere fillers for the networks' weekly serials, and ran as little as fifteen minutes during regular evening programming. Eventually these short musical programs were expanded into sixty-minute variety-style programs, airing weekly during prime-time programming.

The four largest networks, NBC, CBS, DuMont, and newcomer ABC,[1] fiercely battled for viewership during the late 1940s and early 1950s, in part by programming the new vaudeo[2] and musical variety format. NBC and DuMont in particular adapted radio and theatrical genres like vaudeville and variety and developed them as staples for postwar programming with such popular variety programs as the *Texaco Star Theater*, *Your Show of Shows* and the *Colgate Comedy Hour*. CBS also experienced improved ratings because of its popular variety program, *Toast of the Town*, hosted by Ed Sullivan. Retrospectively, the four networks' early domination owed partly to their innovative adaptation of radio and theatrical mediums for television's mass audiences during the postwar era (Mayerle 1983).

Female musicians appearing in television's musical programs confronted changing attitudes about mass culture, yet continued to draw upon prior media like film and radio, two forums driven by the star system with its emphasis upon spectacle and glamour. Moreover, the industry's increasing promotion of leisure activities in domestic and private spheres—while also encouraging consumerism through the single corporate sponsorship of television programs—led to mass culture's increasing role as a symbolic mediating force of private and familial relations. Indeed, early variety television envisioned popular culture as a vessel for promoting "proper" American values and identities, betraying its more conservative postwar ideology. Television hosts like Ed Sullivan, Milton Berle, and Dinah Shore, while relatively liberal in their frequent inclusion of nonwhite musical artists (MacDonald 1992, 11–12), often promoted highly traditional familial and gender values by highlighting the particular roles of audiences members, as prom queens, housewives, and business owners, for example. During the 1950s, the commercial interests of corporate sponsors and the consequential economic imperative of program ratings required that the networks attract mass audiences by representing popular culture through a more generalized, nonparticular nonethnic identification (MacDonald 1994, 4) that often entailed the incorporation of a selective but widely appealing variety of musical genres and comedy.

In this chapter, I investigate the various ways that female jazz musicians performed in and contributed to the relatively new medium of television during the 1950s. By comparing these jazz women's mass- and locally mediated representations, one begins to recognize how television accommodated expanding audiences by musical variety programs' promotion of established interwar jazz genres such as swing, boogie-woogie, and blues along with newer popular idioms (pop, crooning, and rhythm and blues), as well as the occasional showcasing of innovative jazz styles such as cool jazz and bebop. In particular, I highlight the format of the variety program

because of its pivotal role in television's early transformation into a mass medium—and also because female jazz and crossover musicians more frequently appeared in this format than others. Moreover, as the networks developed such family-oriented variety programs, they also sought to feminize programming in order to attract the important female demographic critical to television's early reception. Correspondingly, jazz women's television performances variously reinscribed a gendered musicality and multigenre musical aesthetic in 1950's variety revues.

In my analysis of television's female jazz representations, I first compare those programs starring Ina Ray Hutton and Ada Leonard that revived the all-girl band format in the context of musical variety during the early and mid-1950s. I then examine the television representations of three prominent postwar female performers: Hazel Scott, Peggy Lee, and Lena Horne. These three performers of jazz *and* popular music interacted with and negotiated the changing public expectations for performing women because of the growing influence of television. Their performances represent three very different responses to the heavily racialized and gendered performing context of television during the postwar era.

I first provide a historical context to the expansion of national television and its development of the variety program format during the postwar era. I also offer a brief investigation of the network system (which first promoted variety television), of postwar television audiences, and of the particular role that jazz and popular musicians of differing races, genders, and ethnicities played in the increasingly popular format of vaudeo and variety revue.

Television's Expansion

During the 1920s and 1930s, television experimented with a variety of local programming until the medium became more established via four networks in the late 1940s. Even so, initially at least, network formats relied heavily upon radio for content and style. As early as 1939, seasoned radio, film, and theater performers like Ethel Waters agreed to appear in single broadcasts to test the viability of television. Waters, for example, first performed a dramatic sequence from her hit play *Mamba's Daughters* (Bogle 2001, 9). As in early sound films, African American performing women were considered important subjects for testing new mass-mediated formats like sound film, radio, and eventually television (Bogle 2001, 9).

Television continued throughout the war as an experimental and inconsistent medium with Americans preferring to attend movies or listen to weekly radio broadcasts. It wasn't until after World War II that more Americans dedicated disposable income to such expensive pastimes. Further, it was nearly two decades before commercial sponsors were persuaded of

television's ability to attract significant markets for financial investment. According to historian Donald Bogle, even during the late 1940s, when more Americans were tuning into television programs, sponsors were charged a mere $1,510 for a sixty-second TV commercial in contrast to $27,215 for a minute of radio (Bogle 2001. 12).

Media theorists have attributed the decline of film during the 1950s to various changes in American society after World War II. These include the increasing vertical integration of the three major industry television networks NBC, ABC, and CBS (by the early 1950s, DuMont failed to compete with the three networks), the increasing dependency of local television stations upon national network programming, the conservative postwar attitude toward public entertainment and family life, and finally the increased expenditure upon domestic leisure goods like radios, record players, and televisions (MacDonald 1994; Bogle 2001; M. Murray 2003; and Sterling and Kitross 1990). Television historian Matthew Murray claims that the combination of consumer demand, technological developments, massive financial investment (on the back of radio), and governmental policies led to television's becoming a viable mass medium during the late 1940s. Further, the transfer by the FCC of highly coveted Very High Frequency (VHF) electromagnetic spectrum space away from FM radio to TV—together with the FCC's sponsorship of the relatively inexpensive monochrome television technology—provided the favorable economic climate for television's expansion during the 1950s (Murray 2003, 36).

In 1946, only six television stations were broadcasting to 8,000 households. During the 1948–49 seasons, every network had a sponsor and by 1950, more than six million television sets were sold. One year later, sales increased to sixteen million and coast-to-coast broadcast was supported by an expanded infrastructure of coaxial cable at which point television became a mass-mediated, national form (Bogle 2001, 13). By 1951, 579 stations were reaching 89 percent of the American population (Sterling and Kitross 1990, 633; Murray 2003, 658).

Another decision issued by the FCC in 1948 inevitably led to the television networks' oligopoly. In an effort to resolve broadcasting difficulties, the FCC's licensing freeze of 1948 to 1952 ensured that only stations obtaining licenses before 1952 were entitled to continue broadcasting (Murray 2003, 36). Because the majority of these stations were either network affiliates, or network-owned and -operated, national programming came to be dominated by the three major networks, ABC, NBC, and CBS during the 1950s. The fourth, less prominent, television network, DuMont, attempted to compete and also dismantle the three leading networks' control of 1950s' television affiliates. DuMont vied for third place until 1953 when the FCC's approved merger between AVC and United Paramount Studios provided

ABC with a much-needed cash infusion, enabling affiliate status contracts with regional midsize stations (Murray 2003, 39). As the licensing freeze was lifted, the centralized program model had proved profitable with its national distribution, big sponsors, and large-market affiliates.

As the licensing freeze was lifted in 1952, network affiliates were encouraged to sign "option time" clauses, which often required affiliate stations to clear prime-time programming for nationally distributed network programming (Murray 2003, 37). The networks maintained their oligopoly throughout the 1950s and eventually were able to move away from the single-sponsor format by selling advertising time to multiple advertisers for particular programs (Murray 2003, 37).

Television and Variety Programming

During the late 1940s, the networks implemented nationally syndicated programs to bolster national rankings. In 1948, television experienced a major turning point with the programs *Texaco Star Theater* (NBC) and *Toast of the Town* (CBS), two programs that incorporated radio stars into their family-oriented, variety-style entertainment. Television's reliance upon radio and variety also meant that early television programs incorporated popular African American performers and musicians into weekly shows. In 1948, the New York CBS affiliate contracted black entertainer Bob Howard to host the *Bob Howard Show*, a fifteen-minute variety-style program that featured popular songs from film, radio, and even musical theater. While Howard's performing style corresponded with the sometimes limiting theatrical expectations of black musical artists, this was the first time that American audiences would see a black artist host a variety-style show and control the proceedings of the event (Bogle 2001, 14).

Television historian and cultural critic Richard Butsch (2000) characterizes television programming during the 1950s as lowbrow and dictated by commercial concerns, at least as portrayed by the era's cultural critics. The *New York Times* television columnist Jack Gould, for example, likened it to a "cut-rate nickelodeon." Arts critic Gilbert Seldes, a champion of the "popular arts" in the 1920s and 1930s, described early programming as "rather bad vaudeville . . . unimaginative and tasteless" (Gould 1952; Seldes 1950, 173, 178, 182; as quoted in Butsch 2000, 253). *Saturday Review* editor Norman Cousins condemned television as "such an invasion of good taste as no other communications medium has known" (Cousins 1949; as quoted in Butsch 2000, 253). Mass-culture critics often cited commercialism as bringing programming material down to the lowest common denominator (MacDonald 1994, 30; Butsch 2000, 254).

The racialized schemes for Hollywood productions were largely perpetuated in early television formats. The variety format enabled the limited incorporation of African American performers as guest artists in the largely white program selections. Lena Horne made dozens of musical appearances for variety programs, including *Toast of the Town* and *Colgate Comedy Hour*. Ella Fitzgerald was similarly featured on the *Dinah Shore Chevy Show* and the *Frank Sinatra Show*. Guest appearances by charismatic jazz and poplar music vocalist Billy Daniels on the *Milton Berle Show* and on Sullivan's *Toast of the Town* led, in 1952, to the second nationally syndicated and first corporate-sponsored African American variety program, the *Billy Daniels Show*, which aired Sunday evenings for fifteen minutes on ABC (MacDonald 1992, 19–20). Other 1950s primetime, musical variety television shows included mostly white jazz artists and pop stars and were generally designed for family audiences to accommodate television's limited number of stations (pre-cable). In this respect, television's 1950s' mass audiences resembled the middle-class, mass audiences for variety and vaudeville performances during the first decades of the twentieth century.

The few black-led musical-variety programs, like those of Nat King Cole, Hazel Scott, Billy Daniels, and Bob Howard, however, provided a different context for showcasing a variety of guest stars, and highlighting African American musical performers. Unfortunately, these programs experienced greater difficulties finding corporate sponsorship during the late 1940s and 1950s, especially because of the one-sponsor-per-program format implemented by programs such as *Paul Whiteman's Goodyear Revue* or the *Pat Boone Chevy Show*. Sponsors were reluctant to provide funds for all-black casts or black-led programming fearing the backlash of southern, conservative audiences—or simply because of a perceived bias that black programs would not attract mass white audiences (Bogle 2001, 76).

The other networks infrequently promoted black artists in various forms during the 1950s, mostly notably NBC with the *Nat King Cole Show*, airing for sixty-four weeks during 1956 and 1957. The program initially aired as a fifteen-minute musical program but was expanded to a half-hour in July of 1957 (MacDonald 1992, 65–70; Bogle 2001, 76). According to MacDonald, the show's ratings began to improve in some urban areas, and in 1957, with its new Tuesday-night half-hour slot, it rated number one in New York and number eight in Los Angles (MacDonald 1992, 67). After being rescheduled once again for Saturday evenings at 7:00, the *Nat King Cole Show* eventually went off the air in December 1957. Apparently, Southern stations refused to carry the program and NBC could no longer interest a major sponsor. Cole complained bitterly to *Ebony* magazine about the poor time slot and especially about the lack of sponsors for the show:

Madison Avenue, the center of the advertising industry, and their big clients didn't want their products associated with Negroes. . . . They scramble all over each other to sign Negro guest starts to help boost the ratings of white stars, but they won't put money on a Negro with his own program. I'm not a chip-on-the-shoulder guy, but I want to be frank about this. Ad Alley thinks it's still a white man's world. *The Nat King Cole Show* put the spotlight on them. It proved who dictates what is seen on TV: New Yorkers and particularly Madison Avenue. They control TV. They govern the tastes of the people. (quoted in Bogle 2001, 77)

In the postwar era, the networks promoted a range of jazz performers in televised musical variety shows including *Eddie Condon's Floor Show* (1949–1950), *Adventures in Jazz* (1949), *Cavalcade of Bands* (1950–51) (which often aired shorts of jazz films from the 1930s and 1940s), the *Steve Allen Show* (1950–52), as well as jazz-centered programs like *America's Greatest Bands,* hosted by Paul Whiteman; *Stage Show,* hosted by the Dorsey Brothers (1954–56); *Music '55,* hosted by Stan Kenton (1955); the *Nat King Cole Show* (1956–57); and finally the *Stars of Jazz,* hosted by Bobby Troup in Los Angeles from 1956 to 1959. These programs continued the legacy of promoting wartime swing and jazz acts but also introduced mass audiences to new jazz performers and composers like Charlie Parker, Dizzy Gillespie, and Stan Kenton.

Private versus Public Leisure

Television viewing habits of the 1950s and the concomitant changing attitudes exhibited by Americans suggest an increasing prioritization of private over public life. Butsch (2000) illuminates the lifestyle differences initiated by increased television viewing as more Americans developed what came to be considered a suburban lifestyle and focused more attention upon household leisure activities, like watching television, using automobiles, and converting the home into a place of domestic convenience. In Butsch's (2000) view, this new private-oriented lifestyle signaled "a cultural shift in the importance given public life versus privacy, community versus nuclear family" (247). In this sense, the imagery of television helped to reformulate the public and private spheres with its emphasis upon the familial and the private (249).

As network television continued a process of programming consolidation, the networks incorporated content that would attract not only family audiences but also the significant female viewership that increasingly constituted an important demographic. According to media scholar Denise Mann, television sponsors aggressively catered to women in their advertising and program content. Mann (1992) also claims that the television variety show was an extension of the Hollywood industry's prior recognition of the female consumer as a viable and important audience, especially through

the "mass-circulation magazines surrounding Hollywood and its star system" and one that "the broadcast industry sought to incorporate as an audience for its own mass-media forms" (42).

In an effort to entice female audiences, many variety programs incorporated female performers either as guest stars or as weekly hosts. Dinah Shore, Martha Raye, Peggy Lee, and Hazel Scott all hosted their own variety and/or music shows during the 1950s. According to media scholar Lola Clare Bratten (2002), 1950s' television hosts were encouraged by the industry to construct gendered personas that combined notions of domesticity, popular culture, consumerism, and an assimilated American middle-class identity. Specifically, Bratten examines Dinah Shore's heavily mediated persona as an "all-American," feminine television host and uncovers her transformation from a dark-haired, Jewish singer of African American–inflected blues and popular music with "Schmaltz" to a blonde-haired, suburban singer of popular songs. According to Bratten, this transformation facilitated her success as a mainstream female variety television star of the 1950s. Consequently, Shore's physical transformation (nose job and platinum blonde hair) enabled her to subvert her ethnic and Jewish specificity to make her Chevrolet's most potent and successful spokesperson.

In addition to the non-particularization of female television stars, the decade from 1946 to 1956 served as a transformative moment in mass-mediated audiences' relationships to star performers. Television variety shows were initially successful in incorporating "recycled" Hollywood stars by transitioning them into television hosts (such as Martha Raye and Jack Benny). Television hosts often straddled a dual position as both "down-to-earth" everyday personalities and Hollywood stars. By surveying the most popular entertainment magazines, Mann uncovers the industry's attempt to target the lucrative and important female suburban demographic. The networks' commodification of television variety programming with its single-sponsor programming format (for example, the *Colgate Comedy Hour*) was able to cash in on the star spectacles of Hollywood films as well as the ethnic and gender-specified formats of vaudeville and variety revue. For television audiences, however, any ethnic or class specificity was eliminated, enabling a mass feminized identification with television hosts like Dinah Shore, Jack Benny, and Martha Raye.

Early television scholars, however, generally neglect the central position of music and the use of outmoded popular music formats like swing, crooning, Broadway hits, and even waltz music. Such music attracted not only middle-aged feminine suburban audiences, but the entire family; variety programs typically held early and mid-evening spots. Granted, many variety programs featured "mature" musical hosts like Paul Whiteman or

Dinah Shore; they also, however, centered entire programs on established popular culture musical themes. Programs featuring the music of celebrated musical composers like George Gershwin or Jerome Kern, or variety programs centered on guest stars like Peggy Lee or Frank Sinatra, proved popular with female and the more general multigenerational family audiences.

The implementation of female hosts was one way in which the industry attempted to sustain and expand its growing female audiences. Shows like the *Dinah Shore Show*, the *Hazel Scott Show*, the *Martha Raye Variety Program*, the *Ina Ray Hutton Show*, Ada Leonard's *Search for Girls*, the *Lorraine Cougat Show*, and *Songs For Sale* (often featuring Peggy Lee), offered prominent examples of the seasoned female musical performer of 1950s variety television programming. Moreover, female jazz musicians who also crossed over into popular and even classical domains were often solicited to host these musical and theatrical variety programs. Jazz women hosted variety programs in which they performed a variety of musical genres, including jazz, swing, blues, light classical, popular songs, and torch songs. In this way, these performers created a bridge between wartime genres like swing and boogie-woogie and its aging fans and contemporary but conservative musical trends, which promoted softer styles like crooning, ballads, and torch songs.

Often the initial hosts of television's variety programs were more than seasoned popular and jazz musicians; many also had experience in other visual mediums, especially film. Hazel Scott's roles in *The Heat's On* (1943), *I Dood It* (1943), and *Rhapsody in Blue* (1945) provided her with the technical expertise to transition into television formats. Similarly, Peggy Lee's many film performances in jazz shorts and feature films like *Mr. Music* (1950), *The Jazz Singer* (1952) and *Pete Kelley's Blues* (1955) endowed her with the proper skills to negotiate the visual challenges of live television programming. Finally, Lena Horne's many specialty musical appearances in MGM's musical spectaculars of the 1940s and 1950s, such as *Broadway Rhythm* (1944) and the *Ziegfeld Follies* (1956), significantly informed her many television appearances during the 1950s.

The necessary relationships between crossover jazz and popular music stars and the film industry, and television's growing reliance upon prior multimedia gendered representations initiated important mechanisms by which early variety television audiences acquired music during the post-war era. I return to these connections in chapter 11 when I investigate the varying relationships cultivated among film, theater, and radio and their impact upon variety television formats. More importantly, I underscore the consequential adaptive strategies incorporated by three of variety television's contrasting 1950s musical female hosts: Lena Horne, Peggy Lee, and Hazel Scott.

CHAPTER TEN

Variety Television Revives All-Girl Bands

❊

During the early 1950s, two media that still supported all-girl big bands were television and radio, two environments where all-girl performances could be mass-mediated and/or visually represented. Earlier experimentations in film and the industry's predilection for visually representing (and fetishizing) all-girl bands as attractive young women in swing and sweet bands created a precedent for exhibiting all-girl bands in the newest technological visual media. Further, many female bandleaders active during the 1930s and 1940s, such as Ada Leonard and Ina Ray Hutton, performed not only as touring musicians but also in short subject musical films and feature-length Hollywood musicals. Ina Ray Hutton's appearances with the Melodears in various Paramount films during the 1930s and Ada Leonard's 1940s musical SOUNDIES aided their transition into the medium of television during the 1950s, especially considering the symbiotic relationships developed between the national television networks and the film studios (such as the case of Paramount and Los Angeles–based television station KTLA).

African American female instrumentalists, not often given opportunities to establish film relationships in earlier decades, only occasionally appeared with female groups on variety television during the 1950s. Famed Central Avenue trumpeter Clora Bryant, having also worked with all-girl bands during the 1940s, collaborated with jazz violinist Ginger Smock for a CBS variety show in 1951 entitled *The Chicks and the Fiddle;* it lasted only six weeks, as advertisers prematurely withdrew support. As previously noted, sponsorship for African American artists during the largely culturally segregated 1950s was virtually nonexistent, even for crossover artists like Nat King Cole, and especially difficult for African American female performers (Bogle 2001, 76; Tucker 2000, 322).

Variety Television Revives All-Girl Bands / 211

Figure 10.1. Hutton features the saxophones on *The Ina Ray Hutton Show* (KTLA 1951). Courtesy Fred MacDonald.

By 1950, Ina Ray Hutton, who had been working with a male band since 1944 was persuaded once again to headline an all-girl unit. In 1950, KTLA commenced an hourlong variety show featuring "the blonde bombshell" (fig. 10.1). One press release bragged that KTLA's new variety show "explodes [with] a whole screenful of glamorous girls on TV sets . . . girls and girls only are featured" (Holly 1950). After viewing a prep rehearsal, *Down Beat*'s Hal Holly acknowledged the musical capabilities of the "gal" musicians and even the expert musical leadership qualities of Ina Ray Hutton. Holly claimed that "Ina Ray, whom we had always regarded as more decorative than useful as a bandleader, actually knows what she's doing with that music in front of her" (Holly 1950). He also discovered that Hutton's selection of musicians was based "principally upon their musicianship" and reported the women's professional ambitions: they even bragged that they would compete with the guys of Local 47 (the Los Angeles Union) for prestigious jobs based upon "musical merit" alone (Holly 1950). Still, sexist attitudes about the sexual function of all-girl bands persisted during the early 1950s, as betrayed by Holly's suggestion that "every musician in this band could do the show in a bathing suit—and why hasn't producer Klaus Landsberg thought of that sooner?" (Landsberg 1951).

In the early years of television, Klaus Landsberg, general manager of Los Angeles station KTLA, was credited for programming more live music shows than any other West Coast TV station. In November 1951, Landsberg queried, "Does music belong on television?" Answering his own question, Landsberg articulated what few emerging modernist jazz critics would admit: "People want to watch musical performances, not just listen to them." He further added that television could enhance listening experiences: "Careful image selection in tune with the music can assist concentration and interpretation and create far greater enjoyment of music than the ear alone could receive" (Landsberg 1951). Landsberg's critically acclaimed music television programs collected no fewer than five Emmys in 1951 with the *Ina Ray Hutton Show* receiving one (Landsberg 1951). Other highly rated musical programs included *The Spade Cooley Show; Dixie Showboat*, with Nappy Lamare; *Bandstand Revue*, with Frank Devul; and *Frosty Frolics*, with Manny Strand.

Television historian J. Fred MacDonald claims that while most local television stations succumbed to network domination during the late 1940s, one of the few markets to sustain local programming was Los Angeles, the fourth-largest population center in the United States. Home to the nation's film industry, the cities' many television stations experienced little trouble acquiring capital, talent, and facilities. By 1949, Los Angeles boasted seven local television stations with only three affiliated with networks (MacDonald 1994, 89). Significantly, KTLA, as the subsidiary television station to Paramount, pooled many of its musical variety performers from the studio's rosters.

In February 1951, KTTV (also of Los Angeles) television producers took notice of Hutton's television success and announced their own all-girl variety show, starring Ada Leonard and her all-girl orchestra. Leonard's *Search for Girls* aired on Friday nights from 10:30 to 11:30. Again, *Down Beat*'s reviewers downplayed the two bandleaders' musical qualifications with the assumption that female bandleaders functioned primarily as attractive glamour props. *Down Beat* asserted that Ada "has charms that made it unnecessary for her to prove anything important as to musical matters" ("Ada Leonard All-Girl Crew" 1951). In the 1950s, women's groups were rarely compared to men's groups, but often compared to other women's groups.

For a special *Down Beat* interview, Ada Leonard diverted questions that continually compared Hutton's unit with her own. For example, Holly's first question: "What do you think about Ina Ray Hutton and those girls she has on her KTLA show?" Ada responds in a much-rehearsed fashion as if she anticipated the bait: "Television is like a ray of light opening the road to opportunity for girl musicians. The first time we've had a real chance to get

anywhere in music." Unnerved by her cool, he digs a bit deeper, this time seeking physical comparisons: "What about those gowns Ina wears? They're so tight, everyone is waiting, hoping for an accident. On your first show you wore something that was light and sort of flimsy—sort of revealing. Did you do that just to be as different from Ina as possible?" (Holly 1951).

Again deflecting the question, Leonard responds with familiar refrains about feminine collaboration: "Girl musicians work together better than men. Less temperament. In our band the more experienced musicians pitch in and actually help the newcomers. They don't try to show them up by outplaying them. The girls have been a team right from the start" (Holly 1951). Later, refusing questions about sex appeal and feminine competition, she chooses instead to praise the improvisational capabilities of four band members, including trombonist Frankie Rossiter, alto saxophonist Zackie Walters, trumpeter Fern Jarof, and pianist Jo-Ella Wright.

Eventually, Leonard redirects the interview to expand upon the difficulties of women musicians and family life. Her comments were perhaps the first serious consideration of the subject printed in *Down Beat* during the 1950s:

Girl Musicians find it hard to fit their careers in with home life. Some of my musicians are married and have children. They have to hire baby sitters to make rehearsals and shows. I'm not married because I don't think I could be a bandleader and provide the right kind of home life for my husband—unless I married a musician who had an understanding for the problems of the professional musician. (Holly 1951)

By April 1951, San Diego television reviewers were also publicizing an all-girl trio, named the Cactus Cuties, apparently in response to the success of Los Angeles's *Ina Ray Hutton Show*. In characteristically arcane industry lingo, one reviewer likened the advent of televised all-girl bands to stripteases: "And since the filmland square circle has taken strip teasing to its over-publicized bosom, San Diego comes up with a disrober named Dagmar (an item which confuses TV fans)" (Freeman 1951). Clearly, the reception of all-girl bands during the postwar era was colored by cynicism surrounding the substitution of live jazz sites with sexualized female performances like strip acts.

How then did all-girl variety programs incorporate music and all-girl bands into their programs for television audiences during this era? In general, early variety programs are difficult to locate. In many cases, the networks did not consider these programs worthy archiving material, in part because of their poor quality and also because of the limited value placed on them by cultural critics. Occasionally, excerpted copies offer a glimpse of the design and layout of these brief feminine vaudeo shows. J. Fred MacDonald of the Chicago Film Archive lent me one such copy

Figure 10.2. Hutton's band takes a chorus in *The Ina Ray Hutton Show* (KTLA 1951). Courtesy Fred MacDonald.

for viewing. In this episode of the *Ina Ray Hutton Show* of 1956, Hutton performs a similar role as in earlier short subject film appearances. However, in the short sequences that I viewed, the program prioritized a familiar medley of popular music and jazz standards over her dancing skills.

During the opening excerpt, Hutton introduces her all-girl band before showcasing a "music-packed" show including such popular hits as "Melody of Love," "I Could have Danced all Night," and "When My Sugar Walks Down the Street" (fig. 10.2). In the first musical excerpt, "When My Sugar Walks Down the Street," Hutton introduces three instrumentalists who perform a short Dixieland trio featuring the clarinet, trombone, and trumpet soloists in a "breakdown" section within the standard AABA Tin Pan Alley arrangement of this popular tune. The song became a favorite for theatrical and film performers appearing on television during the 1950s, including Eddie Condon, Duke Ellington, and Judy Garland.[1] During these excerpts, the band plays other popular, yet outdated musical numbers in typical swing and big band arrangements including songs from the Broadway productions *Show Boat* and *My Fair Lady*. Not surprisingly, *Show Boat*'s rerelease in 1951 must have created a resurgence of interest in the musical's songs—and also in its assimilationist racial themes.

Later during the show, Hutton leads the band in a call-and-response musical number, inflecting a suburban, girlish vocal intonation. Consequently, Hutton's expert dancing is overshadowed by the cute, feminine vocal imitations that make up the majority of her interactions with the other female musicians. The program continues with musical numbers presented by the band and variety specialties performed by various female musicians, including the Latin singing trio the Malagon Sisters; comedian Beatrice Kay; and dancers, in a manner similar to other early 1950s musical variety programs.

After three years performing for West Coast television audiences, Hutton admitted that she was ready to get back on the road, worrying that performing exclusively for regional audiences would limit her national appeal: "I'm getting itchy feet. . . . I've been in local television for a long time now and I'm afraid the people back east will forget about me unless I grab the chance to take my band on the road" (Ames 1954). However, the daunting task of committing two dozen female musicians to strenuous tour schedules remained a difficult obstacle to overcome, as expressed by Hutton in the same interview: "I've built my current band from local girl musicians and most of them are rooted to homes here. . . . It will be hard to get them moving again if we go on the road. Most of them hate to think of doing one-night stands again" (Ames 1954). It appears that Hutton did not go on the road in the early 1950s but continued working local engagements until 1955.

By 1952, the newly revised West Coast all-girl band television format abruptly ended.[2] Ina Ray Hutton's two-year contract with KTLA was not renewed and Ada Leonard's show was dropped after a single year. Again, the trade magazines attributed these show's original allure and ultimate demise to sex appeal. In reference to the shows' cessation, *Down Beat* queried "Is Sex on Its Way Out?" The primary reason cited for both Hutton's and Leonard's short television run was the bands' relative inabilities to compete successfully with comparable male bands. One reviewer stated "Ina and Ada made every effort to assemble bands in which musicianship was placed ahead of glamour (though there are some real cover kids in both outfits and the overall line-up could supply plenty of cheesecake) but neither was able to produce a band that any honest critic could compare favorably with the average male ork" ("Is Sex On Its Way Out?" 1952).

After two years struggling to meet the expensive salaries of leading female jazz instrumentalists, Leonard switched back to male musicians. In a final interview, she proclaimed that women musicians were simply too hard to find: "There are only five girls in the whole U.S. who are capable

of playing first-chair trumpet. . . . There are only three girl drummers and only three girl altos who could handle their parts in a band such as I have now." In another *Down Beat* interview, she also attributed the scarcity of expert all-girl bands to the psychological stigma of performing in all-girl units: "Top-notch girl musicians don't like to work in all-girl bands. They like to feel that they've been hired not because of their looks or their sex appeal, but because they are good musicians" (Holly 1955c).

Other well-known jazz soloists who did perform exclusively with male bands confirmed Ada's reasoning. Jazz harpist Corky Hale mirrored these sentiments in a 1952 *Down Beat* interview. "It's like this," she explained, "If a girl is a good musician she doesn't want to work in an all-girl band because it implies she is working in it because she is a girl. A girl doesn't feel successful as a musician unless she can work with guys—just like one of them. She wants to feel she's been hired not because she's a girl but because she can play the job" (Holly 1952). Trumpeter Norma Carson also expressed her views about the perils of trying to be a female musician: "I've never found it an advantage to be a girl. If a trumpet player is wanted for a job and somebody suggests me, they'll say 'What? A chick.' And put me down without even hearing me." Her views about the disadvantages of playing in all-girl groups are similar: "When you're forced to work with all-girl groups you realize there are never enough good girl musicians at any one time in one place to make a good band. You never progress unless you get to play with better musicians, and I've never played with the kind of musicians I wanted to—I've had very few kicks" (Feather 1951).

Despite Hutton's discontinued KTLA contract, the *Ina Ray Hutton Show* had been so successful during the early 1950s, that she was invited to organize a new all-girl band again in 1955 for a national program on NBC (figs. 10.3–10.5) and produced by Guild films (producers of the successful *Liberace Show*).[3] The show aired Wednesdays at 10:30 P.M. on KRCA in Los Angeles. Hutton was interviewed during her preparation for the national program, and she once again elaborated upon the difficulties and rewards of recruiting all-girl bands: "We worked really hard getting this show organized. I canvassed the entire country looking for girl musicians and I believe the look of the band and the way it sounds indicates that we have the choice group. I'm proud of every one of them. . . . Playing in an orchestra to most men is a job. To a woman it's an honor (Ames 1956).

In another interview, Hutton reinforced the seriousness and professionalism of her female musicians: "There's no easy way . . . no namby-pamby stuff. A girl has to be a good musician, and a good girl instrumentalist is

Figure 10.3. Hutton's saxophones featured on *The Ina Ray Hutton Show* (NBC 1955).

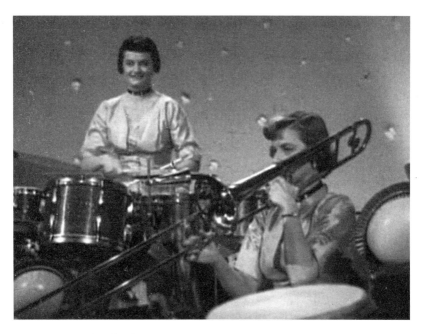

Figure 10.4. Dixieland breakdown on *The Ina Ray Hutton Show* (NBC 1955). Courtesy Fred MacDonald.

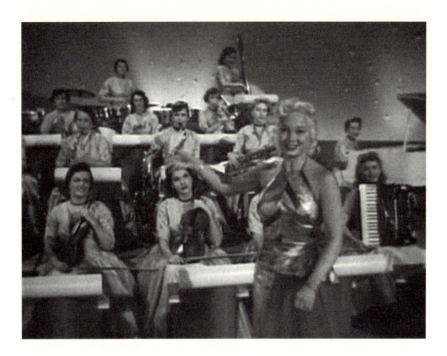

Figure 10.5. Hutton introduces the band on *The Ina Ray Hutton Show* (NBC 1955). Courtesy Fred MacDonald.

hard to find. I should precede that by saying that they're there. When you find one, she's excellent. There's no in-between. They're either no good or they're dedicated, and when they're dedicated, they're great" (Fink 1956). Her prior experience with her local all-girl television show in Los Angeles led Hutton to proclaim: "I found out the girls would stay when they didn't have to travel" (Fink 1956). In many respects the same obstacles for all-girl bands of the 1920s existed for all-girl bands of the 1950s: many young women found it difficult to combine family lives as mothers and wives with the rigorous touring schedules of professional jazz musicians.

In 1956, Hutton's national show was reviewed by Los Angeles papers as outranking other variety-style programs, even Milton Berle's: "She was an immediate success with her unique combination of sex and saxes. Milton Berle and the fireside theater shows were consistently left in the lurch on local ratings because of her drawing power" (Ames 1956). In addition to the many expert instrumentalists in the group, performing with her 1956 band was singer and electric guitarist Janie Davids, and the insertion of the instrument was still a relatively new phenomenon in big band ensembles. Despite the show's initial high ratings, however, the program was dropped after only six weeks ("Ina Ray Hutton Sets Those Curves for TV" 1956).

In 1955, Hutton was also contracted by Universal for a film *Girl Time,* which was also rumored to feature her all-girl band. One press review summarized Hutton's upcoming all-girl film: "Ina Ray Hutton, the blond bombshell who also directs a girl's orchestra, is sticking to her 'girls only' motto even in the flickers. She has just signed with Universal International for a film built around the format of her former KTLA show. Ina says only gals will be in the cast. I'll bet the crew will be composed of goggly-eyed men, Ina." (Ames 1954) Unfortunately, I was not able to confirm whether this film was produced as a feature length film or a variety style television program.

While a few all-girl bands achieved limited success during the early and mid-1950s, jazz women of the conservative McCarthy era struggled to find adequate live and mediated performance opportunities. Just as male jazz musicians sought new kinds of professional opportunities, female musicians were forced to seek a broader range of musical repertoire, smaller group venues, and other kinds of musical employment—this despite the brief resurgence of variety style all-girl programs aired largely on the West Coast during these years. Regional differences among the Midwest, the East Coast, and the South also suggested that the West Coast remained more open to such female-centered entertainment programs. Arguably, these programs lasted as long as they did in the difficult postwar climate because of the skill and effervescence of West Coast performing women who fiercely battled for their place in professional music unions. However, it was those crossover female soloists and veteran theater and film personalities who more broadly influenced television's national audiences during the 1950s, and it is their contributions to this new medium that I now examine.

Television's Musical Variety Guests
Hazel Scott, Peggy Lee, and Lena Horne

❀

Although the all-girl television musical programs of Hutton, Leonard, Bryant, and others were relatively short-lived, regionally produced programs (especially popular with West Coast audiences during the 1950s) sometimes featured female jazz vocalists and instrumentalists as hosts and special soloists for national television formats. Their highly feminized images and their diverse repertoire of jazz, blues, and popular music facilitated their incorporation in these family-style variety shows. In this chapter, I consider three television jazz and popular music performers whose careers were enhanced by the growing medium of television and who helped to sustain musical variety and vaudeo as a popular format throughout the 1950s.

The Hazel Scott Show

Hazel Scott was one of only a few African American jazz musicians to host a television show during the 1950s. During the late 1940s and early 1950s, Scott made several guest appearances in various variety television programs, including Ed Sullivan's *Toast of the Town* and Steve Allen's *Songs for Sale* ("On Television" 1952). Eventually in 1950, Scott was contracted to host her own fifteen-minute musical program for a New York station, airing Friday evenings at 7:45. The show was soon adopted by the DuMont network and increased to three times a week, Mondays, Wednesdays, and Fridays (Bogle 2001, 15). Programming Hazel Scott's show on the Du-Mont network may have indirectly reflected DuMont's anti-oligopoly politics; he battled the FCC for many years, hoping to increase the number of available national network stations as well as increase the variety of programming and content for America's mass audiences.

Various industry journals such as *Variety* favorably reviewed the show, emphasizing her respectable character and versatile talents: "Hazel Scott has a neat little show in this modest package. Most engaging element in the aired is the Scott personality, which is dignified, yet relaxed, and versatile" (quoted in Bogle 2001, 16).

According to Bogle, Scott's show failed to secure a major sponsor in September 1950 despite the show's positive ratings in the Hooper system (Bogle 2001, 18). Scott's contract was not renewed and her show was canceled in late September 1950. Journalists attributed the cancelation of the show to Scott's listing in the blacklist newsletter *Red Channels*, in June 1950 (Bogle 2001, 18). One headline read simply "Redlist Costs Hazel Scott Job" (quoted from *The Compass*, in Bogle 2001, 18).

After 1950, the next television series to star an African American female performer relied not upon the respectable and cultivated presentation of musical performers like Hazel Scott, but rather upon tried-and-true caricatures circulated via vaudeville, musical theater, and especially radio's racial comedies. *Beulah*, a radio comedy series introduced in 1939, originally featured white racial dialect performers including Marlin Hurt and Bob Corley as the archetypical comedic but gregarious Southern maid character. During the 1940s, CBS radio scripted a black actress for the role, casting Hattie McDaniel, the first African American to win an Academy Award (for her role in the 1939 *Gone With the Wind*). Eventually during 1951, ABC syndicated a national television series of the program staring Ethel Waters as *Beulah* (Bogle 2001, 20), a role that significantly contrasted with the refined, real-life persona of jazz musician and television host Hazel Scott. Nonetheless, Scott's success via television defied the conservative and persistent racial prejudices of the industry throughout the 1950s, even if only regional and short-lived.

Scott's outspoken political activism, her insistence upon racially integrated audiences, and her relationship with Café Society's Barney Josephson certainly contributed to her listing in the McCarthy era's *Red Channels* in 1950. *Red Channels*, a publication of the "Counterattack," was designed to weed out communist performers and entertainers from American society. In its published mission statement, *Red Channels* detailed its mission:

One, to show how the Communists have been able to carry out their plan of infiltration of the radio and television industry. Two, to indicate the extent to which many prominent actors and artists have been inveigled to lend their names . . . to organizations espousing Communists causes and Three to discourage actors and artists from doing so. (Scott 3624)

John Crosby of the *Herald Tribute* went so far as to claim that *Red Channels* had become the bible of the entertainment industry.

In September 1950, Scott agreed to appear before the House Un-American Activities Committee for a panel that included Ku Klux Klan member Congressman Woods of Georgia (B. Reed 1998, 124). During the hearing, Scott lambasted the event and proclaimed that the hearings themselves were un-American. Shortly after Scott's hearing, she publicly proposed that entertainers boycott those radio and television networks that blacklisted performers included in the *Red Channel* listings (B. Reed 1998, 124).

In Hazel Scott's published testimony before the committee, she pleaded for a more just process whereby Americans—and specifically entertainers—would be given proper and formal "channels" to clear their names of communist charges before being abruptly released from contracts with the various networks. Moreover, she attacked the "mudslinging" and "vile" tactics adopted by the Counterattack, including indexing suspected members in *Red Channel*:

We should not be written off by the vicious slanders of little and petty men. We are one of your most effective and irreplaceable instruments in the grim struggle ahead. We will be much more useful to America if we do not enter this battle covered with the mud of slander and the filth of scandal. (Scott 3615)

And in her printed but unspoken statement she railed against the political atmosphere of the early 1950s cold war era:

This is the day for the professional gossip, the organized rumor monger, the smear artist with the spray gun. The game of attacking and defaming your neighbor is not only practiced by the overzealous, the misguided, and the super patriot, but also by the Communists themselves to spread confusion, hysteria, and ultimate panic.

(Scott 3619)

In her testimony, Scott also reiterated the words of Eddie Cantor who said, "Let somebody bigger than a bigot sit in judgment of the accused" (Scott 3625).

Scott's listing in *Red Channels* most likely tainted her relationship with the DuMont network regardless of the progressive politics of president Allen DuMont. Although she was never officially charged with communist activities or sympathies, historians Bogle and Reed frequently link the demise of her show with her name's appearance in *Red Channels* (Bogle 2001, 15; B. Reed 1998, 124). Other factors probably contributed to Scott's termination, including the DuMont network's financial struggles and eventual demise during the 1950s (MacDonald 1994, 59). Nevertheless, the *Hazel Scott Show*, broadcast from New York from July 3 through September 29 of 1950, was the first network television musical variety program to be hosted by and to feature an African American woman in a characterization that was cultured, musically prolific, and highly respectable.

After the termination of Scott's show, she appeared infrequently on other variety television and radio programs. In the mid-1950s, Scott moved to France and established herself as a popular, jazz, and classical music soloist, performing throughout Europe. During this time, however, she continued to provide guest appearances for American radio and television programs, including spots on Ed Sullivan's *Toast of the Town* and the celebrity quiz show *What's My Line?* Scott was also featured on *Dial M for Music* in 1967, performing French and American jazz pieces and medleys, including a tribute to Django Reinhardt ("Television this Week" 1967).

Although I was unable to locate Scott's DuMont show, Bogle writes a brief description of the opening of one particular episode. Here, he provides a glimpse of the self-conscious and highly mediated representation of Scott's musical persona: one of elegance, refinement, and worldliness:

The Hazel Scott Show opened with the camera panning across an urban skyline, then revealing a set that was supposedly a room off the terrace of a posh penthouse. There sat the shimmering Scott at her piano, like an empress on her throne, presenting at every turn a vision of a woman of experience and sophistication. Energetically, she might perform Gershwin's "'S Wonderful," or "I'll Remember April" or a swing version of Brahms's "Hungarian Dance Number 5" or a torch song or a spiritual (on which she would accompany herself on the organ). Surprisingly her urbane fare and style worked well for television. (Bogle 2001, 16)

The few extant descriptions of Scott's television show depict her musicality, refinement, and versatility—qualities that Scott carefully cultivated in her musical performances throughout her life.

Scott's television performance in 1955 for the March of Dimes fundraiser was similar in this respect. This time Scott is featured as part of a trio performing with bassist Charles Mingus and drummer Rudolph Nichols. Characteristic of her tendency to mix high and low and classical and popular musical genres, Scott performs "A Foggy Day" in an intimate, yet progressive jazz style. Scott begins with legato, arpeggiated passages suggesting an impressionistic eight-measure meditation. The regular Tin Pan Alley, 32-bar form is introduced by Mingus and Nichols as Scott begins the "head." Scott takes the first and only solo, in swingtime over the 32-bar form, vocalizing as she embellishes and improvises over the melody. The song ends with a short vamp as the musicians quietly fade out.

Following her first musical selection, Scott emphasizes the need for extended support for the March of Dimes to help adults and children suffering from leukemia and polio "regardless of their age, race, color or creed." Then Scott introduces the next performance number casually, "And now I am going to sing a song for you in French." She then opens *Autumn Leaves* with an extended, classically oriented passage as she sings lyrics in French by

composer Joseph Kosma and Jacques Prévert. She reveals her knowledge of the popular French original stating: "It's known in America as 'Autumn Leaves' and in Europe as 'Les Feuilles Mortes.'" The song became famous in France after variety performer and chansonnier Yves Montand performed it in the film *Les Portes de la Nuit* in 1946. Scott performs an extensive impressionistic passage on the piano, until she begins singing and playing the head, this time in straight-time while Mingus and Nichols join in.

Scott's simple yet refined image in this short March of Dimes commercial was in many respects typical of how she performed throughout most of her career. In 1945, for example, Scott was featured in the Gershwin biopic *Rhapsody in Blue,* as a nightclub entertainer who sang in French and performed various swing-inflected, classical, and boogie-woogie versions of Gershwin's music. Her television persona for this short commercial remains consistent with these earlier Hollywood film presentations, where Scott simply performs as herself: an elegant nightclub piano soloist who renders famous classical and jazz hits into technically proficient, mixed-rhythmic mediations on high and low genres. In terms of class, Scott's television persona resembled Cole's: both artists sought to overcome the debilitating stereotypes of black theatrical roles by projecting their cosmopolitan elegance and musicality, introducing the various musical numbers, while eschewing any offbeat or heavily racialized humor. Further, both artists maintained their immaculate appearances, exhibiting sophisticated and fashionable designs in settings that suggested class, style, and a sense of modern luxury.

Peggy Lee's Variety Appearances

While Scott's televised musical image corresponded with earlier film appearances from the 1940s, during the 1950s, jazz singer Peggy Lee cultivated a variety of musical personas in order to negotiate the varying aesthetics of television, jazz, and musical variety. In one respect, Lee incorporated and maintained her characteristic cool, laid-back performance style that paralleled current jazz trends—especially those most inspired by the California disposition, namely, the cool jazz style. Yet her visual appearances reflected the lingering Hollywood aesthetics of spectacle and glamour as well as a physically restrained performance mannerism that critics often portrayed in racialized terms as subtle, but sexually charged and highly erotic. Finally, Lee continued to personify a down-to-earth, small-town, all-American girl in her reserved demeanor and friendly disposition.

Unlike other popular musical television hosts, such as Dinah Shore, who mostly sang popular songs, Broadway hits, and crossover jazz standards,

Lee performed a repertoire dominated by jazz, blues, and jazz-inflected popular songs. Even during later decades, her expansion into genres like rock and pop continued to prioritize a jazz or blues interpretation. Lee's tenure with Benny Goodman, her dozens of recordings in small jazz combos with jazz guitarist Dave Barbour, pianist Jimmy Rowles, and trumpeter Pete Candoli (among others) for Decca and Capital, and her extensive national tours—all established her as one of America's premier female jazz vocalists during the 1930s and 1940s.

Lee also gained experience performing in other mediums including radio, nightclubs, recordings, and especially film. Her roles in Hollywood films in the 1940s and 1950s including *Stage Door Canteen* (1943) with Benny Goodman, *The Powers Girl* (1943), the remake of *The Jazz Singer* (1952), and *Pete Kelly's Blues* (1955), provided her experience with visually mediated entertainment forms; in that sense, her frequent invitations in variety television were not unexpected. Lee also shared a brief musical scene with America's favorite crooner, Bing Crosby in 1950 for the film *Mr. Music* (Paramount). Although she appears only briefly, singing "Life is So Peculiar" with Bing Crosby (with husband Dave Barbour on guitar), her performance was favorably noted by jazz critics.

During the late 1940s and through the 1950s, Lee became a frequent guest in variety television programs including the *Paul Whiteman's Goodyear Revue*, the *Pat Boone Chevy Showroom*, *Music Stand*, the *Jackie Gleason Show* and the *Frank Sinatra Show*. Along with other jazz performers like Duke Ellington and Sarah Vaughan and even Ada Leonard and her all-girl jazz band, Lee was featured in the short subject Snader Transcriptions of the early 1950s. According to film historian and archivist Fred MacDonald, Snader Transcriptions were filmed in Chicago from 1950 until 1952 and were intended as fillers for television programs that ran short of their allotted time (personal conversation, January 2007).

Lee's 1950s film appearances were certainly influenced by her television image as an everyday, hardworking woman, and multigenre singer. Her 1955 film rendition of a failed alcoholic jazz singer in *Pete Miller's Blues,* for example, aligned her with working-class values and popular music identifications. Moreover, critics frequently pointed to Lee's unassuming, down-to-earth "Lutheran and Scandinavian" heritage to present her not as a Hollywood diva, but as a hardworking, musically gifted, but modest, small-town girl. This characterization evolved from notions of an Anglo-Saxon work ethic and contrasted with the ways that middle-class black female performers were often misrepresented as part of an urban underclass, and characterized as drug-addicted, oversexualized, or love-abused victims (characterizations

that were also exploited when representing African American women in musical theater and film).

The timing of Lee's most active performance period, the interwar and postwar periods, required her to negotiate the established Hollywood star system and its public culture as well as the new corporate-sponsored forum of television, which promoted private leisure via a combination of intimacy, popular culture, and consumerism. Representations of Lee during the postwar era exhibit this contradiction as she alternates from the humble, down-to-earth American girl to the sexy, black-coded, and sometimes drug addicted seductress of the smoky nightclub. The *New York Daily Mirror,* for example, emphasizes the small-town qualities of Lee's public persona: "If you gathered all the stars and put them at the feet of Peggy Lee, she'd still be the kid from Fargo, North Dakota. Peggy is the singer with the silken voice who's just thankful that she's liked" (Fields 1949). *Look* magazine's exposé on Lee from 1950 featured a similar story about modest origins and hardworking professionalism cultivated in such humble beginnings.[1]

Beyond her down-to-earth, small-town image, Lee was also celebrated for her expert jazz phrasing and vocal control. *Down Beat* named Peggy Lee the "Number One Girl Singer" of 1946. One year later, respected jazz critic Leonard Feather subjected Lee to one of his prestigious *Metronome* blindfold tests. He similarly described Lee's high standard of musical skill in combination with her humble disposition:

In the world of popular singing, there is a very thin, vague borderline between what is considered by the pundits to be jazz singing (Bessie Smith, Louis Armstrong, Billie Holiday) and what is dismissed as mere popular singing (Dinah Shore, Perry Como, Jo Stafford). Jazz critics, even those on the Moldy Fig side who cling so tenaciously to the old, the pure and the earthy when voting for instrumentalists, contradict themselves and one another widely when it comes to singers, sometimes even vote for a Crosby or a Sinatra where you fully expected them to root for Josh White or Leadbelly. In the charmed circle of singers who have earned praise and respect from both sides of the fence is Peggy Lee. Everybody likes her singing because it is both jazz singing and popular singing. Everybody is happy to be able to praise her, too, because she is one of the nicest and most genuine people in show business. (Feather 1947)

Lee, however, didn't require Feather to lend credence to her musical skills. She succeeded in correctly identifying no fewer than twelve of the sixteen recordings played, including tracks by Billie Holiday, Artie Shaw, Sarah Vaughan, Ella Fitzgerald, and lesser known artists like Slim Gaillard and Lee Wiley. In judging a record by vocalist Lee Wiley, for example, Lee astutely reveals the correct artist but also provides an insightful critique of the recording:

Lee Wiley—I like her. She's one of those singers that a lot of people don't like at first, then when they get to know her they really like her. This isn't a new record—vocal backgrounds have improved a lot since then. You get the feeling that this was a new arrangement, played adequately but without enthusiasm. Nowadays musicians really strive for good phrasing, try to make it jump when it's needed, and take a real interest in what's going on. Three stars. (Feather 1947)

Another Feather review from the mid-1950s praises Lee's musicality while performing at the New York nightclub La Vie en Rose:

Being very cautious about overstatement, we will only say conservatively that Peggy gave the greatest performance we have seen delivered by any singer in a Manhattan club in the last five years—and that includes everybody, male or female, from Lena Horne and Sinatra on down. . . . If you have inferred that we are overboard for Miss Lee, you are right. Peggy does for a song what Jane Russell does for a sweater. If you only know Peggy Lee from records, or radio and TV and theaters, catch her some time in an intimate nightclub like this. If you don't get a genuine thrill—Jack, you must be dead.

(Feather quoted in *Down Beat* [1954], in Richmond 2000, 219)

Despite Lee's prodigious jazz skills, jazz recording companies continued to rely upon the visual iconography of the pinup as well as the more current feminine images populating Hollywood film noir genres. The most persistent of these images depicted female vocalists as temptresses or seducers. The record cover image on Capital's *Rendezvous with Peggy Lee* (1952; fig. 11.1) displayed Lee as a glamorous bombshell. One of Lee's biographers, Peter Richmond (2006) provides an illuminating example of how Lee's visual image from the 1950s continued to prompt highly sexualized associations:

Lee was photographed splayed on her back on some sort of divan, her blond hair in disarray on a pillow behind her, her sparkly green gown suggesting nightclubs, after hours, after sex. Dangly blue earrings framed bright red, seductively smiling lips. The eyes—bright blue, rather curiously, given that hazel was their natural shade—were cast askance. Her décolletage swelled enticingly—at least on the first pressings. On later copies of the records, only about a half inch of swelling breast was visible.

(Richmond 2006, 151)

Richmond (2006) frequently oozes over Peggy's eroticism, especially when describing her musical performances. When depicting her rendition of "Lover" (see fig. 11.2) in the 1952 remake of *The Jazz Singer*, for example, Richmond reduces Lee to a sex addict:

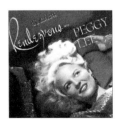

Figure 11.1. Record cover for Peggy Lee's *Rendezvous* (Capital reissue H-151, 1952).

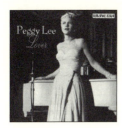

Figure 11.2. Record cover for Peggy Lee's *Lover!*
(Decca 28215, 1952).

Her nightclub performance of "Lover" was nothing short of ecstatic: wild, sexy, unre-
strained, and every bit as enticing as the live version. She was photographed leaning
backing into the curve of the white grand piano, nearly writhing—as if she were pin-
ioned by invisible velvet ropes, trying to get free, but not trying terribly hard. When she
idly rubbed the top of the piano with her hand and a handkerchief, it was as if she were
stroking it sexually. When she reached the climax of the song, she leaned her head back,
and her final, blissful, oblivious word—"*Lo-ver*"—left little to the imagination (211).

While Lee remained a favorite subject of 1950s celebrity and lifestyle
magazines like *Look* and *Life,* her success did not escape the specialty jazz
and popular music magazines like *Metronome* and *Down Beat.* In October
1950, for example, *Metronome* interviewed "Dave" and "Peggy," married at
that time, about their musical philosophies and their favorite artists. Peggy
wrote of Sinatra: "He has a sort of neuter gender feeling that's very appeal-
ing when he sings something like 'It Never Entered My Mind' or 'Guess I'll
Hang My Tears Out to Dry'" (B.H. 1950). Lee's emphasis upon the gen-
dered and performative power of the voice reflected how jazz artists con-
ceived of performance as a highly gendered and racialized act during the
1950s—a period when crossover and feminized performers like Sinatra,
Cole, and Boone frequently guest-starred on variety television.

During the 1950s, Lee's performance style greatly contrasted with that of
other female television musical hosts (for example, Martha Raye). Lee's
preference for performing staples of blues, jazz, and jazz ballads also distin-
guished her from more mainstream musical hosts like Dinah Shore, whose
ethnic erasure and assimilation more readily facilitated a domestic, middle-
class identification; Shore tended to perform popular hits of the day as well
as a repertoire gleaned from Broadway musical productions in combination
with the more popular jazz vocal standards. Unlike Shore, Lee was consis-
tently rated as a top jazz vocalist and often ranked as the postwar era's "top
white vocalist," a persistently racialized musical conception. This review
from *Melody Maker* is representative:

Peggy has a soft, appealing, intimate style of singing, and she knows her jazz; given
the right material she can put a song over with the best of them. In such Capitol re-
cordings as "Ain't Goin' No Place," "Baby, Don't Be Mad at Me" and "A Long,
Long Train with a Red Caboose," Peggy reveals that she is certainly one of today's
top white vocalists. (Tanner 1949)

The naming of jazz artists as "white" or "black" continued to demarcate the reception of performers' live performances and recordings, where authenticity and musical merit were consistently judged according to racialized conceptions.

Lee's Variety Television Performances

Lee performed in and/or hosted several variety shows of the 1940s, 1950s, and 1960s including, *Toast of the Town* (1948), the *Star Spangled Revue* (1950) hosted by Bob Hope, *The Frank Sinatra Show* (1951), *Music Stand* (1951), *TV's Top Tunes* (1951), *Paul Whiteman's Goodyear Revue* (1951, 1952), *Chrysler Shower of Stars* (1956) *The Jackie Gleason Show* (1957), *The Pat Boone Chevy Showroom* (1958), Ed Sullivan's *Toast of the Town* (1962), and the British variety show of the 1960s, *Big Night Out* (1963).

Her performances in variety revue programs varied from single or double song performances to entire shows programmed around Lee's musical repertoire. Occasionally, these programs also scripted Lee into various low-brow comedic skits. For Lee's musical numbers, no expense was spared to duplicate the extravagant staging and production style of 1930s and 1940s variety revues or Hollywood spectaculars, which included the opulence and high production values of the variety stage, complete with chorus girls, choirs, luxurious sets, and sophisticated lighting. During these performances, Lee's restrained and collected performance style markedly contrasted with the extravagance of these musical numbers.

In December 1951, Lee performed as the featured guest on Paul Whiteman's hourlong variety revue program (fig. 11.3). ABC's *Paul Whiteman's Goodyear Revue* was representative of the expensive "spectacular" television production of this period and this episode featured Lee in two extensive variety numbers.[2] Consistent with variety television's corporate sponsorship format, the program is introduced by an antiseptic commercial about the strength and durability of Goodyear tires, and followed by Goodyear singer Maureen Cannon performing the show's theme song. The program's mundane incorporation of these commercial jingles was a jarring contrast to the slick production values of the musical revue numbers.

After the commercial proceedings, Whiteman introduces the main theme of this particular program, "the harp," first in words and then musically in bold symphonic gestures. The highly gendered associations of this instrument made it a logical choice for the Whiteman show, a program that catered to female and family audiences and provided a link to 1930s- and 1940s-era musical revues and their extensive feminine iconography. Whiteman introduces the show with allusions to gendered musical symbolism:

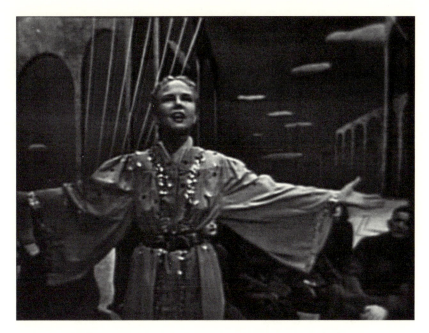

Figure 11.3. Lee sings "Hallelu" on *Paul Whiteman's Goodyear Revue* (ABC 1951). Courtesy Fred MacDonald.

Of all the musical instruments we have today, the harp is one of the oldest and most beautiful. Through thousands of years, people have listened to its gentle music. Think of love songs and of the music of spiritual tunes. Here now is Miss Peggy Lee with the Goodyear chorus and "Little David Play on Your Harp."

For this episode, ABC financed an elaborate set decorated with romantic and feminine images including arches extending into the heavens, harps, and giant, billowing clouds. For Lee's first number, she sings out, in a preacherlike style, while the chorus chimes in with repeated phrases of "Little David Play on your Harp" and "Hallelu." Lee exhorts "Come Down Angels," while the chorus responds with a simple plagal cadence on "Brother." Lee's spirited white evangelical choir adorns simple black robes positioned piously on the floor—Peggy's devout parishioners. The dancers exhibit modern jazz choreography, updating this mass-mediated television revival for younger audiences. Here the conservative religious values of the 1950s are expressed through modernistic musical choreography and musical appropriations of African American religious and vernacular musics.

Whiteman's next piece features harp soloist Gloria Agostini in a highly orchestrated piece, "The Harp Fantasy." The complex arrangement incorporates intergenerational musical genres, including classical music, boogiewoogie, and popular songs ("Shangri La"). Interspersed with various

close-ups of the instrumental soloists are modernistic jazz choreographies performed by four male/female paired dancers, a choir, and stage designs that are angular, bold, and avant-garde.

Following "The Harp Fantasy," Lee sings "Zing Went the Strings of My Heart" with Goodyear jingle singer Maureen Cannon and the featured Goodman male soloist (uncredited). This piece again showcases Lee, who appears uncharacteristically animated in this highly produced format, in contrast to her image as a cool, intimate jazz singer. Lee stands poised between the giant strings of a massive harp, as do the other two singers. The dancers move frenetically in the background and in a modernistic, jazz-style ballet. Whiteman's orchestra performs their arrangement in a slightly swung rhythmic feel, but the melody is performed in a rather straight musical theater performance context romanticized by its "sweet" musical orchestration. Both the choreography and the musical arrangements reflect modernistic 1950s television values through elaborate musical arrangements, which attempted to intersect high and low as well as intergenerational musical genres. The dance sequences similarly reflect such intergenerational values; they execute their moves with a classical ballet technique while incorporating jazz-inspired choreography into the modernistic musical sequences.

The show closes with advertisements for the following week's program in which the *Paul Whiteman Revue* visits an "elaborate beauty fashion salon," as the band plays Whiteman's signature piece "Rhapsody in Blue" before the final words of the sponsor: "The Paul Whiteman Revue has been brought to you by Goodyear—the greatest name in rubber." Whiteman's revue perfectly reflected the conservative ethos of the early 1950s and specifically of television's role in promoting postwar ideologies: it combined notions of intimacy, femininity, musical variety, and domestic consumerism.

A less prominent television piece, which also aired in 1951, presents Lee in a more relaxed setting. The American Cancer Society produced *Music Stand* to recruit donors for its national research association by presenting fifteen minutes of music and fundraising pleas as filler material for network serials. The program mirrored a cheaply filmed radio program, including hidden announcers and brief sketches of a music book to introduce three previously filmed musical shorts of Peggy Lee and Duke Ellington. In this particular telecast, the narrator begins by announcing the cause of the American Cancer Society; he then simply introduces Lee. Again, the films compiled for this television ad are three Snader Transcriptions from 1950, all produced in Chicago (personal conversation with MacDonald, January 2007). The first Snader is a film of Lee singing one of her most commercially successful

songs, "Do Right like Some Other Men Do," recorded originally with Benny Goodman in 1943. In this particular film, Lee performs in an intimate and small jazz setting with husband Davé Barbour on guitar and Rowles on piano, a style and arrangement more akin to her mid-1940's performances. Barbour plays a languid yet provocative solo after Lee's polished yet laid-back rendition.

According to Lee's biographer, Lee became first acquainted with the song via a 1936 recording by Lil Green, which also featured blues artist Big Bill Broonzy. Her 1950 performance is a deliberate imitation of Green's phrasing, especially her vocal articulation. Lee's orchestration and rhythmic feel, however, indicate a more contemporary "cool jazz" approach. Even the filming technique incorporates this aesthetic, with its simple setting of a nightclub stage and warm lighting in black and white and close-ups of Lee and the other musicians improvising.

Following Lee's rendition of "Do Right," the radio-like announcer again pleads for the Cancer Society before introducing Duke Ellington and his performance of "Sophisticated Lady." After an announcement by film star Burt Lancaster, the short program features another Snader of Peggy Lee, this time singing "What More Can a Woman Do?" a poignant ballad written by Lee and Barbour. While this program may have been relatively insignificant in terms of competing against network musical variety programs, the manner of musical presentation and commercial solicitation did correspond with early 1950s musical programs and reflected the continuing influence of radio upon early television formats.

During the late 1950s, Lee continued to be featured in vaudeo and musical revue programs, performing a variety of ballads, jazz standards, and popular songs. In 1958, she guest appeared on *The Pat Boone Chevy Showroom* (figs. 11.4 and 11.5). Vocally, Lee and Boone were well matched because of their restrained, cool vocal styles, and nuanced sense of phrasing. Like Lee, Boone was also a 1950s heartthrob and fulfilled both the adult requirements of soft musical genres and the intimate aesthetics of crooning, while his cool demeanor and good looks popularized him with female teenagers. Later in his television career, Boone was able to reinvent his charismatic personality for the growing TV evangelical community.

In this episode, Lee performs a variety of numbers including the cool jazz tune "It's Nothing," a romantic ballad with Boone entitled "Springtime," and a gospel and rhythm-and-blues–inflected arrangement of "Swing Low, Sweet Chariot." The program begins rather typically by promoting the program's sponsor with an "Ok Used Car" Chevrolet commercial after which Boone introduces Lee: "Peggy Lee is one of America's most versatile singing artists. Not only is she a great singer, but she has had

Figure 11.4. Lee and Pat Boone sing a duet on *The Pat Boone Chevy Showroom* (ABC 1958). Courtesy Fred MacDonald.

a book of poetry published. She's been in a lot of great movies and she is one of this country's outstanding songwriters. So here is the very special Miss Peggy Lee."

Lee then sings the simple, understated "It's Nothing," beginning the tune with a slow rubato introduction embellished by piano rolls, strings, and harps. The "head" evolves via a standard dramatic intro, prompted by a walking bass line leading to the swinging chorus: "It isn't red, it isn't green . . . it's nothing,". . ."It isn't wide, it isn't tall . . . it's nothing." The song features both minimalist jazz accompaniments and filmic backdrops embellished with blues-inflected riffs—a kind of Basie meets Mancini orchestration. The stage design is also highly feminized and features a luxurious parlorlike setting with a vanity, a harp, and velvet curtains. Lee wears a very romantic full-length, lace and beaded white, mermaid-shaped, gown. Victorian chairs, a small fir tree and chandeliers decorate the stage. The scene contrasts greatly with smoky nightclub settings where one might imagine hearing this song performed. The song builds to a climatic shout section in the middle and then transitions into "rhythm changes" repeated twice before the bridge. At the close of the song, Boone walks over to Lee thanking her for her performance and the two then do a bit about the

song, ad-libbing on the lyric "it's nothing" in a kind of Abbott and Co-stello "who's on first" repartee.

The romantic ballad number "Springtime," sung as a duet between Boone and Lee, contains lyrics that depict Lee as a North Dakota girl from a small town. After the duet the camera pans to three teenage girls clapping in PJs and earnestly chatting about a famous couple who is going to have a baby. Boone then performs "More Than You Know" in suit and tie—a crooner ballad staged in a pastoral setting of oak trees, rolling hills, and a windmill, with Boone propped up on a brick fence. During Boone's performance, young women from the live television audience are heard screaming in the background. Close-ups of Boone's face provide the intimate atmosphere fa-vored by early television.

Boone then introduces an "April Love Ballet" by casually mentioning the 1957 hit song "April Love," as featured in Boone's upcoming motion picture of the same name. The ballet begins with sweeping strings and then the melody played by violins as the first dancer enters in a witch mask ac-companied by the Frankenstein monster. A second couple enters, cos-tumed as Medusa and Count Dracula, and is eventually followed by a sec-ond dancing pair, a mummy and batwoman. This scene again catered to

Figure 11.5. Lee sings "It's Nothin'" on *The Pat Boone Chevy Showroom* (ABC 1958). Courtesy Fred MacDonald.

multigenerational audiences with horror film characters, syrupy ballads ("April Love"), and more traditional ballet choreography. Here the concept of combining popular dance, horror film roles, and popular music predated Michael Jackson's music television video, *Thriller*, which later provided a similar mixed-media crossover appeal. At the conclusion of the scene, teenagers are shown talking about the latest horror flicks. These brief PJ interludes in cozy bedrooms appealed to television's domestic sensibility, while also targeting female teenagers.

Peggy's second number, "Swing Low, Sweet Chariot" is again sung with Pat Boone. The intro features Peggy surrounded by girls and boys sitting in wooden chairs as if attending school. The staging disavows the music signifiers, which aurally suggest a musical relationship between a preacher and his/her choir. At the same time, the choreography and musical arrangement integrate black musical idioms, including gospel and rhythm-and-blues, referenced by the many call-and-response choruses as well as the middle section in which the students (as a chorus) begin clapping on beats two and four. The students chime in, singing in a style pre-dating the Swingle Singers but supported by flashy big band riffs executed with flare and bravado. As in the Whiteman harp scene, Lee performs something akin to a televised "Ring Shout Jubilee" for the conservative audiences of variety review. Both Lee and Boone, however, perform with great professionalism, skill, and subtlety, enhanced by their cool, collected mannerisms and performance styles, which ultimately increased their popularity with younger audiences.

When reviewed by the industry, Lee's variety television performances replicated the sentiments of jazz critics and journalists. Her expert jazz skills were often mentioned in tandem with her good lucks, cool demeanor, and humble disposition. Of course, industry reviews also stressed Lee's blonde sexual appeal—appealing to male fans and younger music lovers. Lee's vaudeo reviews, generally short, pithy quips, acknowledged the entertainment value of the program's content. Her musical and visual qualifications were also generally positively mentioned, as in this *Variety* review of the 1953 *Colgate Comedy Hour*: "Peggy Lee, of course, is one of the top pop singers of this day. She purveys a tuneful variety of sex which was evident even when she sang the Halo shampoo commercial, which is still a cavalier way of treating an artist. Her top number done in a cloud of artificial smoke was 'Baubles,' which made an interesting sequence" (*Variety*, 11 December 1953).

Lee was briefly featured in her own musical variety show during the summer of 1951, a program that simply featured Lee in many musical numbers and as host to other guest singers like Mel Torme. *Variety* again mentioned the high level of musicality exhibited by "Miss Lee:"

Following the current network pattern of replacing the top regular comedy airers with musical sessions during the summer, Peggy Lee is pinch-hitting for *Amos 'n' Andy* series with a neat song stanza. One of the top-flight stylists in the trade, Miss Lee registers on this show as an ingratiating femcee who handles her lines slickly. This airer is simply formatted around Miss Lee as the star with assists from guest vocalists and Russ Case's orchestra. Only novel twist on the session is Miss Lee's weekly debut of a new number. On the preem, she introduced "After All, It's Spring" from the upcoming legit musical *Seventeen*. Miss Lee socked across a flock of her wax standards. (*Variety*, 20 June 1951)

By the end of the 1950s, Lee was still active in the television variety format. A review of Lee's guest hosting capabilities on the *Jackie Gleason Show* in 1957 continued to mention her cool performance style and expert musicality:

Miss Lee, who never looked better, was also the hostess with the mostest, whether femceeing or chirping. Her work on the finale, relaxed and charming and typically low-key Lee, indicates that she could have another future, à la Dinah Shore, as a regular in the video sweepstakes. She whammed with a segment from her Capitol album of *The Man I Love*, which could be a hot seller on the grounds 1) that it's a Peggy Lee package, plus 2) Frank Sinatra conducting. (*Variety*, 26 June 1957)

Lee's countervailing representations of the highly racialized erotic night-club jazz singer in tandem with her persistent television image as a friendly, unassuming, all-American, Midwestern gal ensured her continued appearance in variety television up until the 1970s. Lee's career, a long and prolific one, remained connected to jazz aesthetics and the discourse of blackness, whiteness, and musical femininity so central to the highly visually mediated forums of film and television.

Lena Horne and Variety Television

Very few African American female jazz musicians appeared on television as regularly as Peggy Lee. However, jazz vocalists like Ella Fitzgerald and even Billie Holiday continued to provide stunning musical guest appearances on variety television during the 1950s. Of those female musical performers previously promoted by Hollywood in the "spectacular" musical genre, none was more revered during the postwar era than Lena Horne.

Lena Mary Calhoun Horne was born in 1917 in Brooklyn, New York, to parents of African, European, and Native American ancestry. Her complex racial identity and stunning physical appearance contributed to her favorable reception within 1930s New York cabaret culture. Horne's early career as a chorus girl and vocal performer at the Cotton Club, accompanied by such celebrated jazz musicians as Duke Ellington and Cab Calloway, provided her a well-rounded education in various styles of music from Tin Pan Alley, blues, and jazz, to the more exoticized "jungle" music characteristic

of the Cotton's Club 1930s revues. Horne described her early experiences at the Cotton Club as highly educational yet tainted by the exploitative and racially segregated practices of New York nightclubs: "I've worked for white hoods who hired the best Negro talent of the day but wouldn't let Negro people into the club, though it was smack in the middle of Harlem" ("Lena Horne, I Just Want to Be Myself" 1963). Broadway producer Lew Leslie first spotted Horne at the Cotton Club, and subsequently recruited her for the all-black-cast *Blackbird* production of 1939. Leslie even compared Horne to the beloved Florence Mills: "Lena Horne comes closest to the talented Florence Mills of any Ethiopian actress I have ever seen" (Monti 2000, 107, n.19). After various Broadway appearances during the 1930s, Horne landed a job singing with Noble Sissle's prestigious high-society orchestra. While performing with Sissle, Horne adopted Helena Horne as her stage name.

After her successful debut on Broadway as well as her various nightclub performances with celebrated jazz professionals like Noble Sissle, Duke Ellington, Charlie Barnet, Artie Shaw, and Teddy Wilson, Horne was solicited for her first film role in *The Dukes Is Tops* (1938), directed by Milton Nolte and produced by Million Dollar Productions, a Hollywood film company that targeted African American audiences. Horne was only twenty-one during the picture's filming and is featured in one of her few major acting roles during the 1930s and 1940s, not including her leading roles in the all-black-cast *Cabin in the Sky* (MGM) and *Stormy Weather* (Twentieth Century–Fox) in 1943. In 1943, Horne was also invited to tour with white bandleader Charlie Barnet, but after only three months, she decided to quit because of stress caused by racial discrimination while touring with the group. Horne did, however, make a number of recordings with Barnet's band for RCA's Victor label during the 1940s. Shortly after, she moved back to New York to perform at the prestigious, white-patronized Savoy Ballroom.

During the early 1940s, Horne's popularity and reputation grew because of her work in early sound films, her recordings with celebrated jazz musicians, and her nightclub and stage performances. In 1942, Horne was approached by MGM film studios and asked to audition for a long-term contract. Dubious about obtaining equitable Hollywood film roles and compensation, Horne invited NAACP lawyers to accompany her to negotiate the terms of her contract. Even so, her successful seven-year contract with MGM did not offer complex and integrated film roles. Significantly, however, her musical features represented Horne as a serious artist; she thus avoided the more typically demeaning roles given to attractive, light-skinned African American women. Unfortunately, these MGM features

were specialty acts in scenes bearing little relation to the films' main plots. In each of these specialty acts, Horne was never permitted to speak and her scenes were filmed in such a way that they could be easily cut for Southern theater audiences. Despite the limitations of these roles, Horne was the first African American performer to garner a long-term contract with a major Hollywood studio. Her seven-year contract with MGM beginning in 1942 was remarked upon by the black literati during the 1940s and was also proudly announced by the NAACP, who had worked hard to foster more respectful representations of African Americans in Hollywood films.

Theorists of Horne's film career claim that she was the first African American performer to negotiate a contract prohibiting parts considered stereotypical or racist, including those of domestics, mammies, or as exotic dancers in primitive "jungle" scenes (Monti 2000). But Hazel Scott had also managed to negotiate specific clauses in her various contracts with Columbia and MGM about the types of roles she could be asked to play as well as the manner in which she would be portrayed in her film appearances. The studio's solution to such requests often entailed simply including Scott and Horne as themselves in musical and specialty scenes that bore little relationship to the film's overall structure and that could be edited out.

For her Hollywood appearances, Horne's complex ethnic and racial image proved problematic. According to Horne, her producers and directors with MGM advised her to drastically alter her image to something more ethnic or "south of the border," protesting that she "didn't look right" (Horne and Schickel 1965; and Monti 2000, 118–139). Horne was often asked to either darken up or assume a more Latin or Mediterranean appearance; her real multiracial complexity did not fit Hollywood preconceptions.

From 1942 until 1951 Horne made more than a dozen films with MGM, including *Panama Hattie, Cabin in the Sky, The Ziegfeld Follies, Broadway Rhythm, Swing Fever, Till the Clouds Roll By, Studio Visit* and *Words and Music*. During the 1940s and 1950s, MGM sustained a reputation for producing big-budget musical film or "spectaculars," and Horne's prominent role as a starring musical artist bolstered the commercial appeal of these films. In her brief "specialty" acts, Horne appeared in one of two characterizations: as a sultry nightclub chanteuse or as an exotic, ethnic, "South of the Border" variety entertainer (Monti 2000, 119). In Horne's first MGM musical for example, *Panama Hattie* (1942), she performs in an eclectic, Latin American musical number that revealed influences from Carmen Miranda's highly popular exotic Latin music and dance numbers. During the 1940s, Miranda also made a number of films for MGM, expanding MGM's "urban primitivist" appeal (Stanfield 2002).

In some respects, Horne was criticized for being a ploy of the NAACP in Hollywood. For example, African American actors like Hattie McDaniel, who had worked hard during the 1930s and 1940s to secure roles in Hollywood films, sometimes resented the demands made by female musical performers like Lena Horne and Hazel Scott. McDaniel's famous remark that she would rather make $7000 a week in Hollywood playing a maid than working as one is representative of such sentiments.

By the late 1940s, Horne had established herself as a highly versatile artist: a Hollywood musical film performer, a Broadway star, a recording artist, and a featured soloist with prominent jazz bands. Her versatility and credibility placed her in the same league with other mature film and radio stars that were first recruited as guests for the new musical variety and vaudeo television programs of the late 1940s and 1950s. While Lena Horne was not the most active female jazz television performer during the postwar period, her appearances as a guest performer on the most popular network variety programs were considered noteworthy by both the black press and the mainstream entertainment industry.

In many ways, Horne's television appearances in musical and variety programs like the *Ed Sullivan Show* mirrored her performances in her MGM films. In both mediums, she simply performed "specialty" numbers in musical sequences enhancing the diversity, musicality, glamour, and exoticism of these predominantly white variety programs. From the late 1940s to the 1970s, Horne appeared in a number of family-oriented television programs: variety shows; comedy serials and quiz shows, notably *What's My Line?* and *Laugh-in;* and even the children's program *Sesame Street,* where she sang the antiracism song, "It's Not Easy Being Green." During the heyday of variety television, Horne appeared in a number of variety programs for NBC and CBS during the 1950s and 1960s including *Toast of the Town* (1951, 1957), *Your Show of Shows* (1951–1953), the *Colgate Comedy Hour* (1951), *Music 55* (1955), the *Perry Como Show* (1950s and 1960s), the *Steve Allen Show* (1958) (later to became the *Tonight Show*), and the *Dean Martin Show* (1960s). As Horne became more vocal and politically active during the 1960s and 1970s, the decades in which African American variety programs eventually became more lasting programming initiatives, she was also featured in black variety programs like the *Flip Wilson Show.*

Horne performed three times for Ed Sullivan's show during the 1950s, once in 1951 and twice in 1957 (figs. 11.6–11.8). These guest appearances revealed a performer seasoned in the musical theater tradition as well as a leading dramatic song interpreter. During her 1957 Sullivan appearance, Horne promoted her upcoming Broadway role for a black-cast musical

Figure 11.6. Lena Horne and Ed Sullivan on *The Ed Sullivan Show* (CBS 1957). Courtesy Fred MacDonald.

entitled *Jamaica*. During this episode, Horne performed a variety of standards and new jazz/blues pieces including "It's Love," (from the musical *Wonderful Town*),[3] "One for my Baby" (written by Harold Arlen and Johnny Mercer), and "It's All Right With Me" (composed by Cole Porter for the 1953 musical *Can-Can*). "One for my Baby" was first popularized by Fred Astaire in the Hollywood musical *The Sky's the Limit* (1943) and later covered by a variety of blues and jazz singers including Frank Sinatra, Billie Holiday, Ella Fitzgerald, and even Marlene Dietrich.

During the 1950s, the *Ed Sullivan Show* espoused assimilationist (because of Sullivan's frequent hosting of African American, Latino), and other nonwhite artists) as well as respectable, even conservative "family values." These values are clearly evident in the manner in which Sullivan introduces guests and casually interacts with his public and studio audience. Within each show, Sullivan dedicates weekly programs to honored members of the audience. During this particular episode, he mentions Admiral John Clark in the audience as "a very brave American." A salesman is later introduced as president of the National Sales Executives, and then he introduces a "very pretty girl" who was named queen of the New York Press Photographers' ball and featured a quick close-up of her, as he calls out, "June Lundy, will you stand up and take a bow?" The politics and gender

Figure 11.7. Horne sings "One More for My Baby" on *The Ed Sullivan Show* (CBS 1957). Courtesy Fred MacDonald.

values of mainstream America are clearly articulated in these small gestures of intimacy, patriotism, and mass-mediated communality.

Horne shares billing on Sullivan's 1957 program with a less experienced but spectacularly attractive musical performer, Abbe Lane. Lane sings a few numbers with the Xavier Cugat band (she was Cugat's third wife), and her performance style and musical repertoire starkly contrasts with Horne's. Lane performs "A Lazy River" to a triple-feel blues shuffle (the iconic striptease beat) as the boys in the band produce shouts and catcalls during Lane's vocal performance. Lane later sings "You're Just too Marvelous" to a cha-cha-cha accompaniment that featured the many fine percussionists of Cugat's band. Sullivan's choice of Cugat's band and Lena Horne indicated the assimilationist politics of postwar America by incorporating musical genres that, when viewed by mainstream middle-class America, were both familiar and exotic, such as Latin dance rhythms and ballroom dance genres. These musical dance styles would have been distinct from most of suburban America's own particular ethnic and cultural background yet familiar through popular dances and big band recordings and performances. Of course, these formats were extensions of 1940s musical film aesthetics.

And to reassure mass audiences of variety television's affiliation with its middle-class working constituency, Sullivan deflects the ethnicity and cultural background of many of the "ethnic" vaudeville entertainers and comedians with remarks about their personality differences and quirkiness. Sullivan introduces seasoned vaudevillian Carl Ballantine with this description: "Now it is inescapable as you travel around show business you meet a lot of peculiar people, amazing but a little daffy. Mr. Ballantine—vaudeville magician comedian."

Horne's contribution to the *Ed Sullivan Show* is consistent with her film appearances in which she is simply introduced as Miss Horne and then asked to perform some of her "beloved" musical repertoire of the "stage and nightclub." Accompanied by an elaborate jazz orchestra, she performs three numbers representing blues, jazz, and Broadway styles that by 1957 were staples of her popular nightclub repertoire. Her elegant and confident stage presence reinforced her expert theatrical and musical skills (although jazz critics were often dismayed by Horne's categorization as a jazz singer). In many ways, Horne's highly debated racial identity by black and white social commentators as well as the variety of techniques adapted by Horne in her MGM specialty acts influenced the ways that critics responded to her

Figure 11.8. Horne on *The Ed Sullivan Show* (CBS 1957). Courtesy Fred MacDonald.

musical repertoire during the 1940s and 1950s. Although Horne was similarly uncomfortable with the label "jazz singer," her experience with many of the most revered jazz musicians of the 1930s and 1940s endowed her with the interpretive skills to incorporate jazz standards into her repertoire. Horne's vocal technique in such performances might well be likened to the dramatic approach taken by musical theater performers; in this respect her television musical appearances parallel other crossover jazz and popular music vocalists of this decade.

By comparing the reception and representational strategies of these three performing women's—Hazel Scott, Peggy Lee, and Lena Horne—diverse adaptations of televised jazz and popular music performances, one recognizes the powerful matrix of racial identities that continued to drive popular music taste, genre categorization, and most importantly, professional performing opportunities for female jazz musicians. Postwar television's packaging of intimacy, consumption, and popular music in an antiparticularistic context initiated a programming strategy that continued to drive musical genre identifications in the twentieth century (especially with the advent of music television and its emphasis upon visual representations). The limited roles afforded female jazz musicians in television's early variety programs did not necessarily negate their immense appeal, proficiency, and musical creativity. Nonetheless, the seemingly diminished presence of women in jazz during the 1960s and 1970s, however, suggests that this combination of intimacy, consumption, and a feminized musicality was the backdrop for Peggy Lee's final musical comeback, "Is That All There Is?"

Conclusion
The Jazz Canon
(Representations and Gendered Absences)

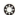

Curtis and Lemmon escape from a Chicago nightclub that's being raided, witness the St.
Valentine's Day Massacre and "escape" into the anonymity of a girl band by dressing up as
femme musicians.
—*Variety,* 23 February 1959

Although we know little about the less mediated activities of women jazz
musicians during the 1950s (especially outside the field of variety televi-
sion), many female musicians did continue to perform in public spheres
after the war. Those that continued playing sometimes resorted to more pe-
ripheral or gendered positions as music teachers, accompanists, church or-
ganists, and vocalists. Some leading jazz musicians, having gained expertise
performing on the road with all-girl bands, altered their performance strat-
egies (after the all-girl bands broke up) by organizing and leading their
own smaller jazz units in groups of combos, quartets, duos, and even as
nightclub soloists. Other ambitious women competed fiercely for the di-
minishing positions in those few established male big bands that outlasted
the war, often being the only female musician in these ensembles. Indeed
many all-girl performers, like Dave Schooler and his 21 Swinghearts saxo-
phonist Doris Swerk, gave up life on the road to get married and raise fam-
ilies. Still others succumbed to negative and chauvinistic attitudes about fe-
male instrumentalists and female jazz musicians and relinquished their
performing positions to returning GI musicians. Additional pressures ex-
erted by the AFM (American Federation of Musicians), and by commercial
studios, booking agents, and managers further encouraged female per-
formers to step down to enable male musicians to "reclaim" their jobs. Di-
rectors of these organizations often protested that women should give up
higher-paying gigs to male musicians because of men's incumbent financial

obligations to support wives and families ("A.F. of M. Urges Considera-
tion for Returned Service Men; Many Locals Already Making Special Con-
cessions for Honorably Discharged Members" 1945).

In light of economic difficulties faced by big bands at the end of World
War II, many larger swing bands downsized, and members began working
with smaller combos and quartets. These smaller groups often traveled
longer distances and worked for less pay to make ends meet. As early as 1946,
leading name bands like Woody Herman gave notice to bandsmen because
of record-low attendance. Other prominent bandleaders either tried new
media, from television to film music, or diminished their ranks to support
smaller, less expensive combos ("Woody Breaks Up His Band" 1946). By the
late 1940s, smaller combos dominated the scenes in Philadelphia, Cleveland,
and other medium- and large-sized cities throughout the country.

Some jazz journalists, who regretted the passing of the big band era, as-
sociated the emergence of smaller combos with the surge of seedy "strip
acts" erected in the previously bustling jazz hot spots. By association, these
newer, smaller jazz combos were devalued for their debased feminine con-
nections ("Strip Acts and Trios—That's All!" 1947; and "Small Combos
Leap in Philly" 1946). In New York, for example, *Down Beat* implicated the
transition from "sax to sex," claiming that the four remaining nightspots
had initiated the transition from "jam to gam" by inaugurating "girlie and
gag show policies" ("Four Spots Left, Jazz Blows Final Breath on 52nd
Street" 1947). Thus, the slow inscription of feminine performances as anti-
jazz became more articulated in the jazz trade magazines during the post-
war period of big band strife and struggle. In essence, the desire for sexual-
ized, female performances (as strip acts and girly shows), debased jazz and
the former venues of serious improvisational performance. Here, male de-
sire encroached upon what jazz modernists increasingly depicted as a mode
of "male" high-art performance.

Profitable ballrooms, hotels, and nightclubs during the early 1940s, also
went bankrupt in the postwar period as they struggled to cover musician's
salaries with door receipts. The music trade magazines reported fewer jazz
band bookings and struggling music scenes in Los Angeles, New York,
Philadelphia, and Chicago with headlines like "Worrisome Days Along the
Street; Biz is Sad" (1946) and "Chicago Barren of Jazz; Mickey Prevails"
(1947).[1] By 1947, postwar job panic reached an all-time high, spanning
both coasts from Rochester to Hollywood. *Down Beat* reported record
joblessness of musicians in Hollywood, claiming "Unemployment to Top
Hunger of '30s."[2]

In an attempt to draw in new music patrons and to satisfy changing post-
war tastes, leading Chicago big band nightspots such as the Trianon, the

Aragon, and the Band Box began altering their offerings to feature sweeter, lighter, and more popular "dance" ensembles over strictly "hot" jazz bands. Dedicated jazz record companies also transformed their productions to favor more popular and "novel" musical tastes from sweet to dance and rhythm and blues ("Signature to Nix Out Jazz" 1947). The postwar period also accompanied new trends toward "legitimate" jazz concerts, organized by intellectual jazz critics, national booking agencies, and modernist cultural pundits. Carnegie Hall and the Philharmonic began integrating "distinctive" jazz ensembles into their concert series. The organizers of these jazz concerts began a process of historicization by featuring a combination of jazz and swing bands in a well-rehearsed, "evolutionary" continuum or as "jazz retrospectives." These concerts were often promoted and narrated with historical slants ("Concerts Keep Cats in Cakes! Musicians Turn to Halls to Tide Them Over Dance Biz Lull" 1947). Norman Grantz's highly publicized "Jazz at the Philharmonic" series more effectively canonized selective Dixieland, modern jazz, and bebop players during the late 1940s than any other organized jazz venture. Other smaller concert series promoted "cutting" contests where selected jazz musicians would be "pitted against each other" in commercial concert contexts (in contrast to the older, and more informal jam sessions) ("Concerts Keep Cats in Cakes!" 1947).

The effects of these intellectual and preservationist projects upon female jazz soloists and all-girl bands were far-reaching. The postwar period accompanied two simultaneous movements in the jazz world that gradually and effectively excised women's performances from the live music performance sphere. The first movement led to the concertization and canonization of the "great" jazz artists, composers, and performers. The induction of selected preeminent jazz masters by an array of jazz experts systematically alienated those artists and ensembles that the various concert promoters, jazz intellectuals, and modernists felt to be overcommercial, gimmicky, or novel. As all-girl bands had frequently been promoted as sexualized spectacles and commercial novelties, and were continually represented by the industry as visual attractions, their inclusion in these new "legitimate" concerts was basically prohibited.

A few leading female soloists, however, who declined positions in all-girl bands, were occasionally permitted into these series. Some of the women included in these concerts were prominent female performers like Mary Lou Williams and Mary Osborne, who received consistent favorable press in the jazz trade magazines and also received significant numbers in the annual music polls. A few female instrumentalists appeared in the new jazz concerts because of their positions with male big bands, like Woody Herman trumpeter Billie Rogers.

The second trend that effectively tainted women's musical performances as superficial was the increasing popularity of sweet and novel bands, epitomized by Lawrence Welk and Raymond Scott, whose music enjoyed great popularity after the war and into the 1950s. The huge success, visibility, and excruciatingly "feminine" presentation of the Hour of Charm further ensured that all-girl performances came to be exclusively associated with sweeter, lighter (and thus, more frivolous) popular musical styles. Their brand of popular music resembled the music of newly emerging novelty and sweet bands like Claude Thornhill and Henry Busse, who were often heavily condescended to and caricatured by "modernists" in the jazz press. The prosperity and enduring image of the Hour of Charm ultimately overshadowed other female jazz performances; their longtime radio tenure made them icons of female musical production.

Doris Swerk, who toured with Dave Schooler and his 21 Swinghearts during the late 1930s and early 1940s, recalled attitudes of male musicians at the end of the war. After touring in more than thirty-eight states (and Canada) and briefly living in New York, Swerk returned to Texas to be with her new husband. There she performed in an all-girl band called Frank Fee and the Honey Bees, named after the director and lead trumpeter (who was also the only male musician in the band). Swerk articulated some of the cynicisms expressed by male musicians at that time:

Well, it was varied. In San Antonio, there were men's bands who kind of resented us, when we first started and they found out that it was going to be a girl's band. One of them said: "I give 'em six months." So it lasted seventeen years. That guy lost his band and his popularity long before we did. We never said anything except to ourselves, because he had been so mean.
(interview with Doris Swerk, 29 November 2002)

By the end of the war, the music press expressed concern for returning GIs by identifying potential jobs and musical provisions for enlisted musicians (especially in those jazz magazines *International Musician, Down Beat, Variety,* and *Billboard*). Consideration for recently discharged military women was rarely so articulated. In an effort to remedy the imbalance, in 1947, Hormel (the meat company that makes Spam) organized a women's drum and bugle corps composed entirely of women recently discharged from the WAVES, WAACS, SPARS, and the Marines. *International Musician* claimed that Hormel came upon the idea after "someone suggested," "With everyone doing some for G.I. Joe, why don't you do something for G.I. Jane?" ("The Hormel Girls' Caravan" 1951). Hormel soon developed the idea of employing female musicians to advertise, entertain, and sell Hormel's canned meat products.

Mr. Hormel quickly recruited women, who "did not necessarily sing or play an instrument" but who could be trained in musical and sales abilities once they joined the troupe. The only requirement was that they were ex GIs. By August 1947, the group consisted of sixty-five girls who "drilled and practiced" for a month prior to entering the American National Legion Convention competition. The women's corps received thirteenth place and many of the "girls returned to their homes." Twenty-one women remained and became a "special sales" force for the company. Eventually, the stipulation that members had to be former members of the military was removed and Hormel hired only professional musicians to complement his girls' orchestra.

By 1951, the Hormel Girls Caravan chauffeured a "twenty-six piece orchestra, a thirty-two voice choir, two announcers, all on the distaff side, and one male conductor, Ernest Villas" ("The Hormel Girls' Caravan" 1951, 16). The orchestra consisted of six violins, five saxophones, four trombones, five trumpets, four rhythm section players, one harp, and one marimba. Two smaller performing units were also developed from members of the orchestra, one as a Dixieland band and the other performing popular "Latin" styles.

After various marketing experiments and sales and performance combinations including door-to-door visits to deliver coupons and promote instore performances, the group was organized into a full caravan, traveling in thirty-five white Chevrolets approximately 30,000 miles per year, and performing concerts, staging parades, radio broadcasts and in-store campaigns for the single purpose of selling Hormel meat products. Their weekly radio broadcasts on two major networks, earned the group the appellation "The Darlings of the Airwaves." Radio broadcasts were promoted as half-hour variety programs that featured a variety of popular music, including "two or three numbers from the hit lists, a medley from a current Broadway or movie musical and the standard popular tunes or ballads" ("The Hormel Girls' Caravan" 1951, 35). The variety format paralleled other televised and radio variety formats from the late 1940s and 1950s as well as earlier vaudeville formats; the Hormel women also performed in sectional "specialties" and novelty numbers featuring the violin and clarinet sections.

Promoters of the organization praised the professional status of the musicians, many of whom had performed in the all-girl bands during the 1940s. Other members were recruited from leading symphony orchestras; still others were recent graduates of major colleges and music conservatories. Yet all the musicians were also members of the American Federation of Musicians union. Surprisingly, in 1960, at the onset of the civil rights movement with the accompanying radical gender and sexuality transformations, the Hormel

Girls were still active and performing in a television series, *Music with the Hormel Girls.* The half-hour variety program continued its traditional format delivering vocal numbers, marches, standards, and variety acts.

The combination of intergenerational musical styles, gendered genres, female musicians, and the promotion of domestic consumer goods was consistent with other feminized musical variety programs of the 1950s. In this context, the longevity of the Hormel television program seems less surprising.

Some Like It Hot

Although Hutton's national program aired for less than two years in the mid-1950s, her series was reputedly quite successful. Marilyn Monroe, as the famous "Blonde Bombshell" in the 1951 film *Some Like It Hot* (released only three years after Hutton's last televised performances), may well have modeled her role "Sugar" after the original "Blonde Bombshell of Swing," Ina Ray Hutton. While the film rehashed the tried-and-true comedic gag of men masquerading as women, perhaps most unorthodox were Curtis's and Lemmon's gendered identities as female musicians in an all-girl band.

By 1959, older audiences would have been familiar with the film performances of Ina Ray Hutton and her Melodears from the early 1930s Paramount shorts, with the band's cameo in the *Big Broadcast of 1936,* and finally with her early and mid-1950s all-girl variety television appearances. Phil Spitalny's Hour of Charm was also featured in two blockbuster Hollywood musical comedies during the 1940s: *Here Come the Co-eds* and *When Johnny Comes Marching Home.*

Nonetheless, *Some Like it Hot* was not the first film to spoof the idea of all-girl bands. Paramount featured a similar comedy in 1946 entitled *Out of This World* featuring crooner Bing Crosby, whose voice is heard but never seen in the film. The film also featured sidelining appearances by the Glamorettes, providing the musical scenes for a "nameless" all-girl band whose luck turns after becoming stranded on the road. The film was mildly praised by the *New York Times,* mostly because of Crosby's expert crooning and the laughs provided by the ventriloquism of leading man Eddie Bracken. The film was criticized, however, for its "dead spots," which included "one number, with five pianos" which according to *Times* critic Crowther, "could be tossed right out the back door." The tone of this review indicates the naturalness of all-girl bands as the subject for comedic burlesque material:

Paramount's genial lampooners are spoofing crooners and swooners merrily in the Paramount Theater's current picture, a wacky musical called "Out of This World." . . . In the broadest kind of satire, Mr. Bracken plays a crooning messenger boy who is engineered into popularity by some squealing and swooning shills. He

gets hooked up with a stranded all-girl orchestra, the leader of which cuts him up in shares to raise money for the railroad fare to New York—only she sells 125 per cent of him. . . . Diana Lynn gives modest assistance as the leader of the all-girl band, and when the two of them together need the calf-rope a musical number is tossed in. (Crowther 1945)

These filmed all-girl appearances, along with the Hour of Charm's radio broadcast, which endured until the late 1940s and the hundreds of live all-girl band performances on local and national circuits during the 1940s, effectively reinforced the idea of all-girl bands as a rather normal occurrence, thus requiring little explanation by 1950s filmwriter and director Billy Wilder. Wilder's *Some Like It Hot* appropriated the model of the sexy, glamorous jazz woman and "Sugar's" brilliant adaptation first awakened American audiences to Monroe's full potential as the most significant American feminine sex object of the twentieth century.

Monroe's *Some Like It Hot* was not even the first film to use the title. Another swing-centered film dating from 1939 with the same title more directly referenced the "hot" jazz scene of the late 1930s. The 1939 film revolved around jazz drummer Gene Krupa and his expert musical band (and also starred a very young Bob Hope). *Variety* promoted the jazz and dance attraction of the picture, claiming that *Some Like It Hot* presents "opportunity for profitable exploitation to attract the jivesters, and can be tied up easily for contests among local alligators and ickies. Krupa puts out some hot stuff for the rug-cutters in his various appearances" ("Some Like It Hot," 10 May 1939). Critics downplayed the story's flimsy narrative, admitting: "Story itself is just an excuse on which to hang Krupa's musical display" ("Some Like It Hot," 10 May 1939).

Wilder's gendered inversion of the 1939 film, which primarily highlighted the musical talents of "hot" drummer Gene Krupa and his band, failed to fully reverse the film's gendered theme: the nameless and largely anonymous girl-band in the 1959 version consisted of actresses who mimicked the motions of male jazz musicians. *Variety* even articulated the anonymity of the female jazz musicians in their description of the plot: "Curtis and Lemmon escape from a Chicago nightclub that's being raided, witness the St. Valentine's Day Massacre and 'escape' into the anonymity of a girl band by dressing up as femme musicians" ("Some Like It Hot," 23 February 1959). Here, the thick cover of gender stereotypes provided the perfect "hiding" place for male stars. The images and belief systems that constructed women musicians primarily as visible ornaments (or, on other occasions, as conduits for male performances) was fully manifest during the late 1950s in Hollywood representations and most famously in the 1959 *Some Like It Hot*.

Another less visible, yet highly successful all-girl band during the mid-1940s was Virgil Whyte and his Musical Sweethearts. Whyte's band developed initially in the quiet Midwestern town of Racine, Wisconsin, in the early 1940s. Inspired by the success of Spitalny's Hour of Charm, Whyte dedicated himself to organizing an all-girl band that performed up-tempo jazz—one that could really swing, in contrast to the Hour of Charm's sweeter performance style. Coincidently, Ben Hecht, screenwriter for the 1939 version of *Some Like It Hot,* actually hailed from Racine, Wisconsin, and would most likely have been familiar with Virgil Whyte's Musical Sweethearts during the early 1940s.

According to archivist and Hecht historian Flori Kovan, Hecht made reference to Virgil Whyte's all-girl band in a separate film produced in 1946, *Specter of the Rose.* Kovan discovered the connection and set up the scene in this way: "In the first scenes of the 1946 film *Specter of the Rose . . .* his road weary but ever optimistic impresario character played by Michael Chekov complains about his recent tour with 'tall crazy blonde women.' He wails about lost luggage in Kenosha, Wisconsin" (Kovan 2008). According to Kovan, "tall crazy blonde women" referred to the Scandinavian heritage of some of Virgil Whyte's band members.

During the 1950s, established female performers like Hazel Scott and Lena Horne offered multigenre musical extravaganzas that increased the popularity, prestige, and exoticism of white-dominated variety programs. The conservative political climate, concomitant with the expansion of the media industry, however, severely affected the professional opportunities of African American artists and others whose political ideals and professional lives were subject to intense speculation and persecution during the McCarthy era. Frequently, jazz artists like Scott emigrated to Europe during the 1950s and found European cosmopolitan cities more amenable, profitable, and tolerant performance environs. Other established jazz performers, having previously worked for Hollywood, more easily negotiated the networks' incorporation of older forms like variety and musical comedies as well as the preservation of the star system. The promotion of domestic consumerism and the expansion of television's mass and feminine audiences helped to secure the position of female jazz performers like Peggy Lee in variety and vaudeo's mixed musical programs well into the late 1950s.

During the war, all-girl bands experienced unprecedented support for their musical offerings, and were appreciated for their loyal and patriotic contributions as they delivered swing and entertained mass male audiences.

As feminine substitutes for drafted male musicians, women's swing performances fulfilled various wartime functions. Female instrumentalists entertained military personal with the latest popular music styles, from "swing" to "sweet" and "hot" jazz. They also kept spirits high on the homefront by providing music for dances and delivering upbeat and wholesome stage acts. In highly segregated homosocial military environments, all-girl bands substituted as surrogate wives, girlfriends, and sisters. Finally, these women's swing performances became connected to static, sexualized, and mass-produced pinup images, as both were promoted by the USO and the war industry to help contain, channel, and legitimate male sexuality in an acceptable American fashion.

The most profitable and visible all-girl bands were female-led, white women's bands. They received greater publicity and performance opportunities because of segregated performance contexts and powerful racial barriers. Those bands most visible to the public were also those all-girl groups who successfully mediated widespread conceptions about female sexuality, wholesome entertainment, and the highly desired and racialized context of hot jazz. Their animated spectacles, which delivered complete stage shows with sexy pinup bandleaders and variety-style acts, dispensed wholesome Saturday entertainment in conjunction with harmless, "everyday" sexual glamour. Bandleaders like Ada Leonard and Rita Rio (featured in 1940s SOUNDIES) entranced audiences with upbeat swing, capable and alluring dances, sexual posturing, and form-fitting costumes.

Rumors that USO female performers were wild and promiscuous became so widespread that, during the war, female swing and jazz performers who toured camp circuits were also assumed to be so. Static and mass-produced erotic poses contained on pinup cards became powerful wartime symbols: all-girl bands, no matter how expert their musicianship, inspired massive applause, hollers, and ogling by male military personnel. The excessive displays of appreciation betrayed men's own fetishized images of young women performing "masculine" and "racialized" jazz, as well as their own misconceptions about jazz women's social responsibilities. Female musicians like Jane Sager recalled that military officers often propositioned women for sexual favors (interview with Jane Sager, 30 August 2002).

Sweet all-girl orchestras led by classically trained male maestros such as Phil Spitalny and Dave Schooler also augmented and refashioned prior "sweet" genres popularized by 1920s and 1930s groups, like those of Paul Whiteman, Hal Kemp, and Kay Kyser. These bands evolved established "sweet" formulas by interjecting them with recognizably feminine musical markers, inserting sweeping string passages, harp flourishes, and reverent choirs of female voices. Their brand of wartime musical femininity

exaggerated gender stereotypes and even eradicated some of the more ambiguous social and gendered roles obtained by women of earlier decades. Put forth as wholesome entertainment, bands like the Hour of Charm attracted whole families and also soothed war-weary souls seeking respites from the sheer exhaustion and atrocities of battle. Women who performed in these ensembles earned professional wages and won chair positions because of their experience with earlier all-girl bands like the Melodears and the Fourteen Bricktops. But Hollywood representations of band members as young, amateur musicians fresh from colleges and high schools further damaged women's abilities to convince booking agents and managers of their legitimate professional status after the war.

Still, other all-girl bands with "hotter" sensibilities, like the International Sweethearts of Rhythm, the Prairie View Co-Eds, and the Darlings of Rhythm, emphasized the individual and particular jazz capabilities of featured soloists like Vi Burnside, Tiny Davis, Pauline Braddy, and Marge Backstrom. Because many of these women received ample press in the black journals (and to some extent by leading jazz critics), they managed to organize and continue to lead all-girl bands after the war. Like the male swing bands of the late 1940s, many women chose to organize smaller combos to satisfy current musical trends or were simply forced to travel with smaller units for financial reasons. Core all-girl units emerged naturally, as leading members intentionally left large ensembles to develop as soloists or arrangers in more intimate and expressive contexts. For example, prominent jazz soloists Vi Burnside and Myrtle Young both led combos made up of former members of the International Sweethearts of Rhythm. From 1948 to 1951, Clora Bryant toured the West Coast with her small jazz combo the Queens of Swing (Tucker 2000b: 322). The Vadel Quartet emerged from Virgil Whyte's band and members of Ada Leonard's band formed the Debutones. Tiny Davis organized her jumping Hell Divers with members of the International Sweethearts of Rhythm, the Darlings of Rhythm, and the Prairie View Co-Eds. Betty McGuire, bandleader of the Sub-Debs later formed her own quartet in 1953 called the Belle-Tones. And finally the Syncoettes trio featuring Vi Wilson on alto sax emerged from the Darlings of Rhythm (Tucker 2000b: 324).

As film subjects, all-girl bands adopted various mediated feminine identities: from the "Cult of Womanhood" (epitomized by the Hour of Charm) to the multitalented "Triple Threat" bands, whose members exuded versatility, glamour, and talent as they performed in various capacities in the vaudeville-style bands (like the Melodears and the Ingenues). And finally, attractive and physically conservative, mixed, and predominantly black bands presented serious women who played professionally, modestly,

and displayed capable soloing skills. In some ways, the films of the 1940s reinforced the construction of women as sexual spectacles, by prioritizing the visual aspects of female swing. Even so, independent black film briefly infiltrated the Hollywood aesthetic and introduced alternate images of musical femininity with the expert jam sessions portrayed in Alexander's *That Man of Mine*. Other Hollywood films provided specialty spots for African American female jazz artists like Hazel Scott and Lena Horne in respectable roles that highlighted these women's class, musical skills, and glamour.

The popular and well-traveled vaudeville-style, all-girl jazz bands of the 1930s drew upon musical patterns established by the leading all-girl groups from the 1920s. Because of the few films that survive from this era, like the Ingenues' Vitaphone short from 1928, one recognizes that the most popular all-girl bands were valued not only for their visual attributes, but for their extreme versatility, and even for their spunky "hot" jazz capabilities. Filmed performances of bands like the Melodears differed from wartime representations in SOUNDIES: the earlier short subject films featured several close-ups of individual soloists and privileged musical arrangements that admitted influences from various forms of popular music including jazz, blues, ragtime, and even minstrelsy. Women instrumentalists of these early theatrical jazz bands were also given more opportunities to improvise over short jazz choruses. By inference, these early all-girl bands still recognized that popular music entailed performing a range of "masculine," "feminine," "ethnic," and "racial" musical genres to satisfy the divergent landscape of American cities. Moreover, their associations with the latest technological and mass-mediated forms ensured that all-girl bands were also appreciated for their own advanced, modern, and novel talents. Unfortunately, it appears that only white bands had access to the most expensive mass-mediated performances: no recorded films of the early pioneering black all-girl bands like the Harlem Playgirls, the Dixie Sweethearts, or the Dixie Rhythm Girls survive from the 1920s or 1930s.

Dance was a central part of all-girl band performances during the 1930s, just as it was for most theatrical forms from vaudeville and variety revues to burlesque and musical comedy. Gradually women's refashioning, adaptation, and imitation of largely black vernacular dance forms became more overtly sexualized and commodified through the chorus-girl acts of the 1930s. As women were implicated in the demise of the national vaudeville networks, their creative and artistic offerings, including their contributions through dance, were not only disregarded but even trivialized as distractions, and later characterized as fluff. Many current jazz histories surprisingly resemble those original cultural critiques from the postwar period, even supporting some of the earliest attitudes toward

modernization, canonization, and, ultimately, the general exclusion of women from the realm of esteemed male soloists, composers, and the larger sphere of "high art."

Although superficially, the jazz canon appears to have evolved independently from the elitist mass-culture critiques of the 1920s, much of jazz's rhetoric after the 1930s actually adopted the gendered hierarchy, which began to constitute and evaluate various artistic genres and mediums by their relative gendered content. After the war, serious jazz criticism began to dismiss those more integrated vernacular forms that relied upon both the physical (jazz dance) and dialogical expressions (active participation by listeners) that typically accompanied early jazz performances. As female bandleaders innovated styles of bandleading through dance and expressive modes of conducting, their performances were devalued as excessively sexual or feminine. Female bandleaders like Ina Ray Hutton, Rita Rio, and Ada Leonard were often disparaged, ridiculed, and condescendingly represented in the jazz trade magazines, which more and more sanctioned the slow alienation of women's groups.

Initially, women's performances gained currency through their novelty appeal. During the war, all-girl bands were continually misrepresented as sudden and temporary phenomena. Finally, during the period of postwar musical strife, all-girl bands experienced a brief resurgence in television, especially as hosts or guest artists in the highly successful musical variety and vaudeo format. But the stronger currents of jazz criticism, classicism, and canon formation prevailed as more than three decades of musical contributions, participation, and performative innovation by women effectively disappeared from the pages of jazz scholarship.

Although I'm tempted to plead for a revisionist historical project, and praise the productions of these unsung women's bands, I'm more satisfied exposing the philosophical precedents, development, and eventual static reproduction of such a jazz canon. Such reproductions gradually collapse in upon themselves; "authentic" or canonized jazz no longer sustains the interest of the majority of Americans, nor of younger African Americans nor even of the many other ethnic and cultural groups comprising urban America. And women are still largely absent from the concert stages, nightclubs, and airwaves that feature jazz. Consistently when I play, I hear, "it's so unusual to see a woman playing a saxophone." Even more telling, "There's something so sexy about seeing a woman play the sax."

Perhaps the first headline to predict the death of jazz contained a modicum of truth ("And this Kinda Stuff will kill Jazz Dead" 1946).[3] Part of jazz *was* dead, as women's participation and interaction with the larger jazz community largely subsided. Other parts of jazz died as well, as "serious"

jazz no longer expressed and connected with the cultural, emotional, and lived realities of many of its fans. The days that my grandparents and other jazz fans from their generation lovingly invoked as they described couples ecstatically dancing all through the night to the sounds of the big bands, spoke to a deep and joyful connection with those women and men who played, danced, sang, and entertained during America's transformation from regional cosmopolitan varieties to an internationally driven mass culture.

Filmography

❊

Ada Leonard and Her All-Girl Orchestra

El Cumbanchero. 1950/1951. Snader Telescriptions. Studio Films.
Hotcha Chornia Brown. 1950/1951. Snader Telescriptions. Studio Films.
Indiana. 1950/1951. Snader Telescriptions. Studio Films 7506.
It's So Nice to Have a Man Around the Show. 1951. Snader Telescriptions.
It's the Same Old Shillelagh. 1950/1951. Snader Telescriptions.
Poinciana. 1950/1951. Snader Telescriptions.
Search for Girls. 1951. KTTV television series.

Bessie Smith

St. Louis Blues. 1929. RCA. Distributed by RKO Radio Pictures. Directed by Dudley Murphy.

Billie Holiday

Symphony in Black: A Rhapsody of Negro Life. 1935. Paramount Pictures. Featuring the music of Duke Ellington. Directed by Fred Waller. Presented by Adolph Zukor.

Frances Carroll & the Coquettes

Frances Carroll & The Coquettes. 1939. Vitaphone B220. With Eunice Healey and Viola Smith. Directed by Roy Mack. Photographed by Ray Foster.

Dale Cross's All-Girl Band

Mad About Her Blues. 1946. Filmcraft Productions. Soundies Distributing Corporation of America. Featuring Tommy Morton, Dorothy Drew, and Dorothy Blute. Produced and directed by William Forest Crouch.

Dave Schooler and His 21 Swinghearts

I Love You Too Much. 1941. Soundies Distributing Corporation of America.
In an Eighteenth Century Drawing Room. 1941. Minoco Productions. Soundies Distributing Corporation of America. Re-released by Castle Films, 1946.
Isn't That Just Like Love. 1941. Minoco Productions. Re-released by Castle Films. Featuring Sylvia Froos.

Night Ride. 1941. Minoco Productions. Soundies Distributing Corporation of America.

Pavanne. 1941. Minoco Productions. Soundies Distributing Corporation of America, re-released by Castle Films in *The Music Album: All-Girl Melody Makers.*

Scheherezade. 1941. Minoco Productions. Soundies Distributing Corporation of America.

Tchaikowskiana. 1941. Minoco Productions. Soundies Distributing Corporation of America. Re-released by Castle Films in *The Music Album: All-Girl Melody Makers.*

The Glamourettes (Glamorettes)

Liberty on Parade. 1943. Soundies Distributing Corporation of America. With the Keene Twins. Directed by Dave Gould. Produced by Sydney M. Williams.

Swing it, Mr. Schubert. 1942. RCM Productions. Soundies Distributing Corporation of America. Featuring Carol Adams and the Glamourettes. Directed by Josef Berne. Produced by Sam Coslow.

Green's Twentieth Century Faydettes

Green's Twentieth Century Faydettes. 1929. Vitaphone 710.

Green's Flapperettes "Leading Girl's Jazz Band" (original title: "Green's Twentieth Century Faydettes, No. 2"). 1929. Vitaphone 711. Bandleader Nina Grey.

Harry Wayman's Debutantes

Harry Wayman and His Debutantes. 1927. Vitaphone 2261.

Hazel Scott

Broadway Rhythm. 1944. Metro-Goldwyn-Mayer. Directed by Roy Del Ruth.

"Episode 2.49." 1949. *Toast of the Town* (later renamed *The Ed Sullivan Show*). CBS television series.

"Episode 4.11." 1950. *Toast of the Town* ((later renamed *The Ed Sullivan Show*). CBS television series.

GI Movie Weekly: Sing with the Stars I. Ca. 1944. Official Film Misc. War Department. Produced by Army Pictorial Service in cooperation with the Music Section Special Services Division.

GI Movie Weekly: Sing with the Stars II. Ca. 1944. Official Film Misc. War Department. Produced by Army Pictorial Service in cooperation with the Music Section Special Services Division.

I Dood It. 1943. Metro-Goldwyn-Mayer. Directed by Vincente Minnelli.

Presenting Hazel Scott with Her Trio: March of Dimes 1955. 1955. With Charlie Mingus on bass and Rudie Nichols on drums. Uncredited.

Rhapsody in Blue. 1945. Warner Brothers. Directed by Irving Rapper.

Something to Shout About. 1943. Columbia Pictures. Directed by Geromy Ratoff.

The Hazel Scott Show. 1950. DuMont Television Network.

The Heat's On. 1943. Columbia Pictures. Directed by Gregory Ratoff.

Ina Ray Hutton and Her Melodears

Accent on Girls. 1936. Paramount Pictures. Directed by Fred Waller. Also released by National Telefilm Associates.

"Organ Grinder's Swing/Stardust Medley." 1937). In *Complete Performances: 1937–1965*. A special collection from the Swing-Time Video Collection, No. 122, 1986. Produced by Walley Heider.

Ever Since Venus. 1944. Columbia Pictures. Produced by Rudolph Flothow. Directed by Arthur Dreifuss. (Male Band.)

Fashions in Music. 1935–1936. (Melodears trio.) Uncredited.

Feminine Rhythm. 1935. Paramount Pictures. Directed by Fred Waller.

"Girl Time." 1955–56. *Purex Show*. Television series.

Ina Ray Hutton and Her Orchestra. 1943. Paramount Pictures. Directed by Leslie Roush. (Male band.)

Jazz Ball. (1958) 1991. NIA Pictures. Compiled by Herbert L. Bregstein. Republic Pictures Corporation (television program). Re-released by Pearl Entertainment, 1991.

Ladies That Play. 1934. Paramount Pictures. Directed by Fred Waller.

Meet the Bandleaders, No. 105. 1984. Swing-Time Video. Directed by Leslie Roush. Produced by Walley Heider. Re-released by Kartes Video Communications under the title *The Big Bands*.

"Star Reporter." (1930–1937). In *New Deal Rhythm*, 1995. Hollywood's Attic.

Swing, Hutton, Swing. 1937. Paramount Pictures. Directed by Fred Waller. Produced by Adolph Zuckor. An NTA Release.

The Big Broadcast of 1936. 1935. Paramount Pictures. Directed by Norman Taurog. Presented by Adolph Zukor. Produced by Benjamin Glazer.

The Ina Ray Hutton Show. 1951–52. KTLA television series, Los Angeles.

The Ina Ray Hutton Show. 1956. NBC television series. Produced by Guild Films.

Ingenues, Ray Fabing's Ingenues

The Band Beautiful. 1928. Vitaphone 2572.

Maids and Music. 1937. Pictoreels. Featuring Ray Fabing's Ingenues with Janice Walker and Bernice Parks.

Syncopating Sweeties. 1928. Vitaphone 2573.

The International Sweethearts of Rhythm

Harlem Jam Session. 1946. Associated Artists Productions. Photography by Don Malkames. Film editing by Theodore Markavic.

How 'Bout that Jive. 1947. Associated Artists Productions. Produced by William D. Alexander.

International Sweethearts of Rhythm. 1946. Associated Artists Productions. Produced by William Alexander. Featuring Anna Mae Winburn.

International Sweethearts or Rhythm, America's Hottest All-Girl Band. 1986. Jezebel Productions. Produced by Greta Schiller and Andrea Weiss.

Jump Children. 1946. Alexander Productions. Directed by Leonard Anderson. Produced by William D. Alexander.

She's Crazy with the Heat. 1946. Alexander Productions. Directed by Leonard Anderson. Produced by William D. Alexander.

That Man of Mine (Soundie). 1946. Alexander Productions. Directed by Leonard Anderson. Produced by William D. Alexander.

That Man of Mine (Feature Film). 1946. Associated Producers of Negro Motion Pictures. Alexander Productions. Directed by Leonard Anderson. Produced by William D. Alexander.

Tiny & Ruby, Hell Divin' Women. 1988 Cinema Guild. Produced by Greta Schiller and Andrea Weiss.

Jean Rankin's Blue Bells Orchestra

The All Girl Revue. 1929. Vitaphone 818. Directed by Murray Roth. Featuring Lillian Price, Betty Lou Webb, and Ellen Bunting with De Paca and Kazvlki.

Lady Wonderful

Lady Wonderful. 1939. Soundies Distributing Corporation of America.

Lena Horne

Boogie Woogie Dream. 1944. Official Films. Soundies Distributing Corporation of America. Directed by Hans Burger. Produced by Mark Marvin.

Broadway Rhythm. 1944. Metro-Goldwyn-Mayer. Directed by Roy Del Ruth. Produced by Jack Cummings.

Cabin in the Sky. 1943. Metro-Goldwyn-Mayer. Directed by Vincente Minnelli. Produced by Arthur Freed.

Duchess of Idaho. 1950. Metro-Goldwyn-Mayer. Directed by Robert Z. Leonard. Produced by Joseph Pasternak.

"Episode 5.1." 1951. *Toast of the Town* (later renamed *The Ed Sullivan Show*). CBS television series.

"Episode 10.23." 1957. *Toast of the Town* (later renamed *The Ed Sullivan Show*). CBS television series.

"Episode 10.31." 1957. *Toast of the Town* (later renamed *The Ed Sullivan Show*). CBS television series.

GI Movie Weekly: Sing with the Stars II. Ca. 1944. Official Film Misc. War Department. Produced by Army Pictorial Service in cooperation with the Music Section Special Services Division.

GI Movie Weekly: Sing with the Stars III. Ca. 1944. Official Film Misc. War Department. Produced by Army Pictorial Service in cooperation with the Music Section Special Services Division.

Harlem Hotshots. 1945. Metropolitan Films. Directed by Spencer Williams. *I Dood It.* 1943. Metro-Goldwyn-Mayer. Directed by Vincente Minnelli. Produced by Jack Cummings.

Mantan Messes Up. 1946. Toddy Pictures. Directed by Sam Newfield.

Panama Hattie. 1942. Metro-Goldwyn-Mayer. Directed by Norman McLeod.

Stormy Weather. 1943. Twentieth Century Fox. Directed by Andrew L. Stone. Produced by William LeBaron.

Studio Visit. 1946. Metro-Goldwyn-Mayer. Produced by Pete Smith.

Swing Fever. 1943. Metro-Goldwyn-Mayer. Directed by Tim Whelan.

The Duke is Tops. 1938. Million Dollar Pictures. Directed by William Nolte.

Thousands Cheer. 1943. Metro-Goldwyn-Mayer. Directed by George Sidney. Produced by Joseph Pasternak.

Till the Clouds Roll By. 1946. Metro-Goldwyn-Mayer. Directed by Richard Whorf. Produced by Arthur Freed.

Two Girls and a Sailor. 1944. Metro-Goldwyn-Mayer. Directed by Richard Thorpe. Produced by Joseph Pasternak.

Words and Music. 1948. Metro-Goldwyn-Mayer. Directed by Norman Taurog.

Ziegfeld Follies. 1946. Metro-Goldwyn-Mayer. Directed by Vincente Minnelli.

Lorraine Page Orchestra, Lorraine Page and Her Modernettes

Class in Swing. 1940 Universal. With Lorraine Page and Her Modernettes, and the Music Maids. Directed by Larry Ceballos. Musical director, Charles Previn.

Darn That Dream (Soundie). 1940. Globe Productions. Featuring Martha Mears and Bill Roberts.
Parade of the Wooden Soldiers (Soundie). 1940. Globe Productions. Directed by H. L. Reginald. With the Music Maids and Stearns & Deane.
Six Hits and a Miss. 1945. Soundies Distributing Corporation of America.
The Soundies, 1940–1946. 1987. Adventures in Video Cassette.

The Melody Maids

In Love with a Song. 1941. Cameo Productions. Directed by Roy Mack. Produced by Sam Coslow. With Gene Grounds, Charles Baron, and Joan Blair. Recorded by Bobby Sherwood and His Orchestra.

Minoco Maids of Melody

I'm Comin' Virginia. 1942. Minoco Productions. Featuring Aileen Shirley and Her Minoco Maids of Melody.

Peggy Lee

Anatomy of a Murder. 1959. Columbia Pictures. Directed and Produced by Otto Preminger.
"Big Night Out." 1963. *The Peggy Lee Show.* British television variety program.
"Episodes 2.27 and 2.32." 1951. *Cavalcade of Bands.* DuMont television series.
"Episode 1.21." 1958. *The Pat Boone Chevy Showroom IV.* ABC television series.
"Episode 16.6." 1962. *The Ed Sullivan Show.* CBS Television Series.
Jasper's in a Jam. 1946. Paramount Pictures (U.M.&M. T.V.Corporation). Animation by George Pal. Music by Charlie Barnet and vocal by Peggy Lee.
Lady and the Tramp. 1955. Walt Disney Productions. Directed by Clyde Geronimi and Wilfred Jackson.
Midnight Serenade. 1947. Paramount Musical Parade Featurette Series no. 4, title no. 5. Directed by Alvin Ganzer. Produced by Harry Grey.
Peggy Lee and the Dave Barbour Quartet. 1950. Short Subject. Snader Telescriptions.
Pete Kelly's Blues. 1955. Warner Brothers. Directed by Jack Webb.
Stage Door Canteen. 1943. United Artists. Directed by Frank Borzage.
The Jazz Singer. 1952. Warner Brothers. Directed by Michael Curtiz.
The Paul Whiteman's Goodyear Revue, IV. 1951 (30 March) and 1952 (2 December). Featuring Paul Whiteman and Peggy Lee. ABC television series.
The Peggy Lee Show. 1951. Summer replacement series. CBS television series.
The Powers Girl. 1943. United Artists. Directed by Norman McLeod.

Phil Spitalny and His Hour of Charm Orchestra

Big City Fantasy. 1934. Vitaphone. Distributed by Warner Brothers.
Here Come the Co-Eds. 1945. Universal Pictures. Directed by Jean Yarbrough. Produced by John Grant.
"Letter from Iran." [Undated ca. 1945]. *Army Navy Screen Magazine. No. 22.* Selection from *Oklahoma*, "People Will Say We're In Love."
Meet the Maestros. 1938. Paramount Pictures.
Moments of Charm. 1939. Paramount Pictures. Directed by Leslie Roush.
Musical Charmers. 1936. Paramount Pictures. Directed by Fred Waller.
Phil Spitalny and His Musical Queens. 1934. Vitaphone 1719. Directed by Joseph Henabery. Re-released on *Cavalcade of Vitaphone Shorts*, vol. 2.

Phil Spitalny's All-Girl Orchestra. 1935. Vitaphone 1850. Directed by Joseph Henabery.

Sirens of Syncopation. 1935. Directed by Fred Waller. Produced by Adolph Zuckor. Re-released by U.M.&M. T.V. Corporation.

When Johnny Comes Marching Home. 1943. Universal Pictures. Directed by Charles Lamont. Produced by Bernard W. Burton.

Thelma White and Her All-Girl Orchestra

April in Paris. 1946. RCM Productions. Soundies Distributing Corporation of America. Directed by Dave Gould. Produced by Ben Hersh.

Hollywood Boogie. 1946. RCM Productions. Soundies Distributing Corporation of America. Directed by Dave Gould. Produced by Ben Hersh.

Take It and Git. 1946. RCM Productions. Directed by Dave Gould. Produced by Ben Hersh.

Zoot. 1946. RCM Productions. Directed by Dave Gould. Produced by Ben Hersh. Featuring Ellen Connor. Re-released by Official Films.

Virgil Whyte and His Musical Sweethearts

Virgil Whyte and His All-Girl Bands: USO Tours, 1944–1946, vols. 1–4. 1993. Privately produced.

Other Films

The Big Timers. 1945. All-American Newsreel. Directed by Bud Pollard.

Tall, Tan and Terrific. 1946. All-American Newsreel. Directed by Bud Pollard.

Notes

✿

Introduction (pages 1–15)

1. Examples of cultural studies and feminist critiques include Carby (1996 and 1985) and Wallace (1992).

2. Lott (1993b) is an excellent example of this kind of racial and sexual cultural analysis.

3. Folksy (1998) offers a compelling account of the complexity of relationships manifest from the 1920s to the present between jazz musicians, record producers, managers, and music publishers.

1. The Feminization of Mass Culture and the Novelty of All-Girl Bands (pages 19–33)

1. A point of clarification: when "all-girl" appears in the text without a racial or ethnic descriptor, I am referring generally to all-girl performing groups of all races and ethnicities. Although performance contexts were highly segregated, black, mixed, and white groups all performed in variety revues, vaudeville, and film houses that were often controlled by the dominant media industry even if they featured only all-white or all-black performance groups and audiences (that is, white-owned theater and booking organizations like RKO, which promoted predominantly white groups, and white- and black-owned TOBA, which promoted predominantly black groups). Because of the largely segregated-showing contexts of 1920s and 1930s music and film performances, I also illuminate the ways that race became implicated in these performances both by the glaring absence of nonwhite female musicians in the biggest urban vaudeville productions and also by the predominance of racialized representations featured in these mass-mediated jazz performances where black performers were often absent.

2. Throughout this chapter, I have tried to incorporate helpful readers' reviews from *Popular Music and Society* and *Women and Music*.

3. Sherrie Tucker's prolific study of 1940s all-girl bands demonstrates the established presence of women in jazz contexts during the war. This book expands Tucker's assertion that women's engagement with jazz went beyond providing replacements for war-recruited male musicians (Tucker 2000b).

4. This chapter deals with the all-black Harlem Playgirls and their involvement within the blossoming 1930s urban jazz scene as well as within the larger mass-culture industry.

5. The White Rats began as a fraternal organization to protect vaudeville performers from an unscrupulous and increasingly powerful vaudeville theater syndicate. The group waged their first and unsuccessful strike in 1916 (Gemmill 1927).

Only after 1910 did this organization begin to incorporate female performers in order to protect them from predatory managers and agents. Vaudeville historian Alison Kibler points to the gendered hierarchies of vaudeville unions and their interests in preserving "manly" artisan aesthetics, which Kibler illuminates via writings and meeting notes published by the White Rats during the second decade of the twentieth century (Kibler 1999, 206–208).

6. Influencing Adorno's arguments, however, was certainly his own exposure to the highly popular syncopated dance bands and swing polkas performed by celebrated German bandleaders like Peter Kreuder in Weimar-period Germany, groups that later became the featured musical selections of the National Socialists' radio programs and also constituted the bulk of music performed by Nazi dance orchestras. As pointed out by Adorno scholar Richard Leppert, Adorno often inserted the term "jazz" to imply the highly popular and regularly programmed syncopated music of Tin Pan Alley, German syncopated *Schlager* and the instrumental jazz of black and white artists like Jelly Roll Morton and Paul Whiteman (Leppert qtd. in Adorno 2002, 327–372).

7. The Betty Boop cartoon "I'll Be Glad When You're Dead You Rascal You" (1932, Paramount Shorts) is a perfect example of seemingly innocuous animated humor, even as jazz music functioned as audible subtext for the primal, jungle, and misogynistic sexual urges of Betty and her pursuers. The primitivistic scene where Louis Armstrong's disembodied giant head floats ominously over the two minstrel characters as they attempt to rescue the sexually charged adolescent flapper from her jungle capturers is representative.

8. These authors demonstrate the ways that female film viewership during the early twentieth century caused considerable concern for film pundits and culture theorists, who criticized women for their sartorial displays (big hats impeding visual clarity), for their chattiness during films, and finally for their "excessive" enthusiasm toward subjects depicted as lowbrow or inappropriate for female patrons from the "blood-boiling" adaptations of serial mysteries, to overt vocalizing during films for masculine erotic subjects like Rudolph Valentino. Often, classical film advocates felt that feminine viewing habits disrupted the quiet contemplation required for serious film subjects.

9. However, nineteenth-century burlesque predated vaudeville in its incorporation of star female performers and all-female casts. The popular burlesque troupes of the 1860s and 1870s like the Rentz Santley Company and the British Blonde Burlesque Troupe employed European and European American women in satires or parodic adaptations of classical theatrical works and therefore relied less upon what came to be associated with the heavily sexualized burlesque spectacles of the 1920s and 1930s and its privileging of the female striptease dancer. Of course the fantastic reaction to the "ballet" performances in female-performed burlesque as exhibited in spectaculars like *The Black Crook* (1866) initiated the process of theatrically exposing women's bodies for public consumption, a practice that eventually led to the more sexualized and explicit forms of burlesque in the twentieth century (Allen 1991).

10. The Ziegfeld Follies, developed and produced by Florenz Ziegfeld beginning in 1907 and lasting until 1931, was the longest-standing and most successful Broadway variety revue production ever. Ziegfeld originally modeled his revue after the Folies-Bergères of Paris and focused his energies upon exhibiting the feminine sexuality of burlesque within the more refined performance spaces of vaudeville and musical theater. Ziegfeld developed productions featuring a consistent female chorus line within the context of variety revue with its thematic and spectacular productions, popular musical groups, and featured star performers. The Ziegfeld Follies were also heavily influenced by the all-girl spectacles promoted in New York's cabarets and lobster palaces during the first two decades of

the twentieth century. Ziegfeld was perhaps the first to fully exploit women's physique in a public forum for mixed-gendered audiences from a variety of economic classes. His largely successful marketing campaign sought to "glorify the American girl" for New York's diverse audiences while also placating conservatives and religious zealots who decried the blatant commodification and exploitation of the female form. Inspired by industrial models promoting efficiency and automation, Ziegfeld was also credited with "streamlining" the American female chorus line to promote a particular kind of middle-class, Caucasian "American" beauty. Accordingly, he chose only "girls" who met rigid requirements in terms of facial features, height, coloring, and overall physique. For more on the Ziegfeld Follies and its transformation of female performativity in public contexts, see Mizejewski 1999; Davis 1999; and Glenn 2000.

2. The Ingenues and the Harlem Playgirls (pages 34–63)

1. One of the more compelling problems facing scholars of women in jazz is the lack of significant primary material. Ironically, the number of all-girl bands active during the first decades of the twentieth century would suggest a large body of primary and secondary literature. However, the status of these bands as novelties or as purely sexual or commercial attractions often meant that these groups did not receive lengthy reviews by music journalists and that they were not asked to make recordings by the leading record companies. Some of the reviews of the Ingenues were duplicated from a scrapbook maintained by Paula Jones, leading soloist and trombonist of the group. Other articles were found via a general search of 1920s and 1930s newspapers and industry magazines like *Billboard* and *Variety*.

2. During the 1920s, the producers of vaudeville struggled to compete with the lush, elaborate picture palaces. These modern mass-entertainment "cathedrals" offered not only double-feature film presentations but elaborate live entertainment programs that integrated vaudeville, musical comedy, and variety revues with their celebrated chorus-girl spectacles, live symphonic orchestras, and popular jazz bands. Vaudeville theaters implemented the combined theater/sound film events as a response to the overwhelming popularity of sound films and to the rapid centralization of the entertainment industry.

3. The names are pictured next to photos of the women's faces as follows: Grace Brown, Lucy Westgate, Loura Standish, Margaret Neal, Vilma Grimm, Marie Novak, Paula Jones (trombone), Mary Donahoe, Babe Colby, Dorothy Donahoe, Pauline Dove, Alice Pleis, Ruth Carnahan, Juel Donahoe, Frances Gorton, Thelma Lacey, Genevieve Browne, Billie Jenks, Genevieve Washburn, Louise Sorenson and Mina Smith as featured violin soloist.

4. The members of the band in a second *Defender* review were listed with more detail, this time with instrumental indications: "Madge 'Ginger' Fontaine, first sax; Marguerite 'Big Shot' Baxstrom, second sax; Lula 'Mae West' Edge Martin, third sax; Alice 'Kitty' Proctor, first trumpet; Marjorie 'Tootsie' Ross, second trumpet; Jean 'Giggles' Ray Lee, third trumpet; Lula 'Shack Shack' Julius, trombone and guitar; Arvello 'Nero' Moore, piano; Gwendolyn 'Sarg' Kelley, twiggs, bass violin; Marie 'Nookie' Baxstrom, bass horn; Jimmie 'Stuff' Byrd, hides (drums) and Eddie 'Big Chief' doing the seeling" (Ellis 1937).

3. Phil Spitalny's Musical Queens (67–85)

1. A third review of the Palace's offerings captioned "22 Girls and Tom Meighan at Palace," simply advertised the film's leading star and the Chester Hale Girls as "22 dancing beauties" ("22 Girls and Tom Meighan at Palace" 1927).

2. The orchestra also continued performing for hotels and supper clubs as well as for local benefits in New York City. For example, Phil Spitalny and his Girl Orchestra performed for the Actors Annual Benefit staged at the Majestic in New York. Other performers included Hal Kemp and his Orchestra, Ed Sullivan, and Beetle and Bottle (*New York Times,* 10 November 1935, 14).

3. In 1937, Phil Spitalny and his world-famous All-Girl Orchestra opened for *Artists and Models* starring Jack Benny with specialties by Martha Raye, Louis Armstrong, Ben Blue, The Yacht Club Boys, and Connie Boswell (*New York Times,* 4 August 1937, 15). For hotel engagements, the Hour of Charm performed "in dance tempo" for dinner and dance patrons nightly in the Bowman Room and the Biltmore (*New York Times,* 29 November 1938, 26).

4. The new program was nationally broadcast on WEAF at 10 P.M. and once again sponsored by General Electric.

5. This announcement claimed that beyond the four featured recipients, all of the members of the orchestra were from small towns, representing seventeen states.

6. Gendron (1995) argues that these debates assumed modernist binaries of art music versus commercial music and not the high art versus low art dichotomy (37–48).

7. I believe that this is the Vitaphone short *Syncopating Sweeties* (1928) but the credits were missing from the version that I watched. Bradley (1996) provides an appendix of "Selected Short Subjects" that chronologically lists those important early Vitaphone and Fox Movietone short films reviewed in *Variety* in its weekly "Talking Shorts" section from 1928 to 1932 (325–344). From this appendix, I found citations for the Bluebells and the Ingenues.

8. "Dinah" circulated during the 1920s and 1930s as a Dixieland and instrumental jazz tune and was performed in smaller bands with multiple solos and short riffs accompanying soloists. Bands to record "Dinah" prior to the Hour of Charm's vocal chorale include Red Nichols and his Five Pennies and Django Reinhardt.

4. The Blonde Bombshell of Swing (pages 86–110)

1. Slide (1994, 11) credits "Johnny" Hyde, not Alex as encouraging Ina to lead an all-girl band. According to Slide, Hyde was a booking agent with the powerful, but independent vaudeville booking agency headed by William Morris. He also claims that Ina was born Ina Curtis and makes no reference to Odessa Cowen. Tracing all-girl bands active during the Jazz Age and Depression era necessarily entails some speculative reconstruction. Frequently the only available source material, circulated in brief journalistic accounts, remains less than reliable and often highly general. In this case, historians are forced to rely upon press releases, trade reviews, and production notes attached to existing recordings and films. Bits of information derived from the industry papers generally point to managers or big-time producers as the engineers of such all-girl musical groups. Conversely, publicity reviews in newspapers often credit female bandleaders for recruiting female musicians for their all-girl groups. In the case of Ina Ray Hutton and her Melodears it was probably some combination of both, as musical reviews and industry bylines of the group's earliest performances point both to Ina Ray Hutton as the organizer of her all-girl band (Thackrey 1984) and/or to New York managers and producers Alex Hyde and Irving Mills.

2. According to jazz historian Linda Dahl, the band's first incarnation in 1934 consisted of some of these same musicians: Kay Walsh, Estelle Slavin, and Elvirah Rohl on trumpet; Ruth McMurray and Althea Heuman (or Conley) on trombone; Ruth Bradley, Betty Sticht, Helen Ruth, and Audrey Hall on reeds; Jerrine Hyde and Mirriam Greenfield on piano, Helen Baker on guitar; Marie Lebz on bass; and Lil Singer on drums (Dahl 1984, 50). In 1938, most of the group's members were

also listed in personal correspondence written by trumpet player Mardell Owen Winstead. She recounted the members as pianists Ruth Lowe, Gladys Mosier, and Betty Roudebush; saxophonists Betty Sattley, Nadine Friedman, and Marjorie Tisdale; trumpet players Mardell Owen, Kay Walsh, Estelle Slavin; trombonists Fy Hesser, Jesse Bailey, and Alyse Wells; bassist Marge Rivers; guitarist Marion Gange; and drummers Lillian Singer and Virginia Myers (Pfeffer, "Hutton, Ina Ray," *Big Band DataBase Plus,* info.net/).

3. These soloists are also documented on compilations of the Melodears shorts rereleased during the 1980s and 1990s (*Swingtime Video Presents* and *Meet the Bandleaders*).

4. Waller worked intermittently as a parttime inventor and patented such quintessential American objects as water skis, leaded gasoline, and Cinerama—a technique that implemented synchronized projectors to manipulate human peripheral vision, thereby creating greater depth and dimensionality in action sequences.

5. As early as 1932, James Hart suggested that jazz slang entered the mainstream through the lyrics of popular Tin Pan Alley songs like "'S Wonderful" and "Wha'd Ja Do to Me" claiming: "The use of correct language in jazz will stamp a writer's songs as unnecessarily highbrow and hence hinder his sales. Therefore, the song writer allows the vernacular to slip into his compositions wherever it suggests itself" (Hart quoted in McRae 2001, 575). During the 1930s, a number of jazz lexicons and dictionaries were published either as articles or as appendices to jazz biographies of prominent jazz musicians like Louis Armstrong and Cab Calloway (McRae 2001, 575, 579).

6. "The Big Broadcast of 1936" on The American Film Institute Web page, http://www.afi.com, 3 January 2003.

7. Paramount was the same studio that sponsored the *Betty Boop* cartoon series, the *Big Broadcast* musical films series, and many musical film shorts of jazz and popular musicians.

8. *Swingtime Video,* no. 105: *Meet the Bandleaders.* 1984. Kartes Video Communications.

9. The pairing of these two pieces as a medley was probably not coincidental: Mitchell Parish wrote the lyrics to both "Organ Grinder Swing" and "Stardust."

10. The recordings are *Coleman Hawkins: Body and Soul Revisited; Tommy Dorsey, 1936; Lawrence Welk Swings; Brother Jack* (Jack McDuff); *Organ Grinder Swing* (James Smith); *Four Boys and a Guitar* (Mills Brothers); and *The Songs of Shirley Temple's Films.*

11. Liner notes to *Jimmie Lunceford and his Orchestra* (1936). Decca 908, music, Will Hudson; lyrics, Mitchell Parrish and Irving Mills; arrangement, Sy Oliver. First Issue Decca 908; mx 61246.

5. Swinging the Classics (pages 113–133)

1. Scott's name also appeared in the *Red Channels* in 1950, a listing of suspected communist sympathizers in the entertainment industry. Scott appeared before the House Un-American Activities Committee to defend her case. She was never officially charged with communism, nor was she officially blacklisted, but the listing was thought to have significantly limited her performance opportunities post-1950 (Bogle 2001; Mack 2006; B. Reed 1998, 124).

2. According to historian Dwayne Mack, Scott also insisted upon respectable presentations of other African American women in the films that she performed in—including *The Heat's On*, in which she reputedly halted production so that the other "black women in the film were given proper costumes and not depicted seeing their sweethearts off to war wearing dirty Hoover aprons" (Pines quoted in

Mack 2006, 155). As a result of Scott's reputed "radical and outspoken" behavior, she was unfortunately blacklisted by Hollywood executives who ended her Columbia contract and prevented her from making other films until the 1950s during which she appeared in French film noir features including *Disorder in the Night* (Mack 2006, 155).

3. Some of these compilations include *Swinging the Classics* (Vipers Nest 1010, 1939) featuring Tommy Dorsey, Nat King Cole, Charlie Barnet, and others; Arnold Johnson's *Swinging the Classics* (1937 World Records, under the pseudonym "Art Jasper and his Orchestra"); and *Swinging the Classics with the Three Suns* (1940–47 Soundies Distributing Corporation of America).

6. Pinups, Patriotism, and Feminized Genres
(pages 134–167)

1. Gendron (1995) delineates the discursive processes whereby jazz journalists in the major trade magazines, including *Down Beat* and *Metronome,* initiated a formalized conception of jazz as "art" music, modern music, or experimental music through two decades of writing about music. During the war, these journalists typically fell into two camps: the "modernists" (those who favored swing) and the "revivalists" (those who favored Dixieland). Written debates frequently evoked modernist binaries: genres and brand names; art and commerce; folklore and European high culture; progress and the new; technique and schooling; affect and antics; fascists and communists; and black and white.

2. In her explanation of Horne's appeal, Roberts (1993) draws from Said's theorizing of the "Other," Barthes's conception of the voice, and Corbett's analysis of the disavowal of the fissure between the performer and the recorded sound. She posits a process of deracination, an alignment with mass culture, and the necessary accessibility of the physical object required by mass consumption: "The desire for Horne's rewritten image, therefore, is bound up in her mass culture status, and her mainstream, swing appeal. High art, classical and jazz music demand belief in transcendence of sound, while mass culture demands an image, demands physicality and accessibility. According to Corbett, listening to music can involve the disavowal of the cleavage of image and sound as fans try to restore the visual to the disembodied voice. Mass cultural desire, the appeal of the accessible, involves a bringing 'closer' of the object, as Benjamin has suggested, as opposed to the fetishization that high art requests. In the case of Horne's star text, the reinstatement of her visual to her aural track entailed her re-embodiment, which made safe both her interracial eroticism and her mass cultural appeal" (170).

3. Interview with Roz Cron in Los Angeles, 16 February 2001.

4. Telephone interview with Jane Sager, 20 August 2002.

5. As pointed out by jazz film historian and archivist Mark Cantor, the term SOUNDIES is often confused with other types of short subject films made during the 1940s. According to Cantor, SOUNDIES refer only to those three-minute films projected in Panorams, the machines engineered and distributed by Mills Novelty Company in Chicago that utilized a 16 mm motion picture projector that "allowed films to be rear-projected via a system of mirrors: (Cantor's comments to this chapter, 21 August 2006). Other film projector systems produced during these decades were Vis-O-Graphs, Featurettes, and Nickel Talkies; these all projected other formats for short subject films.

6. Feature films, inspired by the multicultural diversity of these musical shorts, began incorporating a greater variety of music and dance by leading black, Latin, and Jewish artists into their Hollywood productions. Hollywood's most enduring war classic, *Casablanca,* scripted a black actor and professional drummer, Dooley

Wilson, as Sam, the pianist, singer, and bandleader of an all-white orchestra at Rick's Café Americaine, a haven for refugees from the Nazis (Erenburg 1998, 184). According to the American Film Institute, Dooley's sometime musical partner and pianist Elliot Carpenter dubbed his piano parts, playing behind the scenes. Apparently, producer Wallis suggested tailoring the part of the piano player for either Hazel Scott or Lena Horne, but to no avail: http://film.chadwyck.com.proxy .uchicago.edu/cgi/htxview?template=basic.htx&content=frameset.htx, 31 August 2006.

7. Many of the SOUNDIES of all-girl bands were discovered in Terenzio, Mac-Gillivray, and Okuda (1991). Several others were discovered at the Library of Congress from an unpublished and nonindexed catalogue of SOUNDIES donated on deposit from Green Tree Productions. Other films were graciously offered for viewing at McDonald and Associates Film Archive in Chicago.

8. Thanks to Mark Cantor for informing me that the music for this SOUNDIE was recorded by Victor Young's radio orchestra and not Dick Winslow's band as is listed in MacGillivray and Okuda's SOUNDIES book (192).

9. Sidelining was a practice that involved actors and/or real musicians appearing in a film with instruments but not actually playing. However, many lesser-known as well as well-known studios that supported male jazz bands also participated in sidelining during the 1940s. Dick Winslow's was one such band that provided soundtracks for some of the sidelining or, rather, "staged" all-girl acts released on SOUND-IES. For a brief defininition of sidelining, see: "Frequently Asked Questions about Music for Film, TV and Multimedia" in *Film Music Magazine* (11 August 2005; http://www.filmmusicworld.com/faq/13.11.html).

10. This was gleaned from Terenzio et al. (1991, introduction), which detailed the grouping of music and entertainment in the SOUNDIES catalogue by race, genre, or ethnicity.

11. Mark Cantor quoted in Tucker 2000 (253, n.6).

12. Mark Cantor's written comments to this chapter, 21 August 2006.

13. Doris Swerk, saxophonist with Dave Schooler and his 21 Swinghearts, confirmed that the band was sponsored by Elliot Roosevelt for their many SOUNDIES. Because of their affiliations to Roosevelt, the band performed on the same circuits as bands such as Tommy Dorsey, Benny Goodman, and Jack Teagarden (interview with Doris Swerk, 29 December 2002).

14. See, for example, the film *Rhapsody in Blue* (1945), which featured mixed genre (classical and jazz) musical numbers by pianist Hazel Scott and mediated some of the high-art/low-art debates of the era. In the film, the work of Gershwin was presented as both popular music, borrowing black and jazz influences, and high art (symphonic music) and was featured in American concert halls as Whiteman performed Gershwin's music for the famous Aeolian Hall concert in 1924. See also appearances by jazz musicians in Hollywood musicals like *Doctor Rhythm* (1938): a film that also satirized "longhair" music and juxtaposed jazz alongside more "respectable" symphonic concert-hall performances. Other swing-inflected films that satirized high-art and low-art distinctions were *Two Girls and a Sailor* (1944; Gracie Allen performs a comic classical concerto), *The Fabulous Dorseys* (1947), *King of Jazz* (1930, Paul Whiteman), and *A Song Is Born* (1948, featuring Danny Kaye as a musicologist and musicians Benny Goodman and Louie Bellson as "field subjects" for Kaye's investigations into the origins of jazz).

15. According to jazz-film scholar Mark Cantor, the John Kirby Sextet was highly active during the period from 1938 to 1946, recording both "hot" jazz and jazz/swing interpretations of classical themes for recordings and broadcasts. Cantor argues that these were not at all satirical, but rather "serious re-investigations of melody and theme." My thanks to Cantor for alerting me to this example.

16. However, Mark Cantor also argues that this would have not been perceived as satirical, considering that many highly respected male jazz bands like the John Kirby Sextet frequently incorporated serious jazz orchestrations of classical themes into their repertoire.

17. Better known today as *Reefer Madness,* a moralistic film intended to warn children of the dangers of marijuana.

18. White soon incurred a nearly life-threatening illness that severely debilitated her swing career although the band appears to have been active for three or four years ("Obituaries: Thelma White" 2005).

19. Each of White's musical SOUNDIES was directed by Dave Gould and produced by Ben Hersh for R.C.M. Productions and distributed by the Soundies Distributing Corporation of America, Inc.

20. Interview with Doris Swerk, 29 November 2002.

21. Liner notes to Time-Life Records *The Swing Era, 1938–1939.* The original Scott recording was rereleased on *The Music of Raymond Scott: Reckless Nights and Turkish Twilights.* 1992. New York: Columbia 53028.

22. *Verlye Mills plays harp with the big band beat! With the Billy May Band,* 1979 (1950s). Huntington Station, N.Y.: Golden Crest.

23. Sylvia Marlowe, *From Bach to Boogie-Woogie* (1940s). New York: General 4006–8.

24. Chusid 1992.

25. *The Swing Era, 1938–39,* Time-Life Records.

26. "In an Eighteenth-Century Drawing Room" from *Glenn Miller Army Air Force Band,* 1956 (1943). RCA LPT-6702.

27. Hal Kemp, *The Great Dance Bands of the '30s and '40s* (1959). RCA Victor, LPM 2041.

28. Maher 1959.

29. Shari Roberts's (1993) chapter "Stormy Weather: Lena Horne and the Erotics of Miscegenation" delineates the crossover appeal of Horne during World War II. Horne was the first African American to appear on the cover of a major mainstream film magazine, *Motion Picture* (October 1944). Another entertainment magazine, *PM magazine,* that featured Horne, noted that her "voluminous fan mail contains a large proportion of letters from servicemen, white as well as Negro."

8. The International Sweethearts of Rhythm and Independent Black Sound Film (pages 180–198)

1. Thanks to Sherrie Tucker, Mark Cantor, and Celia Cain for their many readings of preliminary drafts and for their expert suggestions for improving this chapter. Stills of *That Man of Mine* were also graciously provided by Zoran Sinobad of the Library of Congress.

2. There is much discussion and disagreement concerning the particular period within which third-wave feminism first gained critical reception. I suggest that the film compilations produced during the 1980s of "women in jazz" drew from second-wave impulses, but that these works emerged while new forms of scholarship were under way that attempted to more thoroughly examine the racialized contexts within which women performed and worked during these early decades (1930–1950). Moreover, radical women of color called for new forms of subjectivity in their critique of second-wave feminism for privileging Eurocentric subjects and for ignoring issues of ethnicity and race. Feminist scholars bell hooks (1981), Moraga and Anzuldúa (1981) and Barbara Smith (1983) are often recognized for illuminating these shortcomings and altering the forms of feminist writing and critique during the 1980s and 1990s (Orr 1997, 30).

3. Albeit not always conceived of in feminist terms during the 1940s as Sherrie Tucker (2000b) elegantly points out in her discussion of the group.

4. In addition to the International Sweethearts of Rhythm, Mark Cantor points out that jazz films were also made of the Vs, an African American quarter from this period.

5. From note 12 in Cripps: "REPORT ON NEGRO MORALE," n.d., marked "confidential," entry 3, box 65, "Negro" folder, Bureau of Intelligence, OFF, RG 208, NA-MD (Cripps 1993, 132).

6. This was gleaned by searching "William Alexander" from the homepage in Mark Cantor's Jazz on Film Web site in 2003: http://www.jazz-on-film.com. However, the entry is no longer part of this site.

7. Even those short subjects not distributed by the Soundies Distributing Corporation were frequently referred to as SOUNDIES.

8. Williams directed *The Blood of Jesus* in 1940, which addressed the perils of sinful living and paid tribute to African-American traditional life and black Southern piety.

9. See also the Hour of Charm's "Jazz Etude" performance in *When Johnny Comes Marching Home* (Universal 1943) and their short subject film *Musical Charmers* (Paramount 1936) as well as Dave Schooler and his 21 Swinghearts in the SOUNDIE "The Night Ride" (1941).

10. See, for example, representations of blues women and jazz singers Bessie Smith and Nina Mae McKinney in *St. Louis Blues* (1932) and *The Devil's Daughter* (1939), respectively. Thanks also to Sherrie Tucker for her comments on this section with regard to Hollywood representations of stereotyped black female characters like the Mammy and the Jezebel.

11. Both films of African American sidelining all-girl bands were brought to my attention by feminist jazz and all-girl band scholar Sherrie Tucker.

9. Television, Vaudeo, and Female Musical Hosts
(pages 201–210)

1. This occurred with the support of RCA's technical division.

2. J. Fred MacDonald clarifies that the term *vaudeo* emerged in industry lingo and was probably introduced by *Variety* to refer sarcastically to the new format (e-mail, 15 February 2008).

10. Variety Television Revives All-Girl Bands
(pages 211–220)

1. This song had also been a popular show tune for the musical *Grab Bag* (1924).

2. However, a *Los Angeles Times* article interviews Hutton in 1954 and still mentions her television program, claiming that it outdid other female hosted variety programs (Ames 1954).

3. J. Fred MacDonald claims that the 1955 *Ina Ray Hutton Show* was generally unsuccessful (a "flop"), especially when compared to Guild Film's highly popular *Liberace Show* (e-mail, 11 February 2008).

11. Television's Musical Guests (pages 221–244)

1. Pictures in *Look* magazine were taken by still photographer Stanley Kubrick (Richmond 2006, 180).

2. The show was originally aired on an affiliate New York station.

3. The show premiered in 1953. The song was composed by Leonard Bernstein and the title track was from her RCA 1955 album *It's Love*.

Conclusion (pages 245–257)

1. "Mickey" refers to the compositions of Raymond Scott, who wrote many of the now-famous Looney Tunes musical scores.

2. "Job Panic Hits Hollywood Ranks, Unemployment to Top Hunger of '30s Union Task Relief," in *Down Beat*, 21 May 1947, 1. See also "Rochester Sad, But Stuff's There, Only Two Nights Work per Week for Hornmen at $9 to $12 a Session," *Down Beat*, 23 April 1947, 16; and "Things are Getting Tough Everywhere," *Down Beat*, 7 May 1947, 8.

3. This article lamented the formalization and "concretization" of revived Dixieland and hot jazz stars. Another review in *Down Beat* by Leon Wolf lambasted Norman Grantz's "Jazz at the Philharmonic" concert, "Everything Bad in Jazz Found Here," *Down Beat*, 18 November 1946, 3. A concert in 1946 satirized proclamations about the death of jazz with an event entitled "Jazz Wake"; Willie Weed's "Death takes Holiday, Jazz Wake Fills Hall," *Down Beat* (25 February 1946, 2). Other *Down Beat* articles that protested that jazz wasn't dead yet: "KayCee Jazz May Be Dying, But It's Not Dead Yet" (10[?] September 1947) and "Tour Loot Proves Jazz Hasn't Died" (10 March 1948, 10).

Bibliography

✪

"Ace Harris Quartette Savannah Churchill on the Apollo Stage." 1948. *New York Age,* 3 January, 6.

"Ace Saxophonist." 1943. *New York Age,* 1 April, 10.

"Ada Leonard All-Girl Crew Gets TV Show." 1951. *Down Beat,* 23 March, 5.

"Ada Leonard Band Clicks in Army Camps." 1942. *Down Beat,* 15 February, 19.

"Ada Leonard Ork Will Tour Camps." 1941. *Down Beat,* 1 December, 20.

Adell, Sandra. 1994. *Double Consciousness, Double Bind: Theoretical Issues in Twentieth-Century Black Literature.* Champaign: University of Illinois Press.

Adolph Zukor, Chairman of the Board of Directors, Paramount Corporation: A Biography. Academy Foundation. Margaret Herrick Library, Los Angeles, California.

Adorno, Theodor. 1981. "Perennial Fashion—Jazz" (1967). In *Prisms,* translated by Samuel Weber and Shierry Weber, 129. Cambridge, Mass: MIT Press.

———. 2002. "On Jazz" (1936). In *Essays on Music,* edited by Richard Leppert, 470–495. Berkeley and Los Angeles: University of California Press.

"Advance Synopses: Here Come the Co-Eds." 1944. *Motion Picture Herald* 23 (December): 2242.

"A.F. of M. Urges Consideration for Returned Service Men; Many Locals Already Making Special Concessions for Honorably Discharged Members." 1945. *International Musician,* August, 1, 9.

Agawu, Kofi. 1995. "The Invention of African Rhythm." *Journal of the American Musicological Society* 48, no. 3: 380–395.

Agee, James. 1958. "Pseudo-Folk" (1944). In *Agee on Film: Review and Comments by James Agee,* 2: 404–410. New York: Perigee Books.

Albertson, Chris. 1974. *Bessie.* New York: Stein and Day.

Allen, Robert C. 1991. *Horrible Prettiness: Burlesque and American Culture.* Chapel Hill: University of North Carolina Press.

"All-Feminine Cast seen in unusual film." 1932. *Washington Post,* 17 January, A1.

"All-Girl Revue, Vitaphone No. 818." 1929. *Variety,* 12 June.

"All Girls Orchestra and Jackie Mabley on Apollo Stage." 1947. *New York Age* 26 April, 10.

"All-Star Girl Cast for Town at Para." 1942. *Hollywood Reporter,* 21 December, 3.

Alvarez, Max Joseph. 1982. *Index to Motion Pictures Reviewed by Variety, 1907–1980.* Metuchen, N.J.: Scarecrow Press.

Ames, Walter. 1954a. "Color sets going up in size: Ina Ray Hutton to star in all-girl film." *Los Angeles Times,* 10 December, 34.

———. 1956. "Ina Ray Builds Male Inferiority." *Los Angeles Times,* 29 July, D1.

———. 1954b. "Ina Ray Hutton Has Itchy feet, Wants to Hit Road Again." *Los Angeles Times,* 23 May, E9.

"And Even the Women Raved Over Them." 1937. *Pittsburgh Courier,* 4 December, 20.

"And This Kinda Stuff Will Kill Jazz Dead." 1946. *Down Beat,* 18 November, 16.

Anderson, Karen. 1981. *Wartime Women: Sex Roles, Family Relations and the Status of Women during World War II.* Westport, Conn.: Greenwood Press.

———. 1982. "Last Hired, First Fired: Black Women Workers During World War II." *Journal of American History* 69:82–97.

Andrews, Maxene. 1993. *Over Here, Over There: The Andrews Sisters and the USO Stars in World War II.* New York: Kensington.

"Another All-Girl Show." 1936. *Washington Post,* 18 October, AA4.

"Apollo: Vi Burnside and her All-Girl Band and Revue." 1949. *Los Angeles Daily News,* 4 February, 30.

"Army and Navy: Women." 1944. *Time,* 14 February, 65.

"Artists and Models, in Person: Phil Spitalny and his world famous All-Girl Orchestra." 1937. *Los Angeles Daily News,* 4 August, 15.

"At the Palace: When Johnny Comes Marching Home." 1943. *New York Times,* 11 March, 20.

"Auditions to be Held to Select Band Leader of All-Girl Ork." 1948. *New York Age,* 14 July, 5.

Awkward, Michael. 1995. *Negotiating Difference: Race, Gender, and the Politics of Positionality.* Chicago: University of Chicago Press.

Badger, R. Reid. 1989. "James Reese Europe and the Prehistory of Jazz." *American Music* 7, no. 1:48–67.

Baker, Houston. 1984. *Blues, Ideology, and Afro-American Literature: A Vernacular Theory.* Chicago: University of Chicago Press.

Baker, Josephine, and Jo Bouillon. 1977. *Josephine.* New York: Harper and Row.

Balio, Tino. 1993. *Grand Design: Hollywood as a Modern Business Enterprise, 1930–1939.* New York: Simon and Schuster.

"Band Girls Play Something New." N.d. *Evening World,* 29 July [probably 1931]. Undated clip, Paula Jones Scrapbook.

"Bands Show Boogie Woogie to Broadway." 1941. *Chicago Defender,* 26 April, 21.

Baraka, Amiri [LeRoi Jones]. 1967. *Blues People: Negro Music in White America.* New York: Morrow.

Barlow, William. 1989. *Looking up at Down: The Emergence of Blues Culture.* Philadelphia: Temple University Press.

——— and Cheryl Finley. 1994. *From Swing to Soul: An Illustrated History of African American Popular Music from 1930 to 1960.* Washington, D.C.: Elliott and Clark.

Barrios, Richard. 1995. *A Song in the Dark: The Birth of the Musical Film.* New York: Oxford University Press.

Basil, Dean. 1956. *The Theatre at War.* London: Harrap.

"Battery 600 Selects Hazel Scott as Pin-up." 1945. *Pittsburgh Courier,* 6 January, 13.

"Battle of Music Idea Shifts into Theaters." 1937. *Variety,* 24 November, 43.

"Beau Geste, Phil Spitalny and his World Famous All-Girl Orchestra." 1939. *New York Times,* 4 August, 10.

Bederman, Gail. 1995. *Manliness and Civilization: A Cultural History of Gender and Race in the United States, 1880–1917.* Chicago: University of Chicago Press.

Bell, Nelson B. 1934. "The Dramatic Desk Prowling Backstage, Garners a Few Exclusive Bits of News." *Washington Post,* 14 August, 10.

Benjamin, Walter. 1969. "The Artwork in the Age of Its Technological Reproducibility" (1935). In *Illuminations,* edited by Hannah Arendt, translated by Harry Zohn. New York: Schocken Books.

——— and Theodor W. Adorno. 1999. *The Complete Correspondence, 1928–1940*. Cambridge, Mass.: Harvard University Press.

Berlin, Edward A. 1980. *Ragtime: A Musical and Cultural History*. Berkeley and Los Angeles: University of California Press.

Berliner, Paul. 1994. *Thinking in Jazz: The Infinite Art of Improvisation*. Chicago: University of Chicago Press.

Berrett, Joshua. 1999. *The Louis Armstrong Companion: Eight Decades of Commentary*. New York: Schirmer Books.

"*Betty Boop:* I'll Be Glad When You're Dead You Rascal You." 2007. Paramount, 1932. *Internet Archive*, 7 June, http://www.archive.org/movies/thumbnails.php ?identifier=bb_ill_be_glad_when_youre_dead.

B.H. 1950. "Peggy Lee Goes South of the Border." *Metronome*, October.

"The Big Broadcast of 1936; Good Box-Office Puller in Variety Show Packed With Diversified Entertainment." 1936. *Film Daily*, 14 September.

"Big Broadcast of 1936." 1935. *Variety*, 18 September, 35.

Bigsby, C. W. E. 1980. *The Second Black Renaissance: Essays in Black Literature*. Westport, Conn.: Greenwood Press.

"*Billy the Kid*, Alex Hyde and his Melody Maidens." 1930. *Los Angeles Daily News*.

Black, Gregory D. 1989. "Hollywood Censored: The Production Code Administration and the Hollywood Film Industry, 1930–1940." *Film History* 3, no. 3:167–189.

Blackwelder, Julia Kirk. 1997. *Now Hiring: The Feminization of Work in the United States, 1900–1995*. College Station: Texas A&M University Press.

Bloch, Adrienne Fried. 1988. "Taboos." *Ear: New Music Magazine*, 17 June.

——— and Carl Neuls-Bates. 1979. *Women in American Music: A Bibliography of Music and Literature*. Westport, Conn.: Greenwood Press.

The Blue Book of Shorts. 1930[?]. Margaret Herrick Library, Los Angeles, California.

"Blues Elpees on the Spivey Label." 1965. *Jazz Monthly* 11, no. 7: 25.

Bogle, Donald. 1973. *Toms, Coons, Mulattoes, Mammies, and Bucks: An Interpretive History of Blacks in American Films*. New York: Viking Press.

———. 1980. *Brown Sugar: Eighty Years of America's Black Female Superstars*. New York: Da Capo Press.

———. 2001. "The Hazel Scott Show." In *Prime Time Blues: African Americans on Network Television*, 15–19. New York: Farrar, Straus and Giroux.

Bonds, Mark Evan. 1991. *Wordless Rhetoric: Musical Form and the Metaphor of the Oration*. Cambridge, Mass: Harvard University Press.

Boyer, Horace Clarence. 1979. "Contemporary Gospel—Part 1: Sacred or Secular." *Black Perspective in Music* 7, no. 1:5–58.

———. 1995. *How Sweet the Sound: The Golden Age of Gospel*. Washington D.C.: Elliott and Clark.

Bradley, Edwin M. 1996. *The First Hollywood Musicals: A Critical Filmography of 171 Features, 1927 through 1932*. Jefferson, N.C.: McFarland. (Appendix II: 1928–1932: Selected Short Subjects, 325–345.)

———. 2005. *The First Hollywood Sound Shorts: 1926–1931*. Jefferson, N.C.: McFarland.

Bratten, Lola. 2002. "Nothin' Could Be Finah: The Dinah Shore Chevy Show." In *Small Screen, Big Ideas: Television in the 1950s*, edited by Janet Thumim, 88–104. London: I. B. Tauris.

"Broadway Comes to Town: Unqualified Success of the Ingenues." 1932. *Natal Mercury* (Durban), 27 April, n.p.

Brown, Jennifer Jayna. 2001. "Babylon Girls: African American Women Performers and the Making of the Modern." Ph.D. diss., Yale University.

Brown, Scott E. 1986. *James P. Johnson: A Case of Mistaken Identity*. Metuchen, N.J.: Scarecrow Press.

Bryant, Clora, Buddy Collette, William Green, Steven Isoardi, Jack Kelson, Horace Tapscott, Gerald Wilson, and Marl Young, eds. 1998. *Central Avenue Sounds: Jazz in Los Angeles.* Berkeley and Los Angeles: University of California Press.

Bryant, Rebecca A. 2002. "Shaking Things Up: Popularizing the Shimmy in America." *American Music* 20, no. 2:168—187.

Buchanan, Russell A. 1977. *Black Americans in World War II.* Santa Barbara, Calif.: Clio Books.

Buisseret, David, and Steven G. Reinhardt. 2000. *Creolization in the Americas.* College Station: Texas A&M University Press.

Butler, Judith. 1990. "Prohibition, Psychoanalysis, and the Production of the Heterosexual Matrix." In *Gender Trouble: Feminism and the Subversion of Identity.* London: Routledge.

Butsch, Richard. 2000. "The Electronic Cyclops: Fifties Television" and "A TV in Every Home: Television Effects." *The Making of American Audiences: From Stage to Television, 1750–1990.* New York: Cambridge University Press.

"Bye-Bye Boogie: Hazel Scott leaves Night Clubs and Moves to Concert Stage." 1945. *Ebony,* November, 31–34.

"Café Society Concert." 1941. *Time,* 5 May. http://www.time.com/time/magazine/article/0,9171,795221,00.html, 1 February 2008.

Calvin, S. 1975. "Missing Women: On the Trail to Jazz." *Journal of Jazz Studies* 3, no. 1:4–27.

"Camp Shows' Talent Hunt Opens in 27 Key Cities with Outlook Better." 1944. *Variety,* 21 June, 45.

Campbell, D'Ann. 1984. *Women at War With America: Private Lives in a Patriotic Era.* Cambridge, Mass: Harvard University Press.

Carbine, Mary. 1990. "The Finest Outside the Loop: Motion Picture Exhibition in Chicago's Black Metropolis, 1905–1928." *Camera Obscura* 23:8–41.

Carby, Hazel. 1986. "On the Threshold of 'Woman's Era': Lynching, Empire and Sexuality in Black Feminist Theory." In *"Race," Writing and Difference,* edited by Henry Louis Gates, Jr., 301–316. Chicago: University of Chicago Press.

———. 1992. "Policing the Black Woman's Body in an Urban Context." *Critical Inquiry* 18, no. 4:738–755.

———. 1994. "It Jus Be's Dat Way Sometime: The Sexual Politics of Women's Blues." In *Unequal Sisters: A Multi-Cultural Reader in U.S. Women's History,* edited by Vicki L. Ruis and Ellen Carol DuBois. 2nd ed. New York: Routledge.

———. 1996. "White Women Listen! Black Feminism and the Boundaries of Sisterhood." In *Black British Cultural Studies: A Reader,* edited by Houston A. Baker, Jr., Marthia Diawara, and Ruth H. Lindeborg, 61–86. Chicago: University of Chicago Press.

———. 1999. *Cultures in Babylon: Black Britain and African America.* London: Verso.

Carson, Julia M. H. 1946. *Home Away From Home: The Story of the USO.* New York: Harper and Brothers.

Chafe, William. 1972. *The American Woman: Her Changing Social, Economic, and Political Roles, 1920–1970.* New York: Oxford University Press.

"Changes in Sweethearts." 1942. *New York Amsterdam News,* 28 March, 10.

Channan, Michael. 1994. *Musica Prattica: The Social Practice of Western Music from Gregorian Chant to Postmodernism.* London: Verso.

Charters, A. R. Danberg. 1961. "Negro Folk Elements in Classic Ragtime." *Ethnomusicology* 5:174–183.

"Chicago Barren of Jazz; Mickey Prevails." 1947. *Down Beat,* 15 January.

"Christian and JF. Henderson Stick with B. Goodman." 1940. *Chicago Defender*, 21 September, 1.

Chusid, Irwin. 1992. Liner notes to *The Music of Raymond Scott: Reckless Nights and Turkish Twilights*. New York: Columbia 53028.

"Classified Ad 11." 1938. *Chicago Daily Tribune*, 20 November, B9.

"Cleveland, O, Nov. 3." 1938. *Pittsburgh Courier*, 5 November, 24.

"Co-Eds Best of All Recent Abbott-Costello Starters." 1945. *Hollywood Reporter*, 29 January, 3, 12.

"Co-Eds Called Best A. & C." 1945. *Hollywood Reporter*, 26 February, 10.

Collier, James Lincoln. 1978. *The Making of Jazz: A Comprehensive History*. Boston: Houghton Mifflin.

———. 1983. *Louis Armstrong: An American Genius*. New York: Oxford University Press.

———. 1993. *Jazz: The American Theme Song*. New York: Oxford University Press.

Collins, Charles. 1934. "Veloz, Yolanda Dance Adieu on Variety Stage—Ina Ray Hutton Does New Tricks with Jaz Band." *Chicago Daily Tribune*, 15 October, 15.

"Concerts Keep Cats in Cakes! Musicians Turn to Halls to Tide Them Over Dance Biz Lull." 1947. *Down Beat*, 9 April, 1.

Conrad, Earl. 1945. "Powell's Wedding to Hazel Scott Turns into Political Demonstration." *Chicago Defender*, 11 August, 11.

Cook, Susan. 1998. "Passionless Dancing and Passionate Reform: Respectability, Modernism, and the Social Dancing of Irene and Vernon Castle." In *The Passion of Music and Dance: Body, Gender, Sexuality*, 133–150. Oxford: Berg.

Cooper, Gypsie. 1936. "Can Women Swing?" *Metronome*, September, 30.

Cooper, Zackie. 1928–58. *Papers, 1928–1958: Zackie Cooper*. Schlesinger Library, Radcliffe College.

Cott, Nancy F. 1987. *The Grounding of Modern Feminism*. New Haven, Conn: Yale University Press.

"'Courier Double V' Girl of the Week." 1942. *Pittsburgh Courier*, 27 January, 13.

"Cow-Girls Raid Kearney Army Base." 1946. *Down Beat*, 28 January, 17.

Cox, Bette Yardbrough. 1996. *Central Avenue: Its Rise and Fall, 1890–1955: Including the Musical Renaissance of Black Los Angeles*. Los Angeles: BEEM Publications.

Crafton, Donald. 1997. *The Talkies: American Cinema's Transition to Sound, 1926–1931*. Berkeley and Los Angeles: University of California Press.

"Crazy Combo of Chicks and Cats Clicks at Cove." 1944. *Down Beat*, 15 February, 9.

Crease, Robert P. 1995. "Divine Frivolity: Hollywood Representations of the Lindy Hop, 1937–1942." In *Representing Jazz*, edited by Krin Gabbard. Durham, N.C.: Duke University Press.

Cripps, Thomas. 1978. *Black Film as Genre*. Bloomington: Indiana University Press.

———. 1993a. *Making Movies Black: The Hollywood Message Movie from World War II To the Civil Rights Era*. New York: Oxford University Press.

———. 1993b. *Slow Fade to Black* (1977). New York: Oxford University Press.

———. 1997. *Hollywood's High Noon: Moviemaking and Society before Television*. Baltimore, Md.: Johns Hopkins University Press.

Cron, Roz. 1995a. "Grass and Trees." Provided by Roz Cron.

———. 1995b. "My Road to Zanzibar." Provided by Roz Cron.

———. 1997. "Haunted by El Paso." Provided by Roz Cron.

———. 2001. Interview with author, 16 February, Los Angeles, California.

———. 2007. E-mail to author, 25 July.

Crowther, Bosley. 1944. "Word on Musicals, Convention is Still the Curse of Such Entertainment on the Screen." *New York Times*, 23 April, X3.

Crowther, Bosley. 1945. "Out of this World: The Screen in Review." *New York Times,* 7 June.

Cousins, Norman. 1949. "The Time Trap." *Saturday Review,* 24 December, 20.

Cunningham, Inez. 1923. "One More Woman Gets the Blame." *Chicago Daily Tribune,* 2 June, 17.

"The Cutting Room: The Big Broadcast of 1936." 1935. *Motion Picture Herald,* 31 August, 54.

Czitrom, Daniel. 1982. *Media and the American Mind: From Morse to McLuhan.* Chapel Hill: University of North Carolina Press.

Dahl, Linda. 1984. *Stormy Weather: The Music and Lives of a Century of Jazzwomen.* New York: Limelight.

"Darling of the Gods." 1923. *New York Times,* 15 July, X2.

Davis, Angela. 1983. *Women, Race, and Class.* New York: Random House.

———. 1999. *Blues Legacies and Black Feminism: Gertrude "Ma" Smith, Bessie Smith, and Billie Holiday.* New York: Vintage.

Davis, Lee. 2000. *Scandals and Follies: The Rise and Fall of the Great Broadway Revue.* New York: Limelight Editions.

De Veaux, Scott. 1997. *The Birth of Bebop: A Social and Musical History.* Berkeley and Los Angeles: University of California Press.

D.H.S. 1928. "Adelaide Leyfeld & Paula Jones: Two Typical Ingenues." *Life and Stock and Station Journal,* 3 August. Paula Jones scrapbook.

Display Ad. 1941. *Chicago Defender,* 3 May, 20.

Display Ad 1. 1935. *Chicago Daily Tribune,* 6 July , 12.

Display Ad 10. 1935. *Chicago Daily Tribune,* 6 July, 12.

DjeDje, Jacqueline Cogdell. 1989. "Gospel Music in the Los Angeles Black Community." *Black Music Research Journal* 9, no. 1:35–81.

Doan, Laura. 1998. "Passing Fashions: Reading Female Masculinities in the 1920s." *Feminist Studies* 24, no. 3:663–700.

Doss, Erika L. 1984. "Images of American Women in the 1930s: Reginald Marsh and 'Paramount Picture.'" *Woman's Art Journal* 4, no. 2:1–4.

"Double V Band a Hit." 1942. *Pittsburgh Courier,* 1 August, 15.

"Double V Water and Beauty Pageant Reveals Beauty and Patriotism." 1942. *Pittsburgh Courier,* 12 September, 15.

Draper, James P., ed. 1992. *Black Literature Criticism: Excerpts from Criticism of the Most Significant Works of Black Authors over the Past 200 Years.* Detroit, Mich.: Gale Research.

"*Dream Girl,* Hour of Charm." 1948. *New York Times,* 14 June, 19.

Driggs, Frank. 1977. "Women in Jazz, A Survey." Liner notes to *Jazzwomen, A Feminist Retrospective.* New York: Stash Records.

Du Bois, W. E. B. 1967. *The Souls of Black Folk: Essays and Sketches* (1902). Diamond Jubilee ed. Nashville, Tenn.: Fisk University Press.

Dutton, Walt. 1965. "Local Television has Awakening." *Los Angeles Times,* 31 December, A16.

"Earle." 1935. *Washington Post,* 11 August, 6.

Ellington, Edward Kennedy [Duke]. 1980. *Music Is My Mistress.* New York: Da Capo.

Ellis, Jack. 1937. "Musicians." *Chicago Defender,* 11 December, 18.

"Entertainments." N.d. *Brisbane Courier,* undated clip [probably 1928]. Paula Jones scrapbook.

Epstein, Dena J. 1977. *Sinful Tunes and Spirituals: Black Folk Music to the Civil War.* Champaign: University of Illinois Press.

Erenberg, Lewis A. 1981. *Steppin' Out: New York Nightlife and the Transformation of American Culture, 1890–1930.* Westport, Conn: Greenwood Press.

——. 1998. *Swingin' the Dream: Big Band Jazz and the Rebirth of American Culture*. Chicago: University of Chicago Press.

Erickson, Christine Kimberly. 1999. "Conservative Women and Patriotic Maternalism: The Beginnings of a Gendered Conservative Tradition in the 1920s and 1930s." Ph.D. diss., University of California.

Esedebe, P. Olisanwuche. 1982. *Pan-Africanism: The Idea and Movement, 1776–1963*. Washington, D.C.: Howard University Press.

Ethnic Recordings in America: A Neglected Heritage. 1982. Washington, D.C.: Library of Congress.

"Ever Since Venus, Columbia." 1944. *Motion Picture Herald*, 23 September, 2110.

"Everybody's Confused About Negro Roles in Motion Pix." 1945. *Pittsburgh Courier*, 20 October, 13.

"An Example for 'Democratic' America to Follow: No Racial Discrimination in British A.T.S.; Colored West Indian Girls Enjoy State of Absolute Equality." 1944. *Pittsburgh Courier*, 5 February, 20.

"Ex-Glamour Girl." 1940. *Down Beat*, 1 May, 2.

Eyman, Scott. 1997. *The Speed of Sound: Hollywood and the Talkie Revolution, 1926–1930*. Baltimore, Md.: Johns Hopkins University Press.

"Fair Co-Eds of Forty Second Street." 1927. *New York Times*, 6 November, X4.

Fallows, J. 1963. "Victoria Spivey: Queen Vee." *Coda* 7:2.

Feather, Leonard. 1941. "Swinging the Classics." *New York Times*, 18 May, X5.

——. 1947. "Peggy Lee Submits to Leonard Feather's Blindfold Test." *Metronome*, February.

——. 1951. "This Chick Plays Like Navarro." *Down Beat* 6 April, 3.

——. 1960. *The Encyclopedia of Jazz*. New York: Da Capo.

——. 1980. *Inside Jazz* 2nd ed. New York: Da Capo.

—— and Hal Holly. 1951–52. "Girls in Jazz." *Down Beat*, 19 October 1951, 18 May 1951, 4 April 1952, 4 June 1952, 15 June 1951, 25 January 1952, and 6 April 1951.

"Feminine Band at Earle Best Town Has Seen; Spitalny's Direction Able." 1936. *Washington Post*, 11 January, 22.

Fields, Sidney. 1949. "It's No Longer Cold Outside: Peggy Lee, Always Her Own Weather." *New York Daily Mirror*, 25 June.

"Fine Palace Bill Makes Big Hit." 1926. Unidentified clip, 25 August. Paula Jones scrapbook.

Fischer, Lucy. 1981. "The Image of Woman as Image: The Optical Politics of *Dames*." In *Genre: The Musical*, edited by Rick Altman, 70–79. London: Routledge and Kegan Paul.

——. 1996. *Cinematernity: Film, Motherhood, Genre*. Princeton, N.J.: Princeton University Press.

"Florida Dance Lovers Swing With 'Sweethearts.'" 1940. *Chicago Defender*, 20 April, 20.

Floyd, Samuel A., Jr. 1984. "The Sources and Resources of Classic Ragtime Music." *Black Music Research Journal* 4:22–59.

——. 1987. *Modernism and the Harlem Renaissance*. Chicago: University of Chicago Press.

——. 1990. *Black Music in the Harlem Renaissance*. Westport, Conn.: Greenwood Press.

——. 1991. "Ring Shout! Literary Studies, Historical Studies, and Inquiry." *Black Music Research Journal* 11, no. 2:267–289.

——. 1993. "Troping the Blues: From Spirituals to Concert Halls." *Black Music Research Journal* 4:22–59.

——. 1995. *The Power of Black Music: Interpreting Its History from Africa to the United States*. New York: Oxford University Press.

Fink, John. 1956. "You, Too, Can Lead a Band!" *Chicago Tribune*, 28 July.

"First 80 Race WAACS Arrive." 1942a. *Pittsburgh Courier*, 5 September, 8.

"First WAACS Inducted at Forst McPherson, GA. 1942b. *Pittsburgh Courier*, 5 September, 8.

Folksy, Frank. 1998. *Black Music, White Business: Illuminating the History and Political Economy of Jazz.* New York: Pathfinder.

"Form First WAC Battalion for Overseas Duty: Negro Women Set For Post Office Work in Foreign Zone." 1945. *Chicago Defender*, 20 January, 13.

Fossum, Bob. 1942. "Girls Shouldn't Play Too Much Jazz, Says Ada." *Down Beat*, 1 December, 14.

"Four of the International Sweethearts." 1942. *Down Beat*, 15 March, 10.

"Four Spots Left, Jazz Blows Final Breath on 52nd Street." 1947. *Down Beat*, 15 January, 3.

Francis, Terri Simone. 2004. *"Transatlantic Black Modernism, French Colonial Cinema and the Josephine Baker Museum."* Ph.D. diss., University of Chicago.

"Fred Waller." 1999. *American National Biography*, 550–551. New York: Oxford University Press.

Fredrickson, George. 1971. *The Black Image in the White Mind.* Middletown, Conn.: Wesleyan University Press.

Freedman, Estelle B. 1974. "The New Woman: Changing Views of Women in the 1920s." *Journal of American History* 61, no. 2:372–393.

Freeman, Don. 1951. "Diego, Too, Gets An All-Girl Ork." *Down Beat*, 20 April, 9.

Friedan, Betty. 1963. *The Feminine Mystique.* New York: Norton.

Gabbard, Krin, ed. 1995. *Representing Jazz.* Durham, N.C.: Duke University Press.

———. 1996. *Jammin' at the Margins; Jazz and the American Cinema.* Chicago: University of Chicago Press.

"Gal Tooters Not Rushing to Join the WAAC Bands." 1942. *Down Beat*, 1 December, 2.

Gamester, George. 1990. "T.O. woman scored with $250,000 song." *Toronto Star* 5 April, A4.

Garber, Marjorie. 1992. *Vexed Interests: Cross Dressing and Cultural Anxiety.* New York: Routledge.

Garon, P., and A. O'Neal. 1976. "Victoria Spivey, 1906–1976." *Living Blues*, no. 29:5.

Gates, Henry Louis, Jr. 1984. "The Blackness of Blackness: A Critique of the Sign and the Signifying Monkey." In *Studies in Black American Literature*, edited by Joe Weixlmann and Chester L. Fontenot. Greenville, Fla.: Penkevill.

———. 1985. *Race, Writing and Difference.* Chicago: University of Chicago Press.

———. 1988. *The Signifying Monkey: A Theory of African-American Literary Criticism.* New York: Oxford University Press.

Gemmill, Paul F. 1927. "Types of Actors' Trade Unions." *Journal of Political Economy* 35, no. 2:299–303.

Gendron, Bernard. 1995. "Moldy Figs and Modernists: Jazz at War (1942–1946)." In *Jazz Among the Discourses*, edited by Krin Gabbard, 31–56. Durham, N.C.: Duke University Press.

Gennari, John. 1987. *Modernism and the Harlem Renaissance.* Chicago: University of Chicago Press.

———. 1991. "Jazz Criticism: Its Development and Ideology." *Black American Literature Forum* 25, no. 3:449–523.

George, Nelson. 1988. *The Death of Rhythm and Blues.* New York: Pantheon Books.

George-Graves, Nadine. 2000. *The Royalty of Negro Vaudeville: The Whiteman Sisters and the Negotiation of Race, Gender, and Class in African American Theater, 1900–1940.* New York: St. Martin's.

Gerard, Charley. 1998. *Jazz in Black and White: Race, Culture, and Identity in the Jazz Community.* Westport, Conn.: Praeger.

Gilbert, Douglas. 1940. *American Vaudeville: Its Life and Times.* New York: McGraw-Hill.

Gillespie, Dizzy, with Al Fraser. 1979. *To Be or Not To Bop: Memoirs.* Garden City, N.Y.: Doubleday.

Gilroy, Paul. 1993. *The Black Atlantic: Modernity and Double Consciousness.* Cambridge, Mass.: Harvard University Press.

Ginger Rogers Official Site. 2007. http://www.gingerrogers.com/about/quotes.html, 12 December.

Gioia, Ted. 1997. *The History of Jazz.* New York: Oxford University Press.

"Girl Marines Form Their First Official Band in North Carolina." 1944. *Down Beat,* 1 July, 2.

"Girl Orchestra Wins Achievement Award; Spitalny Group Is Selected by Women's Exposition for Its Work on the Radio." 1938. *New York Times,* 16 March, 15.

Gitler, Ira. 1985. *Swing to Bop.* New York: Oxford University Press.

Glazer, Benjamin. 1930–50. *Papers, ca. 1930 –1950: Benjamin Glazer.* UCLA Archive.

Glenn, Susan A. 2000. *Female Spectacle: The Theatrical Roots of Modern Feminism.* Cambridge, Mass: Harvard University Press.

Gluck, Sherna Berger. 1987. *Rosie the Riveter Revisited: Women, the War and Social Change.* New York: Meridian.

Goffin, Robert. 1996. "Hot Jazz" (1934). In *Negro: An Anthology,* edited by Nancy Cunard, 378–379. New York: Continuum.

"Going Hollywood, Alex Hyde and his Modern Maidens." 1933. *Los Angeles Daily News,* 22 December, 25.

Gotlieb, Robert. 1996. *Reading Jazz: A Gathering of Autobiography, Reportage and Criticism from 1919 to Now.* New York: Pantheon Books.

Gould, Jack. 1952. "The Low State of TV." *New York Times,* 19 October, X13.

Gourse, Leslie. 1995. *Madame Jazz.* New York: Oxford University Press.

Govenar, Alan B., and Jay F. Brakefield. 1988. *Deep Ellum and Central Track: Where the Black and White Worlds of Dallas Converged.* Denton: University of North Texas Press.

Grau, Robert. 1910. *The Business Man in the Amusement World: A Volume of Progress in the World of the Theater.* New York: Broadway Publishing.

"Great Bands at Mardi Gras." 1938. *Pitsburgh Courier,* 5 March, 20.

Grossman, James R. 1989. *Land of Hope: Chicago, Black Southerners and the Great Migration.* Chicago: University of Chicago Press.

"Group of Clever, Pretty, Talented Girls." 1937. *Pittsburgh Courier,* 20 November, 20.

"Group Plans New York Pageant to Combat Racial Prejudice: Inter-Racial Pageant Planned." 1943. *New York Amsterdam News,* 28 August, 17.

Gruhzit-Hoyt, Olga. 1995. *They Also Served, American Women in World War II.* New York: Carol Publishing.

Guralnick, Peter. 1982. *The Listener's Guide to the Blues.* New York: Facts on File.

Gushee, Lawrence. 1994. "The Nineteenth Century Origins of Jazz." *Black Music Research Journal* 14, no. 1:1–24.

Hain, Gladys. 1928. "The Ingenues: A Jolly Band of Girls." *Illustrated Tasmanian Maid,* 3 October, 8.

Hall, Ben. 1961. *The Best Remaining Seats: The Story of the Golden Age of the Movie Palace.* New York: Clarkson N. Potter.

Handy, D. Antoinette. 1981. *Black Women in American Bands and Orchestras.* Metuchen, N.J.: Scarecrow.

———. 1983. *The International Sweethearts of Rhythm.* Metuchen, N.J.: Scarecrow.

Handy, W. C. 1941. *Father of the Blues: An Autobiography*. New York: Macmillan.

Haney, Lynn. 1981. *Naked at the Feast: The Biography of Josephine Baker*. New York: Dodd, Mead.

Hannaford, Ivan. 1996. *Race: The History of an Idea in the West*. Washington, D.C. and Baltimore, Md.: The Woodrow Wilson Center and the Johns Hopkins University Press.

Hansen, Miriam. 1987. "Benjamin, Cinema and Experience: 'The Blue Flower' in the Land of Technology." *New German Critique* 40:179–224.

——. 1991. *Babel and Babylon: Spectatorship in American Silent Film*. Cambridge, Mass: Harvard University Press.

"Harlem's Hot Play Girlies a Savoy Hit." 1937. *Chicago Defender*, 11 December, 18.

"Harlem Play Girls now on Dixie Tour." 1940. *Chicago Defender*, 3 February, 21.

"Harlem Playgirls lose Saxophonist to Cupid." 1938. *Chicago Defender*, 21 May, 19.

"Harlem Playgirls to Play in Youngstown." 1938. *Pittsburgh Courier*, 5 November, 21.

"Harlem Stars At Carnegie." 1941. *Chicago Defender*, 3 May, 20.

"Harlem Talks of Greats of Music World." 1935. *Chicago Defender*, 12 October, 9.

"Harold Nicholas and Girl Orchestra Star Acts at the Apollo." 1944. *New York Age*, 5 February, 10.

Harris, Michael W. 1992. *The Rise of Gospel Blues: The Music of Thomas Andrew Dorsey in the Urban Church*. New York: Oxford University Press.

Harrison, Daphne Duval. 1990. *Black Pearls: Blues Queens of the 1920s*. New Brunswick, N.J.: Rutgers University Press.

Hartman, Susan. 1982. *The Home Front and Beyond: American Women in the 1940s*. Boston: Twayne.

Haskins, James. 1994. *The Cotton Club*. New York: Hippocrene Books.

Hasse, John Edward, ed. 1985. *Ragtime: Its History, Composers, and Music*. New York: Schirmer Books.

——. 1993. *Beyond Category: The Life and Genius of Duke Ellington*. New York: Simon and Schuster.

Hayes, Bob. 1942. "Here and There." *Chicago Defender*, 14 February, 21.

Hayes, Eileen, and Linda F. Williams. 2007. *Black Women and Music: More than the Blues*. Chicago: University of Chicago Press.

"Hazel Scott is Queen Once More in Warner's 'Rhapsody in Blue.'" 1945. *Chicago Defender*, 1 September, 14.

"Hazel Scott, Pianist, in Varied Program." 1945. *New York Times*, 27 November, 18.

"Heart Throb." 1944. *Metronome*, January, 11.

"Heck, Chic Spends Check to Look Chic." 1944. *Down Beat*, 15 December, 4.

Heilbut, Tony. 1985. *The Gospel: Good News and Bad Times*. 3rd ed. New York: Limelight.

Heintz, Michael R. 1985. *Private Black Colleges in Texas, 1865–1954*. College Station: Texas A&M University Press.

Hendershot, Heather. 1995. "Secretary, Homemaker, and 'White' Woman: Industrial Censorship and Betty Boop's Shifting Design." *Journal of Design History*, 8, no. 2:117–130.

Hennessey, Thomas J. 1994. *From Jazz to Swing: African-American Jazz Musicians and Their Music, 1890–1935*. Jazz History, Culture and Criticism Series. Detroit, Mich.: Wayne State University Press.

Hentoff, Nat. 1959. "Race, Prejudice in Jazz: It Works Both Ways." *Harper's Magazine*, June.

——. "The Murderous Modes of Jazz." *Esquire*, 15 September.

"Here Come the Coeds." 1945. *Motion Picture Product Digest Review*, 3 February, 2297.

"Here's Feminine Rhythm . . . And How!" 1939. *Pittsburgh Courier*, 24 June, 20.

Herskovits, Melville. 1941. *The Myth of the Negro Past*. Boston: Beacon.

Herzog, Charlotte. 1981. "The Movie Palace and the Theatrical Sources of its Architectural Style." *Cinema Journal* (Spring): 15–37.

Heylbut, Rose. 1938. "The Hour of Charm; The Most Unusual Girls Orchestra of the Times, From a Conference with its Director Phil Spitalny." *Etude,* October, 638–640.

Hill, Susan T. 1985. *The Traditionally Black Institutions of Higher Education: 1860–1982.* Washington, D.C.: National Center for Education Statistics.

Hirsch, Arnold R., and Joseph Logsdon. 1992. *Creole New Orleans: Race and Americanization.* Baton Rouge: Louisiana State University Press.

Hobson, Wilder. 1939. *American Jazz Music.* New York: Norton.

Hodes, Martha Elizabeth. 1999. *Sex, Love, Race: Crossing Boundaries in North American History.* New York: New York University Press.

Hoeffer, George. 1950. "Lovie Austin Still Active as a Pianist in Chicago." *Down Beat,* 16 June, 11.

Hoffman, Franz. 1989a. *Jazz Advertised, 1910–1967: Index.* Berlin: F. Hoffman.

———. 1989. *Jazz Reviewed, 1910–1967: Documentation.* Berlin: F. Hoffman.

Holly, Hal. 1950. "Ina Ray Ork Looks Good on TV; Plays Well, Too." *Down Beat,* 1 December, 13.

———. 1952. "Corky, the All-Girl Harpist, Won't Talk on Gal Bands." *Down Beat,* 4 June, 14.

———. 1955a. "The Hollywood Beat: Why Ada Selected Men to Replace Girls In Band." *Down Beat,* 23 February, 5.

———. 1955b. "Reporter Fails to Trap Ada Into Scrap With Ina." *Down Beat,* 6 April, 8.

Hollywood in the Thirties: Discussion and Question Transcripts. N.d. Academy of Motion Picture Arts and Sciences. Contains interview with Norman Taurog. Margaret Herrick Library, Los Angeles, California.

The Hollywood Reporter. 1942. 21 December, 3.

———. 1945. 26 February, 10.

Honey, Maureen. 1995. "Remembering Rosie: Advertising Images of Women in World War II in The Home Front War: World War II and American Society." In *Home-Front War: World War II and American Society,* edited by Kenneth Paul O'Brien and Lyn Hudson Parsons, 82–106. Westport, Conn.: Greenwood Press.

"Honky Tonk (with Sophie Tucker)." 1929. *Variety,* 12 June.

"Hood Collection part II: Theatrical, Live theater—15. 'Ingenues,' Central Station." 2007. State Library of New South Wales. http://image.sl.nsw.gov.au/cgi-bin/ebindshow.pl?doc=pxe789_57/a297;seq=45, 4 December.

hooks, bell. 1981. *Ain't I a Woman?* Boston: South End.

———. 1990. *Yearning: Race, Gender and Cultural Politics.* Boston: South End.

"The Hormel Girls' Caravan." 1951. *International Musician,* November, 16, 35.

Horne, Lena, and Richard Schickel. 1965. *Lena.* New York: Doubleday.

Horowitz, Irving Louis, and Charles Nanry. 1975. "Ideologies and Theories about American Jazz." *Journal of Jazz Studies,* 2 June.

"Hot Classicist." 1941. *Time,* 5 October, http://www.time.com/time/magazine/article /0,9171,773793,00.html.

"Hour of Charm Feminine Orchestra Dominates a Feeble Screen Feature." 1939. *Washington Post,* 7 October, 14.

Hunter, Tera W. 1998. "Work That Body: African-American Women, Work and Leisure in Atlanta and the New South." In *Labor Histories: Class, Politics, and the Working-Class Experience,* edited by Eric Arneson, Julie Greene, and Bruce Laurie. Champaign: University of Illinois Press.

———. 2000. "Sexual Pantomimes, the Blues Aesthetic, and Black Women in the New South." In *Music and the Racial Imagination,* edited by Ronald Radano and Philip V. Bohlman, 145–166. Chicago: University of Chicago Press.

Hurston, Zora Neale. 1934. "Characteristic of Negro Expression." In *Negro: An Anthology*. New York: Negro University Press.

Huyssen, Andreas. 1986a. "Adorno in Reverse: From Hollywood to Richard Wagner." In *After the Great Divide: Modernism, Mass Culture, Postmodernism*, 16–43. Bloomington: Indiana University Press.

———. 1986b. "Mass Culture as Woman: Modernism's Other." In *After the Great Divide: Modernism, Mass Culture, Postmodernism*, 44–64. Bloomington: Indiana University Press.

"Ina Ray Hutton & Julia Lee on Apollo Stage." 1948. *New York Age*, 29 May, 5.

"Ina Ray Hutton Comes up the hard way from Queen of Burlesque to Sophisticate." 1940. *New York World Telegram*, 16 September.

"Ina Ray Hutton, Queen of Rhythm at the Astor Roof." 1940. *Los Angeles Daily News*, 27 August, 18.

"Ina Ray Hutton Sets Those Curves for TV." 1956. *Chicago Daily Defender*, 12 June, 17.

"Ina Ray Hutton's Music and Dancing Provide Earle Stage Hit." 1937. *Washington Post*, 25 September, 8.

"The Ingenues (19) Vitaphone No. 2573." 1928. In *Variety*, 17 October, 16.

"The Ingenues, 20—Musical Maids—20 with Peggy O'Neil. Last Engagement before Joining Ziegfeld's New Follies." N.d. Undated and untitled newspaper clip. Paula Jones' scrapbook.

"International Sweethearts of Rhythm and Peters Sisters Head New Apollo Revue." 1948. *New York Age*, 11 December, 10.

"Is Sex On Its Way Out?" 1952. *Down Beat*, 4 June, 3.

Jackson, George Pullen. 1943. *White and Negro Spirituals*. New York: Augustin.

Jackson, P. 1939. "Lilian Armstrong." *Jazz Hot* 30:12.

Jacobs, Lea. 1941. *The Wages of Sin: Censorship and the Fallen Women Film, 1928–1942*. Madison: University of Wisconsin Press.

James, Willis Laurence. 1995. "Stars in de Elements: A Study of Negro Folk Music." Vol. 9 of *Black Sacred Music: A Journal Of Theomusicology*, edited by Jon Michael Spencer. Durham, N.C.: Duke University Press.

"JAPT Opens World Tour, To Tee Off In New England: Interracial Unit Stars Krupa, Ella." 1953. *Chicago Defender*, August.

Jasen, David A., and Trevor J. Tichenor. 1978. *Rags and Ragtime: A History*. New York: Seabury Press.

"Jazz singer Maxine Sullivan dies." 1987. *United Press International*, 8 April.

Jenkins, Henry, III. 1990. "'Shall we Make it for New York or for Distribution?' Eddie Cantor, 'Whoopee,' and Regional Resistance to the Talkies." *Cinema Journal* 29, no. 3:32–52.

"Job Panic Hits Hollywood Ranks, Unemployment to Top Hunger of '30s Union Task Relief." 1947. *Down Beat*, 21 May, 1.

Jones, James T., IV. 1995. "Racism and Jazz: Same as it Ever was . . . or Worse?" *Jazz Times*, March.

Jones, M. 1967. "Lil Armstrong: Royalties and the Old Songs." *Melody Maker*, 8 April, 8.

Jones, M., and J. Chilton. 1971. *Louis: The Louis Armstrong Story, 1900–1971*. London: November Books.

Keil, Charles. 1966. *Urban Blues*. Chicago: University of Chicago Press.

——— and Steve Feld. 1994. *Music Grooves: Essays and Dialogues*. Chicago: University of Chicago Press.

Kein, Sybil. 2000. *Creole: The History and Legacy of Louisiana's Free People of Color*. Baton Rouge: Louisiana State University Press.

Kennedy, Rick. 1994. *Jelly Roll, Bix and Hoagy*. Bloomington: Indiana University Press.

Kenney, William H. 1986. "The Influence of Black Vaudeville on Early Jazz." *Black Perspectives in Music* 14, no. 3:233–248.

———. 1993. *Chicago Jazz: A Cultural History, 1904–1930*. New York: Oxford University Press.

———. 1999. *Recorded Music in American Life: The Phonograph and Popular Memory, 1890–1945*. New York: Oxford University Press.

Kenrick, John. 2007. "A History of the Musical: Vaudeville—Part II." *Musicals 101*: 1996–2003. Http://www.musicals101.com/vaude2.htm, 9 May.

Kent, Ronald Charles. 1993. *Culture, Gender, Race and U.S. Labor History*. Westport, Conn: Greenwood Press.

Kernfield, Barry, ed. 1996. *The New Grove Dictionary of Jazz*. New York: St. Martin's Press.

Kibler, Alison. 1999. "The Corking Girls; White Women's Racial Masquerades in Vaudeville." In *Rank Women: Gender, Cultural Hierarchy in American Vaudeville*, 111–142. Chapel Hill: The University of North Carolina Press.

Kinnon, Joy Bennett. 1997. "Are Whites Taking or Are Blacks Giving Away the Blues?" *Ebony*, September.

Kirk, Andy. 1989. *Twenty Years on Wheels*. Ann Arbor: University of Michigan Press.

Kitawaki, Michiyo. 2000. *"Constructing Black Womanhood: Black Women in Northern Cities During the 1920s."* Ph.D. diss., State University of New York at Buffalo.

Kittrell, F. P. 1992. "Current Problems and Programs in the Higher Education of Negro Women." In *Black Women in Higher Education: An Anthology of Essays, Studies, and Documents*, edited by Elizabeth L. Ihle, 235. New York: Garland.

Kmen, Henry A. 1966. "Negro Music." In *Music in New Orleans: The Formative Years, 1791–1841*. Baton Rouge: Louisiana State University Press.

Knight, Arthur. 1995. *"Jammin' the Blues*, or the Sight of Jazz, 1944." In *Representing Jazz*, edited by Krin Gabbard. Durham, N.C.: Duke University Press.

Kofksy, Frank. 1998. *Black Music, White Business: Illuminating the History and Political Economy of Jazz*. New York: Pathfinder.

Kovan, Flori. 2008. "An All-Girl Band Ben Hecht Knew." Snickersnee Press and Academic and Publisher Research. Http://www.benhechtbooks.net/an_all-girl_band_hecht_knew, 20 May.

Kozarski, Richard. 1990. *An Evening's Entertainment: The Age of the Silent Feature Picture, 1915–1918*. New York: Scribner.

Kuhn, Annette. 1988. *Cinema, Censorship, Sexuality, 1909–1925*. New York: Routledge.

Lamothe, Daphne Mary. 1997. "Ethnographic Discourse and Creole Consciousness and Culture in Harlem Renaissance Literature." Ph.D. diss., University of California.

Landsberg, Klaus. 1951. "Eye Appeal and Music Go Hand in Hand on TV." *Down Beat*, 7 September, 8.

Latham, Angela J. 2000. *Posing a Threat: Flappers, Chorus Girls, and Other Brazen Performers of the American 1920s*. Hanover, N.H.: University Press of New England/Wesleyan University Press.

Laurie, Joe. 1953. *Vaudeville: From the Honky Tonks to the Palace*. New York: McLeod.

Leder, Jan. 1985. *Women in Jazz: A Discography of Instrumentalists, 1913–1968*. Westport, Conn.: Greenwood Press.

Leighbur, Donde. 1945. "Earl Hines Tells Why Girls Were Used Briefly In His Orchestra." *Chicago Defender*, 25 August, 14.

"Lena Horne, I Just Want to Be Myself." 1963. *Show*, September, 62.

"Lena Horne Quits USO Tour in Row Over Army Jim Crow: Star Charges Snub by Camp Commander." 1945. *Chicago Defender,* 6 January, 1–2.

"Leap Year? Not for the Hour of Charm Girl Musicians." 1936. *Washington Post,* 15 March, F3.

Less, Gene. 1994. *Cats of Any Color: Jazz, Black and White.* New York: Oxford University Press.

Levin, Thomas Y. 1990. "For the Record: Adorno on Music in the Age of Its Technological Reproducibility." *October* 55: 23–47.

Lewis, David Levering. 1981. *When Harlem was in Vogue.* New York: Knopf.

Lewis, Randy. 1986. "Women in Jazz: Often a Blue Note." *Jazz Educators Journal* 18, no. 4:54–56.

Lieb, Sandra. 1979. *The Message of Ma Rainey's Blues: A Biographical and Critical Study of America's First Women Blues Singer.* Ann Arbor, Mich.: University Microfilms International.

———. 1981. *Mother of the Blues.* Amherst: University of Massachusetts Press.

Liebman, Roy. 2003. *Vitaphone Films: A Catalogue of the Features and Shorts.* Jefferson, N.C.: McFarland.

"Lionel Stars White Sax Ace on all Dates." 1945. *Pittsburgh Courier,* 24 March, 13.

Loesser, Arthur. 1954. *Men, Women & Pianos: A Social History.* New York: Simon and Schuster.

"Loew's Fox." 1934. *Washington Post,* 23 March, 14.

Lomax, Alan. 1973. *Mister Jelly Roll: The Fortunes of Jelly Roll Morton, New Orleans Creole and "Inventor of Jazz."* Berkeley and Los Angeles: University of California Press.

Lott, Eric. 1992. "Love and Theft: The Racial Unconscious of Blackface Minstrelsy." *Representations* 39:23–50.

———. 1993b. "White Like Me: Racial Cross-Dressing and the Construction of American Whiteness." *Cultures of United States Imperialism,* ed. Amy Kaplan and Donald E. Pease, 474–498. Durham, N.C.: Duke University Press.

———. 1995. *Love and Theft: Blackface Minstrelsy and Working-Class Culture.* New York: Oxford University Press.

Lotz, Rainer, E. 1985. *The AFRS "Jubilee" Transcription Programs: An Exploratory Discography.* Frankfurt: N. Ruecker.

Lugowski, David M. 1999. "Queering the New Deal: Lesbian and Gay Representation in the Depression-Era Cultural Politics of Hollywood's Production Code." *Cinema Journal* 38, no. 2:3–35.

Mack, Dwayne. 2006. "Hazel Scott: A Career Curtailed." *Journal of African American History* 91:153–170.

Maher, James T. 1959. Liner notes to *The Great Dance Bands of the 30s and 40s.* RCA Victor.

Maltin, Leonard. 1972. *The Great Movie Shorts.* New York: Crown.

"Mamie Smith." 2007. *Red Hot Jazz.* Http://www.redhotjazz.com/mamie.html, 2 June.

Mancuso, Chuck. 1996. *Popular Music and the Underground: Foundations of Jazz, Blues, Country and Rock, 1900–1950.* Dubuque, Iowa: Kendall/Hunt.

Mann, Denise. 1992. "The Spectacularization of Everyday Life: Recycling Hollywood Stars and Fans in Early Television Variety Shows." In *Private Screenings: Television and the Private Female Consumer,* edited by Lynn Spiegel and Denise Mann. Minneapolis: University of Minnesota Press.

Margolick, David, and Cassandra Wilson. 2000. *Strange Fruit: Billie Holiday, Café Society, and an Early Cry for Civil Rights.* Philadelphia: Running Press.

Margolick, John, and Emily Gwathmey. 1991. *Ticket to Paradise: American Movie Theaters and How We Had Fun.* Boston: Little, Brown.

"*Marie Antoinette*, Ina Ray Hutton and Her Melodears." 1939. *Los Angeles Daily News*, 26 January, 16.

Martin, Tony. 1983. *The Pan-African Connection: From Slavery to Garvey and Beyond.* Dover, Mass.: Majority Press.

"*The Mask of Fun Manchu*, Alex Hyde and the Musical Charmers." 1932. *Los Angeles Daily News*, 16 December, 24.

Matron [The]. 1935. "Society." *Chicago Defender*, 16 November, 6.

Mayerle, Judine. 1983. "The Development of the Television Variety Show as a Major Program Genre at the National Broadcasting Company: 1946–1956." Ph.D. diss., Northwestern University.

McClary, Susan, and Robert Walser. 1994. "Theorizing the Body in African-American Music." *Black Music Research Journal* 14, no. 1:75–84.

McCord, Kimberly. 1985. "History of Women in Jazz." *Jazz Educators Journal* 18, no. 2:63–66.

McCracken, Allison. 1999. "God's Gift to Us Girls: Crooning, Gender and the Recreation of American Popular song, 1928–1933." *American Music* 17, no. 4:365–395.

MacDonald, J. Fred. 1992. *Blacks and White TV.* Chicago: Nelson Hall.

———. 1994. *One Nation Under Television: The Rise and Decline of Network TV.* Chicago: Nelson Hall.

McGee, Kristin. 2003. "Some Liked it Hot: The Jazz Canon and the All-Girl Bands in Times of War and Peace, ca. 1928–1955." Ph.D. diss., University of Chicago.

McKaie, Andy. 1958. Liner notes to *Ahmad Jamal at the Pershing.* Argo 628.

McKee, Margaret, and Fred Chisenhall. 1981. *Beale Black and Blue: Life and Music on America's Main Street.* Baton Rouge: Louisiana State University Press.

McKenzie, Marjorie. 1945. "Pursuit of Democracy: Women who Got Acquainted with Own kitchens Eager to 'Reconvert' to New Domestics." *Pittsburgh Courier*, 8 September, 7.

McPartland, Marian. 1987. *All in Good Time.* New York: Oxford University Press.

McRae, Rick. 2001. "'What is Hip?' and Other Inquiries in Jazz Slang Lexicography." *Notes* 57, no. 3:574–584.

McWilliams, Trago. 1936. "Lincoln, Neb." *Chicago Defender*, 11 January, 20.

Medin, Bonnie Smallwood, and Ellen Stone. 1981. *Musical Women Marines: The Marine Corps Women's Reserve Band in World War II.* Copyright Stone and Medin: self-published.

Meeker, David. 1977. *Jazz in the Movies: A Guide to Jazz Musicians, 1917–1977.* New York: Arlington House.

Melman, Billie, ed. 1997. *Borderlines: Genders and Identities in War and Peace, 1870–1930.* New York: Routledge.

"Melodears on Loew Bill." 1934. *New York Times,* 1 September, 16.

Meyer, Leisa D. 1992. "Creating G.I. Jane: The Regulation of Sexuality and Sexual Behavior in the Women's Army Corps During World War II." *Feminist Studies* 18, no. 3:581–602.

Meyerowitz, Joanne, ed. 1994. *Not June Cleaver, Women and Gender in Postwar America, 1945–1960.* Philadelphia: Temple University Press.

Milkman, Ruth. "Women's Work and the Economic Crisis: Some Lessons from the Great Depression." In *A Heritage of Her Own: Toward a New Social History of American Women*, edited by Nancy F. Cott and Elizabeth H. Pleck, 507–541. New York: Simon and Schuster.

Mingus, Charles. 1971. *Beneath the Underdog: His World as Composed by Mingus,* edited by Nel King. New York: Knopf.

Mizejewski, Linda. 1999. *Ziegfeld Girl: Image and Icon in Culture and Cinema.* Durham, N.C.: Duke University Press.

"Modern Woman Has No Heart, Schumann-Heink Declares." 1931. *New York Times,* 15 February, 35.

Modleski, Tania. 1991. "Femininity as Mas(s)querade." In *Feminism without Women: Culture and Criticism in a "Postfeminist" Age,* 23–24. New York: Routledge.

Monson, Ingrid. 1996. *Saying Something: Jazz Improvisation and Interaction.* Chicago: University of Chicago Press.

Monti, Gloria. 2000. "Chapter Three: The Bronze Venus." In "This Ain't You Girl! Performing Race and Ethnicity in Hollywood." Ph.D. diss., Yale University. Pp. 100–164.

Moore, Brenda L. 1996. *To Serve My Country, To Serve My Race.* New York: New York University Press.

Moraga, Cherríe and Gloria Anzuldúa, eds. 1981. *This Bridge Called My Back: Writings by Radical Women of Color.* Watertown, Mass.: Persephone.

Murray, Matthew. 2003. "Establishment of the US Television Networks." *The Television History Book,* edited by Michele Hilmes, 35–39. London: British Film Institute.

Murray, Susan. 2002. "Lessons from Uncle Miltie: Ethnic Masculinity and Early Television's Vaudeo Star." In *Small Screen, Big Ideas: Television in the 1950s,* edited by Janet Thumim, 66–87. London: I. B. Tauris.

"Musical Bombshell Soon to Shake Earle Stage." 1942. *Washington Post,* 1 June, 14.

"Musical Union Strong in but 150 U.S. Towns Where Minimum Enforceable—50,000 Out of Work." 1928. *Variety,* 22 August, 24.

Musser, Charles. 1984. "The Chaser Theory." *Studies in Visual Communication* 10: 24–44.

Myers-Spencer, D. 1990. "Hazel Scott, Jazz pianist: boogie-woogie and beyond." *Jazz Research Papers.* Manhattan, Kans.: National Association of Jazz Educators [now *Jazz Research Proceedings Yearbook.*]

Nathanson, Y. S. 1967. "Negro Minstrelsy, Ancient and Modern." In *The Negro and His Folklore,* edited by Bruce Jackson, 36–50. Austin: University of Texas Press.

Naylor, David. 1981. *American Picture Palaces: The Architecture of Fantasy.* New York: Prentice Hall.

Negra, Diane. 2001. *Off-White Hollywood: American Culture and Ethnic Female Stardom.* London: Routledge.

"Negro and White Band Folds." 1937. *Down Beat,* December, 12.

"New Interracial NY National Guard." 1948. *New York Amsterdam News,* 11 September, 3.

"The New Pictures." 1943. *Time,* 29 November.

——. 1945. *Time,* 2 July.

"*Night Unto Night,* In Person! Hour of Charm all-Girl Orchestra." 1949. *New York Times,* 10 June, 33.

"1927 'Follies' Glorify the Glorifier Himself." 1927. *Chicago Daily Tribune,* 28 August, E1.

North, Joseph H. 1973. *The Early Development of the Motion Picture.* New York: Arno.

"On the Air Today." 1936. *Washington Post,* 2 November, X16.

"Obituaries: Thelma White." 2005. Telegraph.co.uk. Http://www.telegraph.co.uk/news/main.jhtml?xml=/news/2005/01/14/db1403.xml&sSheet=/portal/2005/01/14/ixportal.html, 14 January.

Ogren, Kathy. 1989. *The Jazz Revolution: Twenties America and The Meaning of Jazz.* New York: Oxford University Press.

"Ohio Prison Warden Shows Army, Navy How to Abolish Segregation." 1942. *Pittsburgh Courier,* 30 May, 3.

Oliver, Paul. 1961. *Blues Fell This Morning: The Meaning of the Blues.* New York: Horizon.

——. 1970. *Savannah Syncopators: African Retentions in the Blues.* New York: Horizon.

——. 1984. *Songsters and Saints: Vocal Traditions on Race Records.* New York: Cambridge University Press.

Olsher, Dean, moderator. 1996. *Jazz Musicians Discuss Racism in the Jazz World.* National Public Radio, two-part series, January.

"On Television." 1952. *New York Times,* 26 April, 29.

"On the Air Today." 1936a. *Washington Post,* 15 March, F3.

——. 1936b. *Washington Post,* 3 May, F8.

Orr, Catherine M. 1997. "Charting the Currents of the Third Wave." *Hypatia* 12, no. 3:29–45

"Opening of Rhythm Club Gala Event." 1937. *Chicago Defender,* 2 January, 5.

"Other Reviews." 1941. *New York Times,* 27 April, X6.

"Our Blushing Brides, Alex Hyde and his Melody Maidens." 1930. *Los Angeles Daily News,* 7 September, X4.

"Palace." 1927a. *Washington Post,* 14 August, A2.

——. 1927b. *Washington Post,* 5 September, 9.

"Palace Tour: Stage Shows." 2007. American Picture Palaces. American Studies Department at the University of Virginia. Http://xroads.virginia.edu/~CAP/PALACE/stage.html, 2 June.

Palmer, Robert. 1981. *Deep Blues.* New York: Viking.

"Pepper and Salt." 1928. *Wall Street Journal,* 18 February, 2.

Peretti, Burton. 1992. *The Creation of Jazz: Music, Race and Culture in Urban America.* Champaign: University of Illinois Press.

——. 1997. *Jazz in American Culture.* Chicago: American Ways Series.

"The Perils of Pauline, Hour of Charm." 1947. *New York Times,* 7 July, 13.

Peterson, Bernard L. 1993. *A Century of Music in Black and White: An Encyclopedia of Musical Stage Works By, About, or Involving African Americans.* Westport: Conn.: Greenwood Press.

"Phil Spitalny and His Women's Orchestra Will Afford Test of Capital Taste." 1935. *Washington Post,* 31 July, 16.

"Phil Spitalny Orchestra, Vitaphone No. 1635." 1934. *Variety.*

Pieterse, Jan Nederveen. 1992. *White on Black: Images of Africa and Blacks in Western Popular Culture.* New Haven, Conn.: Yale University Press.

Pittsburgh Courier. 1938. 21 January, 20.

Placksin, Sally. 1982. *Jazzwomen, 1900 to the Present, Their Words, Lives and Music.* London: Pluto.

Porter, Lewis, and Michael Ullman. 1993. *Jazz: From its Origins to the Present.* Englewood Cliffs, N.J.: Prentice Hall.

Powell, Adam Clayton, Jr. 1949. "My Life with Hazel Scott." *Ebony* 4, no. 3:42–50.

"Prairie View Co-Ed Band at Apollo For Week's Engagement." 1944. *New York Age,* 8 July, 10.

Purdy, James H., Jr. 1940. "Fire Routes Harlem Play Girls Ork." *Chicago Defender,* 10 February, 20.

Rabinovitz, Lauren. 1991. "Temptations of Pleasure: Nickelodeons, Amusement Parks and the Sights of Female Sexuality." *Camera Obscura* 23:71–88.

Rabinowitz, Peter J. 1991. "Whiting the Wrongs of History: The Resurrection of Scott Joplin." *Black Perspectives in Music Research Journal* 11, no. 2:157–177.

Radano, Ronald M. 1993. *New Musical Figurations: Anthony Braxton's Cultural Critique.* Chicago: University of Chicago Press.

———. 1996. "Denoting Difference: The Writing of the Slave Spirituals." *Critical Inquiry* 22, no. 1:506–44.

———. 2000. "Hot Fantasies: American Modernism and the Idea of Black Rhythm." In *Music and the Racial Imagination,* edited by Ronald Radano and Philip V. Bohlmann, 459–482. Chicago: University of Chicago Press.

———. 2000. "Black Noise, White Mastery." In *Decomposition: Post-Disciplinary Performance,* edited by Philip Brett, Sue Ellen Case, and Susan Leigh Foster, 39–49. Bloomington: Indiana University Press.

———, and Philip V. Bohlman, eds. 2000. "Introduction: Music and Race, Their Past, Their Presence." In *Music and The Racial Imagination,* 1–53. Chicago: University of Chicago Press.

Radway, Janice. 1994. "On the Gender of the Middlebrow Consumer and the Threat of the Culturally Fraudulent Female." *South Atlantic Quarterly* 93, no. 4:871–893.

"The Rape of Vaudeville." 1926. *Variety,* 17 February, 6.

Reed, Adolph L. 1997. *W.E.B. Du Bois and American Political Thought: Fabianism and The Color Line.* New York: Oxford University Press.

Reed, Bill. 1998. "The Movies: Hazel Scott." In *Hot From Harlem: Profiles in Classic African American Entertainment,* 110–128. Los Angeles: Cellar Door Press.

Rhodes, Chip. 1998. *Structures of the Jazz Age: Mass Culture, Progressive Education, and Racial Discourse in American Modernism.* Haymarket Series. New York: Verso.

"*Rhythm on the Range,* in Person: Phil Spitalny and His All-girl Band." 1936. *Los Angeles Daily News,* 2 August, X4.

"Rhythm Reigns On New Bill at Earle Theater; Bing Crosby Hit on Screen and Phil Spitalny Is Smash on Stage." 1936. *Washington Post,* 22 August, X5.

"Rialto Gossip." 1934. *Baltimore Afro-American,* 30 June, 9.

Richmond, Peter. 2006. *Fever: The Life and Music of Miss Peggy Lee.* New York: Henry Holt.

Ries, Frank W. D. 1983. "Albertina Rasch: The Hollywood Career." *Dance Chronicle* 6, no. 4:281–362.

Riis, Thomas L. 1989. *Just Before Jazz: Black Musical Theater in New York, 1890 to 1915.* Washington, D.C.: Smithsonian Institution Press.

Rivera, A. M., Jr. 1946. "Sweethearts Defy Threat; Play Festival." *Chicago Defender,* 29 June, 20.

Robbins, Tom. 2003. *Villa Incognito.* New York: Bantam Books.

Roberts, Shari. 1993. "Seeing Stars: Feminine Spectacle, Female Spectators, and World War II Hollywood Musicals." Ph.D. diss., University of Chicago.

Robinson, Major. 1939a. "Artie Shaw Likely to Have Mixed Band: King of Clarinet Players Hope to Smash Race Prejudice." *Chicago Defender,* 2 December, 20.

———. 1939b. "Mixed Band at Café Society Proves A Hit: Patrons Pleased with Set Up and Musicians Like It." *Chicago Defender,* 30 December, 17.

"Rochester Sad, But Stuff's There, Only Two Nights Work per Week for Hornmen at $9 to $12 a Session." 1947. *Down Beat,* 23 April, 16.

Roebuck, Julian B., and Komanduri S. Murty. 1993. *Historically Black Colleges and Universities: Their Place in American Higher Education.* Westport, Conn.: Praeger.

Roediger, David. 1991. *The Wages of Whiteness: Race and the Making of the American Working Class.* New York: Verso.

Roell, Craig H. 1989. *The Piano in America, 1800–1940.* Chapel Hill: University of North Carolina Press.

Rogin, Michael. 1992. "Making America Home: Racial Masquerade and Ethnic Assimilation in the Transition to Talking Pictures." *Journal of American History* 79, no. 3:1050–1077.

———. 1996. *Blackface, White Noise: Jewish Immigrants in the Hollywood Melting Pot.* Berkeley and Los Angeles: University of California Press.

Rose, Kenneth. 1996. *American Women and the Repeal of Prohibition.* New York: New York University Press.

Rose, Phyllis. 1989. *Jazz Cleopatra: Josephine Baker in Her Time.* New York: Doubleday.

Rosenthal, David. 1992. *Hard Bop: Jazz and Black Music, 1955–1965.* New York: Oxford University Press.

Roth, Mark. 1981. "Some Warner's Musicals and the Spirit of the New Deal." In *Genre: The Musical,* edited by Rick Altman, 41–56. London: Routledge and Kegan Paul.

Rowe, Billy. 1942. "Arranger Eddie Durham Embarks on New Venture: Musical Man Behind Many Famous Orchestras Heads All-Star Girl Outfit." *Pittsburgh Courier,* 12 December, 20.

Rubin, Martin. 1992. *Showstoppers: Busby Berkeley and the Tradition of Spectacle.* New York: Columbia University Press.

Rupp, Leila J. 1978. *Mobilizing Women for War: German and American Propaganda during World War II.* Princeton, N.J.: Princeton University Press.

Rust, Brian. 1987. *Jazz Records, 1897–1942.* 4th ed. New Rochelle, N.Y.: Arlington.

"Ruth Lowe Sandler Toronto Composer Wrote Sinatra Hit." 1981. *Globe and Mail,* 5 January.

Rye, Howard. 1997. "What the Papers Said: The Harlem Play-Girls and Dixie Rhythm Girls (and Dixie Sweethearts)." In *Storyville,* 173–187. Chigwell, England.

Sanjek, David. 1997. "Can A Fujimama Be the Female Elvis?" In *Sexing the Groove: Popular Music and Gender,* edited by Sheila Whitely, 137–167. New York: Routledge.

Santelli, Robert. 1993. *The Big Book of Blues: A Biographical Encyclopedia.* New York: Penguin Books.

Sargeant, Winthrop. 1976. *Jazz: Hot and Hybrid.* 3rd enlarged ed. New York: Da Capo. (Originally published, New York: Arrow, 1938.)

Schuller, Gunther. 1968. *Early Jazz: Its Roots and Musical Development.* Oxford: Oxford University Press.

———. 1989. *The Swing Era: The Development of Jazz, 1930–1945.* Oxford: Oxford University Press.

"The Screen: The Big Broadcast of 1936, a Variety Show With Jackie Okie, at the Paramount Theatre." 1935. *New York Times,* 16 September, 15, 2.

Seldes, Gilbert. 1950. *The Great Audience.* New York: Viking Press.

Shapiro, Nat, and Nat Hentoff. 1966. *Hear Me Talkin' to Ya: The Story of Jazz as Told by the Men Who Made It.* New York: Dover. (Originally published, New York: Rinehart, 1955.)

Shaw, Arnold. 1998. *Let's Dance: Popular Music in the 1930s.* New York: Oxford University Press.

"Shoot the Works, on Stage: Ina Ray Hutton and Her Melodears." 1934. *Los Angeles Daily News,* 20 July, 11.

Showalter, Elaine, ed. 1989. *These Modern Women: Autobiographical Essays from the Twenties.* New York: Feminist Press.

"Showmen's Reviews: The Big Broadcast of 1936." 1935. *Motion Picture Herald,* 21 September, 41.

"Signature to Nix Out Jazz." 1947. *Down Beat* 12 March, 1.

Siomopoulos, Anna. 1999. "Entertaining Ethics: Technology, Mass Culture and American Intellectuals of the 1930s." *Film History* 11, no. 1:45–54.

Sklar, Robert. 1976. *Movie Made America: A Cultural History of American Movies.* New York: Random House.

Slide, Anthony. 1994. *The Encyclopedia of Vaudeville.* Westport, Conn.: Greenwood Press.

Smith, Barbara, ed. 1983. *Home Girls: A Black Feminist Anthology.* New York: Kitchen Table, Women of Color Press.

Smith, Charles Edward. 1955. "Ma Rainey and the Minstrels." *Record Changer* 14, no. 6.

Small, Christopher. 1987. *Music of the Common Tongue: Survival and Celebration in African American Music.* New York: Riverrun Press.

"Small Combos Leap in Philly." 1946. *Down Beat,* 4 November, 2.

Snyder, Robert. 1989. *The Voice of the City: Vaudeville and Popular Culture in New York.* Oxford: Oxford University Press.

"Some Like It Hot." 1939. *Variety,* 10 May.

———. 1959. *Variety,* 23 February, 6.

Somerville, Mrs. Keith Frazier. 1991. *Dear Boys, World War II: Letters from a Woman Back Home.* Jackson: University Press of Mississippi.

"South Keeps Up Ban on Fletcher's Mixed Band." 1943. *Chicago Defender,* 25 December, 12.

Spellman, A. B. 1996. *Four Lives in the Be-Bop Business.* New York: Pantheon Books.

Spencer, Jon Michael. 1997. *The New Negro and their Music: The Success of the Harlem Renaissance.* Knoxville: University of Tennessee Press.

"Spitalny Identifies Weird Song Ending." 1937. *Washington Post,* 18 July, T9.

"St. Louis Blues, Radio Pictures, Colored Dramalet." 1929. *Variety,* 4 September, 13.

Stamp, Shelley. 2000. *Movie Struck Girls: Women and Motion Picture Culture After the Nickelodeon.* Princeton, N.J.: Princeton University Press.

Stanfield, Peter. 2002. "An Excursion into the Lower Depths: Hollywood, Urban Primitivism, and 'St. Louis Blues,' 1929–1937." *Cinema Journal* 41, no. 2:84–108.

"State-Lake, Chi." 1940. *Variety,* 25 December, 47.

Sterling, Christopher H., and John M. Kitross. 1990. *Stay Tuned: A Concise History of American Broadcasting.* 2nd ed. Belmont, Calif: Wadsworth.

Stewart, Baxter. 1964. "Blues and Views." *Jazz Journal* 22, no. 7:22.

Stewart, Jacqueline Najuma. 2005. *Migrating to the Movies: Cinema and Black Urban Modernity.* Berkeley and Los Angeles: University of California Press.

Stowe, David W. 1994. *Swing Changes: Big Band Jazz in New Deal America.* Cambridge, Mass.: Harvard University Press.

———. 1998. "The Politics of Café Society." *Journal of American History* 84, no. 4:1384–1406.

"Strip Acts and Trios—That's All!" 1947. *Down Beat,* 18 June, 13

"Strip-Tease Ada Leonard fronts Ace Fem Outfit." 1941. *Down Beat,* 15 June, 6.

"Student Heart Throb." 1944. *Metronome,* February, 30.

"Studios Using Colored Musicians With Whites." 1943. *California Eagle,* 1 April, 2B.

Sudhalter, Richard M. 1999. *Lost Chords: White Musicians and Their Contribution to Jazz, 1915–1945.* New York: Oxford University Press.

"Sweethearts are Soon to Return." 1946. *Baltimore Afro-American,* 12 January, 8.

"Sweethearts of Rhythm at the Apollo." 1946. *New York Age,* 5 October, 10.

"Sweethearts of Rhythm Clicks in South and West." 1940. *Chicago Defender,* 20 January, 20.

Szwed, John F. 1966. "Musical Style and Racial Conflict." *Phlon* 27, no. 4.

"Take 'Em Off, Take, etc!" 1943. *Down Beat,* 15 January, 2.

"Talkies Have Opened Doors Long Closed." 1929. *Chicago Defender*, 3 August.

"Talking Shorts: New Deal Rhythm." 1934. *Variety*, 15 May.

"Talking Shorts: Phil Spitalny With his Pennsylvania Hotel Orchestra." 1929. *Variety*, 30 January, 14.

"Talking Shorts: The Ingenues, Vitaphone No. 2572." 1928. *Variety*, 20 June, 27.

"Talking Shorts: The Jazz Rehearsal, Vitaphone No. 3760." 1930. *Variety*, 7 May.

Tanner, Peter. 1949. "Meet the Barbours." *Melody Maker*, 5 September.

"Tarzan Finds A Son, Rita Rio and Her All-Girl Orchestra." 1939. *Los Angeles Daily News*, 20 July, 16.

Taubman, Edward. 1941. "Café Music Heard at Carnegie Hall." *New York Times*, 24 April, 24.

Taubman, Howard. 1943. "Swing feature Soviet Benefit: Café Society Assures at Least a Thousand Watches for the Russian Fighting Forces." 1943. *New York Times*, 12 April, 28.

Taylor, Arthur. 1982. "Hazel Scott." In *Notes and Tones: Musician to Musician Interview*, 254–269. New York: Perigee Books.

Taylor, Billy. 1983. *Jazz Piano: A Jazz History*. Dubuque, Iowa: W. C. Brown.

Teachout, Terry. 1995. "The Color of Jazz." *Commentary* 100, no. 3.

"Television This Week." 1967. *New York Times*, 2 April, 119.

Terenzio, Maurice, Scott MacGillivray, and Ted Okuda. 1991. *The Soundies Distributing Corporation of America: A History and Filmography*. Jefferson, N.C.: McFarland.

Thackrey, Ted, Jr. 1984. "Ina Ray Hutton, Leader of All-Girl Bands, Dies at 67." *Los Angeles Times*, 21 February, B3.

"Thanksgiving Week Attraction at the Apollo." 1938. *Pittsburgh Courier*, 19 November, 21.

"Things are Getting Tough Everywhere." 1947. *Down Beat*, 7 May, 8.

"This Girl Band is Much Too Much With Swing and Jitter." 1940. *Chicago Defender*, 15 June, 20.

"Three Wacs Slugged by White Police in Kentucky." 1945. *Chicago Defender*, 28 July, I.

"Tiny Davis." 1949. *New York Age*, 3 December, 20.

Titon, Jeff. 1977. *Early Downhome Blues: A Musical and Cultural Analysis*. Champaign: University of Illinois Press.

"To Send Six Sepia Show Units Overseas: On Talent Hunt for Overseas Units." 1944. *Pittsburgh Courier*, 18 March, 13.

Toll, Robert. 1982. *The Entertainment Machine: American Show Business in the Twentieth Century*. Oxford: Oxford University Press.

Toll, Ted. 1939. "The Gal Yippers Have no Place in Our Jazz Bands." *Down Beat*, 15 October, 18.

Tomlinson, Gary. 1991. "Cultural Dialogics and Jazz: A White Historian Signifies" *Black Music Research Journal* 11, no. 2:229–264.

Torgovnick, Marianna. 1990. *Gone Primitive: Savage Intellects, Modern Lives*. Chicago: University of Chicago Press.

Trachtenberg, Allen. 1982. *The Incorporation of America: Culture and Society in the Gilded Age*. New York: Hill and Wang.

Treadwell, Mattie E. 1953. *U.S. Army in World War II: Special Studies: The Women's Army Corps*. Washington, D.C.: Office of the Chief of Military History, Department of the Army.

Tucker, Mark. 1991. *Ellington: The Early Years*. Champaign: University of Illinois Press.

———. 1993. *The Duke Ellington Reader*. Oxford: Oxford University Press.

Tucker, Sherrie, 1996a. "West Coast Women in Jazz: A Jazz Genealogy." *Pacific Review of Ethnomusicology* 8, no. 1:5–20.

———. 1996b. "Working the Swing Shift: Women Musicians during World War II." *Labor's Heritage* 8, no. 1:46–64.

———. 2000a. "The Prairie View Co-Eds: Black College Women Musicians in Class and on the Road During World War II." *Black Music Research Journal* 1:91–124.

———. 2000b. *Swing Shift: All-Girl Bands of the 1940s.* Durham, N.C.: Duke University Press.

Tucker, Sophie. 1945. *Some of these Days.* Garden City, N.Y.: Doubleday.

"Turn off the Moon, in person Ina Ray Hutton (the Queen of Swing and her Melo-Dears." 1937. *Los Angeles Daily News,* 18 May, 27.

"22 Girls and Tom Meighan At Palace." 1927. *Washington Post,* 28 August, A2.

Ulanov, Bary. 1958. "Women in Jazz: Do They Belong?" *Down Beat,* 17 January, 9.

Unterbrink, Mary. 1983. *Jazz Women at the Keyboard.* Jefferson N.C.: McFarland.

[Untitled.] 1927. *Morning Telegraph,* 20 June. Paula Jones Scrapbook.

Urch, Kathleen Ruth. 1997. "Writing the Em Space of American Modernism: Female Popular Modernity and Cultural Dialogue in the 1920s." Thesis, University of Kentucky.

U.S. Committee on Public Information. 1918. *War Work of Women in Colleges.* Washington, D.C.: Government Printing Office.

"USO Troupe Thrills Doughboys in Persia." 1945. *Pittsburgh Courier,* 13 January, 13.

V., Linda. 1943. "Male Throb Dept." *Metronome,* August, 24.

Valentine, Maggie. 1994. *The Show Starts on the Sidewalk: An Architectural History of the Movie Theater, Starring S. Charles Lee.* New Haven, Conn.: Yale University Press.

"Vaudeville Bills." 1933. *Chicago Daily Tribune,* 21 May, SA8.

"Vaudeville: Ina Ray Hutton and her Melodears." 1934. *Los Angeles Daily News,* 31 August, 14.

"Vaudeville: Miss Babe Egan and Her Hollywood Redheads." 1930. *New York Times,* 9 February, 7X.

"Vaudeville: Rita Rio and her All-Girl Orchestra." 1939. *Los Angeles Daily News,* 21 December, 29.

"Virtual Spectacles." In "American Picture Palaces." American Studies Department at the University of Virginia. Http://xroads.virginia.edu/~/CAP/PALACE/stage.html, 2 June.

"Vita's Play Talking Films as Road Show Substitutes." 1928. *Variety,* 28 March, 5.

W., David. 1938. "Andy Kirk's Band Leaves for Mid-West." *Chicago Defender,* 5 November, 19.

———. 1938. "Blanche Calloway Goes Bankrupt." *Chicago Defender,* 29 October, 19.

"WAC Band Beats Out Victory Tune." 1945. *Chicago Defender,* 12 May, 14.

"WACs Welcome Lena to Fort Knox." 1945. *Chicago Defender,* 20 January, 9.

Wallace, Michele. 1992. "Negative Images: Towards a Black Feminist Cultural Criticism." In *The Cultural Studies Reader,* edited by Simon During, 664–671. New York: Routledge.

Waller, Maurice, and Anthony Calabrese. 1977. *Fats Waller.* New York: Schirmer Books.

Walser, Robert. 1999. *Keeping Time: Readings in Jazz History.* New York: Oxford University Press.

Wang, Richard. 1973. "Jazz Circa 1945: A Confluence of Styles." *Musical Quarterly* 59, no. 4:531–546.

"Wanted: Girl Musicians." 1941. *Down Beat,* 15 June [or July], 23.

"Wanted: Girl Trumpet." 1941. *Down Beat,* 1 April, 23.

Washington, Fredi. 1980. *Fredi Washington Papers, 1925–1979.* New Orleans, La.: Amistad Research Center.

Waterman, Richard. 1948. "'Hot' Rhythm in Negro Music.'" *Journal of the American Musicological Society* 1:24–37.

Waters, Ethel. 1989. *His Eye is on the Sparrow: An Autobiography by Ethel Waters* (1950). New York: Da Capo.

"Waves Try Out." 1943. *Down Beat*, 15 February, 17.

Way, Chris. 1991. *The Big Bands Go To War*. London: Mainstream.

"Wayman's Debutantes, Vitaphone No. 2261." 1928. *Variety*, 26 December, 11.

Welburn, Ron. 1989. "The American Jazz–Writer-Critic of the 1930s: A profile." *Jazzforschung* 21:83–94.

Westbrook, Robert. 1990. "'I Want a Girl, Just Like the Girl that Married Harry James': American Women and the Problem of Political Obligation in World War II." *American Quarterly* 42, no. 4:587–614.

"What's Going on In Amusement? The Ingenues in the 'Ziegfeld Follies' at the New Amsterdam." 1927. *New York Evening Enquirer*, 23 October. Paula Jones scrapbook.

"When Johnny Comes Marching Home." 1942. *Variety*, 23 December, 8.

———. *Down Beat*, 15 May, 1.

———. *Film Daily*, 24 December, 5.

"When Johnny Comes Marching Home, Sleeper; O'Connor Emerges Comedy Star Bet." 1942. *Hollywood Reporter*, 21 December, 3.

"When Johnny Comes Marching Home (Universal)." 1943. *Motion Picture Herald*, 2 January, 1090.

Whiteley, Sheila, ed. 1997. *Sexing the Groove: Popular Music and Gender*. London: Routledge.

Whiteman, Paul, and Mary McBride. 1926. *Jazz*. New York: J. H. Sears.

Whiting, Steve. 1985. "Pianos." In *The Western Impact on World Music: Change, Adaption and Survival*, edited by Bruno Nettl. New York: Schirmer Books/Macmillan.

"Why Not Draft Spitalny's Girl Band Into the Army?" 1942. *Yank, the Army Newspaper*, 5 August, 18.

"Why Women Musicians are Inferior?" 1938. *Down Beat*, February.

Williams, Alan. 1981. "The Musical Film and Recorded Popular Music." In *Genre: the Musical*, edited by Rick Altman, 147–158. London: Routledge and Kegan Paul.

Williams, Gregory L. 1998. "Guide to the Photograph Collections of the San Diego Historical Society." *Journal of San Diego History* 44, no. 2:119.

Williams, Linda. 2001. "Posing as Black, Passing as White." In *Playing the Race Card: Melodramas of Black and White From Uncle Tom to O. J. Simpson*. Princeton, N.J.: Princeton University Press.

Williams, Martin. 1973. Liner notes to *Smithsonian Collection of Classic Jazz*. Smithsonian Institution/Columbia Special Products P6 11891.

Williams, Mary Lou. 1977. Liner notes to *Jazz Women: A Feminist Retrospective*. New York: Stash Records.

———. 1980. "Conversations with Mary Lou Williams: First Lady of Jazz Keyboard." Interview by D. Antoinette Handy, in *Black Perspective in Music* 8, no. 2:194–214.

Williams, T. S. 1936. "Colorado, Den." *Chicago Defender*, 19 September, 20.

Wilmer, Valerie. "Victoria: the Black Queen with Class." *Melody Maker*, 13 September, 38.

———. 1977. *As Serious As Your Life*. London: Quartet.

Wilson, John S. 1981. "A Rare Club Date For Mary Osborne." *New York Times*, 17 July, C20.

Wilson, Ruth Danenhower. 1944. *Jim Crow Joins Up*. New York: War Production Board.

"Wisconsin Historical Images." 2007. Wisconsin Historical Society. Http://www
.wisconsinhistory.org/, 7 June.
"With Ingenues Orchestra." 1937. *Down Beat,* April, 21.
"Woody Breaks Up His Band." 1946. *Down Beat,* 16 December, 1.
Woerner, Gail Hughbanks. 2007. "Behind the Chutes and Elsewhere: Mabel
Strickland, Always a Lady, Always a Cowgirl." Gail Hughbanks Woerner—One
of the foremost authorities on the history of rodeo; http://www.rodeoattitude
.com/dir_hd/gail/index.htm, 9 May.
Woll, Allen. 1989. *Black Musical Theater from Coontown to Dreamgirls.* Baton
Rouge: Louisiana State University Press.
"Women in Steel: They are Handling Tough Jobs in Heavy Industry." 1943. *Life,* 9
August, 75.
"Woman Orchestra Makes Radio Hit; Spitalny Proves Contention That They
Equal Men." 1935. *Washington Post,* 25 May, 9.
Woolston, Florence Guy. 1921. "On Trial." *Harper's Monthly* 144:527.
"Worrisome Days Along the Street; Biz is Sad." 1946. *Down Beat,* 4 November, 1.
Wukovits, John F. 2000. *The 1920s.* San Diego, Calif.: Greenhaven Press.
"Wynonie Harris and All-Girl Band on Apollo Stage." 1948. *New York Age,* 10 July, 5.
Yanv, Scott. 1987. "Rosetta Records: Women in Jazz." *Coda Magazine,* February–
March, 10–11.
"*You Can't Do Without Love* and In Person: All Girl Revue: Joy Cayler, Princess of
the Trumpet and Her All Girl Orchestra." 1945. *Los Angeles Daily News,* 12 No-
vember, 17.
"Ziegfeld 'Buys' Ingenues Many Want Lightner." 1927. *Morning Telegraph,* 20
June, n.p.
Zukor, Adolph. 1953. *The Public is Never Wrong: The Autobiography of Adolph
Zukor.* New York: Putnam.

Index

✢

Page numbers in *italics* refer to illustrations.

Abbot and Costello, 170–71, 175
ABC television network, 94, 203–7, 222
Abes, Holly, 156
Accent on Girls (1936), 88, 99–103, *100*
Ada Leonard and her All-Girl Orchestra. *See* Leonard, Ada
Adams, Carol, 148, *150*. *See also* Glamorettes, The
Adorno, Theodor, 23–24, 266n6
Adventures in Jazz, 208
Aeolian Hall concert (Paul Whiteman), 42–43, 271n14
AFM (American Federation of Musicians), 245, 249
African American jazz: African American adoption of jazz as racial music, 122–24; in all-black-cast musicals, 180–81, 187–91, 196; battle of the bands contests, 90; in *Big Broadcast* variety films, 93–94; black vaudeville, 49–51; "Creole" chorus dancers, 26; Depression-era censorship and, 98–99; exploitation of black musicians, 11; as inspiration for multiracial pluralism, 146–47; media bias and, 13, 35; Paul Whiteman on, 43–44; race records and, 29–30; "soul" imagery and, 102; SOUNDIES performances of, 146; "swinging the classics" and, 113–14, 116–17; urban black population and, 50; white audiences for, 54. *See also* race
African American television programming: African American variety shows, 206–8, 211; early experimental programming and, 204; *Hazel Scott Show,* 210, 221–24;

Hazel Scott television persona, 225; mainstream variety shows and, 202, 207. *See also* race
Agee, James, 130–31
agency/creativity: censorship of female virtuosity, 97–98, 99–100, 110; in early burlesque/variety entertainment, 31; folk music and, 43, 49, 174; *Hour of Charm* female composers, 70–71; Ingenues' musical appropriation and, 43–44, 48–49; musician crediting practices, 69, 71, 75, 135, 174, 197; musicianship as vehicle for, 13–14. *See also* feminine identity; professionalism
Agostini, Gloria, 230–31
Airforce (1943), 168
Albert, Don, 55
Albertina Rasch Girls, 42
Alexander, William, 180, 183–93, 195, 196–97
All-American Films, 184, 196
Allen, Gracie, 91–92, 96, 271n14
Allen, Steve, 208, 221, 240
All-Girl Golden Slipper Band, 196
All-Girl Jazz Bands (1993), 183
All Girl Revue (1929), 82
all-girl revues, 20–21, 32, 38, 48, 62. *See also* chorus-girl acts; female spectacles; Ziegfeld Follies
Of All People (1932), 151
American Council on Education, 186
American Federation of Musicians (AFM), 245, 249
American Film Center, 186
American Newsreel Films, 193, 196

Bon Jon Girls, 69

boogie-woogie: as Ada Leonard influence, 167; "Bach to Boogie-Woogie" concert, 121–23; boogie-woogie dance, 107; at Café Society, 120; Fats Waller as proponent of, 152; as folk music, 122–23; as Hazel Scott influence, 107, 119–20, 129; as "hot" style, 14; as Paul Whiteman influence, 231; racial associations of, 153; in *Rhapsody in Blue*, 125; as Thelma White influence, 151–54, 167; wartime reception of, 210

Boogie Woogie Dream (1942), 138

booking agencies, 20, 49, 51–52

Boone, Pat, 207, 230, 234, 234–36

Borrah Minevitch and his Harmonica Rascals, 146

Boswell, Connie, 268n3

Bottoms Up Revue, 53

Boxcar Rhapsody (1942), 146

Bracken, Eddie, 250

Braddy, Pauline, 191, 254

Bradford, Barbara, 196

Bradley, Edwin, 81, 268n7

Brady, Florence, 82

Bratten, Lola Clare, 209

Brice, Fanny, 97

Briscoe, Baby, 52–54, 67

British Blonde Burlesque Troupe, 266n9

Broadway Rhythm (1944), 115, 125–27, 138, 139, 210, 239

Broonzy, Big Bill, 233

Brown, Jayna Jennifer, 57, 181–82

Brown, Les, 109

Brown, Troy, 52

Bryant, Clora, 202, 211, 221, 254

Bryant, Willie, 54

Bunchuk, Yasha, 88

Bundle of Blues (1933), 89

burlesque: as Ada Leonard influence, 141–42; all-girl spectacles and, 61; commercialization of "girls" in, 69; early all-female troupes, 21–22, 266n9; as feminized form, 69, 148; as Ina Ray Hutton influence, 96; influence on jazz, 9, 141–44; primitivist imagery and, 96–97, 195; as sexualized entertainment, 31, 33, 59, 146

Burns, George, 91–92, 96

Burnside, Violet, 54, 56, 188, *188*, *190*, 191, 254

businessman's bounce, 159

Busse, Henry, 248

Butsch, Richard, 206, 208

Butter Beans and Susie, 51

Butterbeans, Barbara, 196

Byrd, Jennie, 54

Cabin in the Sky (1943), 181, 238–39

Cactus Cuties, 214

Café Society (New York), 113, 115, 118–20, 121–23

Calloway, Blanche, 59

Calloway, Cab: in Betty Boop cartoons, 23; in *Big Broadcast* variety films, 91–92; "Bugle Call Rag" recording, 104; in feature films, 198; in Hour of Charm's repertoire, 75; Irving Mills as agent for, 87; in short subject musical films, 89; in SOUNDIES, 146; theatrical performances by, 61; William Morris as agent for, 30

Candoli, Pete, 226

Cannon, Maureen, 230, 232

canonization: exclusion of women's jazz, 5, 7, 247; jazz as African American art form, 27; origin of the jazz canon, 255–56; postwar preservationism, 247

Cantor, Eddie, 92, 223

Cantor, Mark, 147, 185, 270n5, 271–72nn15–16

Carbine, Mary, 50–51

Carby, Hazel, 7, 58, 60, 132, 181, 190

Carnahan, Ruth, 47

Carnegie Hall (New York), 115, 116, 121–23, 132, 247

Carpenter, Elliot, 271n6

Carroll, Earl, 151

Carson, Norma, 217

Carter, Bennie, 143

cartoons, 23–24, 25, 146, 157–58. *See also* Betty Boop cartoons

Casablanca (1942), 270–71n6

Case, Russ, 237

Castle, Irene and Vernon, 26

Catholic Church Legions of Decency, 97

Cavalcade of Bands, 208

Cavalcade Orchestra, 87

CBS television network, 69, 117, 144, 157, 203–7, 211, 222

censorship. *See* Production Code Administration

Chekov, Michael, 252

Chester Hale Girls, 69

Chevalier, M. Maurice, 39

Chez Paris (Chicago), 87

Chicago Theater (Chicago), 90

Chicks and the Fiddle, The, 211

Chocolate Dandies (1924), 57

Chopin, Frédéric, 123, 155
chorus-girl acts: commercialization of "girls" imagery, 69; in Cotton Club revues, 181, 237–38; cultural representation of, 57–58; feminization of all-girl jazz and, 20–21, 56, 255; "modern woman" influences in, 28; representation of black women in, 181–82; Ziegfeld contributions to, 266–67n10. *See also* all-girl revues; Ziegfeld Follies
Christian, Charlie, 46
Chrysler Shower of Stars, 230
Chusid, Irwin, 158
class: black theater patrons and, 50; black women musicians and, 60; black women's sexuality and, 62; cultural uplift initiative, 62–63; female film viewing habits, 266n8; high/low musical categories, 27, 62, 77–78, 117, 123, 131, 135, 149, 268n6, 270n11; jazz slang and, 269n5; labor unions, 22, 144, 245; orchestrated dance/jazz music and, 26; "respectability" as feminine trait, 21, 33, 56, 78, 150; short subject musical films and, 81–82; slumming and, 101–2; subverted class identity in television variety shows, 209; vaudeville artist recruiting strategies and, 36–37; vaudeville ticket prices and, 22; working-woman image and, 99–100, 171
classical music: overview, 132–33; African American performers and, 114; "Bach to Boogie-Woogie" concert, 121–23; class association with, 62–63; classical training in Spitalny bands, 67–72, 253; Hazel Scott performances of, 114–16, 123–33; in Hour of Charm's repertoire, 75, 253; in Ingenues repertoire, 38–39; Jane Sager reputation in, 142; *Rhapsody in Blue* and, 124; "sweet" jazz style and, 78, 253–54; "swinging the classics" debate, 116–18. *See also* "swinging the classics"
Clowns over Clover revue, 87
Cole, Nat King, 207–8, 211, 225, 230
Colgate Comedy Hour, 203, 207, 209, 236, 240
Columbia Corp., 35, 82
Comeaux, Bessie, 54
Como, Perry, 227, 240
Condon, Eddie, 208, 215
Connie's Inn (Harlem), 26
Constitution Hall, 115
coon shouting, 31
Cooper, Gypsie, 71, 77, 79–80

Cooper, Zackie, 88
Coquettes, The, 142
Corbett, John, 270n2
Corley, Bob, 222
Coslow, Sam, 185
costume: displays of sexual glamour, 38, 69, 74, 89–91, 179, 195, 251, 253; Ina Ray Hutton style, 96, 98; male conductor costuming, 179; military uniforms as, 195; "passing fashions," 100–101; satirization of Victorian respectability in, 150–51; in SOUNDIES, 150–51; uniformity in all-girl revues, 10, 48, 84. *See also* body; sexual identity
Cotton, Jean, 41
Cotton Club (Harlem), 26, 96, 115, 181, 237–38
Cougat, Lorraine, 210
Cousins, Norman, 206
Cowan, Odessa, 86, 268n1. *See also* Hutton, Ina Ray
Cox, Ida, 183
Cripps, Thomas, 98, 184
criticism. *See* music journalism
Cron, Roz, 32–33, 141–42
Croonaders, 82
Crosby, Bing, 69, 89, 91–92, 93, 185, 226, 227, 250
Crosby, John, 222
Cross, Dale, 148–49
Crouch, William Forest, 185
Crowther, Bosley, 250–51
Crump, Eddie, 52–55
Cugat, Xavier, 242
cultural exoticism, 72
Cunningham, Inez, 25
Curtis, Tony, 250–51

Dahl, Linda, 7–8, 37, 268–69n2
Dale Cross's All-Girl "band," 148–49
dance: couple dancing, 26; in early female burlesque, 266n9; exotic dance in *Big Broadcast* films, 96–97; "hot" jazz and, 167; importance in 1930s all-girl bands, 47, 255; Ina Ray Hutton dance routines, 83–84, 90, 95, 102–3, 106, 216; "light dance music" musical category, 78; in sidelining films, 195; in SOUNDIES, 149, 162–63; tap dance, 83–84, 108–9; in television variety shows, 231–32
Dandridge, Dorothy, 93, 146
Daniels, Billy, 207
Darktown Minstrels, 51

Fee, Frank, 248

female impersonators, 82

female spectacles: overview, 8–10; Ada Leonard striptease act, 9, 141–44; Busby Berkeley musicals, 42, 45, 48, 61; commodification of all-girl jazz and, 20–21, 255; feminine subjectivity and, 31–32; SOUNDIES as suggestive of, 148; Ziegfeld Follies, 37, 40–42, 87, 90, 151. *See also* all-girl revues; body; chorus-girl acts; sexual identity

feminine identity: anti-jazz criticism and, 22–23, 25, 56–57; "charming/pleasing" representation, 53, 56, 79–80; commercialization of "girls" imagery, 69; downplayed professionalism, 69–72, 171–74, 254; emotion of early feminine film patrons, 266n8; fallen woman image, 189; "girl next door" cultural type, 148; intimacy/informality as feminine trait, 69–70; "modern woman" cultural type, 24–25, 27–29; novelty acts and, 41; representations in all-girl bands, 45–46; "respectability" representation, 21, 33, 56, 78, 150, 189; television influence on, 208–9; Victorian "cult of white womanhood," 10, 11–12, 171–79, 254; women as corrupting influence, 23, 33, 169–70; working-woman image, 97–98, 99–100, 134, 142, 245. *See also* agency/creativity; sexual identity

Feminine Rhythm (1935), 88

feminism: independence as feminine trait, 80; "modern woman" cultural type and, 24–25, 27–29; third-wave feminism, 183, 272n2

feminization of jazz: adoption of "sweet" style, 109–10, 252, 254; all-girl minstrelsy reenactments and, 48–49; feminization of mass culture, 21–22; reviewers' emphasis on appearance, 53, 74, 166; shifting 1920s gender roles and, 29, 62–63; "triple threat" performer profile, 1, 10, 67, 167, 254; wartime musical genres and, 134–35. *See also* sexual identity

Fetchit, Stepin, 194, 196

Fields, W. C., 90

film. *See* Hollywood; Kinetoscopes; musical feature films; short subject musical films; SOUNDIES

film houses. *See* theatrical entertainment

Fitzgerald, Ella, 104–5, 202, 207, 237

Five Joy Clouds, 52

"flapper" girl bands, 67

flash acts, 1, 41

"flash" jazz style, 94–95, 191–92

Flip Wilson Show, The, 240

Florida, La (Paris), 39

Folies-Bergères, 266n10

folk music: African American racial consciousness and, 122–24; at Café Society, 120; canonization initiatives for, 132; creative agency and, 43, 49, 174; depiction of musicianship and, 174; as feature film subject, 169, 271n14; jazz revivalism and, 270n1; Musical Queens use of, 84; in short subject musical films, 99; as source of national consciousness, 78; as "swinging the classics" resource, 116, 118, 131; as vaudeville feature, 47

Fontaine, Henrietta, 56

Foster, Stephen, 48

Fountaine, Madge, 54

Four Coeds, 52

Fourteen Bricktops, 254

Fox Movietone, 82

Francis, Terri Simone, 181

Frank Fee and the Honey Bees, 248

Frankfurt school social theory, 23–24, 266n6

Frank Sinatra Show, 207, 226. *See also* Sinatra, Frank

Frazee Sisters, 88

Frazier, George, 20

Freed, Arthur, 131–32

Frosty Frolics, 213

Future Stars (1930), 86–87

Gabbard, Krin, 7

Gange, Marian, 88

Garber, Marjorie, 124

Garland, Judy, 215

gender. *See* feminine identity; feminism; feminization of jazz; masculinity; sexual identity

Gendron, Bernard, 7, 268n6, 270n1

genre: as codification of cultural difference, 3; jazz stylistic classifications, 8; television influence on, 244; wartime musical genres and, 134–35

German Weimer-period bands, 266n6

Gershwin, George, 43, 78, 115–17, 124–26

Gibson Navigators, 32

Gilbert, Peggy, 32

Gillespie, Dizzy, 186, 208

GI Movie Weekly series, 115, 127–29

"girls orchestra" ensemble type, 67

Military Dancing Girls, 42

Miller, Glenn: in feature films, 168, 170, 185, 190–91; in SOUNDIES, 157; "swinging the classics" arrangements, 116, 159–61; "swing" style orientation of, 163; wartime swing organizations and, 185

Millinder, Lucky, 90

Mills, Florence, 57, 238

Mills, Fred, 145

Mills, Irving, 20, 67, 86, 87, 106, 145, 158

Mills, Verlye, 157

Mills Brothers, 91–92, 104, 146

Milton Berle Show, 207. *See also* Berle, Milton

Minevitch, Borrah, 146

Mingus, Charles, 224–25

minstrelsy, 20–21, 45, 47–48

Miranda, Carmen, 151, 239

Miss Babe Eagan and Her Hollywood Redheads, 35

Mistresses of Rhythm, 145, 147–48, 166–67, 183. *See also* Rio, Rita

modernism: in *Big Broadcast* variety films, 94; Depression-era feminine imagery and, 98; jazz modernism, 78–80, 135, 270n1; "modern woman" cultural type and, 24–25, 27–29; in television variety shows, 231–32; in Vitaphone shorts, 83. *See also* mass culture; mass media; urban modernity

"modern woman" cultural type, 24–25, 27–29

Moments of Charm (1939), 171

Monogram Theater (Chicago), 51

Monroe, Marilyn, 250–51

Montand, Yves, 225

Moore, Billie, 120

Moore, Florence, 82

Moore, Orvella, 52, 54

Moraga, Cherríe, 272n2

Moreland, Mantan, 196

Morris, William, 20, 30, 145, 268n1

Morton, Jelly Roll, 266n6

Mosier, Gladys, 88

Motion Picture Producers and Distributors of America. *See* Production Code Administration

movie musical spectaculars. *See* musical feature films

Mozart, Wolfgang Amadeus, 159–61, 166

Mr. Music (1950), 210, 226

Murphy, Dudley, 185

Murray, Matthew, 205

Music '55, 208, 240

Musical Charmers (1936), 171

Musical Fashions (1936), 88

musical feature films: all-black-cast musicals, 57–58, 180–81, 189–91, 196–98; big-budget spectaculars, 239; Chester Hale Girls in, 69; depiction of women in, 14, 169–74, 190–91, 255; feminine musical uniformity in, 84; Hazel Scott films, 13–14, 124–32; jazz cameos of the 1940s, 168–69; Lena Horne films, 14, 125–27, 129–32, 138–39, 170, 238–39; patriotic war films, 173–74, 185–86; SOUNDIES and, 134, 182–83, 186; spoofs of all-girl bands, 250–51; "swinging the classics" films, 124–32. *See also* Hollywood

Musical Queens, 13, 80, 82–84, *83,* 109–10. *See also* Hour of Charm; Spitalny, Phil

musicianship: "auditioning" scenes, 127, 187–91; depiction of musical facility, 178–79, 187–89; "flash" jazz style, 94–95, 191–92; gendered double standard of, 79–80, 95–96, 130–32, 135, 166, 190–91, 216–17; gendered instrumentation, 178–79; in the Harlem Playgirls, 54–55, 59; musical training in Hour of Charm, 73–76; musical versatility, 44–45, 59, 61–63, 67, 175, 255; sidelining, 147, 193–96, 271n9; in SOUNDIES, 148, 155–56; in Spitalny bands, 85; in television variety shows, 216–17; in *That Man of Mine,* 180, 187–91, 196. *See also* professionalism

music journalism: antiprofessional depictions of women musicians in, 172–75; black all-girl band reviews, 50; concern for returning GI musicians in, 248; gendered double standard of musicianship and, 79–80, 95–96, 166, 216–17, 256; Hour of Charm reviews, 73–75; Ingenues reviews, 44–45; jazz as high art in, 270n1; jazz invention-by-women views, 25, 29; Melodears reviews, 73–74, 89–90; "modern woman" influences and, 28–29; neglect of all-girl groups, 20; "negrophile" writing, 125; on Peggy Lee, 226–30, 236–37; postwar distaste for integrated forms, 256; on *Some Like It Hot,* 251; on "swinging the classics" performances, 121–33, 158; trade magazine debates on jazz women, 9; on variety television shows, 213–14, 216–17, 219, 222. *See also* anti-jazz criticism

Music Maids (instrumental group), 147

Music Stand, 226, 232–33

music videos, 236, 244

Primas, Pearl, 120

primitivist imagery: in Betty Boop cartoons, 24, 266n7; in Cotton Club revues, 181, 237–38; exotic dance in *Big Broadcast* films, 96–97; in Harlem Playgirls presentation, 56, 60; hypersexual African American stereotype, 181, 189, 197; in Paul Whiteman style, 42; proscription in artist contracts, 239–40; racial caricature, 146, 181; Spitalny distaste for, 79; "urban primitivist" imagery, 239

Printz, LeRoy, 96

Proctor, Alice E., 54

Production Code Administration (PCA), 80, 86, 93, 97, 98, 110

professionalism: assertion of personal/musical agency and, 10; downplayed professionalism, 69–72, 171–74, 254; film depiction of female bandleaders, 170–71; Hazel Scott television persona, 225; marriage as career sacrifice, 77, 80, 142; musical markers of, 8; postwar performing opportunities and, 245; resentment of women's workplace success, 97–98; sex appeal as professional strategy, 90; sheet music/music stands use, 95; in *That Man of Mine*, 187, 196–97. *See also* agency/ creativity, musicianship

prostitution, 21, 59–60

Queens of Rhythm, 49, 61, 63

Queens of Swing, 254

"Queens of Swing" (Harlem Playgirls), 54. *See also* Harlem Playgirls

race: African American adoption of jazz as racial music, 122–24; African American theatrical characterization, 195, 196–98; "all-colored" designation and, 192–93, 197; all-girl minstrelsy reenactments and, 48–49; in Betty Boop cartoons, 24, 266n7; black vs. white musical repertoire, 63; Cotton Club racial discrimination, 238; cross-race/miscegenistic sexual appeal, 119, 137–38; disparagement of black female performers and, 57; Ed Sullivan assimilationist programming, 241; "hot" jazz style and, 102; "international" designation and, 93, 192–93, 197; mediation of stereotypes in African American film, 195; mixed-race bands, 93; neutralized as "experiments in cultural taste," 2;

Orientalism in Kinetoscope images, 3; Paul Whiteman jazz style and, 43–44; racial caricature, 24, 146, 181, 237n10, 266n7; racial discrimination in the military, 137; racial integration, 146; racial invisibility, 137, 192, 197; racial mixing, 26, 119; racial muting, 131; racial segmentation of performance spaces, 11, 33, 50–51, 265n1; racial uplift theory, 184–85; racism in classical music, 114; slumming and, 101–2; "swinging the classics" as racial blurring, 113–14, 119; vaudeville artist recruiting strategies and, 36–37; white all-girl spectacles, 61–62, 253. *See also* African American jazz; ethnicity; primitivist imagery

race records, 29–30, 147

Rachmaninoff, Sergei, 123

Radano, Ronald M., 123

radio: competition with film studios, 92; Hormel Girls Caravan broadcasts, 249; *Hour of Charm* radio broadcasts, 69–72, 268n3; influence on early television, 203–4; *Jubilee* radio broadcasts, 138–39; *Saturday Night Swing Session* program, 157; *Your Hit Parade* program, 157

Radio-Keith-Orpheum circuit. *See* RKO circuit

Rainey, Ma, 29–30

Rankin, Jean, 82

Ratoff, Gregory, 115

Ravel, Maurice, 75, 78, 123, 161, 166

Ray, Marvel, 86

Raye, Martha, 69, 209–10, 230, 268n3

Ray Fabing's Ingenues. *See* Ingenues

Raymond Scott Quintette, 157

Realization of a Negro's Ambition (1916), 185

Red Channels, 222–23, 269n1

Red Nichols and his Five Pennies, 268n8

Reed, Bill, 223

Reefer Madness (1936), 151, 272n17

Reinhardt, Django, 99, 104, 224, 268n8

Reisenweber's cabaret, 30

reissue productions, 146, 182–83

Reitz, Rosetta, 183

Rentz Santley Company, 266n9

reviews. *See* music journalism

Rhapsody in Blue (1945), 115, 124–26, *125*, 139, 210, 225, 271n14

Rhythmettes, 93

Rhythm in a Riff (1946), 186

Rhythm magazine, 158

television compared with, 216; TOBA circuit, 49, 51, 52; USO tours, 137, 141, 143, 151, 185, 193, 195, 253
Towles, Nat, 55
trade magazines. *See* music journalism
Trianon (Chicago), 246
Trigg, Gwen, 54
"triple threat" performer profile, 1, 10, 67, 167, 254
Trooper of Troop K, The (1916), 185
Troup, Bobby, 208
Tucker, Earl "Snakehips," 103, 107
Tucker, Sherrie: on Baby Briscoe, 53; on femininity in Hour of Charm, 171; on the Harlem Playgirls, 55; on the International Sweethearts of Rhythm, 180, 192; on masculinist jazz historiography, 7–8; on wartime Hollywood pinups, 135–36; on wartime jazz women, 5–6
Tucker, Sophie, 21–22, 30–31
TV's Top Tunes, 230
21 Swinghearts. *See* Dave Schooler's 21 Swinghearts; Schooler, Dave
Two Girls and a Sailor (1944), 271n14

United Artists Corp., 82
Universal Corp., 82, 145, 170–75
Uptowners, 93
urban blues, 29–30
urban modernity: black bourgeois concern with women's sexuality, 62; chorus-girl acts as mediating influence, 57–58; cosmopolitanism at Café Society, 118–20; jazz entertainment relationship to, 2; jazz slang as component of, 89; moral panic response to urban popular culture, 58–59; slumming and, 101–2; women as corrupting influence in, 23, 33. *See also* modernism
USO tours, 137, 141, 143, 151, 185, 193, 195, 253

Vadel Quartet, 254
Vallee, Rudy, 92
Vanities of 1942 revue, 115
Variety magazine, 31–32, 86, 222, 236–37, 248, 251
variety revues, 19–20, 39, 53–54, 67, 230
vaudeo television program format, 15, 203, 214, 243, 252, 273n2 (Ch. 9)
vaudeville: all-girl jazz bands competition from, 10; all-girl revues contrasted with, 38; black vaudeville music circuit, 51; class diversity in audiences, 22; feminization of,

21–22, 33, 62–63, 255; Hollywood recruitment of performers, 92; Ingenues influenced by, 37–38, 254–55; media coverage of, 31–32; musical versatility in, 62; "novelty" or "specialty" acts, 21, 41; picture palaces competition with, 267n2; rural southern music in, 47–48; sound film presented in, 33, 38, 267n2; use of all-girl bands, 19, 33, 54; vaudeo television program format, 15, 203, 214, 243, 252, 273n2 (Ch. 9); vaudeville-style jazz bands, 254–55
Victor and his Music Makers, 55
Victorian era: "cult of white womanhood," 10, 11–12, 171–79, 254; satirization of, 150; Victorian representation in all-girl jazz performance, 45–46
Victor Recording Melody Masters, 68–69
La Vie en Rose (New York), 228
Vienna Choir Boys, 93, 96
Villas, Ernest, 249
Virgil Whyte's Musical Sweethearts, 156, 252, 254
Vitagraph Corp., 80
Vitaphone Corp., 37, 61, 80–82, 151, 255
Vocalion Corp., 37

Waller, Fats, 51, 89, 101, 146, 151, 269n4
Waller, Fred, 89, 99, 102–3
Walters, Zackie, 214
Warner, Sam, 81
Warner Bros. Corp., 80–82
Washburn, Genevieve, 39
Waters, Ethel, 57, 60, 204, 222
Wayman's Debutantes, 35
Wayne, Mabel, 69, 71
Webb, Chick, 90, 104
Weiss, Andrea, 183
Welk, Lawrence, 104, 146, 248
Wells, Alyse, 88, 101, 102
West, Mae, 97, 115
Westbrook, Robert, 136
What Price Jazz? (1934), 151
What's My Line?, 224, 240
When Johnny Comes Marching Home (1943), 7, 170–74, 250
White, George, 87
White, Josh, 227
White, Thelma: overview, 151; death of, 272n19; "hot" jazz style of, 14; in SOUNDIES, 145, 148, 151–55, *152–54;* wartime pinup appeal of, 141, 166–67. *See also* Thelma White and Her All-Girl Orchestra

Whiteman, Paul: Aeolian Hall concert, 42–43, 271n14; influence on all-girl repertoires, 109; Ingenues as comparable with, 40, 42; on musical training, 78; sweet style of, 42, 85, 253; "swinging the classics" and, 116–18, 150; swing orchestra style of, 27, 42–44; television career of, 207–8, 226, 230–32, 231

White Rats, 22, 265–66n5

Whyte, Virgil, 156, 252, 254

Wilder, Billy, 251

Wiley, Lee, 227–28

Williams, Bert, 51

Williams, Edna, 187

Williams, Johnny, 158

Williams, Kathleen, 77

Williams, Linda F., 7

Williams, Mary Lou, 120–21, 247

Williams, Spencer, 186, 273n8

Wilson, Dooley, 270–71n6

Wilson, Teddy, 93, 120–21, 123, 238

Wilson, Vi, 254

Winburn, Anna Mae, 187, 191, 197

Winslow, Dick, 271n9

Winstead, Mardell "Owen," 88

Winstead Trio, The, 103–4

Wintergarden Theater, 38; Ingenues performances at, 44–45

Woll, Allen, 181

Women in Jazz compilation video, 183

Women's Christian Temperance Union (WCTU), 68, 97

Women's National Exposition of Arts and Industries, 71

Woode, Henri, 188–89

Woolston, Florence Guy, 29

Words and Music (1948), 239

World War II: appropriation of public support, 136, 140–41; decline of big bands, 109, 245–46; effect on male jazz performers, 9; patriotic war films, 173–74, 184, 185–86; postwar returning GI musicians, 245, 248; racial discrimination in the military, 137; as song lyrics theme, 129; SOUNDIES as wartime patriotism, 147, 149, 151; transformation of sexual identity and, 8; wartime swing organizations, 134–35, 137, 141–43, 253; wartime working women, 134, 142, 245, 253. See also postwar era

Wright, Jo-Ella, 214

Yacht Club Boys, 82, 268n3

Yellowjackets, 88

Young, Myrtle, 254

Young, Victor, 147

Your Show of Shows, 203, 240

Ziegfeld, Florenz, 28, 33, 37, 40–41

Ziegfeld Follies, 37, 40–42, 87, 90, 151, 266–67n10. See also chorus-girl acts

Ziegfeld Follies, The (1946), 138, 210, 239

Zoot (1946), 151

Zukor, Adolph, 171

MUSIC/CULTURE
A series from Wesleyan University Press
Edited by Harris M. Berger and Annie J. Randall
Originating editors: George Lipsitz, Susan McClary, and Robert Walser

Banda:
Mexican Musical Life across Borders
by Helena Simonett

Global Soundtracks:
Worlds of Film Music
edited by Mark Slobin

Subcultural Sounds:
Micromusics of the West
by Mark Slobin

Music, Society, Education
by Christopher Small

Musicking:
The Meanings of Performing and
Listening
by Christopher Small

Music of the Common Tongue:
Survival and Celebration in African Ameri-
can Music
by Christopher Small

Singing Our Way to Victory:
French Cultural Politics and Music During
the Great War
by Regina M. Sweeney

Setting the Record Straight:
A Material History of Classical
Recording
by Colin Symes

False Prophet:
Fieldnotes from the Punk Underground
by Steven Taylor

Any Sound You Can Imagine:
Making Music/Consuming Technology
by Paul Théberge

Club Cultures:
Music, Media and Sub-cultural Capital
by Sarah Thornton

Dub:
Songscape and Shattered Songs in Jamaican
Reggae
by Michael E. Veal

Running with the Devil:
Power, Gender, and Madness in Heavy Metal
Music
by Robert Walser

Manufacturing the Muse:
Estey Organs and Consumer Culture in Vic-
torian America
by Dennis Waring

The City of Musical Memory:
Salsa, Record Grooves, and Popular Culture
in Cali, Colombia
by Lise A. Waxer

ABOUT THE AUTHOR

Kristin A. McGee is an assistant professor of popular music at the University of Groningen in the Netherlands.